Mark E. Neely, Jr., Harold Holzer, and Gabor S. Boritt

The Confederate Image

P R I N T S O F T H E L O S T C A U S E

University of North Carolina Press / Chapel Hill and London

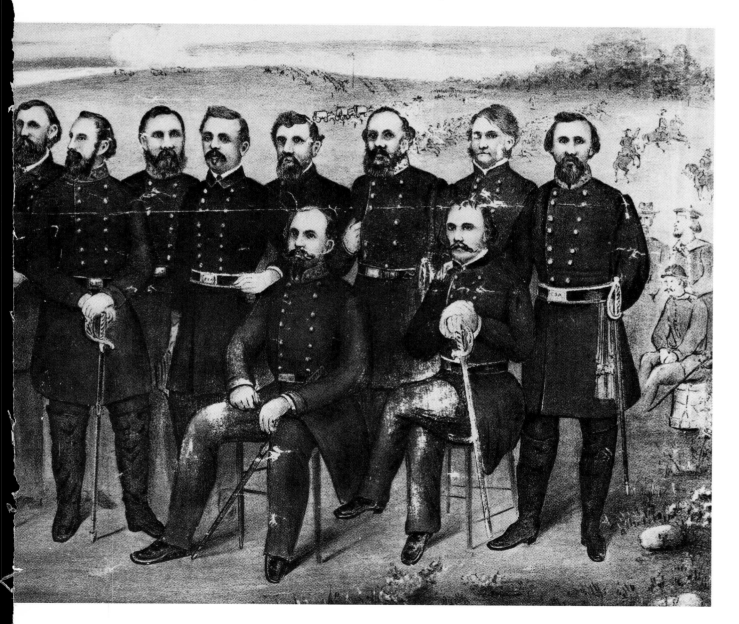

© 1987 The University of North Carolina Press

All rights reserved

Manufactured in the United States of America

Library of Congress Cataloging-in-Publication Data

Neely, Mark E., 1944–

 The Confederate image.

 Bibliography: p.

 Includes index.

 1. United States—History—Civil War, 1861–1865—
Portraits. 2. United States—History—Civil War,
1861–1865—Art and the war. 3. Confederate States of
America in art. 4. Portrait prints, American.
I. Holzer, Harold. II. Boritt, G. S., 1940–
III. Title.

E467.N44 1987 769′.49973713 86-30797

ISBN 0-8078-1742-2

ISBN 0-8078-4197-8 (pbk.)

For Edith Holzer, again and always.

H.H.

For Anita Wilson Norseen Hooker,

and to the memory of Russell Houghton Hooker.

G.S.B.

Contents

Color plate section follows page 2.

Introduction: The Burial of Latane

Douglas Southall Freeman, eminent historian of the Confederacy and biographer of Robert E. Lee, remembered Southern children "gazing from infancy" at an inspiring picture that graced the walls of many of their homes. The pictures provided something more than mere decoration. By questioning their mothers and fathers about them, Freeman recalled, new generations of Southerners had learned "with their first history lessons the story that inspired their parents." Freeman was not the only learned observer to take note of the picture and its impact. Frank Vandiver spoke of its "fantastic popularity," saying, "Copies can still be found in attics and other hiding places." And as late as 1976, Virginius Dabney reported that the picture "still hangs in Richmond homes."

The ubiquitous picture of which these scholars spoke was a nineteenth-century engraving showing a group of white women and black slaves performing a burial service over a coffin draped with a heavy cavalry overcoat. Not only was it a representative tribute to the Southern dead but, as the *Confederate Veteran* observed in 1929, it also depicted "the spirit of the women of the South." As much as any other Confederate image, it successfully touched a special chord of memory for the people of the South. The Virginia judge who, in 1963, purchased the original painting on which the engraving was based testified that he had heard the story of the picture "since I was a child, and throughout my life have seen many of the steel engravings hanging on walls of this county and neighboring counties. I really believe that these engravings helped to hold the Southern People together as one after the war."[1]

The engraving was entitled *The Burial of Latane*, and its story originated in the Peninsular Campaign of 1862, when the Confederacy repulsed the first massive Union assault against Richmond. With the aid of an exultant Confederate press, the new heroes who emerged from this campaign captured the popular imagination. Chief among them was Robert Edward Lee, who assumed command when Joseph E. Johnston was incapacitated, and who somehow managed to turn back superior Union forces. Among the most flamboyant of the new Confederate heroes was J. E. B. ("Jeb") Stuart, the swashbuckling cavalry commander who staged a dramatic and daring four-day reconnaissance ride around the entire Union force, providing Lee with information crucial to Confederate success on the Peninsula. Stuart lost only one man during the entire mission—a twenty-nine-year-old doctor named William D. Latane. This lone casualty, a captain of volunteers from a prominent Virginia family, would come to enjoy a fame that for a time rivaled that of his daring commander.

Such a turn of events seemed unlikely in the summer of 1862. The Stuart reconnaissance mission encountered little initial resistance, but on June 13, the second day of the sweep, a Federal force moved onto a road near Old Church in Hanover County, north of Richmond, and Stuart ordered the company nearest the enemy to attack. It was Latane's unit. In the skirmish that followed, the Union force was turned back, but Captain Latane—who charged ahead, sword drawn, in a failed attempt to behead the rival commander—was shot four or five times and killed. As Richmond journalist John Esten Cooke observed, Latane's violent death ignited an instant legend. "As the men of his company saw him lying bloody before them," he wrote, "many a bearded face was wet with tears." Stuart, whose vivid battle reports helped create his own cavalier image, later stated that Latane died "leading his squadron in a brilliant and successful charge, the enemy routed and flying before him," adding, "his regiment will want no better battle cry, than 'Avenge Latane.'"[2]

Not even Jeb Stuart could have predicted that Latane would become more than an inspiration to a small unit

of troops—that instead, he would be transformed into one of the best-known and most deeply mourned of all the lower-echelon casualties of the war. The sanctification was attributable to a poem and, in large measure, to a popular print. The print did not, however, portray Latane's charge or fall, but, rather, the way he was laid to rest. An original artistic response to a commonplace occurrence of war successfully elevated this minor tragedy into a major legend.

After Latane's death at Old Church, his brother John, a lieutenant in the same company, took charge of the body. When a corn cart from the nearby Westwood Plantation rolled into view, John Latane asked whether it might be used to transport his brother's remains away from the fighting. Aided by the slave who was driving the wagon, Latane cleared the cart of its cargo, loaded his dead brother into the back, and returned with the body to Westwood, two miles away.

There were no white men living there at the time —all were at the front—but Mrs. William Brockenbrough, the mistress of Westwood, took the body into her home and sent Lieutenant Latane back to his unit, assuring him that William would be buried "as tenderly as if he were her brother." Mrs. Brockenbrough's sister-in-law, Mrs. Willoughby Newton, who at the time was visiting Summer Hill, the adjoining family plantation, observed: "Oh, what a sad office. This dear young soldier, so precious to many hearts, now in the hands of sorrowing, sympathizing friends, yet, personally, strangers to him." Mrs. Newton probably did not know it, but she was touching a cultural nerve. So many young Southern soldiers were dying alone in unfamiliar places that the Latane episode could symbolize the collective fears and hopes of the entire Confederacy.[3] These women became the symbolic angels of mercy prayed for by every mother whose son might face a similar fate.

The day after the battle, slaves from Westwood and Summer Hill fashioned a simple coffin and cleaned and dressed the body. Mrs. Brockenbrough cut a lock from Latane's hair, "as the only thing we could do for his mother." Then she dispatched a slave to fetch the family minister to preach the funeral service. But Union pickets blocked the messenger, preventing him from reaching the clergyman. And so the women "took the body of our poor young Captain, and buried it ourselves in the graveyard at Summer Hill, with no one to interrupt us." Mrs. Newton read the Episcopal funeral service herself, witnessed by Mrs. Brockenbrough, a few slaves, and a group of small children; the little girls covered "his honoured grave with flowers." Latane and a member of the plantation family killed earlier in the war now lay "side by side," Mrs. Newton recalled, "martyrs to a holy cause."[4]

Almost immediately, the details of Latane's death and burial were widely reported in the Richmond newspapers. Then, for the July–August issue of the *Southern Literary Messenger*, John R. Thompson contributed a eulogy in verse. Thompson, the twenty-four-year-old owner of the *Messenger*, was an important literary voice in the South. An ardent sectionalist, he described his magazine as "a guardian of Southern rights and interests . . . ever prompt to defend those rights and interests when they are made the objects of ruthless assault." Thompson did not serve in the Confederate army, but he did serve the cause with poetic tributes to Confederate martyrs, including Turner Ashby and Jeb Stuart. The most famous of his efforts described the death and burial of the captain from Virginia, a tribute not only to "our early lost, lamented LATANE," but to the heroic women who had laid his body to rest. It was these women who

. . . in accents soft and low,
Trembling with pity, touched with pathos, read
Over his hallowed dust the ritual for the dead.

The poem caused an instant sensation, and before long it had been republished as a broadside and was being distributed on the streets of the capital.[5]

Let us not weep for him, whose deeds
 endure;
 So young, so brave, so beautiful; he died
As he had wished to die—the past is sure.
 Whatever yet of sorrow may betide
Those who still linger by the stormy shore,
Change cannot touch him now, or fortune
 harm him more.

And when Virginia, leaning on her spear—
 "Victrix et Vidua," the conflict done—
Shall raise her mailed hand to wipe the tear
 That starts as she recalls each martyred
 son,
No prouder memory her breast shall sway
Than thine, our early lost, lamented
L A T A N E.

One of the Virginians who undoubtedly read or heard recitations of Thompson's poem was a young local artist named William De Hartburn Washington, a distant relative of the first president. Washington had studied art under Emanuel Leutze. Well schooled in historical painting, the Confederate artist decided to attempt what he probably supposed would be a highly saleable canvas based on "The Burial of Latane." Mrs. Newton, with prayer book in hand, was to be the central figure of the scene.

Washington completed his 4′ by 3′ canvas (plate 1) in 1864. According to one account written some forty years later, it was first exhibited in a local framing shop; another recollection placed the premiere showing at Richmond's Minnis and Cowell photography studio, where the picture reportedly attracted "throngs of visitors" and created "a furor." All accounts agree that *The Burial of Latane* was exhibited at the Virginia state capitol where, according to an irresistible legend, a bucket was placed in front of it to encourage donations to the cause. Another bit of folklore claims that a farm woman sold her cow to come all the way to

Richmond so she could throw her wedding ring into the collection pail.[6]

Despite the romantic fervor aroused by its unveiling, however, Washington could not at first find a buyer for the picture. "In those grim days," one contemporary observer explained, "no one had money to spend on paintings." Finally the picture was sold to a private collector, but it soon vanished, remaining lost for generations. In any case, the original canvas was eclipsed in importance by the hugely successful print adaptation, which achieved widespread circulation in the South after the war and earned positions of honor in innumerable Southern parlors, as historians Freeman, Vandiver, and Dabney remembered so vividly (fig. 1).

The engraving was produced by A. G. Campbell, who probably worked from a photograph of the canvas Washington had commissioned before disposing of the original. The print sold at first for twenty dollars, a hefty sum in the impoverished postwar South, and its broad circulation testifies to the devotion the Lost Cause would inspire for years to come. It also testifies to some considerable promotional genius in its behalf. The *Southern Magazine*, heralding the print as an "extraordinary" work of art, began offering copies as premiums for $1.50 annual subscriptions. The "superb steel engraving," they said, would be sent through the mail, "securely boxed." "We feel assured," the publishers added, "that no one can see this large and splendid Engraving—which will make a most beautiful and appropriate ornament for any parlor—without wishing to possess it."[7]

At around the same time, the magazine's publishers offered all of their agents one free copy of the Campbell print for every five orders from their stock list of books. "For orders of fifty books," they promised, "twelve copies of the engraving will be given." The publishers heralded the scheme as "an opportunity that is seldom offered," adding, "we feel sure you will miss a chance of making money if you do not engage with us at once. The Engraving you can easily sell for

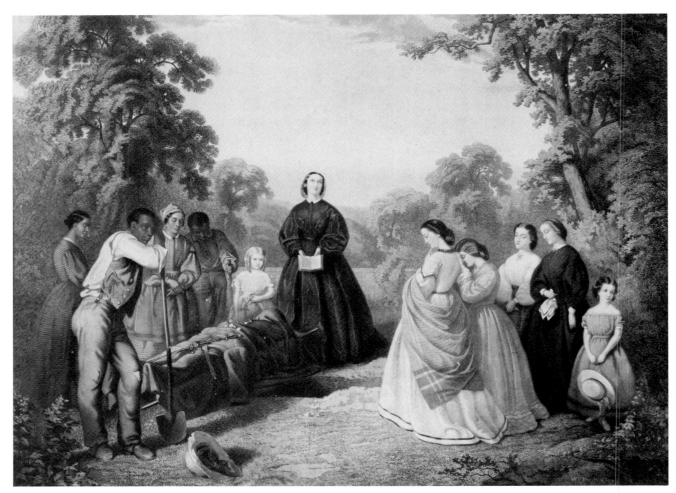

Figure 1.
A. G. Campbell, after William D. Washington, *The Burial of Latane*. Signed, lower left: "W. D. Washington 1864." Copyrighted by W. H. Chase. Published by William Pate, New York, 1868. Engraving, 24 x 31⅞ inches. Among the most popular of all prints of the Lost Cause, Campbell's engraving was a tribute to the sacrifices of the heroic women of the Confederacy. Few of its many owners realized, however, that the women actually portrayed were the flower of Richmond society. Memories proved a little vague by the turn of the century, when Richmond gossip Thomas Cooper DeLeon identified the models, but they included DeLeon himself, Page McCarty, William B. Myers, Jennie Pegram, Mattie Waller, Lizzie Giles, Mattie Paul, and, as the little Newton girls, Imogen Warwick and Annie Gibson. The hardest job, DeLeon remembered, was posing as "the corpse on the bier. . . . To lie prone for forty minutes under a heavy cavalry overcoat, on a rough cot and beneath a sun-heated tin roof was not inspiring, save with changed first syllable" (DeLeon, *Belles, Beaux and Brains*, 291). (*Eleanor S. Brockenbrough Library, Museum of the Confederacy*)

$5.00, as it is in every particular a first-class piece of art. If you have any friends in this city, write them to call and see it at our store, and report to you their opinion of it."[8]

Campbell's print of *The Burial of Latane* became one of the most famous icons of the Lost Cause, a tribute to the vision of its artist, the skill of its engraver, and the marketing ingenuity of its publisher and promoters. By capturing both the universal sorrow over so many young men lost in war and the valor of Southern women left behind to raise families, maintain homes, and cope with emergencies, the picture registered an emotional impact on several levels. It extolled the virtues of womanhood and faith and the common bond of mass mourning, and, not incidentally, it portrayed black men as eternally loyal to the peculiar institution that shackled them. The comfortable mixing of black and white people, suggesting harmonious master/slave relations, must have appealed to whites who felt threatened by sweeping changes in the South's racial system after the war. Writing in the *Confederate Veteran*, Mrs. William Lyne recognized that above all the print symbolized "the sacredness of those days when the women of the South had to take the place of men and even read the burial service for the dead, for the men were all in the war." Douglas Southall Freeman thought it uniquely expressive of "a tradition of the lofty devotion of womanhood."[9]

And women were important customers for prints. As early as the 1850s the Reverend G. W. Bethune had written that prints were to be considered "signs of fondness for home, and a desire to cultivate virtues, which make home peaceful and happy." That sentiment was echoed in the Beecher sisters' 1869 bible of the family hearth, *The American Women's Home*. Catherine Beecher and Harriet Beecher Stowe preached the value of displaying "reminders of history and art." Through popular art, they contended, "children are constantly trained to correctness of taste and refine-

ment of thought."[10] Surely it was the print's ability to convey the spirit of this important cultural tradition that helped guarantee the unparalleled popularity of *The Burial of Latane*, one of the few Lost Cause images to portray the war from a woman's point of view.

A "symbol of the sacrifice and courage of the women and men who had experienced the debacle of war," as art historian Jessie Poesch has described it, *The Burial of Latane* "became an emblem of the Lost Cause." And yet, despite its immediate popularity and its sustained impact on Southern culture, the print has only recently become the subject of published studies and has remained unexamined in the context of the countless other "Lost Cause" images produced in the years after Appomattox.[11]

More than a century has passed since Campbell's engraving and scores of other pictorial tributes to the heroes and martyrs of the war were first circulated throughout the South. These pictures served to revive and sustain Southern identity after the collapse of the Confederacy, providing a visual accompaniment to the embracing and enduring myth of the Lost Cause. But there has been no attempt either to categorize or criticize this body of American graphic art or to place it in the context of the culture that inspired it and the commerce that created it. This book begins that process.

The clearest indication of historians' neglect of these prints lies in their failure heretofore to notice that, for all their importance in helping "to hold the Southern People together as one after the war," the pictures were almost entirely the products of Northern craftsmanship. A. G. Campbell engraved *The Burial of Latane* in 1868 for William Pate, the proprietor of one of New York City's best-known printmaking houses. This Yankee entrepreneur invested three thousand dollars in the plate. Together the painter, the engraver, the printer, and the numerous purchasers of the print gave unwitting testimony to the reemerging bonds of American nationalism, for the very symbols

of fealty to the Confederacy would not have existed without the complicity of Northerners. Leaders of the Lee Memorial Association, the Jackson Monument Association, and other diehard Southern patriots soon trekked North to contract with Yankee engravers, printers, and distributors for lithographs and engravings with which they hoped to evoke memories of, and raise funds for, the Lost Cause. Northern printmakers seized the opportunity offered by a reopened Southern market to profit from prints of Confederate subjects. In fact, of some 150 separate-sheet lithographs and engravings with a Confederate theme published between 1866 and 1907, less than a half-dozen were produced in the states of the former Confederacy.

As much as we might like to imagine what transpired when a representative of the Lee Memorial Association commissioned a Lee portrait from Adam Walter—the same Adam Walter who had recently engraved an extremely popular print of the Lincoln family—we will probably never know. For printmaking was a business. Its proprietors and craftsmen kept their eyes on the market and attempted to predict future demand. These talented men and women did not work with an eye to posterity; they did not leave the sort of written records that would permit the modern student of prints to reconstruct the origins of their works. They left only the works themselves, dozens and dozens of them: portraits of Robert E. Lee, Stonewall Jackson, and Jefferson Davis; deathbed scenes, battle vignettes, and flags—beautiful pictures, crude and ugly ones, large ones and small, maudlin scenes and inspiring ones.

It is difficult to imagine an era in which such humble pictures satisfied a mass hunger for evocative portraits and scenes. But in the century before instantaneous photography, cinema, and slick magazines, such images were precious, and they found honored places above Southern hearths. The visual records of the Lost Cause, made in the North after the cause was lost, were ample, as the following pages should prove, and remain stunning even to the jaded eye of the modern American.

Part I

The Cause, 1861–1865

Printers News Ink
Who has any for sale?
Where is it?
What is the price?
Why doesn't somebody make it?
Nothing would pay better.
Where is ink made?
Address us immediately.

—Advertisement in *Southern Confederacy*,
 May–June, 1862

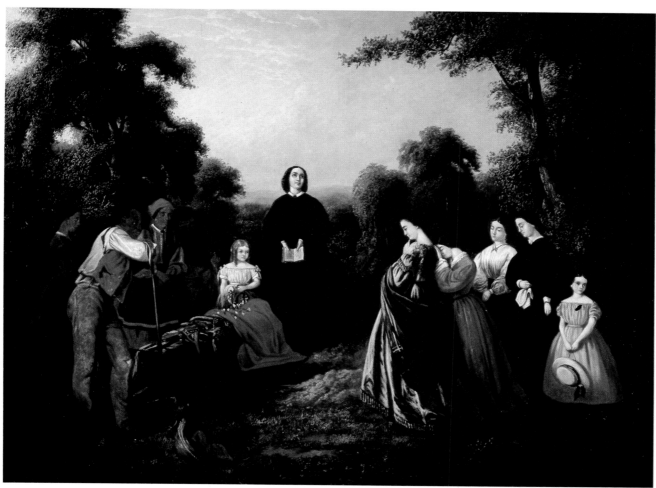

Plate 1.
William DeHartburn Washington, *The Burial of Latane*. Oil on canvas, 36 x 46 inches. Richmond, 1864. One of the most famous of all Lost Cause images and the model for one of the most popular Lost Cause prints (see fig. 1), this painting successfully elevated a small tragedy of war, the burial of a cavalry captain, into the realm of Southern folklore. To execute the canvas, Washington made sketches at Miss Pegram's School for Girls in Richmond, presumably selecting models more attractive than the original characters portrayed in the scene. In addition to the loyal slaves, the painting depicted: Mrs. Willoughby Newton (center), performing the Episcopal burial service in the forced absence of a minister; her sister-in-law, Mrs. William Brockenbrough, who generously took in Latane's body and offered to bury it as she would her own brother; and the children of the adjoining Westwood and Summer Hill plantations outside Richmond. One early reviewer described the scene as showing "the mantled body by the open grave, the faithful group around it, the pious matron reciting the beautiful burial service . . . a fair-haired little girl who has brought flowers from the garden to strew upon the dead; the lovely women sorrowing for the fate of their brave champion, and the humble slaves looking reverently on." To this sentimental critic, "The whole forms a most touching and impressive scene, the spirit and sentiment of which have been very sympathetically rendered by the artist" (quoted in Turnbull Brothers advertising sheet, Museum of the Confederacy, Richmond). (*Judge John E. DeHardit Collection. Photograph courtesy Virginia State Museum*)

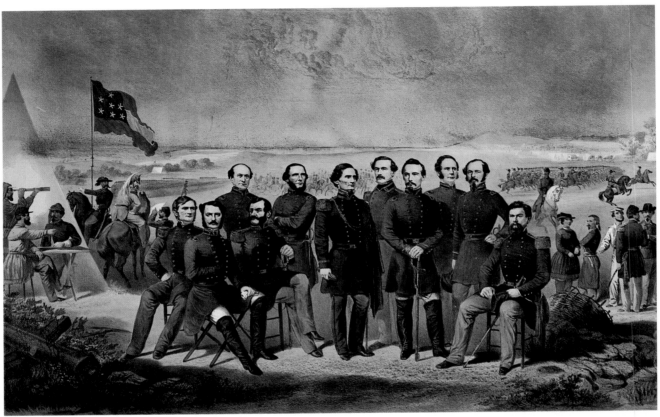

Plate 2.
[Printmaker unknown], [*Jefferson Davis and His Generals*]. Published by Goupil et cie, Paris, and Michael Knoedler, New York, ca. 1861. Hand-colored lithograph, 18⅝ x 27 inches. The eleven early Confederate heroes pictured here, several of whom were soon forgotten, included (from left to right) Leonidas Polk, John Bankhead Magruder, a General Simmons, George N. Hollins, Ben McCulloch, Jefferson Davis, Robert E. Lee, P. G. T. Beauregard, Sterling Price, Joseph E. Johnston, and William J. Hardee. The likenesses of several of the generals—Johnston, Lee, and Hardee, for example—were based on Mexican War era photographs more than a decade out of date. (*Prints Division, The New York Public Library, Astor, Lenox, and Tilden Foundations*)

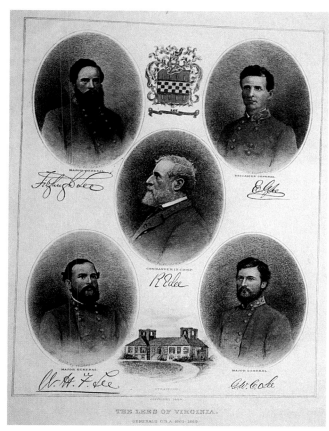

Plate 3.
Charles B. Hall, *The Lees of Virginia. / Generals C.S.A. 1861–1865*. New York, 1898. Hand-colored etching, 12¾ x 10 inches. A tribute to the patriotic tradition of what might be called the first family of Virginia, this Northern-made print featured medallion portraits of (clockwise from upper left): Fitzhugh Lee, the general's nephew and a Civil War cavalry commander of note; Edwin Gray Lee, best remembered as the son-in-law of Robert E. Lee's artillery chief, William N. Pendleton; and Lee's sons, George Washington Custis and William Henry Fitzhugh (Rooney), the latter a celebrated Union captive during the war. The portrait of the paterfamilias is based on Julian Vannerson's 1863 profile photograph. Also represented are the family crest (top) and the general's birthplace, Stratford Hall (bottom), which, ironically, had been sold long before when the general's half-brother, Henry, went into debt. But Lee loved pictures of Stratford, because they recalled, he said, "scenes of my . . . happiest days" (Jones, *Personal Reminiscences*, 364). (*Louis A. Warren Lincoln Library and Museum*)

Plate 4.
P[ierre]. S. Duval and Son, *Meeting of Generals Grant and Lee Preparatory to / The Surrender of General Lee / And His Entire Army to Lieut. General U. S. Grant. April 9th 1865*. Published by Joseph Hoover, Philadelphia, 1866. Lithograph with tintstone, 16⅝ x 23¾ inches. The stubborn legend that evolved after Appomattox held that Lee had surrendered to Grant outdoors in an apple orchard. In reality, Lee merely spent some time before his fateful meeting in such a setting and did not meet Grant on horseback until the day after the surrender. Among the many prints issued in defiance of these facts was this romantic one by Duval, which purports to show that the two generals met *before* the surrender. Lee had, in fact, requested such a meeting, but Grant refused the invitation. As Grant put it, "wars produce many stories of fiction, some of which are told until they are believed to be true" (Grant, *Personal Memoirs*, 2:488). (*Louis A. Warren Lincoln Library and Museum*)

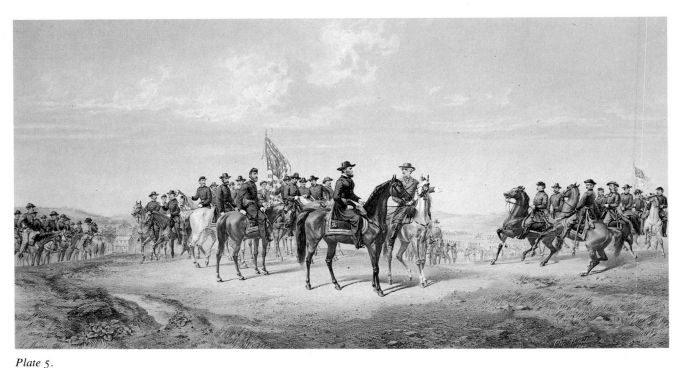

Plate 5.
Otto Boetticher, *Grant and Lee*. Watercolor on paper, 15¼ x 26⅝ inches. N.p., ca. 1866. This painting depicts an actual meeting of Lee and Grant the day after the surrender occurred. Boetticher must have had a print in mind from the start when he composed the scene, for the scale of the watercolor is small and quite near the final dimensions of the lithograph derived from it (see fig. 42). The lithographer, Louis Maurer, though an experienced artist who had worked for Currier and Ives for years, was unable to capture in his medium the morning haze that Boetticher rendered in the background. (*Louis A. Warren Lincoln Library and Museum*)

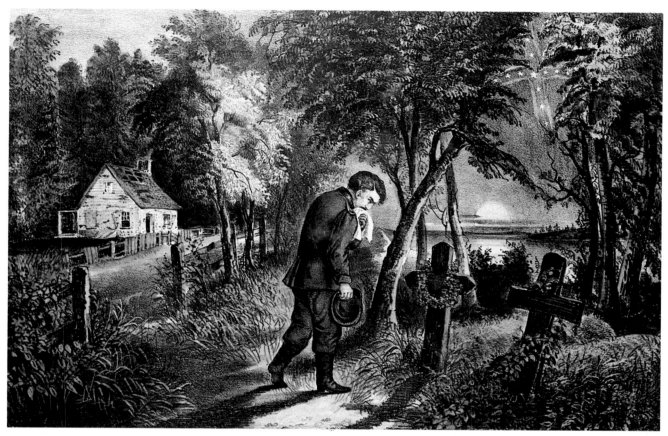

Plate 6.
Currier and Ives, *The Lost Cause.* New York, 1871. Hand-colored lithograph, 8⁷⁄₁₂ x 12²⁄₃ inches. A print created for the Southern market by the most famous of Northern printmakers, this sentimental image depicts the return of a Confederate veteran to his long-untended homestead, where he encounters two graves, presumably those of his wife and child. As the sun sets in the background, symbolizing the descent of Southern independence, the stars and bars rise over home and headstones, with the emblem positioned vertically to resemble a cross: a reminder that once it was Lost, the Cause became genuinely holy to some. (*Louis A. Warren Lincoln Library and Museum*)

Plate 7.
[Printmaker unknown], after Henry Mosler, [*Leaving for War*]. N.p., ca. 1873. Chromolithograph, 19 x 25¼ inches. The bright green of this brilliantly colored chromo contrasts sharply with the dreary browns of Mosler's companion painting of *The Lost Cause*, which depicted the same soldier's sadness at returning to his deserted and crumbling cabin. This print was meant to show the verdant spring of Confederate hope. (*Eleanor S. Brockenbrough Library, Museum of the Confederacy*)

Plate 8.
W. J. Morgan and Company, *Barbara Frietchie*. Copyright, W. W. Welch, Cleveland, 1896. Hand-colored lithograph, 18 x 24 inches. Ostensibly a tribute to the elderly patriot who defiantly waved the American flag in the face of Stonewall Jackson's invading armies, this print succeeded also, whether consciously or not, in celebrating Jackson's chivalrous response to Barbara Frietchie's cry, as immortalized by Whittier, "Shoot if you must, this old gray head!" To accommodate the picture's artistic scope, the streets of little Frederick, Maryland, here assume almost Champs Elysée proportions, as gray-clad Confederates march perhaps twenty abreast. The artist may have been inspired by photographs of triumphant postwar veterans' parades on Washington, D.C.'s broad avenues. The rather exact portrait likeness of Barbara Frietchie was not matched by the mounted figure representing Jackson, here drawn routinely as a rather anonymous-looking bearded Confederate officer. (*Louis A. Warren Lincoln Library and Museum*)

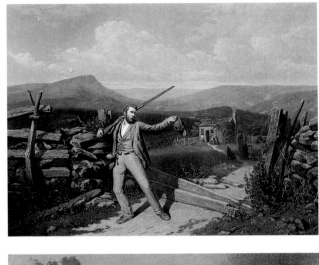

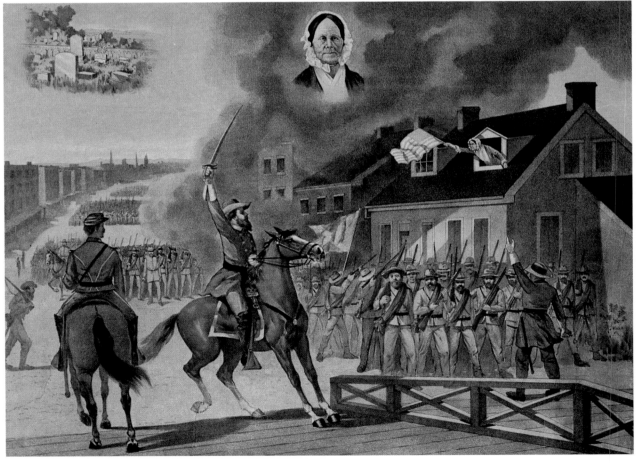

Plate 9.
Henderson-Achert Lithograph Company, *The Above Is a True Picture of Stonewall Jackson / And His Boyhood Home, Situated on the West Fork River, Lewis Co. W. Va.* Copyright by S. E. Barrett, Weston, W. Va. Published in Cincinnati, 1889. Chromolithograph, 13⅜ x 20½ inches. A portrait based on what Mary Anna Jackson called the general's "home look" photograph formed the centerpiece of this curious print showing Jackson's boyhood home in ruins. Unlikely as a souvenir of such a dilapidated site, this print, vouched for in the caption by local West Virginia notables, has the look of a fund-raising premium— perhaps part of a campaign to save the homestead or build a monument. (*Library of Congress*)

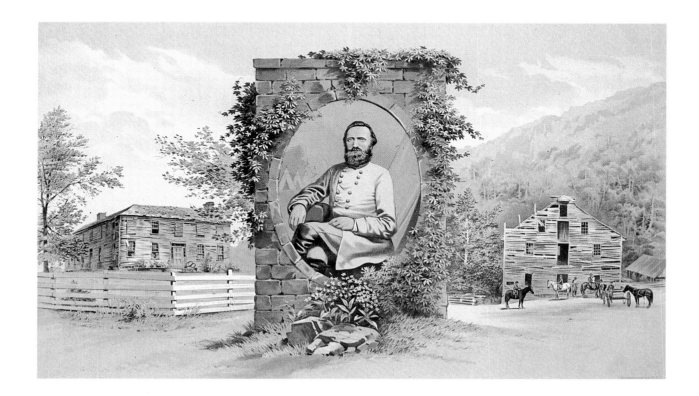

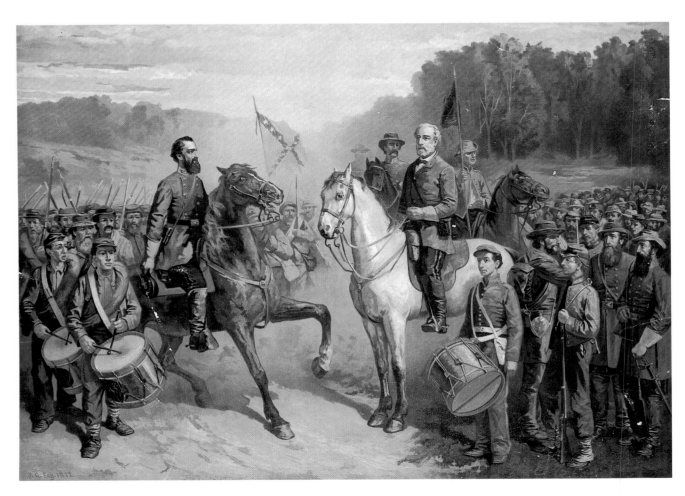

Plate 10.
Turnbull Brothers, after J. G. Fay, *The Last Meeting of Lee and Jackson.* N.p., 1879. Chromolithograph, 22½ x 30⅝ inches. One almost senses the renewed vigor of the old Confederacy in this print, conceived as Reconstruction ended and the last Federal troops were removed from the South. One understands immediately the popular status of the two great Confederate commanders from this imaginary scene. Artist J. G. Fay produced the original picture in 1877 and his signature and the date appear in the stone, but the print was not copyrighted until two years later. An eyewitness to this scene remembered that "General Jackson listened attentively and his face lighted up with a smile while General Lee was speaking" (Major T. M. R. Talcott, quoted in Long, *Memoirs of Robert E. Lee*, 255). (*Library of Congress*)

Plate 11.

[Frederick] Halpin, after E. B. D. Julio, [*The Last Meeting of Lee and Jackson*]. New York, 1872. Engraving, 26⅝ x 20⅞ inches. Signed: "Julio / St. Louis Mo 1869." A soldier who saw the two generals together remembered: "Jackson was riding a raw-boned sorrel, with his knees drawn up by the short stirrups, his eyes peering out from beneath the low brim of his padded cap; there was absolutely nothing about him, save the dingy stars on his collar, to indicate his rank. Lee, on the contrary, was clad in a neat uniform, without decorations, rode an excellent and carefully groomed horse, and every detail of his person, every movement of the erect and graceful figure of the most stately cavalier in the Southern army, revealed his elevated character. . . . The Almighty had made both these human beings truly great; to only one of them He had given the additional grace of looking great" (Mason, *Popular Life of General Robert Edward Lee*, 106–7). Artist Julio was careful to show precedence not only in looks but in gesture for Lee, who clearly commands a Jackson who is shown here looking to Lee for leadership. This image enjoyed a publishing life of more than thirty years. As late as 1907 the Jamestown Official Photographic Corporation issued a reprint, making it one of the most enduring of all Confederate images. Julio offered the original to Lee, but he refused, saying, "I desire you to have all the benefit as well as the credit of your labors" (Lee

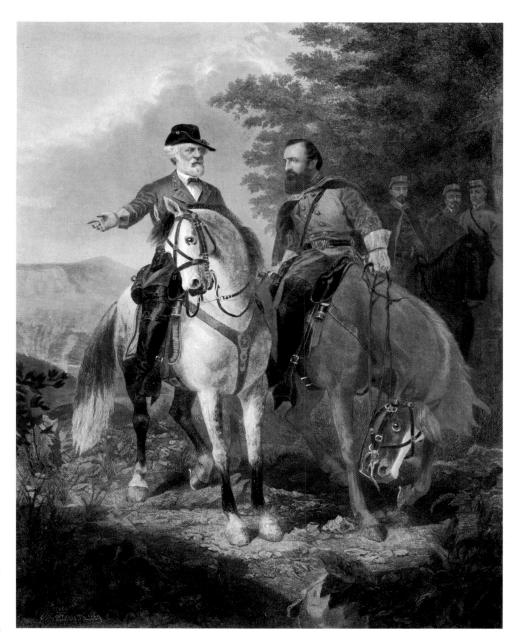

to "Q. D." Julio, August 21, 1869, in Jones, *Personal Reminiscences*, 275). (*Anne S. K. Brown Military Collection, Brown University*)

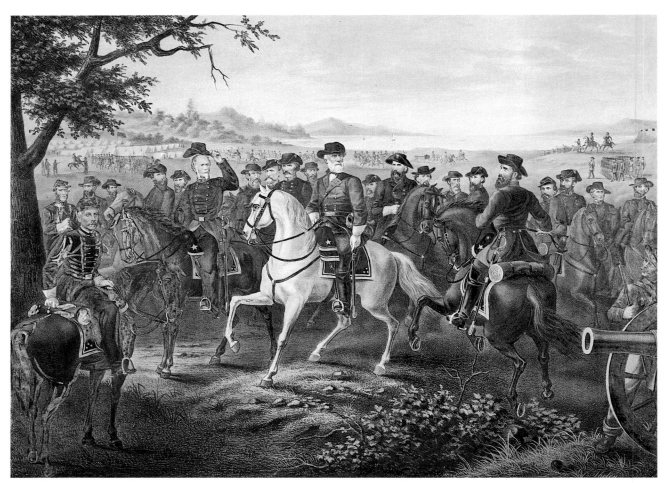

Plate 12.
[Charles and Augustus] Tholey, *Lee and His Generals.* Printed by [Joseph] Hoover. Published by John Calvin Smith, Philadelphia, 1867.

Hand-colored lithograph, 17⅞ x 23¹³⁄₁₆ inches. Modeled after "an original sketch," Tholey's postwar group picture was a clever composite of portraits based on photographs of Con-

federate commanders, all on improbable bodies and horses gathered around Lee. The council of war depicted here never took place, nor did Lee ride a white charger; Traveller,

of course, was gray. But such details apparently did not matter to audiences eager for heroic images of their Lost Cause saints. (*Library of Congress*)

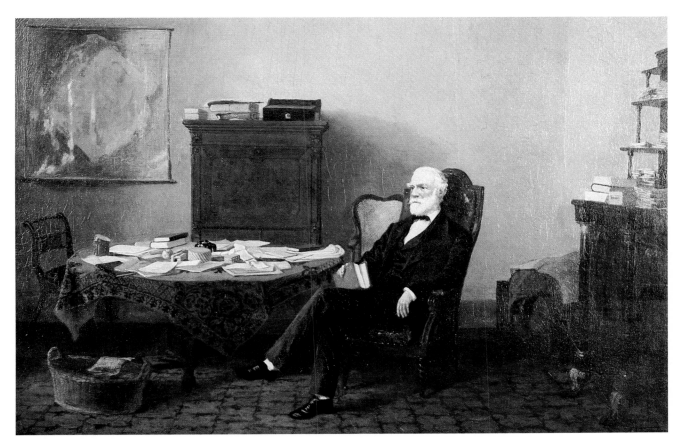

Plate 13.
Adalbert Johann Volck, *Robert
E. Lee in His Study at Wash-
ington College*. Probably Lex-
ington and Baltimore, ca.
1872. Oil on canvas, 17 x
21½ inches. According to
Volck's claims in 1900, he be-
gan this portrait from life
shortly before Lee's death and
completed the general's torso
back in Baltimore, employing
a local judge as a model. The
print adaptation of this painting
(see fig. 74) was to be issued
to raise funds for a monument
to Stonewall Jackson. (*Valen-
tine Museum*)

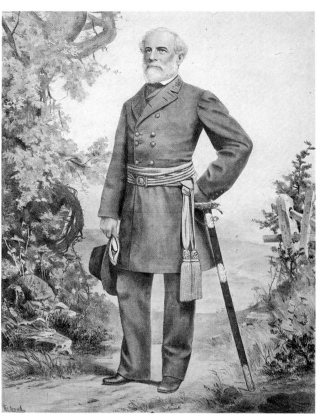

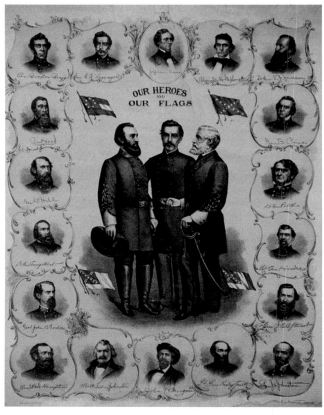

Plate 14.
Vic. Arnold, after Vannerson, *Robert E. Lee*. Published by A. S. Seer, New York; copyright by Jon. P. Smith, Brooklyn, 1882. Hand-colored lithograph, 33⅜ x 24⅝ inches. This pose was adapted from two Vannerson photographic models, with the head of one (see fig. 83) superimposed onto the body from the only photograph of Lee wearing a sash. The result was this imposing full-figure composite of Lee in a sylvan setting. The printmaker added a hat in Lee's right hand to emphasize the new outdoor venue of the image. (*Anne S. K. Brown Military Collection, Brown University*)

Plate 15.
Southern Lithographic Company, *Our Heroes / and / Our Flags*. New York, 1896. Lithograph with chromolithographed central portrait group, 22¾ x 17½ inches. It is not clear what the printmaker had in mind with this design. Even though Beauregard was placed in the center of the main grouping, Lee was made to dominate, gesturing with one hand and holding his impressive dress sword with the other. The Lee portrait is based on a Vannerson profile photograph. The Beauregard portrait is repeated in a cameo inset at the upper left, and the Jackson recurs at upper right in a mirror-image of the central portrait. President Jefferson Davis and Vice President Alexander H. Stephens appear in the top row of heroes, in an otherwise overwhelmingly military tribute. Another print of the same title included centerpiece depictions of Lee and the Lee memorial, and still another version substituted Joseph E. Johnston for Beauregard. The last-named version of the print was advertised in the *Confederate Veteran* at the turn of the century for $7.50. (*Louis A. Warren Lincoln Library and Museum*)

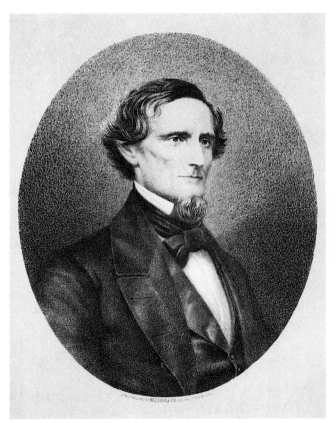

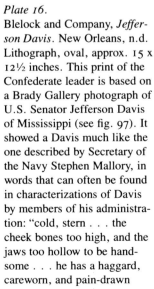

Plate 16.
Blelock and Company, *Jefferson Davis*. New Orleans, n.d. Lithograph, oval, approx. 15 x 12½ inches. This print of the Confederate leader is based on a Brady Gallery photograph of U.S. Senator Jefferson Davis of Mississippi (see fig. 97). It showed a Davis much like the one described by Secretary of the Navy Stephen Mallory, in words that can often be found in characterizations of Davis by members of his administration: "cold, stern . . . the cheek bones too high, and the jaws too hollow to be handsome . . . he has a haggard, careworn, and pain-drawn

look" (Mallory, quoted in Davis, *The Long Surrender*, 21–22). Blelock and Company was active in New Orleans until the city fell to Union forces, whereupon the firm apparently moved to New York until the end of the war. It returned to Louisiana and was listed in the New Orleans city directory again by 1866. As this print bears a New Orleans address, it was most likely produced either in 1861 or after 1865. (*Eleanor S. Brockenbrough Library, Museum of the Confederacy*)

Plate 17.
[Printmaker unknown], [*Jefferson Davis*]. N.p., n.d. Chromolithograph, oval, 16¾ x 13¾ inches. None of the popular prints of Davis seems to capture the aristocratic handsomeness and military bearing

that most commentators noted upon seeing him. This rare print errs on the side of primitivism and perhaps suggests Davis's iron will without retaining enough aristocratic elements. (*Louis A. Warren Lincoln Library and Museum*)

Plate 18.
A. G. Campbell, *J. E. Johnston* [with facsimile signature].
New York, n.d. Hand-colored mezzotint engraving, oval, 11⅝ x 9¹⁄₁₆ inches. An associate said that Johnston bore "an habitual expression of firmness & austerity." Johnston's photographers captured that look well and the printmakers retained it. His "ready appreciation of humor," on the other hand, seems nowhere ascertainable from his prints (Govan and Livingood, *A Different Valor*, 30). (*Louis A. Warren Lincoln Library and Museum*)

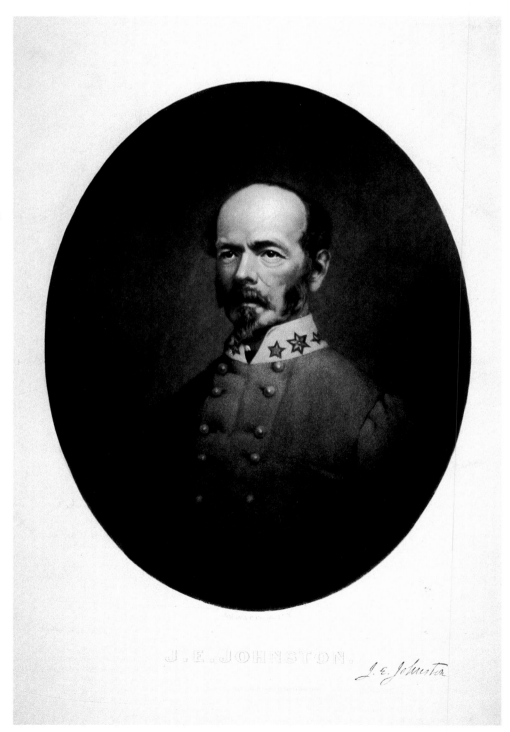

J. E. JOHNSTON.

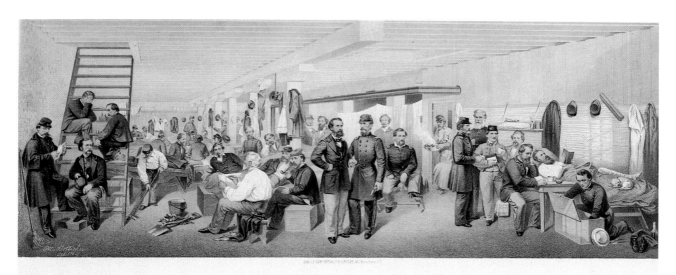

LIBBY PRISON
UNION PRISONERS AT RICHMOND Vᴬ
FROM NATURE BY ACT. MAJOR OTTO BOTTICHER

Paris, GOUPIL & Cⁱᵉ New York Published by GOUPIL & Cⁱᵉ M Knoedler Successor 772 Broadway London, GOUPIL & Cⁱᵉ

Plate 19.
Sarony, Major, and Knapp, *Libby Prison: Union Prisoners at Richmond Va. From Nature by Act. Major Otto Botticher*. Published by Goupil et cie, Paris and London, and Michael Knoedler, New York, 1863. Hand-colored lithograph, 7 x 18 inches. Libby Prison, which held only Union officers, gained an unsavory reputation. The *Civil War Dictionary* still calls it "perhaps the most notorious prison after Andersonville." Publication in the North, in 1863, of this surprisingly pleasant scene based on the original work of a Union artist who had been an inmate there, suggests that its infamy came late. (*Anne S. K. Brown Military Collection, Brown University*)

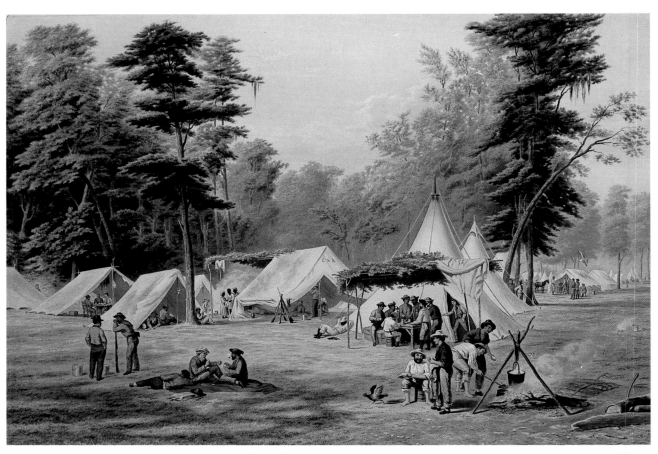

Plate 20.
M. and N. Hanhart, *Confederate Camp During the Late American War From the Original Painting by C. W. Chapman, Ordnance Sergeant, 59th Virginia Regiment, Wise's Brigade.* Published by Louis Zimmer, London, 1871. Chromolithograph, 10⅝ x 15¼ inches. Persons wishing to purchase a copy of this print could contact either Zimmer, in London, or Professor F. S. Holmes, in Charleston, South Carolina. The chromo was altered from Chapman's original to include the casual figure at left, hands in pockets and buckets laid down, chatting with the artist himself. Chapman posed alone for the photographic model on which he based his self-portrait, but he seemed out of place in the camp scene until the water carrier was added. (*Eleanor S. Brockenbrough Library, Museum of the Confederacy*)

1 / Engravers Wanted

On April 8, 1861, John B. Jones, the Baltimore-born editor of the *Southern Monitor* in Philadelphia, packed up his "fine old portrait of Calhoun, by Jarvis" and left his wife and children to seek clerical employment in the Confederate government.[1] It was fortunate for him that his family made him take the picture, as he would have little chance to replace it with fresh Confederate icons over the next four years of toil, poverty, and scarcity.

The Confederate States of America made only a minuscule contribution to the beaux arts. Historians and bibliographers have documented an impressive outpouring of literary publications that, given the crippling material shortcomings of the agrarian Confederacy, attested to the Southern people's longing and talent for literature, poetry, and culture in general. But there was no corresponding miracle of Southern graphic arts, minor or otherwise. Some historians have hinted that this scarcity of visual symbols may have been attributable to an absence of tough national will or sincere nationalism within the new Confederacy. This theory confuses a lack of nationalism with an artistic and technological inability to create and reproduce the *symbols* of nationalism. In terms of visual representations, the cause was lost for the Confederacy by 1862. The national will was present much longer, but the means to express it were gone.[2]

In the graphic arts, the Confederacy proved a hapless victim to accidents of political and military history. Before the war, the South had imported much of its popular art from Europe and from the Northern publishing centers of New York, Boston, Philadelphia, Hartford, Cincinnati, and Chicago. Only a small part of the South's graphic needs had been met by indigenous craftsmen, with those residing in Baltimore and New Orleans supplying many of the prints. For example, graduates of the Virginia Military Institute and other proud Virginians could obtain lithographs of

the school printed by Edward Sachse and Company of Baltimore. Southerners of a musical bent could purchase sheet music with attractive illustrated covers produced by Blackmar of New Orleans.[3]

In the winter of 1860–61, when seven zealous states of the Deep South boldly gambled on secession and a chance for a separate national destiny, they doubtless counted on taking with them the areas that happened to encompass the South's limited print industry. Baltimore's skilled lithographers and engravers might well have wrought a miracle of Confederate graphic arts had Maryland followed its sister slave states into the Confederacy, but the Lincoln administration acted decisively to arrest secession-minded members of the Maryland legislature before they could meet to take the state out of the Union. A year later President Lincoln saw the wisdom of Admiral David Dixon Porter's plan to capture New Orleans, and when the city fell to David G. Farragut's fleet on April 25, 1862, the Confederacy lost its last reserve of printmaking. When, eight months later, Union authorities in that city learned that artist J. E. Mondelli was painting a portrait of Stonewall Jackson, they arrested him.[4]

What Baltimore, as a part of the Confederacy, might have contributed to the South's own graphic depiction of its cause will become clear in the chapters that follow, filled as they are with the stories of Baltimore artists and printmakers producing some of the most famous Confederate images. The potential of New Orleans as a graphic arts center was briefly glimpsed in the works of artist A. Persac, which were lithographed by Pessou and Simon. *Camp Moore (Tangipaho, Lna) 1861* (fig. 2) and *Camp Walker (Metary Ridge, Lna) 1861* depicted the training camps, located just outside of New Orleans, of Louisiana's earliest enthusiastic Confederate volunteers. Confederate camp scenes provided inspiration for a number of later prints, and Persac's picture, with its charming details of soldiers cooking, civilians visiting the camp, and a railroad

Figure 2.
Pessou and Simon, after A. Persac, *Camp Moore (Tangipaho, Lna) 1861*. New Orleans, ca. 1861. Lithograph, 13⅜ x 17⅜ inches. Nestled in the pine woods, as many Confederate camps would be in the future, the early training ground for Louisiana troops depicted here seems to have held some of the best-uniformed and most precisely drilled troops in Confederate history. Prints produced after the war, unlike this rare Confederate imprint, often emphasized the barefooted raggedness of Southern soldiery. But in the dawn of secession shown here, loyal Southerners naturally stressed their ability to field and supply soldiers as fine as those of any country. This lithograph even avoided portrayal of the South's agrarian image by including a busily puffing train in the background. (*Courtesy The Historic New Orleans Collection, Museum/Research Center Acc. No. 1966.5*)

train passing in the background, deserves greater fame than it has received. Had it not been for Admiral Farragut, the Confederacy would no doubt have been well served by these talented New Orleans printmakers and other local artists.

Importation of prints was likewise hopeless. The Northern states were not about to make prints of Confederate heroes available to the enemy. England and France would have been willing and able to supply such pictures, but they were cut off by the increasingly effective Northern blockade of the Confederate coast. A few prints might have been prepared for export, but they naturally found little space on board the small blockade runners when cargoes of vital war matériel and higher-priced luxury goods were in much greater demand.

The relative scarcity of graphic images in the South was not due to a lack of desire or taste. The yearning and appreciation for visual renderings of their cause were clearly present in the Confederate States of America. Educated military officers, for example, occasionally wondered aloud how they might look in pictures, even amidst their desperate preoccupation with the need for military victories. Once in the winter of 1862–63, while Stonewall Jackson was maintaining winter quarters in Moss Neck, Virginia, the austerely puritanical general found himself in improbably worldly surroundings, described thus by one of his staff:

> General Jackson established his Headquartrers near Corbin Hall, which was one of the handsomest residences in Virginia. . . . The General declined all invitation to occupy any portion of the mansion, but established his Headquarters in tents. He soon consented, however, to occupy an attractive outbuilding known as "the office" for his official Headquarters. The surroundings of the room . . . were in strange contrast with the habits and tastes of the present military occupant. There were . . . books for sportsmen and horsemen. . . . There was fishing tackle, traps, skins of beasts and foxes, antlers of deer, plumage of birds and fowls; curious pictures, allegorical or sportive, engravings of "Boston" and other celebrated horses, gamecocks in bloody pictures, cats of fine breed and special dogs in frames.[5]

At a jolly dinner held in this room, an officer "suggested . . . that a drawing of the apartment should be made, with the race-horses, Game-cocks, and terriers in bold relief, the picture to be labelled, 'Views of the winter-quarters of General Stonewall Jackson, presenting an insight into the tastes and character of the individual.'"[6] It was a typical scene for popular engravings and, significantly, the officer gave it in jest precisely the sort of title period engravings often bore.

Other officers had occasion to note good-naturedly the power of the satirical graphic arts of the North. Lieutenant-Colonel Arthur Fremantle, a British visitor to the Confederacy, described another lively dinner, this one with General P. G. T. Beauregard and other guests: "After dinner, Major Norris showed us a copy of a New York illustrated newspaper of the same character as our 'Punch.' In it the President Davis and General Beauregard were depicted shoeless and in rags, contemplating a pair of boots, which the latter suggested had better be eaten. This caricature excited considerable amusement, especially when its merits were discussed after Mr. Robertson's excellent dinner." Ordinary Confederate infantrymen, lacking a supply of caricatures, more or less created them in their heads, as Fremantle observed: "[On the retreat from Gettysburg] The road was full of soldiers marching in a particularly lively manner—the wet and mud seemed to have produced no effect whatever on their spirits, which were as boisterous as ever. They had got hold of coloured prints of Mr. Lincoln, which they were passing about from company to company with many remarks upon the personal beauty of Uncle Abe. The same old chaff was going on of 'Come out of that hat—

I know you're in it—I sees your legs a-dangling down,'
&c."[7]

Common soldiers occasionally noticed the graphic
disadvantages of the Confederate cause. Carlton Mc-
Carthy, a private in the Richmond Howitzers, made a
long list of the enormous odds against which the boys
in gray fought, including some things rarely noticed by
later historians:

> The Confederate soldier fought bounties and
> regular monthly pay; the "Stars and Stripes," the
> "Star Spangled Banner," "Hail Columbia,"
> "Tramp, Tramp, Tramp," "John Brown's Body,"
> "Rally round the Flag," and all the fury and fa-
> naticism which skilled minds could create,—op-
> posing the grand array with the modest and
> homely refrain of "Dixie," supported by a mild
> solution of "Maryland, My Maryland." He
> fought good wagons, fat horses, and tons of
> quartermaster's stores; pontoon trains, of splen-
> did material and construction, by the mile;
> gunboats, wooden and iron, and men-of-war; il-
> lustrated papers, to cheer the "Boys in Blue"
> with sketches of the glorious deeds they did
> not do.[8]

But the Confederate States of America possessed
little with which to satisfy longings for the pictorial.
Persons with basic skills in the graphic arts, not to
mention talent and genius, were scarce. So desperate
was the fledgling country for engravers that it had
serious difficulty even printing a respectable-looking
national currency. When the War Department ordered
Captain John Wilkinson of the Confederate States Na-
vy "to proceed to England and purchase a steamer
suitable for running the blockade, to load her with
arms, munitions of war, and other supplies, and to
bring her into a Confederate port with all dispatch,"
some of the precious cargo space was reserved for
the Confederate treasury. "Besides the purchases made

through my agency," Wilkinson recalled later, "a large
quantity of lithographic material had been brought by
Major Ficklin for the Treasury Department; and twen-
ty-six lithographers were engaged for the Confeder-
ate Government." Captain Wilkinson continued: "The
Scotch lithographers found abundant employment in
Richmond, as the Government 'paper mills' were run-
ning busily during the whole war; but the style of their
work was not altogether faultless, for it was said that
the counterfeit notes, made in the North, and exten-
sively circulated through the South, could be easily
detected by the superior execution of the engraving
upon them!"[9]

Political factors also played their part in limiting
print production in the Confederacy. Its peculiar politi-
cal culture generated little market for the sort of cam-
paign portraits and posters that were a staple of print
production in the Northern United States. In 1861 a
vigorously competitive two-party system of mass poli-
tics was unique to the North. The Confederacy had no
political parties and therefore did not attract the ac-
tive agents who, every four years, had created popular
prints of partisan heroes. Moreover, the six-year presi-
dential term stipulated by the Confederate Constitution
meant that the short-lived nation never held a national
electoral contest that might have focused popular at-
tention on political figures and generated a demand for
campaign prints.

Eventually, war-induced scarcities of materials and
manpower also played a part in stifling print produc-
tion in the Confederate states. From the very begin-
ning of the war, the South was confronted with grow-
ing shortages of once-plentiful supplies. For example,
when artist John R. Key, nephew of Francis Scott Key,
was inspired to paint the capture of Fort Sumter, he
could find no canvas and was forced to work on burlap.
Early on, some tried to make a national virtue of neces-
sity. One Southern periodical noted in June 1861: "The
paper on which the present number . . . is printed, is

far inferior to that we are in the habit of using. Cut off, as we are from our regular manufacturer, we must ask our friends to make due allowance. Ere long we will be an *independent* people,—relying upon and helping ourselves instead of building up our enemies." Paper and ink no longer streamed into the region from the North, and what little could be supplied by Southern mills quickly inflated in price. By 1862 the same Southern periodical that had hoped for independence and native industries in 1861 was making "no apology for the . . . color and quality of the paper. . . . The paper will serve as an excellent mark, to show the hardships of the war." A concurrent shortage in manpower—artists and printers were conscripted into the army along with other young Confederates—helped doom the Southern picture-publishing industry almost as soon as the war broke out.[10]

The availability of that most basic of requisite supplies—paper—was at first merely unpredictable, inspiring the *Confederate States Almanac* to joke that a Southern newspaper could be "short enough for a pocket handkerchief one day, and big enough for a tablecloth another." When the paper flow had been reduced to a trickle, newspapers began using colored stock in "as many hues as Niagara in the sunshine." One Savannah editor complained, "we are reduced to printing on paper, which, half the time, nobody can read." By the middle of the war, the supply drought became more acute and some newspapers were printed on wallpaper. The South boasted only one-twentieth of America's paper mills to begin with, and when the Union took Nashville in 1862, the Confederacy lost one of its largest remaining sources. The *Richmond Enquirer* confessed in that same year: "Thousands upon thousands of dollars invested in printing materials are now lying idle . . . for want of paper." As paper vanished, so did the writers and craftsmen who worked with it. By one account, of seventy-five newspapers published in Mississippi before the war, only nine sur-

vived. One Southern newspaper, forced to fold in late 1862, cited the absence of compositors, printers, and editors and observed plaintively, "The devil only is left in the office."[11]

The Confederacy's total mobilization of white manpower for war ruthlessly devalued all personal skills except those related to military service. The handful of Southern painters and illustrators who might have created original works of art, to serve as models for engravers and lithographers, usually found themselves toting muskets, pitching tents, and killing Yankees. The Confederacy also paid, in the realm of graphic arts, for its sins of deprivation visited on generations of black Southerners. Although this great reservoir of slave power supplied the essential labor pool necessary to allow the conscription of a large percentage of white males, with only one known exception blacks, because they had been prohibited from learning to read, write, or draw, failed to fill the gap in graphic arts on the home front.[12]

"Official" publishing was a heavy drain on limited pools of talent. Before the war, Richmond had its share of picture publishers. The German-born Edward Beyer's *Album of Virginia*, for example, was lithographed in Europe but published in the future Confederate capital in 1858. After secession, the new nation required postage stamps and paper currency, and the efforts of Richmond printers had to be diverted. Government stamps and currency would be expected to feature portraiture in imitation of Northern-made products to which the citizens had long ago become accustomed. But if there were any expectations that such quality could be sustained in the Confederacy, they were quickly shattered.[13]

At first the Confederacy ordered engraved bills from the American Bank Note Company of New York City, but when the war started that source was abruptly cut off. Left to their own devices, Southerners produced $50 million in new currency a month as well as a flood

of state notes, bonds, and corporate notes. Most were now lithographed, not engraved, and nearly all featured portraiture of inferior quality. As one observer said of the Confederate notes he saw, "neither in material nor execution would they have reflected credit on a village printing-office."[14]

The Confederacy achieved slightly better results with its postage stamps, but the products still proved inferior to the Federal stamps that for decades had featured engraved portraits of Washington and his fellow founders. The first contract to print Confederate stamps went to the Richmond firm of Hoyer and Ludwig, who wrote to Postmaster General John H. Reagan in April 1861: "Enclosed we send you samples of postal stamps. The ten-cent stamps represent the C.S. Flag, which we have engraved. The two and five-cent stamps we only made the drawings of, which we intend to make if the order should be given to us. The twenty we would like to make with President Davis' portrait, in which case you have to furnish us with a good likeness, if you should favor us with the contract for making the stamps. . . . Hoping you will give us preference to Northern Houses." The firm never produced the twenty-cent Davis stamps proposed in their letter but, rather, lithographed five-cent stamps in unperforated sheets of one hundred each. The adaptation of a current Davis photograph was rudimentary and coarse, but the effort was immediately praised by the *Richmond Daily Dispatch*, which noted on October 17, 1861: "Their introduction supplies a want which has heretofore seriously taxed the public endurance. The stamps . . . are ornamented with a very excellent bust of President Davis. Messrs. Hoyer & Ludwig, of this city, have the credit of supplying the Government with these needed articles."[15]

Hoyer and Ludwig remained active in the production of lithographed postage stamps throughout the war. One of their employees, Richard E. Hendrick, recalled years later that the firm's twelve presses were used "most of the time" to print Confederate stamps and money. Hendrick recalled in vivid detail the Hoyer and Ludwig procedure for stamp lithography. "I dampened the stone," he remembered, "Fritz Schrank 'rolled up' [inked], then I laid on the sheet, and 'pulled' the impression. At first my output was 200 sheets per day, but I soon got it up to a ream—480 sheets. You see, I was getting $5.00 a week in Confederate money, with a bonus for all over 200 sheets pulled per day."[16]

In October 1861 Postmaster General Reagan decided to look beyond Richmond for improvements. He asked a Confederate emissary, en route to England in search of a source for arms shipments, to make arrangements also for the importation of finished stamp-making plates. The emissary was able to contract with Thomas de la Rue and Company, who in turn had artist Jean Ferdinand Joubert de la Ferte engrave a Davis stamp. More than two million stamps, plus the la Ferte plates, arrived in the Confederacy from England in February 1862.[17]

The la Ferte stamp was a vast improvement over the Hoyer and Ludwig products, but when the supply was depleted another Richmond firm, Archer and Daly, was given the la Ferte plates and hired to re-create the issue at home. The result, not surprisingly, was nowhere near the quality of the English printings.

The ongoing efforts of the Confederate government to master the art of printing currency and stamps help in part to explain why other printmaking specialties—including portrait engraving and lithography—did not thrive in the South during the Civil War. According to Confederate postal historian August Dietz, printing plants and their workers were under the control of the government throughout the war. One Hoyer and Ludwig worker, for example, was abruptly assigned to a rival firm in South Carolina. And later, when Hoyer and Ludwig petitioned for a replacement, the reassigned worker's own brother was detailed by his army unit to work in Richmond on production of a ten-cent stamp.[18]

Modern governments might well understand the compelling propaganda value of political graphics, but the Confederacy, like most governments of the period, failed to comprehend their potential impact. Throughout the war, the printing of stamps and money was the highest priority of the few remaining printmakers, and the creation of display icons all but vanished.

Conceivably, Southerners were too preoccupied with survival to notice that they were iconographically deprived. Prints may have seemed frivolous in what one observer called "a nation of Crusoes" whose "necessities became luxuries." Yet there is evidence to suggest that the people did want to know what their heroes looked like. The vexing situation could be summed up by the frank advertisement in the Confederacy's leading pictorial newspaper: "Engravers Wanted."[19]

Engravers Wanted.
Desirous, if possible, of illustrating the "NEWS" in a style not inferior to the "London Illustrated News," we offer the *highest salaries* ever paid in this country for *good* ENGRAVERS. Address .
AYRES & WADE,
" Illustrated News,"
Richmond, Va.

Figure 3.
A. Hoen and Company, after A. Grunevald, cover for "The Palmetto State Song," by George O. Robinson. Sheet music cover published by Henry Siegling, Charleston, S.C., ca. 1861. Lithograph, 9½ x 8¼ inches. This, the only known picture of a secession convention at work, failed to capture the fevered atmosphere of excitement in which the delegates worked. Although this piece was lithographed in Baltimore, South Carolina eventually developed a graphics industry of its own during the Civil War, when the Confederate government moved some of its essential printing operations further south. (*Library of Congress*)

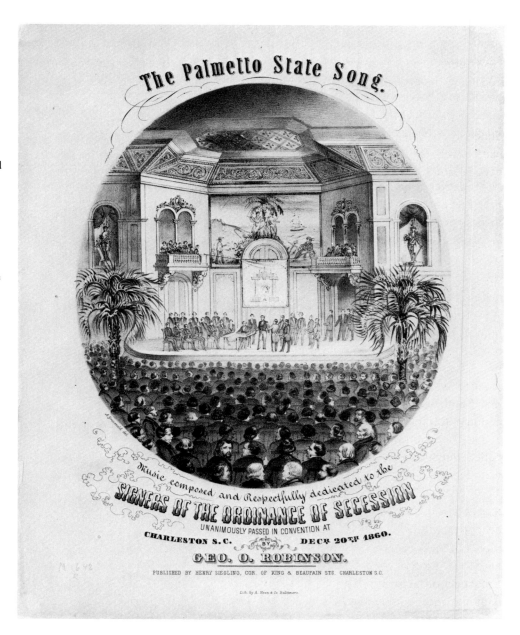

Print production in the Confederacy occurred mainly during the months immediately following secession, and the tiny surviving body of Confederate-made engravings and lithographs gives a distorted view of the Confederate experience. The Confederate States of America was born, as the United States had been some eighty years earlier, in a spirit of high hopes. Southerners, as steeped in the lore of the American Revolution as anyone on the North American continent, believed that they were offering their honor, lives, and fortunes for the defense of liberty—as they understood the word in 1861. They expected, or at least hoped, to find their George Washington, and, not surprisingly, the early Confederate prints reflected this hopeful mood.

A handful of surviving prints helps document the optimistic beginnings, and not the tragic later history, of the Confederacy. The dominant theme was celebration: pictures of soldiers in spruce uniforms; patriotic music covers; and, above all, images glorifying the man Southerners expected to become the father of their country, Jefferson Davis.

The secession ordinances of the various states were hailed much as the Declaration of Independence had been in the old Union. "The Palmetto State Song" (fig. 3), with a lithographed cover illustration of the signers of the South Carolina secession ordinance, may have been the first such tribute. Hoyer and Ludwig of Richmond produced a facsimile of Virginia's document, and New Orleans's Pessou and Simon lithographed the Louisiana ordinance in both English and French. Perhaps the most interesting of the lot was a handsome print that celebrated Georgia's early steps toward secession. *The First Flag of Independence Raised in the South, by the Citizens of Savannah, Ga. November 8th, 1860* (fig. 4) was lithographed in Savannah, after a drawing by a Belgian-born artist named Henry Cleenewercke. Among the likely purchasers of such prints were the participants in the events they depicted, and, not surprisingly, Charles C. Jones, Jr., one of the orators portrayed on the balcony in the Savannah picture, bought one to send home to his parents. His letter of June 21, 1862, provides a rare glimpse of what a sophisticated contemporary customer thought of a popular print:

> Enclosed I send a copy of a lithograph representing in a humble way the first great meeting of the citizens of Savannah when they realized for the first time the necessities for a grand revolution. The occasion has never had a parallel in the history of our city; and as an humble memento of an eventful past this rude lithograph will in after years possess no ordinary interest. The individual "spreading himself" with every conceivable energy and earnestness from the balcony of the clubhouse may be Colonel Bartow or Judge Jackson; or it may be the subscriber, then mayor of the city. We all spoke, using that balcony as a rostrum, on that night to the assembled multitudes, who swayed to and fro on every hand like the sea lifted by the breath of the tornado. We added fuel to the flame; and that meeting, it is said, contributed more to secure the secession of Georgia and to confirm the revolution in adjoining Southern states than almost any other single circumstance of the times. It was followed by similar demonstrations throughout the length and bredth of the cotton-growing states. It evoked unmeasured surprise and condemnation from the Northern press. It stayed the hands of our sister city Charleston, and gave an impulse to the wave of secession which soon swept with a rapidity and a strength, indicating no returning ebb, all over the land. But few copies were struck off—say, a thousand— and they were widely circulated throughout the country.[1]

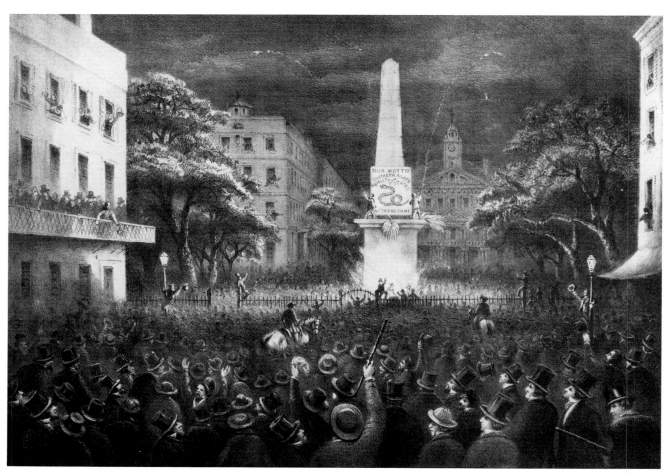

Figure 4.
R. H. Howell, after Henry Cleenewercke, *The First Flag of Independence Raised / in the South, by the Citizens of Savannah, Ga. November 8th, 1860. / Dedicated to the Morning News.* Savannah, ca. 1861.

Lithograph with tintstone, 13 x 14 inches. The copy of this lithograph at the Library of Congress bears a handwritten inscription to John Devereux, Jr., indicating that one Joseph Prendergast "helped to make the above Banner and himself painted the lettering thereon." Whoever performed the work was certainly familiar with the symbols of the American Revolution, as he copied the famous snake and the motto "Don't tread on me." A similar banner, 2 x 3 feet in size, carried in a Savannah political parade in December 1860, is now at the Fort Pulaski National Monument, Tybee Island, Ga. (*The Boston Athenaeum*)

Like most Confederate prints, as Jones's letter shows clearly, this one stemmed from the era of early enthusiasm. Politicians were still striving to take credit for secession, not, as they did later, to blame it or Confederate defeat on others. The same buoyant spirit clearly inspired the prints of the first great Confederate hero, routinely described as "our first president," Jefferson Davis.

Blackmar, of New Orleans and Augusta, published sheet music entitled "Our First President Quickstep"—though, of course, Davis was destined to be not only the first but also the last and only president of the Confederate States of America. Similar early confidence in the cause was reflected in *Jefferson Davis, First President of the Confederate States of America* (fig. 5). Lithographed by Hoyer and Ludwig, the print demonstrates the seldom-achieved height of Confederate lithography, a solid competence fully the equal of vastly more famous Northern lithographers.

J. C. Hoyer, a jeweler, and Charles Ludwig, a German-born printmaker, became associates in the lithography trade at the beginning of the war. Their brief partnership, which dissolved by 1866, nevertheless was responsible for several of the rare surviving Confederate graphics, including *Map of the Confederate States of America*, published in 1861 by A. Morris; *Map Showing the Battle Grounds of the Chickahominy*, drawn by painter Edwin Sheppard and published in Richmond, probably in 1862; and the facsimile of the Virginia secession ordinance, likely published in 1861. Hoyer and Ludwig lithographs vividly document the flush enthusiasm of the early Confederacy.[2]

Northern bias in the writing of the history of the popular arts has long obscured Hoyer and Ludwig's work. Harry T. Peters, for example, a New Yorker and the premier chronicler of America's lithographers, overlooked Hoyer altogether and noted only one print by Ludwig, a small folio picture of William and Mary College that was doubtless produced before the war.[3]

Figure 5.
Hoyer and Ludwig, after J. Wissler, *Jefferson Davis / First President of the Confederate States of America.* Published by Tucker and Perkins and Company, Augusta, Ga. Copyrighted by James T. Paterson, Virginia, 1861. Lithograph, 27¼ x 21¾ inches. The bright-eyed and hopeful-looking person in this portrait was actually a United States senator rather than the president of the Confederacy, for the likeness was copied from a pre-secession photograph by the Brady Gallery. (*Eleanor S. Brockenbrough Library, Museum of the Confederacy*)

Had the South won the war, however, the works of Hoyer and Ludwig might appear in a much different light now, and they would doubtless be praised by knowledgeable scholars and collectors for uniquely and enthusiastically documenting the popular culture of an emerging nation.

Although *Jefferson Davis, First President* parallels in quality and appeal the early Northern prints of Abraham Lincoln, other Davis prints diverge sharply from the image of his counterpart in Washington. If the Union commander-in-chief seemed a most unlikely military man, Jefferson Davis, with his erect bearing, suggested the natural soldier, and printmakers readily cast him in that role.

Davis was not at all reluctant to play the role. Nineteenth-century heads of state were not far removed from the era of absolutist kings and emperors, and they could hardly resist the temptation of leading their countries' forces in actual battle. Abraham Lincoln helped supervise a small battle at Norfolk, and later he somewhat foolishly exposed himself to fire when Confederate troops threatened Washington. Queen Victoria longed to lead her armies to victory in the Crimea.[4] Davis may have been even more infatuated with the martial ideal and appears to have regarded his own talents as lying mainly in the military sphere.

A West Point graduate and a former secretary of war, Davis was a bona fide war hero. At the Battle of Buena Vista in the Mexican War, Colonel Davis formed his Mississippi riflemen into a "V" formation, which halted a Mexican attack. Later critics of Davis's performance as president of the Confederacy have argued that the glory of that episode in Mexico went to Davis's head, with the result that he always thought he knew more about military strategy than he really did. The idea was first suggested by the president's contemporary newspaper critics. Near the end of the war, the *Richmond Examiner* commented: "If we are to perish, the verdict of posterity will be, Died of a V." Varina Davis's later memoir of her husband's life gave telling

proof that he toyed with the idea of assuming a direct military role. In 1863 he told her, "If I could take one wing and Lee the other, I think we could between us wrest a victory from those people."[5]

Evidence suggests that the Southern people would hardly have been surprised. At first, they almost expected Davis to play a double role. "How do you like our new government, and especially our President, General Davis?" a Georgian asked in March 1861. The mayor of Savannah, writing shortly after the firing on Fort Sumter, spoke of "our worthy President (at once soldier and statesman)." Davis may have qualified as both soldier and statesman, but colonel was the highest rank he ever achieved. He refused a commission as brigadier general at the end of the Mexican War because the offer came from the Federal government rather than the state of Mississippi. But Davis once defended the American penchant for using honorary military titles in a way that revealed his infatuation with things military. Speaking to William Howard Russell of the *London Times* on May 9, 1861, President Davis said, "In Eu-rope . . . they laugh at us because of our fondness for military titles and displays. All your travellers in this country have commented on the number of generals, and colonels, and majors all over the States. But the fact is, we are a military people, and these signs of the fact were ignored. We are not less military because we have had no great standing armies. But perhaps we are the only people in the world where gentlemen go to a military academy who do not intend to follow the profession of arms."[6]

The militant South was ready to see their president assume an active military role. When John H. Reagan, a Texas politician soon to become the Confederate postmaster general, first called on the new president in Montgomery, he told Davis he would not have voted for him to hold his current high office, "not, however, because I distrusted his fitness for the high office, but because I wanted him at the head of the army." Mrs. Louis T. Wigfall, wife of another Texas politician close

to the Davis presidency, wrote to her daughter on May 30, 1861, "The President is to take the field; but I don't know the exact programme, and if I did it would not be safe to write it." Expectations were high during the first Battle of Bull Run, and on July 21, 1861, Mrs. Wigfall wrote again, "The President went down to-day, but I don't know exactly in what capacity, whether he will command or not."[7]

When news got out that the president had left Richmond for the battlefield, many Confederate citizens quickly concluded that Davis had personally taken command. These Southerners may indeed have seen the qualities of George Washington in Davis: military hero, father of his country, first president. Richmond diarist John B. Jones remarked of the president's departure on the day of the battle:

> I have always thought he would avail himself of his prerogative as commander-in-chief, and direct in person the most important operations in the field; and, indeed, I have always supposed he was selected to be the Chief of the Confederacy, mainly with a view to this object, as it was generally believed he possessed military genius of a high order. In revolutions like the present, the chief executive occupies a most perilous and precarious position, if he be not a military chieftain, and present on every battle-field of great magnitude. I have faith in President Davis, and believe he will gain great glory in this first mighty conflict.

The story produced a surge in the already high morale of the populace. "What a world of heroism in that act of our worthy President," wrote Charles C. Jones, Jr., to his father on July 24, 1861, "leaving Richmond and in person leading the center column on that fearful battlefield!" One of Jones's relatives believed that "our noble President . . . arrived in time to mingle in the battle and lead the middle column of our army to the charge." Indeed, on the day after the battle, Varina

Davis entered diarist Mary Chesnut's room and said excitedly that "a great battle had been fought—Jeff Davis led the center, Joe Johnston the right wing, Beauregard the left wing of the army." Mrs. Chesnut concluded glumly that Davis was "greedy for military fame," but she purged the comment from her published diary.[8]

It is little wonder, then, that Hoyer and Ludwig leaped to the conclusion that Davis went to Bull Run as a general. Certainly, however, they were wrong to present him in full military uniform in *President Jefferson Davis. Arriving in the Field of Battle at Bull's Run* (fig. 6).[9] Hearing the same news that electrified the rest of the Confederacy—that President Davis had taken the field—Hoyer and Ludwig apparently seized on an available military equestrian portrait and quickly copied it, using a Davis photograph for the head, which, as a result, did not rest in an anatomically natural way on the body. In their haste, the lithographers gave both the president's body and the foreparts of Davis's horse a crudely two-dimensional look. Enthusiastic purchasers, eager to acquire a picture of the father of their country, probably ignored such faults.

Richmond insiders were by no means fooled by the mythical aspects of Davis's trip to the Bull Run battlefield. Assistant Secretary of War Albert Taylor Bledsoe wanted to turn a man out of office for saying in a newspaper that the president had arrived too late to see any real action, but in the sophisticated salon of Mary Boykin Chesnut, whose husband would soon become a member of Davis's staff, many knew that what the newspaper printed was "*true*." Mrs. Wigfall knew the truth as well and told her daughter: "In the next fight I suppose of course the President will take the field. He got down too late this time—just as they [the Yankees] had begun to retreat."[10]

Davis himself did little to quash the rumors of his military role. At the War Department, Bledsoe and John B. Jones got their impression that Davis had commanded from the president's own dispatch:

Figure 6.
Hoyer and Ludwig, *President Jefferson Davis. Arriving in the Field of Battle at Bull's Run*. Richmond, ca. 1861. Hand-colored lithograph, 9¼ x 8⅞ inches. The fanciful scene suggests that Davis donned a plumed hat and a military uniform—in this case an odd-looking blue one with epaulettes—to assume direct command of the Confederacy's first great battlefield triumph, a contention unsupported by facts. But there was no denying that the president looked natural in such equestrian scenes. Seeing Davis on his "beautiful gray horse" in June 1861, diarist Mary Boykin Chesnut remarked: "His worse enemy will allow that he is a consummate rider, graceful and easy in the saddle" (Woodward, *Mary Chesnut's Civil War*, 84). (*Courtesy Harold Holzer*)

Both Col. B. and I were in a passion this morning upon finding that the papers had published a dispatch from their own agent at Manassas, stating that the President did not arrive upon the field until the victory was won; and therefore did not participate in the battle at all. From the President's own dispatch, and other circumstances, we had conceived the idea that he was not only present, but had directed the principal operations in the field. The colonel intimated that another paper ought to be established in Richmond, that would do justice to the President; and it was conjectured by some that a scheme was on foot to elect some other man to the Presidency of the permanent government in the autumn. Nevertheless, we learned soon after that the abused correspondent had been pretty nearly correct in his statement. The battle had been won, and the enemy were flying from the field before the President appeared upon it.

In a speech delivered outside Richmond's Spotswood Hotel when he returned on the night of July 23, Davis declined direct credit for the victory, but he described the cheers of wounded soldiers and the rallying of broken ranks for a final victorious charge.[11]

Therefore, the story survived—survived even the wreckage of Davis's general military reputation in the war's later years—and eventually appeared in softened form in Frank H. Alfriend's *Life of Jefferson Davis*, published in 1868. Alfriend contended that the Confederate president arrived on the battlefield "while the struggle was still in progress," that "to [the troops] his name and bearing were the symbols of victory," and that "while the victory was assured, but by no means complete, he urged that the enemy, still on the field . . . be warmly pressed, as was successfully done."[12]

Joseph E. Johnston, one of the president's most sourly unrelenting critics, was not about to let Alfriend's claims stand. Johnston, along with General Beauregard, had commanded the Confederate troops at Bull Run, and he had been present when Davis arrived on the field. When he recalled the event in his 1874 memoirs, which were among the earliest produced by a major Confederate military figure, Johnston described the Alfriend stories as "fancies." President Davis, Johnston insisted, "arrived upon the field after the last armed enemy had left it, when none were within cannon-shot, or south of Bull Run, when the victory was 'complete' as well as 'assured,' and no opportunity left for the influence of 'his name and bearing.'" General Beauregard, himself hardly a Davis partisan, recalled years later that he found Davis at Johnston's headquarters at 10 P.M. "Arriving from Richmond late in the afternoon," Beauregard wrote, "Mr. Davis had immediately galloped to the field, accompanied by Colonel Jordan. They had met between Manassas and the battle-field the usual numbers of stragglers to the rear, whose appearance belied the determined array then sweeping the enemy before it, but Mr. Davis had the happiness to arrive in time to witness the last of the Federals disappearing beyond Bull Run."[13]

The Hoyer and Ludwig print offers not only a vivid reminder of Southern expectations but also an interesting clue to Jefferson Davis's self-image. His 1881 book, *The Rise and Fall of the Confederate Government*, featured an engraving of the "Members of the President's Staff," depicting nine military men, among whom perhaps the most famous was Mrs. Chesnut's husband, James. There is no corresponding Lincoln print because there was no corresponding group in the Lincoln administration. President Lincoln organized his office entirely as a civilian affair, with a former newspaperman and a Brown University graduate serving as his secretaries. It was notoriously easy to gain access to the president in Washington. Such was not the case in Richmond. Davis seems to have attempted to run his office as something of a military command post, and John B. Jones described it this way in No-

vember 1862: "What a change in the Executive Department! Before the election, the President was accessible to all; and even a member of Congress had no preference over the common citizen. But now there are *six* aids, cavalry colonels in rank and pay, and one of them an Englishman, who see the people, and permit only certain ones to have access to the President. This looks like the beginning of an imperial court."[14]

Nor is the melodrama suggested by the Hoyer and Ludwig print entirely wide of the mark. The next spring, President Davis took to the saddle again. Before he left for the Seven Pines battlefield, however, he packed some of his books, his sword, the pistols he had used at Buena Vista, and his dressing case and sent them to his wife Varina, safely away from the front in Raleigh, saying darkly, "they might have a value to the boys in after time, and to you now." At Seven Pines on May 31, Postmaster General Reagan warned the president, who apparently came under fire once, not to expose himself to the enemy. Davis returned to Richmond that night, but he went back to Gustavus Smith's headquarters on horseback on June 1 and came close to blundering into the range of a Federal battery. In the Seven Days' Battles at the end of June, Davis again "was on the field, but did not interfere with Lee," as John B. Jones put it. "Every day he rides near the battle-field, in citizen's dress, marking the fluctuations of the conflict, but assuming no direction of affairs in the field." Davis seemed to long for some miraculous opportunity to assume a personal military role. Indeed he told his daughter after the war, when she asked what he would like to do if he could live his life over again, "I would be a cavalry officer and break squares."[15]

Europeans easily accepted the romantic military image of the Confederate president as well. In a group portrait of Davis and his generals (plate 2)—in which Beauregard overshadows Robert E. Lee, John Bankhead Magruder is given a conspicuous role, and Joseph E. Johnston's portrait is based on an early photograph —Davis is again portrayed in uniform. The Parisian firm of Goupil et cie, which copublished the lithograph in New York through distributor Michael Knoedler, knew little enough about the Confederacy to depict some European-style uniforms in the background of the imaginary scene.

Davis may not have appeared at the front after the summer of 1862, but John B. Jones reported during the Seven Days that "Some of the people still think that their military President is on the field directing every important movement in person." Jones, from bitter and somewhat embarrassing experience after First Bull Run, knew better, yet even he had written as late as December 23, 1861, "It is said our President will command in Mississippi himself."[16] Davis's reputation for military expertise, however, plummeted as Confederate armies suffered repeated defeats. His military image barely survived the Civil War, except in books like Alfriend's admiring biography or when printmakers grew lazy, as did Frederick Bourquin of Philadelphia with his 1879 *Generals of the Confederate Army* (fig. 7). Bourquin's lithographer pirated Goupil's earlier design, added men who became famous later in the war, made adjustments for changing reputations (Lee's and Beauregard's), and dressed the figures in more familiar and appropriate gray uniforms. In prints, if not in history, this was the last gasp of Davis's high military reputation, and his role in Bourquin's print owed more to the lithographer's economy or sloth than to the tenacity of Davis's military image.

As the war progressed, President Davis lost icon status in most Southern homes, but not in Europe. There one could find portraits of the Southern statesman well past the time when the Confederacy had lost the ability or desire to produce them. Pierre Metzmacher's portrait engraving appeared in Paris in 1862, published in tandem with a similar engraving of Abraham Lincoln. And, in a phenomenon that still evades an altogether satisfactory explanation, the most antislavery nation in the Western world, Great Britain, clung to a romantic image of the Confederate president

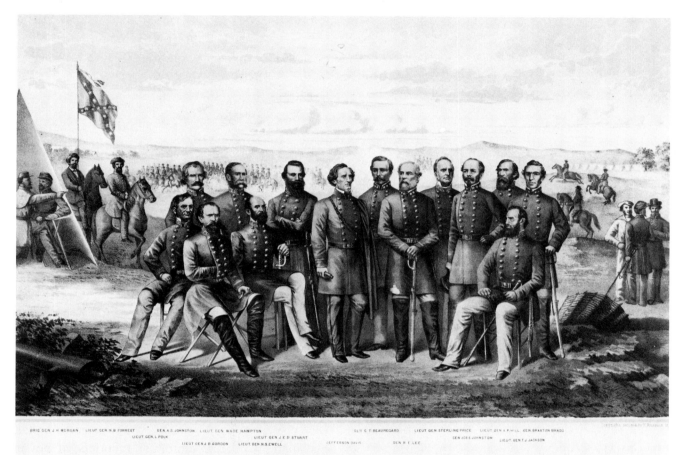

BRIG GEN J H MORGAN LIEUT GEN N B FORREST GEN A S JOHNSTON LIEUT GEN WADE HAMPTON GEN G T BEAUREGARD LIEUT GEN STERLING PRICE LIEUT GEN A P HILL GEN BRAXTON BRAGG

LIEUT GEN L POLK LIEUT GEN J E D STUART GEN JOS E JOHNSTON LIEUT GEN T J JACKSON

LIEUT GEN J B GORDON LIEUT GEN N S EWELL JEFFERSON DAVIS GEN R E LEE

THE GENERALS OF THE CONFEDERATE ARMY

Figure 7.
F[rederick]. Bourquin, after Shlaginlaufin, *The Generals of the Confederate Army*. Published by National Publishing Company of Philadelphia, 1879. Lithograph with tint-stone, 14¾ x 22 inches. Expanding on the design of a Goupil print (see plate 2) made nearly two decades earlier, this lithograph depicted sixteen Confederate heroes rather than eleven. Moreover, five of the men shown in the earlier print have been replaced in this one by generals who earned their reputations after the first year of the war. One famous Confederate general, however, was excluded from Bourquin's print: James Longstreet—not because of what he did during the war but for what he did afterward: join the Republican party. (*Library of Congress*)

Figure 8.
Th[oma]s Koppel, *Jefferson Davis. / From the Latest Photograph Now in Possession of the Family*. Published by V. De la Rue, [London], 1865. Lithograph, 18½ x 14¼ inches. Despite the false air of intimacy suggested by the mention of the Davis family, this print was based on the standard prewar photograph, copied directly rather than in reverse, thus appearing as a mirror image when prints were pulled from the stone. Koppel generally softened Davis's rather chiseled angularity, perhaps to make the lean American look more conventionally aristocratic for his sympathetic British audience. (*Louis A. Warren Lincoln Library and Museum*)

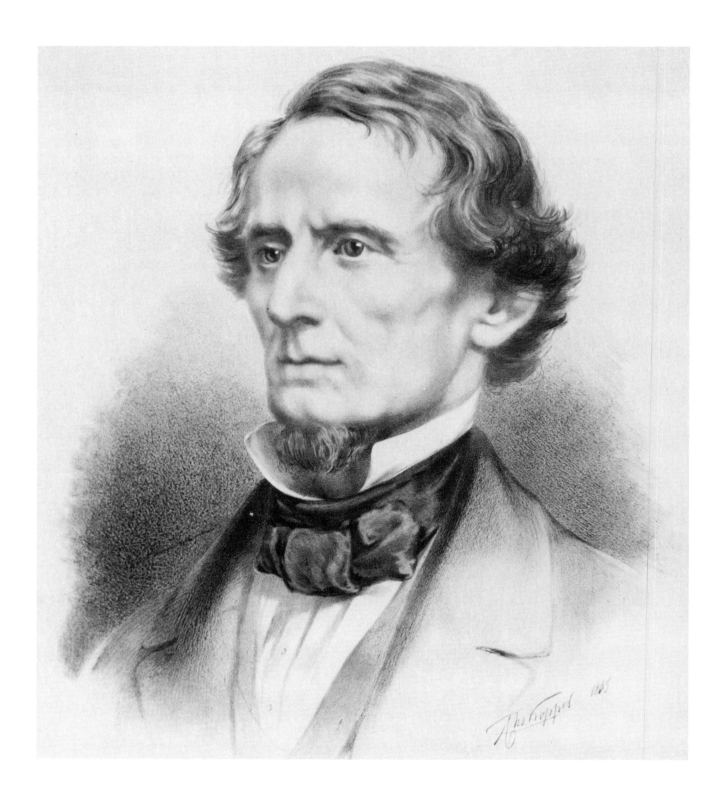

that many Confederates themselves soon abandoned. The conservative British view was put succinctly by Alexander J. Beresford-Hope, member of Parliament, devout Anglican, and a founder of the *Saturday Review*. In a series of extremely pro-Southern lectures on the American Civil War delivered in 1861, he said: "Without relying too much on physiognomy, I appeal to the *carte-de-visites* of both Lincoln and Davis, and I think all who see them will agree that Jefferson Davis bears out one's idea of what an able administrator and a calm statesman should look like better than Abraham Lincoln, great as he may be as a rail-splitter, bargee, and country attorney."[17]

The British print industry managed to feature Lincoln in but one small engraving and only two known lithographs, one of them published after his assassination. No representation of the Northern president equalled the size or quality of Thomas Koppel's large folio lithograph, *Jefferson Davis. From the Latest Photograph Now in Possession of the Family*, published in London in 1865 (fig. 8). How many copies of this or other European prints of Davis reached the Confederate States of America, to be displayed in patriotic Southern homes during the war, cannot be documented, but probably their numbers were few, not only because of the blockade but also because Davis's admirers grew ever fewer while his bitter enemies became legion. By the time Baltimore artist John Robertson arrived at the Confederate White House in Richmond in 1863 to paint President Davis from life, there was no longer either a domestic Confederate print industry to adapt the canvas into an engraving or lithograph or much of a domestic demand for popular graphics of "our first president."[18]

Figure 9.
Probably William B. Campbell, *Gen. P. G. T. Beauregard.* Published in the *Southern Illustrated News*, June 20, 1863. Wood engraving, 5¾ x 4 inches. This fierce-looking portrait was not published until two years after the general's initial military successes at Sumter and Manassas. He never regained the glory of his first campaigns, but the colorful Creole remained popular in his native state. Writing of his return home to New Orleans after the war, his biographer and close associate Alfred Roman reported that Beauregard was greeted by citizens who "flocked out from their houses, waving their handkerchiefs and pressing around his horse to shake the General by the hand" (Roman, *Military Operations of General Beauregard*, 2: 415). (*Rare Book Division, The New York Public Library, Astor, Lenox, and Tilden Foundations*)

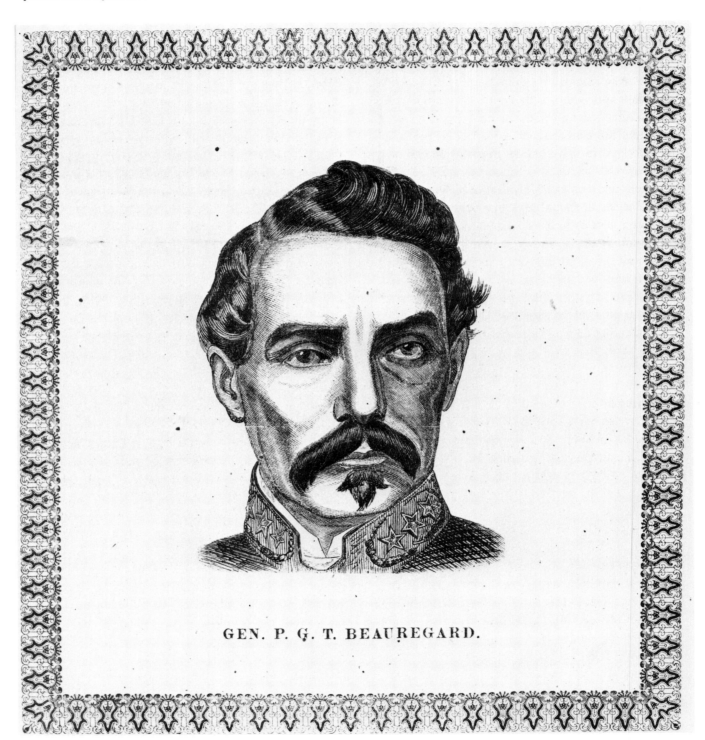

GEN. P. G. T. BEAUREGARD.

3 / Engraving Acceptable to All

In the fall of 1862, Richmond publishers Ayres and Wade launched the Confederacy's first pictorial news weekly, the *Southern Illustrated News*, with the motto on its masthead: "Not a luxury, but a necessity." Like many "necessities" in the wartime South, its price was high. Subscriptions were offered at seven dollars per year and four dollars for six months, with "no county or individual money taken."

There are no surviving subscription lists, and runs of the paper are now rare, but there is evidence of its broad circulation and popularity. Late in 1862, the *Southern Literary Messenger* noted, perhaps with some envy, the "remarkable success of the *Southern Illustrated News*. The proprietors issued a Prospectus, and before the first number was printed, money and orders enough to pay the cost of two numbers were received. Since then, the paper has grown with wonderful rapidity, and is said now to be making money at the rate of $50,000 per annum." An "illustrated family newspaper . . . devoted to the cause of our country in this trying hour," the *News* gamely combined devotion to the cause with resigned acceptance of the harsh realities of a Confederacy perpetually short of manpower, manufacturing, and supplies.[1]

In editorial format and graphic design, the *Southern Illustrated News* was an obvious but inferior imitation of the thriving picture papers from London and New York, especially the English weekly whose name it adapted, the *Illustrated London News*. For two years, the *Southern Illustrated News* struggled to duplicate the combination of battlefront reporting and sketches and literary pieces that made its Northern and English models so successful. But almost from the beginning, the *News* encountered serious obstacles.

Advertising, slight from the outset, never expanded appreciably and eventually all but vanished. Paper quality was poor from the start and grew even poorer. The *News*'s artists, when it had any available, were not the best. None was ever assigned to the front to record

the vivid scenes of war first-hand and make the kind of life sketches that the speedy wood engravers of *Harper's* and *Frank Leslie's* routinely translated into timely newspaper woodcuts. Instead, the artists on the *Southern Illustrated News* seemed permanently desk-bound, using out-of-date photographs as models for straightforward portraiture. To make matters more difficult, basic supplies, including the very wood that its engravers needed to cut their illustrations, were constantly in short supply. Yet there was no shortage of ingenuity or ambition at the *News*. Just as the proprietors got out their popular first issue, Richmond's older and stuffier organ, the *Southern Literary Messenger*, apologized to its readers: "The present double number would have contained as much matter as the last, had not the government seized the paper mills in this city, and we failed to get paper in North Carolina." Somehow, the well-managed *News* had found a paper supply adequate to print its first issue.[2]

The *News*'s maiden issue, which appeared on September 13, 1862, in the ripe enthusiasm following victory on the Peninsula, featured on the front cover a small woodcut by engraver John W. Torsch (see fig. 55) showing an uncharacteristically balding Stonewall Jackson. And the paper's first portrait of the hero of Fort Sumter, P. G. T. Beauregard (fig. 9), did not appear until June 1863. Nevertheless, for twenty-five months the *News* indisputably provided Southerners with their principal source of regularly delivered popular pictures.

Despite a shaky start, the *Southern Illustrated News* pledged in its first editorial to match or surpass its Union rivals. "By the aid of pen and pencil," the editors vowed, they would

> present more vividly to the reader the grand and imposing events that are happening around us. . . . The illustrations we shall furnish will be honestly and faithfully drawn and engraved by competent and experienced artists. We cannot

engage to give pictures of victories that were never won, or to sketch the taking of capitals that never surrendered, as have the illustrated weeklies of Yankeedom. Nor shall we attempt to make one engraved head serve as a portrait for "poet, statesman, fiddler and buffoon"—passing off the likeness of a British orator for an American divine, and bringing it out again, upon occasion, for a new Major General.[3]

The *News* also warned readers not to look for many examples of the very thing it was promising to feature: pictures. "While we expect each week to increase the number of engravings, yet our aim shall be, not *number*, but *quality*," continued the introductory essay. "We shall present engravings of battles as they actually occured, and not fancy sketches originating only in the brain of our artists—also maps showing the localities and positions occupied by the contending armies, which will prove invaluable to the general reader at the present time. Our engravings and biographical sketches of the distinguished men connected with the present struggle for Southern independence will, in the meantime, be continued, from week to week, until completed." The newspaper proved unable to keep all of its promises. The number of engravings never did increase—except for the introduction of occasional illustrations for fiction—and through the entire run of the paper, not a single battlefield scene and only one map appeared on its pages.[4]

Instead, the newspaper that advertised itself as "a handsomely embellished literary journal" with "engraving acceptable to all" continued to publish, week after week, head-and-shoulders portraiture accompanied by brief, laudatory biographical data. Military heroes were the order of the day. Yet no portrait of Jackson appeared again until after his death. Only two issues featured engravings of Lee. And Jefferson Davis, the commander in chief of the Confederate forces, *never* appeared anywhere in the newspaper.[5]

In the beginning the paper briefly enjoyed the talents of a Baltimore wood engraver named John W. Torsch. The premiere issue of the *News* boasted of securing "the valuable services of that excellent Artist, Mr. Torsch, late of the 'Maryland Line,' who will be ably assisted by the artistic pencil of Mr. King, long connected with the Minnis Gallery." King's connection with Richmond's leading photographic studio gave the newspaper access to the latest portraits. Torsch himself became available, apparently, because of the disbanding of the First Maryland Infantry, C.S.A., on August 17, 1862. He and King designed the *News*'s elaborate masthead, a representation of the Virginia Monument surrounded by Fort Sumter on one side and a plantation mansion and riverboat on the other. The design, the *News* asserted, reflected "great credit" on the two artists. Torsch and King apparently enjoyed working together. They sketched a series of scenes of Civil War battles near Richmond and intended to publish them as engravings. But they were too much absorbed by work on the fledgling newspaper.[6]

Among the Southern generals featured on the pages of the *Southern Illustrated News* in late 1862 were Jeb Stuart, Edmund Kirby Smith, Braxton Bragg, Leonidas Polk, Ben McCulloch, and John Hunt Morgan and his staff. There was also a "truthful engraving" of Joseph E. Johnston (fig. 10), from a Julian Vannerson photograph, as well as an Ernest Crehen woodcut of *Miss Belle Boyd, / The Rebel Spy.*

One of its more ambitious efforts was the portrayal of the martyred General Turner Ashby, depicted in an awkwardly rendered equestrian portrait (fig. 11). Here was a rare thing for the *News*, a scene witnessed in the field by Virginia painter William H. Caskie, who at the time was serving as a private under Ashby's command. Impressed "with the bold and picturesque appearance" of the general as he sat on his "beautiful white steed," Caskie later sketched "the gallant soldier" from memory. The result, the *News* proclaimed, was a "more accurate likeness of rider and horse" than could "have

Figure 10.
Probably John W. Torsch, after a photograph by Julian Vannerson, *General Joseph E. Johnston*. Published in the *Southern Illustrated News*, November 1, 1862. Wood engraving, 6¾ x 4³⁄₁₆ inches. In publishing this crude woodcut of Johnston, the *News* described it as a "truthful engraving." Although it was precisely copied from the most frequently adapted Johnston photograph, this and perhaps other copies of the engraving itself contained distracting flaws like the long white lines under the subject's nose and through his tunic, probably caused by poorly fitting woodblocks. (*Rare Book Division, The New York Public Library, Astor, Lenox, and Tilden Foundations*)

been obtained even from the Camera itself." The rigid engraving of the Caskie sketch was accompanied by a poetic tribute to the general, who had been killed during the Battle of Port Republic on June 9, 1862:

See what a grace was seated in that brow!
An eye like Mars, to threaten and command;
A station like the herald Mercury,
New-lighted in a Heaven-Kissing hill;
A combination and a form indeed.[7]

The lines—which are not so identified in the article—come from Hamlet's soliloquy on contemplating two portraits, "counterfeit presentments" of his father and his uncle. The literary allusion is unerringly appropriate here. The passage even begins, "Look here upon this picture . . . ," words that might easily have introduced the *News*'s tribute to Ashby. This intelligent use of Shakespeare by the *News*'s editors exemplifies the sophistication with which nineteenth-century writers pursued their craft.[8]

On November 8, 1862, less than two months after the *News*'s maiden issue, principal engraver John W. Torsch vanished from its pages. He had become Captain Torsch, commander of Company E, 2d Maryland Infantry, a regiment composed mostly of Southern-sympathizing Marylanders who had come to Richmond after the war began. Once Torsch departed, the *News* had to reach far to find another man with the requisite graphic skills. Under the banner, "Our Corps of Engravers," the paper announced the arrival of a new "principal artist, Mr. Wm. B. Campbell, late of Savannah, under whose special supervision the illustrating department of our paper will be immediately placed." Campbell had genuine experience, much of it acquired in New York, where he worked for *Frank Leslie's*. He came South after secession and served in the Confederate army, and then he was hired "to engage in the 'labor of love,' that of illustrating the 'NEWS.' With a corps of artists, with Mr. Campbell at

its head, we have no fear for the result." Once again, the paper's confidence may have been overstated. To Campbell's credit the cover illustrations of the *News* did become much larger, beginning in November with a front-page picture of Major General A. P. Hill, and they were placed in elaborate scrolled frame designs. But the quality of the portraiture did not markedly improve.[9]

The *Southern Illustrated News* never kept its shortcomings a secret. Before the end of 1862 it was openly advertising for "two apprentices, to learn the wood engraving business." Another advertisement pleaded for "Box Wood" for woodcut making. Taking note of this shortage, a patriotic contemporary suggested native white birch, mountain laurel, and dogwood as replacements for previously imported materials. But wood was not the only essential item in short supply. The portraits engraved on the wood were necessarily based on photographic models, and photographs were scarce too. In December 1862, openly admitting a shortage of models, the paper asked readers to send photographs of Confederate generals James Longstreet, D. H. Hill, Henry H. Sibley, and others.[10]

The dearth of models was also apparent from the paper's advertisements. One announcement heralded an offer by an entrepreneur named Lee Mallory to put together an exhibition of "war illustrations" in leading Southern cities. But first he, too, needed what the *News* was having trouble obtaining: pictures. For two years Mallory advertised in the paper for "sketches of Scenes and Incidents connected with our Army, such as Views of Camps, Battle-Fields, Maps &c."[11]

The only time the *Southern Illustrated News* printed a paid notice for a popular print created in the Confederate states came in mid-1863, when Mississippi publisher H. C. Clarke announced his "accurate and faithful" lithograph of the "siege and bombardment of the City of Vicksburg, Miss.," including the "Yankee bombarding fleet" pounding the "heroic 'Hill City.'"

Figure 11.
Probably John W. Torsch, after William H. Caskie, [*General Turner Ashby*]. Published in the *Southern Illustrated News*, October 18, 1862. Wood engraving, 6 x 5¼ inches. This equestrian portrait appeared on the cover of the *News* to illustrate a long tribute to the "tenderly cherished" memory of the martyred general, portrayed here as a romanticized cavalier. The designer of the scene was famous in the Confederacy for a very different sort of work. "His bump of veneration," said one Richmond resident about artist Caskie, "was never visible to the amateur phrenologist. . . . His sketches were often the extreme of caricature" (DeLeon, *Belles, Beaux and Brains,* 282). The engraver, Torsch, as a member of the First Maryland Infantry, may have been present at Ashby's death. (*Rare Book Division, The New York Public Library, Astor, Lenox, and Tilden Foundations*)

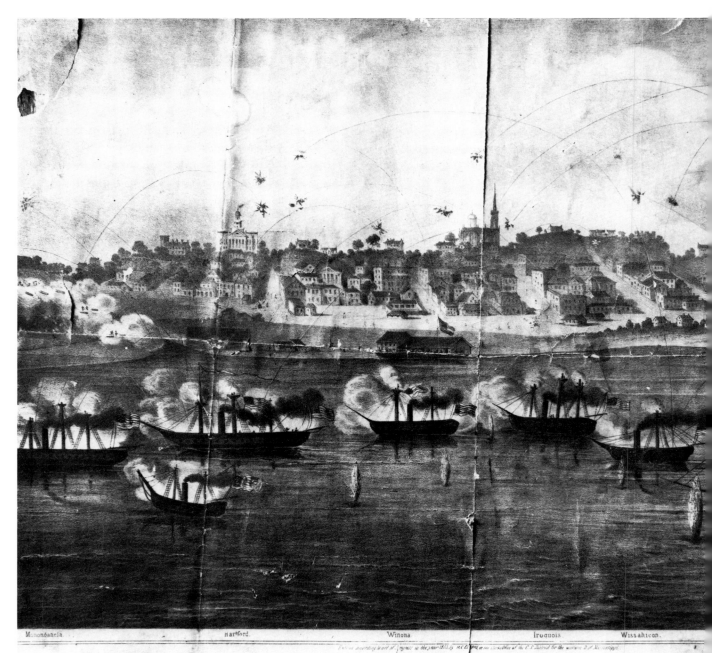

Monongahela Hartford Winona Iroquois Wissahicon

THE BOMBARDMENT OF THE CITY OF VICK

On the ever memorable 28th of June 1862.

Figure 12.
B. Duncan and Company, *The Bombardment of the City of Vicksburg. On the ever memorable 28th of June 1862.* Published by H. C. Clarke, Vicksburg, 1863. Lithograph, 13½ x 20 inches. Publisher Clarke advertised this print, "executed in the best style of art," for sale at five dollars each, postage free. By the time the print was issued, Vicksburg had fallen to Union forces and Clarke had relocated in Mobile, Alabama. The obvious difficulties of this catastrophic period for the Confederacy may help to explain the print's rarity today. The only known copy was found folded as backing for another print hanging in Vicksburg's old courthouse, a landmark that survived the bombardment. In fact, its dome is visible in the lithograph under a shellburst on the hilltop at left. (*Old Court House Museum, Vicksburg*)

Not long afterward, the *News* also reviewed the print and, not unexpectedly, declared that it had been "gotten up in very superior style, and, as far as we are able to judge, gives an admirable and accurate idea of the terrific bombardment." Only one known copy (fig. 12) of the print survives.[12]

Despite the scarcity of pictures in the Confederacy, Southern critics nevertheless quickly grew impatient with the *News*. At Christmas time in 1862 an observer for the *Savannah Republican* charged that the picture weekly's engraved portraits were "miserable daubs." The *News* shot back with a blistering and near-scatological response to this "supercilious . . . atrabilious critic" for what it termed his "sour rebukes": "Abuse cannot harm us; honest criticism may do our artists . . . much good. . . . We shall continue to print the best and most popular paper in the Confederacy, without regard to the sensibilities of persons laboring under hepatic derangement, and whose opinion of pictures, as of everything else, will continue to be jaundiced, until they consent to the mollifying influence of a course of blue pills." Yet criticism seems not to have impeded the paper's uncanny success.[13] The *Southern Literary Messenger* commented on the *News* in April:

> Its circulation is now something enormous for a paper of its class in the South. We could wish its Editors would pay less attention to the Theatre and more to the illustrations. Not that we complain of the quality of its cuts, which are as good as the ink and paper of the times permit, but in a professedly illustrated paper the literary matters should be subordinate to the pictures. The best articles of the best writers will not insure success half so quickly or so certainly as a plenty of even mediocre pictures.[14]

In 1863, having already portrayed pictorially the Confederacy's principal warriors, the *News* began featuring more obscure generals: Lafayette McLaws on

April 4, John S. Williams on April 11, James S. Archer on April 18. There was no improvement in timeliness; General George Pickett's portrait did not appear until mid-August 1863, six weeks after his famed charge at Gettysburg. The same issue carried an engraving of Fort Sumter to mark the second anniversary of its surrender, an anniversary that had taken place four months earlier.[15]

Increasingly aware of its flaws, the *News* advertised the approach of its second year with promises of "many improvements . . . in the general appearance of the paper," but real improvements were difficult to discern. A new low point was reached late in the summer of 1863 when the military took over a nearby railroad line "and prevented the arrival of our useful supply of paper." In this event even the ingenuity of the *News* failed and an entire issue had to be cancelled.[16]

Artists remained in short supply as well, prompting a plea for fresh talent late that summer. "*Engravers Wanted.* Desirous, if possible, of illustrating 'The News' in a style not inferior to the 'London Illustrated News.' We offer the highest salaries ever paid in this country for *good engravers*." An advertisement published a few weeks later announced the imminent arrival of five new artists. The promised upsurge in quality and quantity never arrived.[17]

By early 1864 advertising placements plummeted, and the publication began to shrink in size. Several issues were not only pathetically thin but featured few illustrations, most of them over-inked because of a suddenly undependable printing process. The skimpy issue of October 29, 1864, featured only one cartoon and no portrait engravings at all. With this whimper, life ended for the *Southern Illustrated News*.

The demise of the *News* spelled an end to the reliable creation and delivery of homemade print portraits to the Confederate nation. Yet the history of this doomed newspaper testifies to the craving for pictures and words in the image-starved Confederacy. As the *Messenger* put it, "The greed of the Southern people, for literature, is shown in the remarkable success of the Southern Illustrated News."[18]

4 / Dissolving Views

Despite grim struggles and military preoccupations, the people of the Confederacy seem to have retained their sense of humor. Even prickly General Joseph E. Johnston, for example, got off an occasional quip; when he heard about the easy Confederate victory at Fredericksburg, he wrote to Senator Louis Wigfall: "What luck some people have. Nobody will ever come to attack me in such a place."[1] Beauregard and other officers could enjoy humor at their own expense, as the dinner with Lieutenant-Colonel Fremantle showed. Therefore, it is not surprising that the Confederacy's output of lithographs and engravings included cartoons and caricatures, not only in the *Southern Illustrated News* and the short-lived humor magazine called *Southern Punch*, but in separate-sheet prints as well.

The brief career of *Southern Punch* (from August 1863 to August 1864) might appear to suggest that the Confederacy had little to laugh about. Indeed, the comic weekly has been called "the saddest of comics," and one distinguished historian of the Confederacy argued that "the Confederate literature of humor lacked the verve and color that distinguished the tales of the great prewar Southern humorists. Life now was too grim for that." He went on to say, "Yet humor did survive the war." Indeed, in graphics, humor fared quite well when compared with the Confederacy's meager output of portraiture and other prints.[2]

The most intriguing cartoons are the rare *Dissolving Views of Richmond*, published by Blanton Duncan in Columbia, South Carolina, probably in 1862. The four lithographed poster cartoons poked fun at George B. McClellan's Peninsular Campaign. The first (fig. 13) depicted him in an oversized Napoleonic chapeau and satirized his alleged penchant for sending inflated reports of victory over the telegraph wires. The second in the series (fig. 14), though it is rather confused and unfocused, is nevertheless interesting for the extremely rare self-image of the Confederacy revealed in the idealized figure to the viewer's right. Although the caption would seem to indicate that the character is Stonewall Jackson, the general looked nothing like the figure in the cartoon. Jackson's role in the Peninsular Campaign was not particularly glorious, and his customarily modest, even somewhat seedy attire rarely matched the cavalierly feathered, wasp-waisted, and peg-panted soldier in the lithograph. This dashing fellow represents only what some Confederates thought their military leaders *should* look like. The third lithograph (fig. 15) made a serious attempt at a portrait likeness of McClellan. The fourth (fig. 16) showed McClellan, in a Napoleonic hat, congratulating his troops on victory. The troops, well drawn but in conspicuously European-looking uniforms, are crippled, blinded, lamed, and discouraged and appear to be derived perhaps from some British print of the Crimean War, many of which showed war's less glorious side. Several of these Confederate lithographs contained quaintly charming but idealized skylines of Richmond in the background, cityscapes seemingly lifted from European prints rather than from any actual view of the capital.

Whatever their faults, the *Dissolving Views of Richmond* are little worse than the average Northern separate-sheet cartoons in quality of execution, but their inability to reproduce a true likeness of the early Confederacy's greatest hero, Stonewall Jackson, is significant—and a sure sign that both photography and printmaking were failing to meet the demand for portraiture. The sole wartime lithographic or engraved likeness of Jackson—of any quality—was a small frontispiece lithographed by Richmond's Ernest Crehen for John Esten Cooke's *Life of Stonewall Jackson*, published in the Confederate capital in 1863.[3] A similar print, a portrait of Jeb Stuart executed in like style by the same Ernest Crehen (fig. 17), provides more accurate clues to the uses of such pictures and the direction the Confederate image might have taken had economic hardship and military defeat not put an end to im-

The youthful Napoleon quietly sitteth down upon his base before Richmond intending to take it when he gets ready.

Figure 13.
[W.J. or J.W.], *Dissolving Views of Richmond. / Scene 1st.* Published by Blanton Duncan, Columbia, S.C., ca.

1862. Lithograph, 11½ x 16⁷⁄₁₆ inches. Although skillfully drawn, this cartoon is nevertheless confusing because the depiction of General George

B. McClellan is not a portrait likeness at all. Instead, he was drawn to look exactly like Napoleon, although the picture would have been more effec-

tive had McClellan's face peered out from under the oversized Napoleonic hat. (*The Boston Athenaeum*)

DISSOLVING VIEWS OF RICHMOND.

He concludeth to change ye base of his operations, and is ably seconded therein by ye gallant Stonewall.
He giveth way to a pressure coming from the rear.

Figure 14.
[W.J. or J.W.], *Dissolving Views of Richmond. / Scene 2d.* Published by Blanton Duncan, Columbia, S.C., ca. 1862. Lithograph, 11½ x 16⁷⁄₁₆ inches. In this muddled scene, the cartoonist created a richly humorous image by depicting McClellan's famous change of base from the York River to the James in the face of the enemy as a head-over-heels somersault. The South's infatuation with the cavalier image, however, robbed McClellan's ridiculously Napoleonic uniform of any real sting, for the Confederate figure also appears rather dandified. (*The Boston Athenaeum*)

Figure 15. [W.J. or J.W.], *Dissolving Views of Richmond. / Scene 3d.* Published by Blanton Duncan, Columbia, S.C., ca. 1862. Lithograph, 11½ x 16⁷⁄₁₆ inches. Purchasers of the entire series of cartoons could appreciate the contrast between the dilapidated eagle in this scene and the proudly puffed-up bird in the first. But such buyers could also note some small discrepancies. Here, for example, "Stonewall" carries a musket rather than a saber, as in the second cartoon. This is the only one of the series that was initialed by the unknown artist, in the stone at lower right. (*The Boston Athenaeum*)

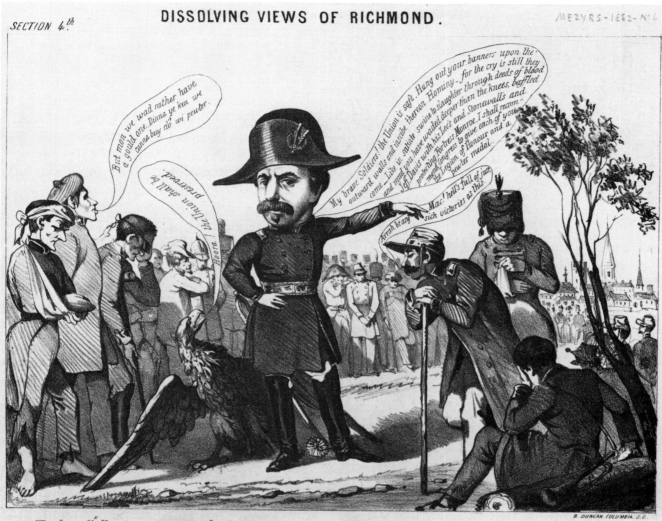

The "small" Napoleon after the fatigues of the week, congratulates his victorious companions on the 4th July for their gallant deeds.

Figure 16.
[W.J. or J.W.], *Dissolving Views of Richmond. / Scene 4th.* Published by Blanton Duncan, Columbia, S.C., ca.

1862. Lithograph, 11½ x 16⁷⁄₁₆ inches. McClellan's congratulatory victory speech is here cynically received by his battered troops. The soldiers

speak with foreign accents, making this lithograph one of the earliest embodiments of the myth that the Confederacy was overpowered by immigrant

hordes from the North. (*Prints Division, The New York Public Library, Astor, Lenox, and Tilden Foundations*)

Figure 17.
E[rnest]. Crehen, *Genl Stuart*.
Richmond, [1863]. Litho-
graph, oval, 3⅜ x 4½ inches.
Autographed: "Yours truly /
J.E.B. Stuart / Warpath. Sept.
3d. 63." Stuart hid a youthful
face beneath his abundant
whiskers—in fact he was not
yet thirty when the war began.
And his flashy attire and rakish
manner obscured rather strait-
laced and puritanical personal
habits. A sincere evangelical,
Stuart liked laughter and banjo
music in camp but allowed no
drinking, swearing, or disso-
lute behavior. (*Eleanor S.
Brockenbrough Library, Mu-
seum of the Confederacy*)

age making in the Confederacy after 1863. The only known copy of the Stuart print, which looks as though it might have originated as a frontispiece design also, is autographed by the subject and dated September 3, 1863.

The Stuart lithograph and the stylized image of Jackson in the *Dissolving Views* suggest that Stuart, a dandified and flamboyant soldier, may have better embodied the early Confederate ideal than the Cromwellian Jackson. Stuart did not hold as high a command as Jackson, but he was more the cavalier. Whatever the limits of the cavalier myth in Confederate society, it seems likely that it would have been at its strongest within artistic circles in Virginia. The Southern chivalric ideal survived there even amidst the bloody realities of defeat. Wounded Confederate officers, recovering in Charlottesville well after the Battle of Gettysburg in 1863, held a "tournament" on the grounds of Monticello. Reported Louisa Wigfall's soldier brother: "Some of the Knights—with only one arm to use—[were] holding reins in their teeth and dashing valiantly at the rings with wooden sticks, improvised as spears for the occasion." He even mentioned "the attendant cavaliers in a more or less disabled condition."[4]

This modest handful of surviving Confederate prints should not leave the impression that the Confederacy was merely the caricature Mark Twain described as doomed to unrealistic military efforts and thus destined to defeat because its citizens had read Walter Scott and believed him. Like the sharp-eyed observer, Mrs. Chesnut, there were Confederate artists who captured a rather different likeness.

This different view is best shown by the little-known series, identified as "comic and sentimental Valentines," issued by George Dunn and Company of Richmond in 1863. The prints embodied Confederate humor in a guise as perennial as warfare itself, by taking a sharply critical look at home front types who did not measure up to the military needs of a society at war.

Without bitterness, the unknown artist delineated certain elements of society universally hated by soldiers and ardent patriots: slackers (fig. 18), for example, and male civilians who enjoyed the company of women the soldiers must leave behind (fig. 19)—types that the *Southern Literary Messenger* denounced as "ye despicable fops and popinjays, that dance pretty dances with flirts and fools in cozy parlours."[5]

Civilians and soldiers alike despised the hoarders, speculators, and extortionists who exploited the scarcities of a blockaded and besieged society. In Richmond, John B. Jones filled his diary with denunciations of "extortioners." As early as September 7, 1861, he attributed the problem to Jews and thus may have spoken an assumption common enough to explain the stereotypically large hook nose in a particularly vicious caricature (fig. 20): "The Jews are at work. Having no nationality, all wars are harvests for them. It has been so from the day of their dispersion. Now they are scowring the country in all directions, buying all the goods they can find in the distant cities, and even from the country stores. These they will *keep*, until the process of consumption shall raise a greedy demand for all descriptions of merchandise." Richmond newspaper editor Edward A. Pollard, writing in 1865, echoed the slur: "Oranges . . . , if they existed in Richmond, would be ticketed in some Jew's window at twenty dollars apiece."[6]

An early entry in Jones's diary, dated May 23, 1862, was similar to many that followed:

> Oh, the extortioners! Meats of all kinds are selling at 50 cts. per pound; butter, 75 cts.; coffee, $1.50; tea, $10; boots, $30 per pair; shoes, $18; ladies' shoes, $15; shirts, $6 each. Houses that rented for $500 last year are $1000 now. Boarding, from $30 to $40 per month. Gen. Winder has issued an order fixing the maximum prices of certain articles of marketing, which has only the effect of keeping a great many things out of

market. The farmers have to pay the merchants and Jews their extortionate prices, and complain very justly of the partiality of the general. It does more harm than good.

Like the greedy merchant in the caricature, Jones kept records of the increasingly outrageous prices of goods. He declared that "Our patriotism is mainly in the army and among the ladies of the South. The avarice and cupidity of the men at home, could only be excelled by ravenous wolves; and most of our sufferings are fully deserved. Where a people will not have mercy on one another, how can they expect mercy?" He came to believe that the real heroism of the Confederacy lay with its self-sacrificing and faithful women and children, the victims depicted outside the capitalist's window in the cartoon.[7]

The *Croaker* (fig. 21) was among the more original of the home front depictions. Despite the grim military situation, Confederate diarists generally kept a stiff upper lip, and even the most realistic chroniclers were impatient with nay-sayers who croaked about defeat and were in a perpetual state of mourning for the Confederacy. As early as January 1862, a Richmond pundit was mocking the "Croaker" for saying always, "We are in a horribly bad way." And by 1864, when the Confederacy's plight was very serious indeed, Jefferson Davis was moved to fierce eloquence by the challenge of the croakers. He told a mass rally in Augusta, Georgia: "This Confederacy is not played out as the croakers tell you. Let every man able to bear arms go to the front and the others must work at home for the cause. Our states must lean one upon the other; he who fights now for Georgia fights for all. We must beat Sherman and regain the line of the Ohio. Let men not ask what the law requires, but give whatever freedom demands." The mourning crepe on the croaker's hat in the cartoon offered a reminder of the grimmest of all Confederate statistics: one-fourth of the South's able-bodied males died for the cause, a large majority of them from dis-

Figure 18. [Printmaker unknown], *No. 3. The Hospital Rat*. Published by George Dunn and Company, Richmond, n.d. Wood engraving, 8½ x 7½ inches. A matron of the largest hospital in America during the Civil War, Richmond's Chimborazo Hospital, recalled that soldiers used the term "hospital rats" to describe certain "hangers-on . . . [and] would-be invalids who resisted being cured from a disinclination to field service. They were so called, it is to be supposed, from the difficulty of getting rid of either species" (Pember, *A Southern Woman's Story*, 18–19). This particular example of the species has the ears, nose, and sharp teeth of a rodent. (*The Boston Athenaeum*)

THE HOSPITAL RAT.

Figure 19. [Printmaker unknown], *No. 4. Lady Killer.* Published by George Dunn and Company, Richmond, n.d. Wood engraving, 9¼ x 7¼ inches. The poem below the portrait of a fatuous drone was intended to reassure patriots and soldiers that young women were not fooled by the wiles of such fops. Nevertheless, the dude's dress and the dancing in the background served as reminders that gay social life went on in Richmond, even at "starvation parties" where no food or drink was served. (*The Boston Athenaeum*)

LADY KILLER.

The thing is known, with all its treacherous wiles,
Its false caresses, and undoing smiles;
Shallow and foppish, up to all the arts
That make us smile, but do not gain our hearts.

[ANON. YOUNG LADY.

George Dunn & Comp'y, Publishers, Richmond, Va.

Figure 20.
[Printmaker unknown], *No. 12. "Anathema on him who screws and hoards."* Published by George Dunn and Company, Richmond, n.d. Wood engraving, 7 x 6 inches. The widow outside the window weeps at the high prices visible on this unpleasant speculator's sheet: "Flour $10,000 / Salt 25,000 / Bacon 50,000." (*The Boston Athenaeum*)

Figure 21.
[Printmaker unknown], *No. 2. Croaker*. Published by George Dunn and Company, Richmond, n.d. Wood engraving, 9⅛ x 7¼ inches. This doomsayer, symbolized here as a crow, has on his bookshelves these gloomy titles: Gibbon, *Decline and Fall*; *Last Days of Pompeii*; *Sorrows of Werter* [*sic*]. The bust of Diogenes, above right, clearly has not found an honest man in this croaker. (*The Boston Athenaeum*)

Figure 22.
[Printmaker unknown], *No. 16. "You look at a star from two motives."* **Published by George Dunn and Company,** Richmond, n.d. Wood engraving, 9¾ x 7 inches. The printmaker relied on a pun and an unlikely quotation for humor. He referred to "Victorious" Hugo and quoted Diogenes as saying "Them's my sentiments." Ironically, at some point during the Civil War, the finery worn by the lovers in the print would have been humorous enough, for even well-to-do people in the Confederacy eventually wore homespun. (*The Boston Athenaeum*)

eases that swept the camps of young men who had previously grown up in rural isolation, seldom exposed to sickness.[8]

The other more heroic and sentimental subjects were more conventional, showing soldiers better fed and better uniformed and belles far better dressed than was possible for most in 1863. To look at the dapper suitor in one of these so-called Valentines (fig. 22) is not to see the realities of Confederate Richmond, where, as early as November 1862, one government clerk complained: "Clothing is almost unattainable. We are all looking shabby enough."[9]

Ironically, these little-known Valentines and caricatures may well have represented the pinnacle of Confederate achievement in the graphic arts. Their distinction lies in their touching on timeless themes of societies at war, but their method can best be described as merely competent. And, indeed, competence is the most that can be claimed for any Confederate print. There were no works of genius, no pictures that symbolized the Confederate experience in enduring ways, none that survived the Civil War to become icons of the Lost Cause. Indeed, there were no pictures that any Southerner recalled in the better-known war diaries and memoirs and no pictures used in any known later exhibition of Southern works of art. The prints of the Confederacy were truly lost and remained so.

The cause was lost, too, by 1865, but not the Confederate image. After a brief hiatus, the Lost Cause by 1866 began to emerge in pictures as the cause itself had never been celebrated. And it did so because of Northern technology, craftsmanship, and artistic ability.

5 / "Confederate" War Sketches

He is best known for his frequently reproduced caricatures of Abraham Lincoln: the familiar cartoon of the president-elect, disguised in a Scotch cap and military cloak, cowering inside a freight car as he passes through Baltimore en route to his inauguration; the image of the sixteenth president as a harem dancer, lifting his veil to reveal that he is a Negro; or the inspired image of the Great Emancipator as Don Quixote, wearing archaic armor and straddling a rickety old horse in quest of the impossible dream of racial equality.

But the artist who created these enduring images, Adalbert Johann Volck, was more than a cartoonist who adroitly satirized Northern prey. In a brief, clandestine career, working under unavoidable distribution constraints that limited his reach, Volck left an indelible legacy of graphic proselytizing. He not only created some of the most artistically accomplished, though vitriolic, views of the North and its people, but also some of the most idealized images of the South, its heroes, and its ordinary citizens.

Volck might well have become the Confederacy's premier visual propagandist had he not resided and worked in Baltimore, a city within Lincoln's Union. His works were Confederate prints in subject matter only; they were printed and distributed in the North. There, inhibited from circulating his etchings in customary commercial form and unlikely to find sympathetic journalistic outlets to reproduce them, Volck spent the war publishing for a minuscule group of no more than two hundred subscribers. He had little hope of disseminating his art in the blockaded Confederate states, the natural audience for his highly charged views of the Yankees.

His only biographer has claimed that "what Thomas Nast . . . was to do for the North, Volck . . . did for the South."[1] But this claim is exaggerated, at least in terms of the artists' contemporary popular impact.

Whereas Nast's sketches were regularly engraved for the popular Northern picture weeklies, Volck's works enjoyed no comparable mass circulation, and as far as is known, no circulation whatsoever in the Confederacy until after the war was over. Today his are perhaps the most familiar of all pictures of Confederate subjects, but that very familiarity has bred confusion about the artist's place in iconographic and political history. Volck's fame is essentially the product of a turn-of-the-century rediscovery of his pictures, not their wartime impact. By definition, he was not a Confederate but a Copperhead artist—a Northern etcher with Southern principles.

Yet no discussion of "Confederate" images would be complete without a thorough examination of Volck's work. His etchings could not have greatly aided the cause, but they certainly had an effect on the image of the Lost Cause. And in their own time these prints crystalized for their small audience in Baltimore, that most Southern of Northern cities, all the sensibilities and aspirations, all the undisguised prejudices and myths, that fueled its sympathy for the Confederacy.

To Volck, the "Confederate War Etcher," the South was a bastion of virtue, where ladies faced sacrifices nobly, where generals prayed in camp, and where loyal slaves happily protected their white masters from Yankee intruders. Everything Northern, on the other hand, Volck viewed with acidic contempt. Free blacks were debauchers, thieves, or beggars, and Union soldiers were dishonorable plunderers and rapists. Ironically, this German immigrant was one of the first artists to develop the myth that the North's numerical supremacy depended on using the dregs of Europe to fight its battles. His etching of the *Valiant Men Dat "fite mit Sigel"* portrayed the German-American troops of General Franz Sigel as killers of helpless women and children.

Only an accomplished artist could have communicated such exaggerated sentiments successfully, and

or technical fa-
century, accus-
ganda of World
k. As one critic
nous composi-
ouch of humor
)lck knew how
used it with a
iring the main
ing but vitriol
unrelieved a
:ed by World
:male corpse
y pictures as
ar Series of
h her breast

ty and deli-
his Lincoln
is shocking
yrics to the
was either
'evolent at
next, sel-
le was far

)lzsck in
/ relocat-
ss father
:, young
it he al-
ummers
'e led to
and the
...uu aiiei the unsuccessful revo-
lution of 1848 in the German states and went south to
Baltimore in 1851, earning a degree from the Balti-
more College of Dental Surgery the following year.
In 1858 he joined the Allston Association, an artists'

club whose members proved passionately pro-Southern during the war. By the end of the decade, he had a successful practice, a house in the city, and a country home in suburban Catonsville.[3]

Then came the Civil War. It is impossible to say exactly what inspired Volck to his ardent pro-Southern perspective, but in Baltimore, he was anything but alone in these views. Perhaps Volck's assimilation into a city that became mad for secession best explains his political views. He had married a Baltimore woman, a former patient named Letitia Alleyn. He even became an Episcopalian—adopting the religion of Robert E. Lee, but hardly that of a typical Bavarian. And his brother, sculptor Frederick Volck, who spent the war years in Virginia, was as ardently pro-Confederate as Adalbert. When, in early 1861, General Benjamin F. Butler occupied Baltimore, Dr. Volck rededicated his life. The prominent dentist retreated to the subterranean world of the Baltimore underground.[4]

The level of his participation in what Northern Republicans called Copperhead activities, however, has never been clear. One of his contemporaries argued:

> He espoused the Confederate cause at its incipiency, and was a special agent of the Confederate government, scorning any pay. He personally conducted across the Potomac River in a private boat artizans, skilled mechanics and men seeking service in the Confederate Army. Strange to say, he was never apprehended. Money which he had made by his profession and varied talents he invested in Confederate bonds, feeling confident of the success of the cause, so at the end of the War he was absolutely cleaned out, having left to him only the memory of his deeds, which he was of too modest a nature to dilate upon.

Eulogists and historians have at one time or another underscored Volck's artistic devotion to the Confed-

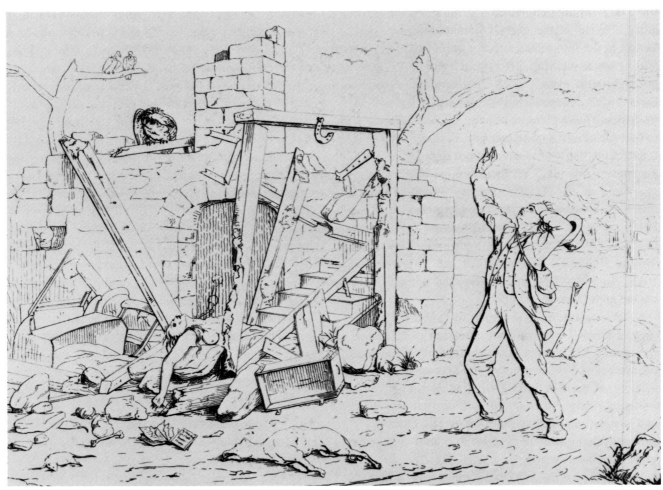

Figure 23.
Adalbert J. Volck, *Tracks of the Armies*. Baltimore, ca. 1863. Etching, 5⅝ x 7½ inches. The returning Confederate's shock at the scene that greets him is expressed melodramatically here, but the conditions that confront him are also melodramatic. His dead wife, nude and with strands of hair clutched in her fingers, is portrayed as the victim of rape and murder. In fact, murders of civilians by enemy soldiers were rare during the Civil War, as were rapes. The usual rape victims in the South were not white, but black. (*Louis A. Warren Lincoln Library and Museum*)

eracy by claiming that he was also a blockade runner, a smuggler of medical supplies, keeper of a "safe house" for Confederates in Baltimore, a Rebel spy, and a personal courier for Jefferson Davis. Volck's own self-dramatizing assertion, which certainly contradicts the testimony of others, claimed that he was the victim of "frequent arrests."[5]

There is no hard evidence to prove that Volck was any of these things, or that he was actually ruined by the war. The statement by his contemporary that he was never apprehended does seem accurate. Earlier writers claimed that Volck had been captured and held for a time at Fort McHenry, but the arrest records for the fort, although they are by no means complete, do not reveal that the dentist was ever detained there.[6]

However, there is no disputing the fact that Volck was acquainted with President Davis. Postwar letters from both Davis and his wife, Varina, indicate some familiarity between Volck and the entire Confederate first family. In an 1867 note from Montreal, for example, Mrs. Davis wrote: "It gives me great pleasure to be able to send the accompanying photographs, and I hope that they may sometimes serve to recall us to you pleasantly. . . . Maggie insists upon being remembered even in a postscript." The photographs might have been requested as models for a portrait, but the reference to the regards from the Davis's daughter suggests some degree of friendship.[7]

Whatever the nature of his other wartime activities on behalf of the Confederacy, it was as an artist and publisher of popular prints that Volck most effectively documented his convictions. In response to Benjamin F. Butler's activities in Baltimore, for example, Volck produced a series of satirical attacks against the general under the title, *Ye Exploits of Ye Distinguished Attorney and General B.F.B. (Bombastes Furioso Buncombe)*. Comparatively raw artistically, the prints were, in the artist's own words, "made early in the war at the time of Butler's occupation of Baltimore."[8]

Probably around the same time, Volck launched another portfolio, *Comedians and Tragedians of the North*. It was an incomplete effort that lacked unifying captions, title page, or index but offered superbly rendered, pungent visual humor in such portrayals as Henry Ward Beecher as "Broder Beechar," a black man; U.S. Secretary of the Treasury Simon Cameron as a thief; and pro-Union Maryland Governor Thomas H. Hicks as Judas, with the shadowy figure lurking behind him and proffering a bribe bearing an unmistakable resemblance to President Lincoln.

Volck's most famous work was yet to come. In 1863, under the rather obvious pseudonym of "V. Blada"—an anagram derived by reversing the first five letters of his given name and adding the initial of his surname—Volck secretly published the first ten etchings in a proposed series entitled, *Sketches from the Civil War in North America*. Complete with a salmon-colored index cover sheet and etchings printed on heavy paper, the entire production bore a London publishing imprint, as did a prospectus issued concurrently to advertise the collection. A subsequent edition—the so-called "second and third issues"—of "V. Blada's War Sketches" increased the number of published etchings to thirty. More were planned, perhaps as many as sixty-two.

By 1864–65 there were indications that Volck's plans would never be realized. In a revised prospectus, dated 1864 and also bearing a London imprint, "the author" warned subscribers that "in consequence of the great depreciation in Currency, and consequent high rate of Exchange, he finds that the present rate of Subscription will barely cover cost of the materials required for completing the undertaking, leaving nothing to repay the time and labor bestowed upon the work." Subscribers were asked to advance their next installment payments or pay a higher price later. Those who complied with the request, however, were disappointed. The next section of the "undertaking," which

was to boast seventeen prints of scenes such as "Lincoln's Meeting with the Southern Peace Commissioners" and "Butler's Reign in New Orleans," never appeared. The reasons for the interruption have remained a matter of conjecture. But the explanation seems relatively simple: the *Sketches* had not originated in London in the first place. They were printed by Volck himself in Baltimore, and quite probably he abandoned the effort when it became apparent that the cause was lost.[9]

These claims for London publication have confounded generations of iconographers, some of whom have conjectured that Volck shipped his plates to England, where they were printed and the prints run back to the South through the blockade. Notwithstanding such legends, there is every reason to believe that the entire London copyright claim, including the spiel about falling exchange rates in the accompanying advertising material, was nothing more than a subterfuge. Asked in 1905 to explain the origins of these prints himself, Volck admitted that he had done the work at home: "After long days, day by day, of the harder professional work, from nightfall to far into the small hours, I worked alone on these sketches, drawing, etching, and printing them myself alone. There are only 200 copies by my hand in existence . . . issued to subscribers only."[10] As recently as 1948, the director of the Maryland Historical Society, writing to Volck's daughter for help in describing a newly opened exhibition of her father's works, admitted: "We do not know how to answer the questions. It is commonly said that the etchings were first published in London. I have always felt some doubt about this and wonder if you can enlighten us." There is no record of a reply. Volck may have invented the London imprint to deflect suspicion by Federal authorities in Baltimore; he probably selected England as his imaginary venue because of the romance attached to blockade running as well as the English reputation for both sympathy with the Confederacy and superior printmaking.[11]

After they were printed in Baltimore, Volck did send his last twenty plates to London, possibly to the De La Rue Company—the early publishers of Davis portraits for both Confederate currency and a separate-sheet print—for republication "after peace should be re-established." But when the original plates were recovered years later, Volck learned they were "all ruined by verdigris and scratches. Feelings and times had changed much of my sentiment of the war and I had neither heart nor energy to make them over again." And then the artist added, in a revealing afterthought, "with one exception, they cannot be called 'caricatures.'"[12]

Volck was right. The majority of his war sketches were not caricatures, although which one of the thirty he so described is not known. Rather, they were graphic political propaganda, however artistically skilled. They were full of invective for the enemy, cataloging not only their many supposed sins but also the overwhelming virtues of a righteous and very superior South. The etching of *Jennison's Jayhawkers* setting fire to a farm, abducting a woman, and shooting at the backs of other females as they flee across a field contrasts sharply with the gloating scene of *General Stuart's Raid to the White House*, for example. And the brutally disparaging portrayals of free blacks, both in the North and in Haiti, are comparable to the equally unrealistic view of *Slaves Concealing Their Master from a Searching Party*, a depiction that presaged an important myth of the Lost Cause.

The original sketch for the latter print (fig. 24) bears a signature and date, 1861, which is not reproduced in the etched plate. That surprisingly early date surely makes Volck one of the first to adumbrate the durable myth of the faithful slave. Whether inspired by a factual account of slaves hiding their masters from Federal soldiers or wholly imagined, the idea could not yet have been in wide circulation in 1861, for in that year Union advances into the Confederacy were so meager that few masters needed to hide from Federal troops. Whatever his inspiration, Volck identified an idea that

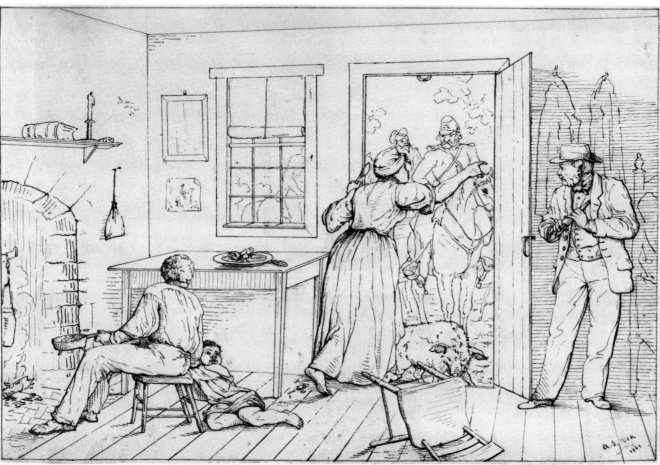

Figure 24.
Adalbert J. Volck, *Slaves Concealing Their Master from a Searching Party*. Baltimore, 1861. Pen and pencil drawing, 6⅜ x 8⅞ inches. In Volck's romanticized view of Southern life, slaves inevitably protected their white masters. In this scene, the master—pistol in hand, ready to defend his freedom—hides behind a door while a slave misleads the Yankee soldiers. The slave child on the floor appears well fed and content. This is the model for one of the ten etchings published in the original "London" version of Volck's *Sketches From the Civil War in North America*, whose contents were about evenly divided between pro-Southern and anti-Northern scenes. (*M. and M. Karolik Collection. Courtesy Museum of Fine Arts, Boston*)

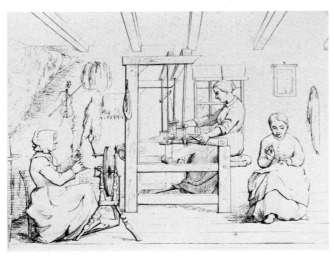

Figure 25.
Adalbert J. Volck, *Making
Clothes for the Boys in the
Army*. Baltimore, ca. 1863.
Etching, 5 x 6½ inches. Issued
as plate no. 11 in the first sup-
plement to the "London" edi-
tion of *Sketches*, this beauti-
fully balanced composition
salutes a familiar object of
Volck's admiration—selfless
Southern womanhood. As his-
torian Frank Vandiver has said:
"Clothes became expensive be-
yond common reach, since the
army consumed most of the
production from the big mills
in North Carolina and the
lesser ones across the land.
And so the old arts of carding,
spinning, and weaving took re-
newed vigor" (Vandiver, *Their
Tattered Flags*, 173). (*Louis A.
Warren Lincoln Library and
Museum*)

would become a standard of Lost Cause literature.
Miss E. M. White of Lexington, Virginia, for exam-
ple, spearheaded a successful postwar drive to place
near Stonewall Jackson's home a granite memorial in-
scribed in bronze:

> A tribute by the white friends of Rockbridge
> County in grateful remembrance of the faithful-
> ness and loyalty of the old servants of the past.
> They loved their owners and were trusted and
> loved by them.[13]

Another beloved image—that of the saintly, heroic,
and deeply religious Southern woman—was also de-
picted by Volck. In *Making Clothes for the Boys in the
Army* (fig. 25), such women labor together to provide
supplies for the fighting men of the Confederacy. And
in *Cave Life in Vicksburg during the Siege* (fig. 26), an
impoverished lady kneels to pray for salvation from a
grim existence implicitly imposed on her by Yankee
barbarism.

Perhaps the most effective of Volck's images of ci-
vilian life in the wartime South, however, was his
Offering of Church Bells to Be Cast into Cannon (fig.
27). The print was likely inspired by an appeal from
General Beauregard in early 1862. The Creole general
asked the planters of the Mississippi Valley "to send
your plantation-bells to the nearest railroad depot, sub-
ject to my order, to be melted into cannon for the
defense of your plantations." The fame of the letter
rang far and wide in both North and South. In Balti-
more an alert Volck created a scene dominated by an
Episcopal priest in the traditional religious pose of
Christ showing his stigmata. The print focused on the
gift of two bells, one mounted by a cross. An ordnance
officer, holding calipers to measure the thickness of
the metal, gazes reverently at the priest. Other repre-
sentative Southerners, conspicuously upper-class ones
with top hats and cloaks as well as one rustic-looking
frontiersman, follow the priest, one woman clutching a

serving vessel. A candlestick and a cooking pot under-
neath the forge further testify to individual domestic
sacrifice for the cause—here distinctly depicted as a
holy cause.

Once again Volck, his view perhaps distorted by his
physical distance from the Confederate states, proved
more sentimental than some real Confederates. Gen-
eral Braxton Bragg scornfully noted at the time of
Beauregard's appeal that the Confederacy had plenty
of metal in New Orleans and more cannons than men
who knew how to fire them. Beauregard's appeal men-
tioned the offer of church bells in other historic strug-
gles, but the actual request was only for plantation-
bells. Whatever Beauregard had in mind in the way
of bells, only forty-three were offered; of those, twen-
ty-nine were declined, probably for want of railroads
to carry them. Beauregard's flamboyant address had
more significance in the realm of myth than metal-
lurgy.[14]

Volck's work could have had little impact on the
Confederacy. With only two hundred sets published,
for subscribers who could hardly have been resident
beyond enemy lines, these pictures probably remained
unseen in the South until after the war. Volck's contri-
butions nonetheless have been routinely exaggerated
by iconographers and historians. Some speak of him
as though he had been a resident of the Confederate
States of America, and not a Southern sympathizer
behind Union lines. William Murrell cited Volck for
making "the most important contribution to American
graphic humor in the South," and George McCullough
Anderson made similar claims in his study of Volck's
work. Yet it was only after the war that Volck etch-
ings were republished—for new generations of enthu-
siasts—in enough quantity to fuel the misconception
that he had reigned as the South's greatest carica-
turist.[15]

Porter and Coates of Philadelphia republished
Sketches from the Civil War in North America as Con-

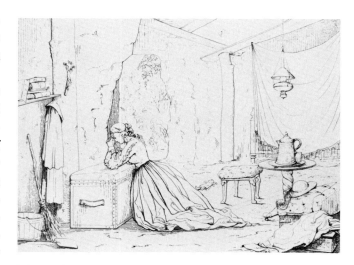

Figure 26.
Adalbert J. Volck, *Cave Life in
Vicksburg during the Siege.*
Baltimore, ca. 1863–64. Etch-
ing, 6³⁄₁₆ x 4³⁄₁₆ inches. Num-
ber 30 in the "London" edition
of *Sketches* (from the second
supplement), this spare por-
trayal illustrates the hardships
facing the Vicksburg women
who "made preparation to live
under the ground during the
siege" of spring 1863. Accord-
ing to one diarist of the period:
"Caves were the fashion—the
rage—over besieged Vicks-
burg. Negroes, who under-
stood their business, hired
themselves out to dig them, at
from thirty to fifty dollars, ac-
cording to the size. . . . So
great was the demand for cave
workmen that a new branch of
industry sprang up and became
popular" (Mary Ann Lough-
borough, quoted in Jones,
Heroines of Dixie, 232).
(*Louis A. Warren Lincoln Li-
brary and Museum*)

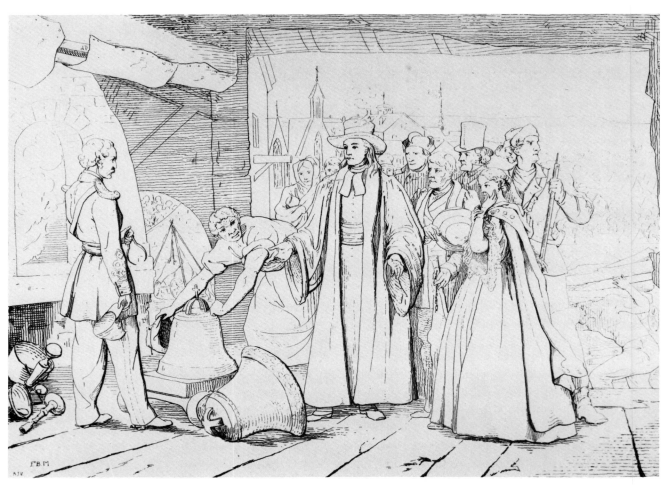

Figure 27.
Adalbert J. Volck, *Offering of Church Bells to Be Cast into Cannon*. Baltimore, 1863–64. Etching, 6³⁄₁₆ x 8⁷⁄₁₆ inches. The theme of this print, more than any other by Volck, betrays the artist's European origins. The town shown in the background, as in other Volck prints, resembles the close-knit stone villages of Europe more than the sprawling ramshackle wooden towns of individualistic America. Yet the etching also has its American elements—most notably, the contrast between the handsome whites and the simian black man. (*Louis A. Warren Lincoln Library and Museum*)

federate War Etchings around 1882 (the watermark date on the paper used for the circular that heralded its appearance). The edition was supposedly printed from the original Volck plates on fine paper, seamlessly affixed to heavier paper, and offered with a board cover tied with strings; the printing was limited to one hundred sets. Yet another edition of *Confederate War Etchings* appeared about ten years later, lithographed onto thin tissue awkwardly glued to heavier backing, in a smaller size than Volck's originals. Finally, in 1917, William Abbatt of Tarrytown issued a bound photogravure edition as a supplement to the *Magazine of History*, with Murat Halstead's assessment of Volck, originally published in *Cosmopolitan Magazine* in 1890, reprinted as an introduction.

As for Volck himself, after the war he prospered anew as a dentist, earning repeated tributes from his colleagues in Baltimore. He never again took up caricature, but he did pursue other art forms and make further direct contributions to the myth of the Lost Cause. Around 1870 Volck was commissioned to paint three canvases as models for chromolithographs, which would be sold to raise money for a statue of Stonewall Jackson. Adalbert's involvement probably came through his brother, Frederick, who had made a death mask of Jackson and no doubt hoped (though he was doomed to disappointment) to receive the commission of the Jackson Monument Association. From sketches he made at the cemetery in Lexington, Adalbert painted a picture of Lee at Jackson's grave. The painting is lost, but a chromolithograph by Charles or Augustus Tholey was published by Eckhardt of Philadelphia (see fig. 71). Another chromolithograph reproduced Volck's painting of Lee in his study (see fig. 74 and plate 13). There was evidently to be a third picture, but the Jackson Monument Association was not as well organized as its Lee counterparts, and this portion of the money-raising scheme was apparently abandoned.[16]

Volck's artistic career continued. In 1872 Emily V. Mason's reverential Lee biography appeared, featuring "illustrations with 17 original designs by Professor Volck." The dentist also produced illustrations for a pamphlet called *The Grasshopper: A Humorous Cantata*, published in Baltimore in 1878. For the most part, however, Volck turned to repoussé work in silver, copper, and bronze. Clippings in his surviving scrapbooks indicate that he won critical acclaim as "one of the most versatile" and as the "dean of the Baltimore artists."

By 1905 the aged Volck had drifted into anonymity. The Library of Congress even wrote him to inquire whether the institution's newly acquired *War Sketches* might actually be attributable to him. Only then did Volck formally admit that he was, indeed, "V. Blada."

The renewed appreciation for Volck is misinformed, because it overrates his impact by failing to distinguish carefully between his postwar prints and the limited number of etchings actually produced during the war. Furthermore, current enthusiasts have stubbornly accentuated Volck's humorous efforts while minimizing his graphic propagandizing. There has thus been a tendency to underrate war-induced passions and a commitment to white supremacy as motivating factors in his work.

Murat Halstead, a Republican newspaperman who knew Lincoln and witnessed the Civil War, came close to an accurate appraisal of what Volck had tried to accomplish as an underground printmaker during the War: "We find these etchings full of the sharpest scorn and of rancorous hatred . . . a record of the fierce animosities, the bitter resentments, the implacable prejudices, the passion, the frenzy and the ferocity of the war." In the assessment of an insightful modern art historian, echoed by observers from the black community, the works seemed "emotion-laden diatribes of bitterness and hate."[17]

Ironically, Volck came to rue the anti-Lincoln cari-

cature for which he was best remembered. In his 1905 letter to the Library of Congress he confessed, "I feel the greatest regret ever to have aimed ridicule at that great and good Lincoln." But he went on to insist, in a seldom-quoted afterthought, that "outside of that the pictures represent events as truthfully as my close connections with the South enabled me to get at them." As if to accentuate his loyalty to the Lost Cause, in 1909—the year most Americans were celebrating Lincoln's hundredth birthday—the eighty-one-year-old Adalbert Johann Volck presented to the Confederate Museum in Richmond a carved silver shield dedicated to the "Brave Women of the South . . . as a continued reminder to those of the present generation of the splendid example of self-sacrifice, endurance and womanly virtue displayed during the war between the states, and which still exists as an important factor in making the New South greater and more prosperous than ever." The women of the South indeed made great sacrifices during the war and long after it, and Volck was nearly alone in noting this in the visual arts.[18] Where the myth of the Lost Cause was concerned, Adalbert Volck, like many of his fellow Confederate artists, remained unreconstructed.

6 / Let It Be Robert E. Lee

For an incipient nation that prized its cavalier tradition and its vital link to the American Revolution—a nation whose great seal featured an equestrian portrait of George Washington—Robert E. Lee seemed the ideal candidate for instant glorification by the image makers once the Old Dominion joined the new Confederacy. By all logic, Richmond's printmakers should have rushed out engravings and lithographs of the man who had turned down the top command in the United States Army to fight for his state and the South.

But in fact, the Confederacy failed to produce a single separate-sheet print portrait of its greatest hero during the entire course of the war. Contrary to the impression left by the plethora of surviving Lee prints, all of which date from the postwar era, Lee did not emerge as a pictorial subject until after he had surrendered to Ulysses S. Grant. The explanation for this dearth lay not only in the short-lived Confederate printmaking industry but also in the sluggish growth of Lee's fame: his rise ironically coincided with the fall of the print-publishing industry in the Confederacy. In addition, Lee's appearance changed so radically during the war that desk-bound Southern printmakers would have faced problems depicting him even had they enjoyed the resources to do so. And Lee, a typically modest Victorian gentleman, did not help matters; he encouraged the taking of precious few photographic models during the war. As a result, while the cause lived, the image of Robert E. Lee did not—at least not in prints for the family parlor.

In the early days of Southern independence, printmakers turned instead to the new president, Jefferson Davis, who at first seemed to suggest military as well as political heroism. In the early literature of the cause, it was the decidedly noncavalier Stonewall Jackson who preceded Lee as a Confederate hero; Jackson's eminence was solidified by his martyrdom in 1863 and celebrated, if not in separate-sheet prints, at least in eulogies, biographies, and sheet music covers—one produced in the Confederacy and two issued in the North during the war.

Historian Emory Thomas has argued that the deprivations of war quickly "denied the Cavalier myth" for most Southerners, transforming not only their political and economic systems but also their culture and the people themselves. Thus, Thomas argues, it was Jackson who dominated poetry and the earliest war histories as the South transferred the emphasis of its political culture from the passive preservation of antebellum traditions to the active fight for independence. There is some evidence to support this view; for example, the *Southern Literary Messenger* called Jackson, when he died, "the . . . chieftain loved and trusted beyond all others." The editors proved also to be anything but old-fashioned in their outlook. "Cannonading with feathers," they said in September 1863, "is the equivalent of chivalry in this age. Aesthetics in warfare is an obsolete idea." In general, this journal conceded Lee rather unemotional praise and painted Jackson as the South's sentimental favorite, "that go-ahead, really great fighter—the pride and joy of the people," though they admitted "some diversity of opinion among military men in regard to Gen. Jackson's qualities as a strategist and commander of an army."[1]

The sluggish development of Lee's pictorial image in the South would seem to bear out Thomas's theory as well, as it took the retrospective romanticism of the Lost Cause era to inspire multitudes of Lee prints. But another cavalier, Jeb Stuart, was featured in popular graphics published in the Confederacy during the war. Where Lee was concerned, other factors were surely at work to inhibit the emergence of a hero whose portraits would have been coveted had they been available.

Lee was neither a president nor a battlefield hero in the first year of the war, although his record, his lineage, and his dramatic refusal to fight against his state might have been enough to inspire some printmakers under ideal conditions. The early course of Lee's image in prints is better explained by the commerce and

techniques of printmaking than by the uncertain history of the cavalier myth.

One frequently overlooked problem was Lee's radically changing appearance. Robert E. Lee seemed to age twenty years in twenty months of service in the field. At the outset of the war, he probably had dark hair and a black moustache. By 1862, some of his hair had fallen out, what remained had turned gray and later would turn white, and he had grown a magnificent white beard. Even more difficult for printmakers who were dependent on accurate photographic models, Lee left behind no representations of his new appearance. The most recent photograph of him available during the war was more than ten years old, nearer his Mexican than his Civil War experience. Northern printmakers could easily keep pace with Abraham Lincoln's changes in appearance, first by drawing whiskers onto his beardless campaign pictures, later by adapting readily available new photographs. Lee changed too much, and too quickly, to permit haphazard artistic guesswork, and for too many months he failed to have a new photograph taken that reflected his new look.

Yet Lee was certainly a picturesque soldier. From earliest adulthood, he was an almost impossibly handsome man, possessed of the kind of appeal that inspired men without making them envious and caused women to turn away from him to hide their reddening cheeks. Studying him across a dinner table when he was only twenty, a relative thought to herself: "You certainly look more like a great man than any one I have ever seen." Age merely improved his appearance. To South Carolina widow Mary Pinkney Izard, for example, the wartime Lee was "the nearest to a perfect man I ever saw . . . handsome, clever, agreeable, highbred, &c. &c." And to diarist Mary Chesnut he was distinguished "at all points." Seeing her in a Richmond church one day, Lee bowed to her, and the sophisticated Mrs. Chesnut "blushed like a schoolgirl."[2]

That he was also the quintessential gentleman was seldom overlooked. As an 1886 print (fig. 28) later demonstrated, Lee could also boast a family tree to equal—some would say to explain—his own seeming perfection. In a land of aristocrats and great families, few men carried a nobler bloodline. Lee's family, his military secretary later commented, was as "worthy of him as he was worthy of it." The earliest known ancestor, according to Robert E. Lee himself, was Launcelot de Lege, who followed William the Conqueror to England and fought at the Battle of Hastings. Another ancestor, Lionel Lee, Earl of Lichfield, accompanied King Richard on one of his crusades. And on his mother's side were a soldier who had fought with Marlborough at Blenheim and a colonial governor of Virginia. As one of his prewar colleagues later admitted, Robert E. Lee was "the nearest in likeness to that classical ideal, Chevalier Bayard—*Sans peur et sans reproche*." Mrs. Chesnut made the same comparison years later, describing Lee as "of the Bayard . . . order of Soldiers."[3]

Lee's father, a Revolutionary War hero and onetime Virginia governor, had enjoyed a spectacular early career as well. As a wartime aide later boasted, Robert E. Lee was "the son of 'Light Horse Harry' of the Revolution. The North can boast no such historic names as we, in its army." The Lee family men (plate 3) seemed to regard their heritage as the source of further obligation to service.[4]

But there was another element in Lee's image of perfection: a spotless life of unblemished honor. His first schoolmaster remembered "a most exemplary student in every respect." A West Point classmate recalled "a model cadet" whose clothes always "looked nice and new." The only surprise was that Lee graduated, not first, but second in his class. He earned not a single demerit during his entire four years at the academy.[5]

When he was ready to marry, he looked no farther than the Virginia aristocracy. The woman he courted

Figure 28.
[Printmaker unknown], after Mrs. Hattie Mann Marshall, *Lee Family of Virginia and Maryland*. Copyright by Mrs. H. A. Marshall. N.p., 1886. Lithograph with tintstone, 32¾ x 25¾ inches. Interest in family trees was growing everywhere, North and South, toward the end of the nineteenth century, a consequence of the new emphasis on heredity sparked by Darwinism and also by reaction against heavy immigration from parts of Europe that had previously been little represented in America. Yet prints with a genealogical theme seem appropriately Southern; one cannot imagine a similar tree for Abraham Lincoln or Ulysses S. Grant being published at the same time. (*Library of Congress*)

was none other than the daughter of the celebrated "Child of Mount Vernon," the grandson of Martha Washington. Mary Custis was hardly the most beautiful of the women who would have happily become Mrs. Lee, but it seemed almost predestined that he would choose her. Lee worshipped George Washington and the Washington tradition of duty and service. Moreover, Lee's own family was no longer wealthy. Mary was heir to the family estate at Arlington, which was filled with Washington relics, including the bed in which he had died. It was, as Lee's biographer Douglas Southall Freeman wrote, a home that would "deepen his reverence for the Washington tradition," which Lee himself eventually came to exemplify for some. In the words of a contemporary, the marriage made Lee, "in the eyes of the world," the "representative of the family of the founder of American liberty." An early biographical sketch of Lee in the *Southern Literary Messenger* referred to him as "the grandson of Washington, so to speak."[6]

Of course, the above was the mythical version of Lee's early life; the reality may have been somewhat different. His famous father had, in fact, plummeted from grace early in his son's life. An incurable profligate, he exhausted the family fortune, wound up in debtor's prison, and died alone and miserable. Lee's half brother embroiled himself in one of the most notorious sexual scandals of his era. Some said Robert maintained his famous tight reserve to emphasize that he was cut from a different mold. Others have even conjectured that Lee was repressed and morbid, but if this was so, he managed to conceal such imperfections from his contemporaries.

Of course the real Robert E. Lee was more complicated than the one-dimensional hero earnestly portrayed by the image makers after the Civil War—but not much more. Lee's adult life was remarkably like the legend. If he was much less than perfect, five generations of biographers have failed to discover so.

Lee's military career, nevertheless, was not an endless series of triumphs. He rose in rank slowly, and he frequently found himself assigned to tedious engineering projects. He did fight in the Mexican War, however, where he made an enormously favorable impression on commanding general Winfield Scott. "Old Fuss and Feathers" was so fond of Lee that a later eulogist recalled hearing Scott say: "If I were on my death-bed to-morrow, and the President of the United States should tell me that a great battle was to be fought for the liberty or slavery of the country, and he asked my judgement as to the ability of a commander, I would say with my dying breath, 'Let it be Robert E. Lee.' "[7] Lee moved on to West Point, where he served as superintendent. Later he led the force that put down John Brown's raid at Harpers Ferry.

When the Civil War appeared unavoidable, Lee became a reluctant secessionist. "I can anticipate no greater calamity for the country," he wrote in a famous 1861 letter, "than a dissolution of the Union. I am willing to sacrifice everything but honour for its preservation." Such nobly expressed sentiments would help reconstruct Lee's image after the war and make him palatable as a symbol of reunification and sectional reconciliation. Although "opposed to secession and deprecating war," Lee rejected the invitation of his old commander, Winfield Scott, to take over the Union armies. "I shall return to my native state and share the miseries of my people," he said, adding in his letter of resignation from the army: "Save in defense of my native State, I never desire again to draw my sword."[8]

That defense was required almost immediately, but Lee did not receive an offer from Richmond comparable to the flattering one from Washington. Instead he was relegated to the mountains of western Virginia where, in an army of child recruits and young officers, some critics called the fifty-four-year-old general "Granny Lee." Worse, there were those who labeled him a "showy presence" without military backbone.

After Lee's failure in the 1861 Cheat Mountain campaign, Edward A. Pollard charged that the debacle was due entirely to "a general who had never fought a battle, who had a pious horror of guerrillas, and whose extreme tenderness of blood" made him eschew confrontation and combat. To the *Richmond Whig*, the future hero was "Evacuating Lee, who never risked a single battle with the invader."9

Not until Davis summoned him to Richmond as military advisor in March 1862, and then elevated him to the command of the Army of Northern Virginia that June, did Robert E. Lee finally emerge from the obscurity and controversy of his early wartime service. Davis's faith in Lee never faltered, and that faith saved the general from oblivion. About the best that could be said of Lee when he came to the capital in March was that he had "a reputation to make." By the end of the Peninsular Campaign that summer, the same observer had to admit that "Gen. Lee's reputation now overshadows all others." Cautious writers even then reminded the public that "Beauregard was a great name" before and after Manassas and "so was Johnston." Reputations could be undone; besides, in "the blaze of Lee's deserved glory, Stonewall Jackson has not been forgotten." Not until 1863, after Jackson's death sent image makers in search of new heroes, did Lee finally become, in the words even of Jackson's first biographer, the ideal "exponent of Southern powers and courage . . . come not by chance in this day to this generation," but "born for a purpose." To a New York newspaper, Lee seemed the South's "representative man," to which designation a Southern admirer responded, "What more could we ask?"10

What the South did ask for were pictures of the new hero. Lee's emergence triggered an understandable demand for portraiture. The people of the Confederacy now wanted to know what Lee looked like—wanted also, perhaps, to bear witness to his growing fame by displaying his portrait. Unfortunately, engravers and lithographers were unable to respond in a timely or precise manner.

Lee himself was no stranger to the art of portraiture. It was de rigeur for Virginia men of his class to sit for paintings. He had done so twice, first in 1838, for a William Edward West portrait his wife had judged "a very fine likeness," and later, as superintendent of West Point, for another military portrait, this time by R. S. Weir. Recalling that the latter had been accomplished in a single sitting, Robert E. Lee, Jr., commented that his father "never could bear to have his picture taken, and there are no likenesses of him that really give his sweet expression. Sitting for a picture was such a serious business with him that he never could look pleasant."11

This may explain why Lee so seldom visited photography studios during his middle years. The major exception was for one surprisingly civilian pose (fig. 29), complete with top hat in lap, which was taken around 1850, probably at Mathew Brady's gallery in Washington. It was so uncharacteristic that later copiers of the photograph usually added a phony uniform, and it was this likeness that a decade later became the sole model for the early print portraits of Lee. By 1863 it was not an accurate Lee, but it was the only one the South would know for some time. Not that Lee's family minded. As late as September 1863, Mrs. Chesnut was given a copy of the photograph by none other than Mary Custis Lee, with the explanation that it was "taken soon after the Mexican War. She likes it so much better than the later ones," Mrs. Chesnut wrote in her diary. "He certainly was a handsome man then—handsomer even than now. I shall prize it." She did prize the little photograph, and it joined other celebrities in her album. Some Southerners might have wished to show their veneration for Lee by hanging a print on the walls of their homes, but in the Confederacy this proved impossible. There were no Confederate-made parlor prints of Lee.

Figure 29.
[Photographer unknown (possibly the Mathew Brady Gallery)], [*Robert E. Lee*]. Probably Washington, ca. 1850. The earliest known photographic portrait of the future commanding general, the picture suggests a balding but still handsome and robust Lee. It was taken around the time he was supervising construction of new military defenses for Baltimore. Observing him about this time, Richmond matron Mary Pegram Anderson recalled "the handsomest man that I had ever seen. Tall, erect, his well-proportioned form clad in the blue and gold of the U.S. Army . . . his hair and moustache . . . were a rich brown . . . his face noble in every line" (from a fragment in Lee clipping file, Library of the Museum of the Confederacy). (*The New York Public Library*)

By 1863 Southerners had more on their minds than home decorations. The least fortunate among them, as Volck showed, were living in caves to escape Union shelling. Others found their homes pillaged, like the Southern lady who reported that advancing enemy troops had stolen her "beautiful engravings" off the wall. Mary Custis Lee had long ago packed up the contents of her beloved Arlington and shipped them to an aunt's nearby estate. Inside the crates, she remembered, were "all our wine and . . . pictures."[12]

Given these conditions, it is not altogether surprising that the only wartime prints of Lee published in the South were not designed for parlor walls but for the picture press. In the South this meant the *Southern Illustrated News*. On December 13, 1862, the *News* first addressed the problem—not with a Lee likeness, but with a candid acknowledgment that its readers were indeed clamoring for one, and an explanation of sorts for the delay:

> Numerous enquiries having been made of us in regard to the publication of the picture of this distinguished officer, we take pleasure in informing the readers of the "N E W S" that our *artists* are now engaged on a magnificent full-page picture of the great Captain, which will be published in a short time. The engraving will be executed with the greatest care, and we feel warranted in saying, will be one of the most artistic pieces of work of its kind ever gotten up in the South.
>
> News-dealers desiring an extra number of copies of the paper containing the portrait had better notify us at once.[13]

For all their preparation, when the woodcut (fig. 30) finally appeared a month later, it bore the incorrect caption "ROBERT EDMUND LEE." The print was the work of staff artist W. B. Campbell, and proved to be little more than a crude mirror-image adaptation of the

ROBERT EDMUND LEE,
COMMANDER-IN-CHIEF OF THE CONFEDERATE FORCES.

Figure 30.
William B. Campbell, after "Rees" (Brady), *Robert Edmund Lee / Commander-in-Chief of the Confederate Forces.* Published in the *Southern Illustrated News*, December 13, 1862. Wood engraving, 6 x 4¾ inches. Lee no longer looked like this when he took command of the army, but, with no accurate photographic model to consult, the engraver adapted the old beardless pose, changing some details to disguise its source. Campbell reversed the print into a mirror image and added significant waves of hair on both sides of Lee's head. He also approximated a three-star general's collar, although there is no evidence that Lee ever wore a uniform like this one. The attribution to photographer "Rees" is a mystery; probably he was one of the many photographers who pirated and reissued the original when demand for Lee images first blossomed in 1862. (*Rare Book Division, The New York Public Library, Astor, Lenox, and Tilden Foundations*)

old Brady photograph Mrs. Lee and Mrs. Chesnut so admired (see fig. 29). To its credit, the *News* was frank in admitting that this long-awaited Lee was already hopelessly outdated:

> We present in this issue of our paper an engraving of this distinguished general, finished in Campbell's best style. The picture is from a photograph taken some ten years ago—the only one, we believe, extant of the distinguished chieftain. We are told that the General now looks somewhat different from the picture herewith presented, his face at present being covered with a heavy, snowy beard, while the anxieties and cares incident to the discharge of his arduous duties have slightly furrowed his brow and tinged his locks with gray. . . . As an artistic piece of work the engraving given in this number will compare favorably with any similar work ever gotten out in the North.[14]

Even at a time of intensified Southern nationalism, it was clear that the standard of good engraving was Northern engraving.

The *News* hastened to promise that "as soon as possible, we will present our readers with a picture of The General as he now appears." That would require a photograph of the changed Lee, and he seemed unable or reluctant to sit for one. Lee, however, was not reluctant to discuss his new appearance with his daughters. In a charming letter to one of them, he explained: "I have a beautiful white beard. It is much admired, at least much remarked on." Writing to a daughter-in-law in a more playful mood, he described his new elder-statesman military image this way: "My coat is of gray, the regulation style and pattern; my pants are of dark blue, as is also prescribed, partly hid by my long boots. I have the same handsome hat which surmounts my gray head (the latter is not prescribed in the regulations) and shields my ugly face, which is marked by a white beard as stiff and wiry as the teeth of a card. . . . But tho age with its snow has whitened my head, and its frosts have stiffened my limbs, my heart, as you well know, is not frozen."[15]

This is the image of Lee with which most Americans would become familiar, and it is difficult to imagine Confederate citizens clinging instead to the hopelessly outdated Lee image of the Southern press of early 1863. But in an age when such images were anything but commonplace—two generations before instantaneous photography and invention of the gravure reproduction process brought immediacy to image making—such relics could be revived with relative impunity. It was fortunate for publishers who were unable to find updated models from which to work that the public's gullibility was as high as its expectations were low. The same outdated image of *Roberto Lee* (fig. 31) was published even by the more sophisticated publishing houses of Europe. Not until the war ended and the portrait publishers of the North began to focus their attention and skills on the Lee theme did engravings and lithographs of the general finally begin to do justice to the subject in both artistry and circulation.

Despite the demand for such pictures evidenced in the pages of the *Southern Illustrated News*, the paper's promised second engraving of Lee did not appear until nine months after the first. The updated Lee (fig. 32), still labeled "Robert Edmund," was published on October 17, 1863. This time, the weekly claimed that its portrait gave "as good an idea of the appearance of the 'great captain of the age' as can be conveyed on wood." Engraved by Torsch, the woodcut offered yet another mirror-image view, this time of a more current photograph (fig. 33), a pose believed by some historians to be the sole camera study of Lee made in the field during the war. The photograph, by Minnis and Cowell of Richmond, more likely was taken during one of the general's wartime visits to the capital.[16]

The *News*'s second and final woodcut of Lee, al-

Figure 31.
Garcia, after a photograph by the Mathew Brady Gallery, *Roberto Lee*. Published by N. Gonzalez, Madrid, ca. 1865. Lithograph, 7 x 5½ inches. Garcia gave Lee a more cheerful expression than he wears in the photograph, along with thinner and lighter eyebrows that make him look younger. The epaulettes, taken from a retouched version of the photograph, complete the image of this Mediterranean-looking officer. In yet another indication that printmakers were generally nonpartisan, Garcia produced a companion print for Gonzalez of Lee's rival, *Ulysses S. Grant. / general en gefe*. (*Anne S. K. Brown Military Collection, Brown University*)

Figure 32.
John W. Torsch, after Minnis and Cowell, *General Robert Edmund Lee*. Published in the *Southern Illustrated News*, October 17, 1863. Wood engraving, 5¼ x 4 inches. The second and last portrait of Lee for the Confederacy's leading picture weekly, this modest woodcut may have offered Southerners their first view of Lee with his new beard. Seeing him thus for the first time, Mary Pegram Anderson, who so admired the Lee she had encountered years earlier, "ventured to protest against the heavy beard," adding, "to the woman's eye [it was] a pity to conceal any of his noble features. He seemed amused, and laughingly said, 'Why, you would not have a soldier in the field not look rough, would you?'" Mrs. Anderson finally concluded that while the "new" Lee "seemed many years older, and, of course, much saddened," he also appeared "grander and more impressive than ever" (from a fragment in Lee clipping file, Library of the Museum of the Confederacy). (*Rare Book Division, The New York Public Library, Astor, Lenox, and Tilden Foundations*)

Figure 33.
Minnis and Cowell Gallery, [*Robert E. Lee*]. Photograph, ca. 1862–63. One of the most frequently engraved and lithographed Lee photographs, it was also routinely pirated by Southern photographers during the war, and by Northern ones—notably Brady's principal publishers, E. and H. T. Anthony—afterward. Note how the top of the lapel on Lee's uniform has been placed under one of his top buttons to hold it flat, perhaps a photographer's device to make the subject look neat. (*The New York Public Library*)

Figure 34.
Printmaker unknown, after Frank Vizetelly, *The Rebel General R. E. Lee*. Published in *Harper's Weekly*, March 14, 1863. Wood engraving, 5 1/16 x 3 1/4 inches. The only known portrait of the general as he looked on the field, this picture captured a Lee image in transition, somewhere between the handsome young officer of the Mexican War and the benign white-haired father figure of the 1860s. Writing to his daughter-in-law, Lee joked: "In fact, an uglier person you have never seen, and so unattractive is . . . [my face] to our enemies, that they shoot at it whenever it is visible to them" (quoted in Blackford, *War Years*, 109). Also pictured is the *Harper's* advertisement announcing and describing the woodcut. (*Louis A. Warren Lincoln Library and Museum*)

THE REBEL GENERAL LEE.

WE publish on page 173 a portrait of the rebel General ROBERT E. LEE, commanding the rebel army on the Rappahannock. It is from a drawing recently made by Mr. Vizetelly, the correspondent of the London *Illustrated News*, and, as will be seen, differs very materially from the portraits which are current at the North, which are taken from old photographs made before the war.

Robert E. Lee was born in Virginia about the year 1808. He entered West Point, where he received the usual military education at the cost of the Government of the United States. He grad-

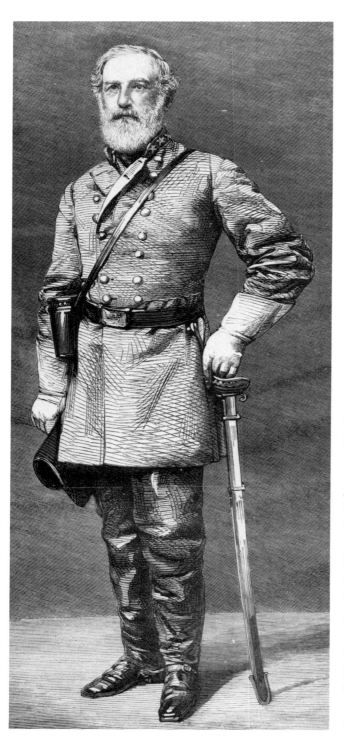

Figure 35.
Frank Vizetelly, after Minnis and Cowell, *General Robert Edmund Lee, Commander-in-Chief of the Army of the Confederate States of America.* Published in *The Illustrated London News*, June 4, 1864. Wood engraving, 9¼ x 6⁷⁄₁₆ inches. Republished in *Harper's Weekly* on July 2, this sketch provided the only wartime view of Lee in full battle uniform, including sword. Describing his appearance, the London weekly commented: "He is exceedingly plain in his dress, and you look at his costume in vain for the insignia of rank. . . . He cares but little for appearances" (fragment in Lee clipping file, print collection, New York Public Library). (*Louis A. Warren Lincoln Library and Museum*)

though modest, was nonetheless far superior to the squat full-figure Lee created some months earlier by Frank Vizetelly, the thirty-two-year-old *Illustrated London News* camp artist. Republished in *Harper's Weekly* for a curious but not worshipful audience, the woodcut (fig. 34) was accompanied by a biographical sketch noting that Lee "wears his years well and strikes you as the incarnation of health and endurance." Ironically, Lee was at this time actually in failing health, quite likely suffering from both heart disease and high blood pressure, which may have given him the ruddy complexion so many observers mistook for glowing fitness. "Old age and sorrow," he confided later that year, "are wearing me away." It did not matter that the reality failed to measure up to the image. The victor of the Peninsula and Fredericksburg had to be pictured as a hale warrior, especially by the pro-Confederate British press, and this no doubt enhanced Lee's reputation as he readied for the battles of Chancellorsville and Gettysburg.[17]

Lee himself did not much like Vizetelly's work. He thought the artist's companion sketch of Stonewall Jackson "failed to give his fine candid and frank expression, so charming to see and so attractive to the beholder." Nonetheless he sent a copy of the published woodcut of himself home to his wife, describing it jocularly as "a likeness of your husband that has come from beyond the big water." Then he went on to describe the man it portrayed: "He is a hard-favoured man and has a very rickety position on his pins. I hope his beard will please you, for the artist seems to have laid himself out on that. We are poor judges of ourselves and I cannot therefore pronounce as to his success."[18]

Nor did Lee do much to ensure that successful images were created. Once, when Mary proposed dispatching a photographer to the front, Lee warned: "I can make no promises or engagement, & perhaps the very day he might come, I should be obliged to be in the field." Besides, Lee reminded his wife, "You know

I am the worst sitter in the world & am a very poor subject to take." As he had said to her earlier about a proposed painting, "any portrait . . . should it resemble the original would not be worth having." When Lee finally sat for the patient photographer, he commented lightheartedly on the result: "Do advise all artists to amuse themselves with the photographs & give wide range to their fancy."[19]

For the moribund Confederate printmaking industry, the photographs were too late. The few remaining wartime newspaper woodcuts of Lee came only from the North and Europe. For example, the general was back before the camera at Minnis and Cowell's Richmond gallery in late 1863, looking far older—his hair thinner and whiter, his beard now bleached as white as snow.

The picture from that sitting was adapted by both the *Illustrated London News* and *Harper's Weekly* (fig. 35) in early June 1864. The London weekly called the striking full-length picture of Lee "a faithful likeness of one of the greatest soldiers of the age . . . a gentleman by birth, breeding and social position," and the best military mind, they calculated, since Washington and Wellington. Little wonder that back home in Virginia people were celebrating him as "the most successful general of the age" and "a thorough gentleman in his manners," not to mention as a soldier who "rides like a knight of the old crusading days."[20] Victories had brought Lee international and domestic fame, but the full pictorial emergence of this great captain would have to wait until Appomattox.

7 / Images of Peace

Nothing Robert E. Lee did in the field inspired more prints than did his surrender to Ulysses S. Grant on April 9, 1865. That Appomattox shaped Lee's image favorably in crucial ways was doubly ironic. In the first place, pictures of the event dealt with a potentially humiliating episode in his life; no general wants to be remembered for surrendering. In the second place, the man these Northern prints were meant to celebrate, Ulysses S. Grant, wholly disapproved of the artists' enterprise. When a congressional committee approached the Northern conqueror soon after the war to propose a painting of Lee's surrender for the rotunda of the Capitol, Grant refused. He said he would never take part in producing a picture that commemorated a victory in which his own countrymen were the losers. Appomattox scenes, then, pleased neither the conquered nor the conquering hero. But they clearly pleased the people. Many such prints were produced, and in these images lay great promise for Robert E. Lee.[1]

The mere fact that Lee had given up the rebellion at Appomattox helped cleanse his image in the North, where all the surrender prints originated, and encouraged his depiction with all the dignity eyewitnesses ascribed to him. The general who hated guerrilla warfare thus presented a sharp contrast with the despised Jefferson Davis, who urged his other generals to take to the hills and continue the war. Nor was Lee another Cornwallis, who refused to attend his surrender ceremony at Yorktown, thus, according to Lee's father's memoirs, "dimming the splendor of his long and brilliant career"—a passage that Robert E. Lee may well have read and remembered.[2] And even though Appomattox prints were designed to honor Grant, Lee's inclusion in the scenes put him on an equal footing with the victor—perhaps because there would be little glory for Grant unless it could be shown he had defeated a worthy foe. Nor was it terribly difficult for Northerners to show respect for a rival commander who had defeated their greatest army at Bull Run, Fredericksburg, and Chancellorsville and held Grant at bay for nine months before Richmond. Although many were inaccurate, these prints helped popularize a more resonant image of Lee than mere portraiture could convey.

The Appomattox prints, intentionally or not, helped elevate Lee to a status not shared by any other figure of the Confederacy—that of a living symbol of reconciliation. By depicting him unbowed before Grant, the printmakers demonstrated that reunion could be accomplished without subjugation. Appomattox prints showed Lee in surrender but not humiliation and thus made him an icon of peace rather than defeat. The aide who selected the McLean house as the site of Lee's meeting with Grant, Colonel Armistead L. Long, put it this way: even "vanquished," Lee was "yet a victor."[3]

Another witness to the surrender was shocked at Lee's appearance on that fateful spring day. "He is growing quite bald," J. William Jones observed, "and wears one of the side locks of his hair thrown across the upper portion of his forehead, which is as white and as fair as a woman's." Nonetheless, to A. L. Long, General Lee never appeared more grandly heroic than on this occasion: "All eyes were raised to him for a deliverance which no human power seemed able to give. . . . Under the accumulation of difficulties his courage seemed to expand, and wherever he appeared his presence inspired the weak and weary with renewed energy. . . . During these trying scenes his countenance wore its habitual calm, grave expression. Those who watched his face to catch a glimpse of what was passing in his mind could gather thence no trace of his inner sentiments." Yet just after he had signed the surrender papers and emerged from the McLean house, an observer confessed that Lee seemed "older, grayer, more quiet and reserved . . . very tired."[4] He would not be so portrayed.

Northern printmakers in search of contemporary descriptions of Lee's appearance at Appomattox needed

to look no further than the *New York Herald* report of April 14, 1865: "Lee looked very much jaded and worn, but, nevertheless, presented the same magnificent *physique* for which he had always been noted. . . . During the whole interview he was retired and dignified to a degree bordering on taciturnity, but was free from all exhibition of temper or mortification. His demeanor was that of a thoroughly possessed gentleman who had a very disagreeable duty to perform, but was determined to get through it as well and as soon as he could."[5]

Moreover, according to Charles Marshall, another Lee aide, there was "no theatrical display" about the simple, dignified meeting. It was, he said, "thoroughly devoid of any attempt at effect," even though, to Marshall and his comrades, it represented "the greatest tragedy that ever occurred in the history of the world." This emotional juxtaposition—the high drama held in check in favor of stoicism and reserve—created a memorable scene, at the center of which sat the imperturbable Lee. As one of his field commanders asked in a Lee eulogy delivered five years later: "What man could have laid down his sword at the feet of a victorious general with greater dignity than he did at Appomattox?"[6]

Even Massachusetts historian Charles Francis Adams, Jr., agreed. Writing thirty-seven years after the surrender, the son of Lincoln's minister to Great Britain termed Appomattox "the most creditable episode in all American history—an episode without blemish—imposing, dignified, simple, heroic." To Adams, Lee's heroism in surrender had come to symbolize "the loyal acceptance of the consequences of defeat . . . which I hold to be the greatest educational lesson America has yet taught to a once skeptical but now silenced world."[7]

Two of the earliest print depictions of Lee's surrender at Appomattox accurately reflected the "simple" atmosphere in which the event occured—erring, uncharacteristically, on the side of understatement. One was a primitive scene (fig. 36) published by J. Kelly

and Sons of Philadelphia. Another, more plausible, print was the work of Currier and Ives of New York, a firm that had earned a reputation for prompt response to newsworthy events. Their 1865 lithograph (fig. 37) portrayed only Grant and Lee, seated together with Lee's surrendered sword lying symbolically between them—even though Grant never asked for its surrender and Lee never offered it. In reality, the two commanders sat at separate tables throughout the proceedings and were attended by military aides. The intimacy suggested by Currier and Ives was entirely unsupported by facts.[8] Yet eight years later, when the firm issued a revised print, making it horizontal rather than vertical, they failed to alter the critical historical detail. This pictorial intransigence demonstrates nicely the self-absorption of the nation's leading lithographers. In the intervening years several far more accurate Appomattox depictions had been published, but Currier and Ives did not seem to notice.

In artistry and accuracy, a superior interpretation of the surrender was the 1867 lithograph (fig. 38) by Major and Knapp of New York. The surprisingly subtle group scene boasted good portraiture, based on appropriate photographic models (fig. 39); its only glaring error lay in showing the wrong staff officer copying the peace terms at a desk in the foreground. There was an obvious explanation for the improved accuracy. The print was copyrighted by Wilmer McLean, owner of the house in which the surrender took place, in an apparent effort to capitalize on the event. McLean's parlor had been all but plundered by Union officers after Lee and Grant left. Tables and chairs had been carried off and pictures removed from the parlor walls, with small sums of money more or less thrown at their owner by staff members. But the Major and Knapp print, despite its high quality, apparently failed to make for McLean the fortune he had anticipated. Within years he had abandoned his Appomattox home, and by the end of the century it had crumbled into a ruin, not to be reconstructed until after World War II.[9]

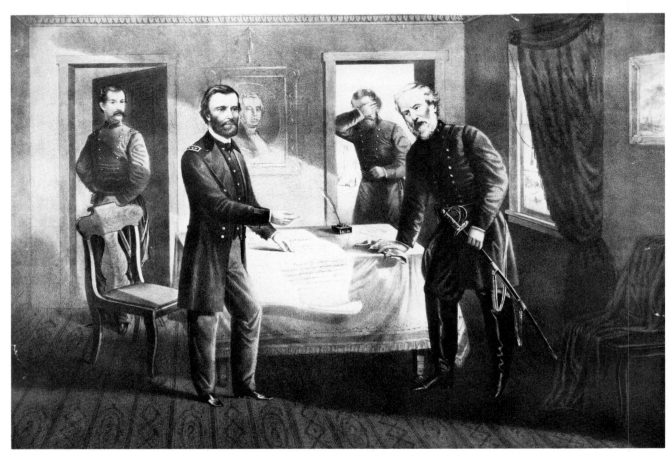

Figure 36.
H. Thomas, *Gen. Lee Surrendering to Lieut. Gen. Grant.* Published by J. Kelly and Sons, Philadelphia, 1865. Lithograph, 16⅞ x 24⅝ inches. The early copyright date on this rare and primitive depiction of the McLean house scene may help explain its point of view: it was probably rushed to market to exploit the news of the surrender, and in his haste lithographer Thomas likely invented the odd details he presents. The comically formal scroll that Grant unfurls, for example, is labeled "Terms of Surrender," and as he prepares to sign it, a distraught Lee grasps a handkerchief. A Confederate aide weeps openly in the background, while, for contrast, a Union aide grins rather smugly. The portrait of George Washington in the background attests to reunification. The Lee portrait is based on Minnis and Cowell's photograph (see fig. 33). (*Prints Division, The New York Public Library, Astor, Lenox, and Tilden Foundations*)

Figure 37.
[Nathaniel] Currier and [James Merritt] Ives, *Surrender of Genl. Lee. at Appomattox C. H. Va. April 9th 1865.* New York, 1865. Hand-colored lithograph, 12⅜ x 8⁷⁄₁₆ inches. The first of Currier and Ives's two depictions of the surrender scene (the second was a minimally altered 1873 horizontal version), this simple but fanciful depiction included such symbolic touches as an olive branch pattern for the wallpaper and placement of Lee's sword on the table between the two commanders. In reality, the walls were not so decorated, and Lee made no offer of his sword; Grant and Lee did not even sit at the same table during their meeting. Currier and Ives added a weeping Confederate soldier in the background of the 1873 variant. The portrait of Lee was again based on Minnis and Cowell (see fig. 33), with Lee's eyes made to turn decidedly toward Grant. (*Louis A. Warren Lincoln Library and Museum*)

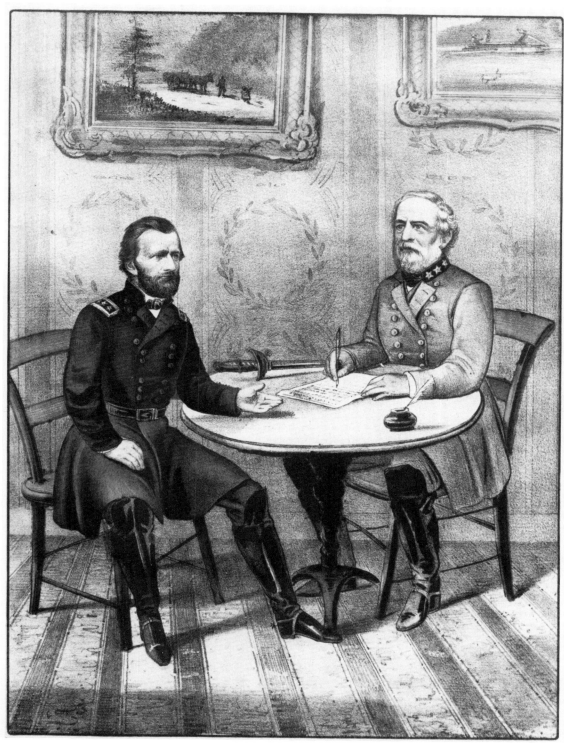

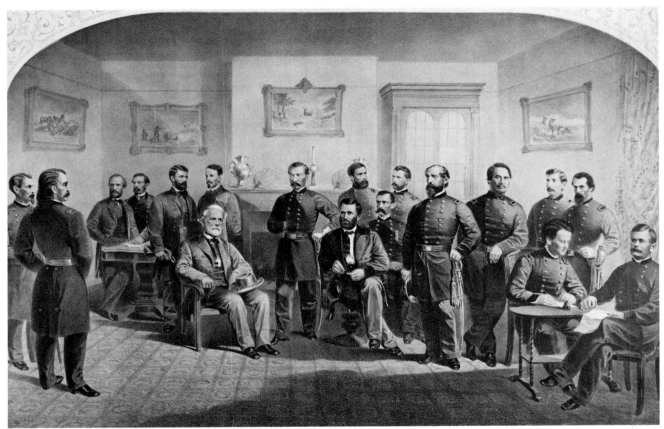

Figure 38.
[Henry B.] Major and [Joseph F.] Knapp, *The Room in the McLean House, at Appomattox C.H., in which GEN. LEE Surrendered to GEN. GRANT.* Copyrighted by Wilmer Mc-Lean. Published in New York, 1867. Lithograph with tint-stone, 19⅛ x 29 inches. Commissioned as a fund-raising device by the owner of the house in which the surrender occurred, this handsome print showed portraits of several personalities closely copied from photographs. The source for the Lee group, for example, is a camera study made by Mathew Brady a few days after the surrender (see fig. 39), in which the commander posed with two of his aides. Note also that the printmaker reversed Lee's seated figure from the photographic model, so he faces Grant. Lee's sphynx-like expression is chiefly attributable to the printmakers' reliance on the grim photographic source, but the result conveys the impression of Lee recorded years later by his victorious rival. "As Lee was a man of much dignity, with an impassible face," wrote Grant, "it was impossible to say whether he felt inwardly glad that the end had finally come, or felt sad over the results, and was too manly to show it" (Grant, *Personal Memoirs*, 2:489). Among the others shown in the room are George Armstrong Custer (second from left); Philip Sheridan (between Lee and Grant); and Lee's Gettysburg foe, George Gordon Meade (standing at Grant's left). The officer shown copying the surrender terms is identified in the key to the print as General Wesley Merritt; in reality, that chore fell to Colonel Ely S. Parker, shown here rather casually leaning on the arm of the chair in which he should have been sitting. (*Louis A. Warren Lincoln Library and Museum*)

Figure 39.
Mathew Brady, [*Robert E. Lee with two aides*]. Photograph, Richmond, April 16, 1865. Brady took six pictures of Lee on the general's first full day at home after his return from Appomattox. For this and a similar portrait, Lee posed with two staff aides, the identity of one of whom has confounded scholars for generations. At right is certainly Colonel Walter Taylor, later a Lee biographer. Historians have identified the other variously as Lee's son Custis or his son Rooney. The key to Major and Knapp's print listed the figure as Lee's other chief aide, Charles Marshall, but this identification must be discounted because the printmakers may have invented it to fill a gap in photographic models. (*Library of Congress*)

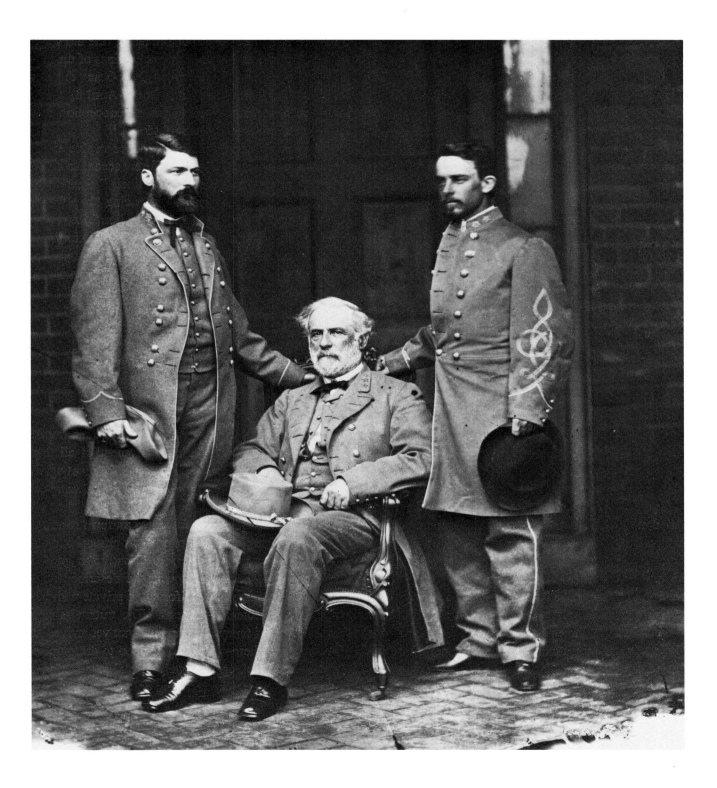

Currier and Ives and Major and Knapp each tried to come to terms with the rather undramatic quality of an event whose most frequently remembered sounds were those of a quill pen scratching the terms of surrender on paper. For these printmakers the news value and historic consequences of the event did not seem to require much embellishment. But for others, myth took precedence over reality. Within days after the surrender an Appomattox legend was born, soon to be nurtured in a body of fanciful prints. No one is certain of its origins, but it proved to have enduring appeal. As Grant wrote in his memoirs, "like many other stories, it would be very good if it was only true."[10]

The legend held that Lee had surrendered to Grant, not inside the McLean house, but in an apple orchard somewhere outside town. It was a romantic story, conjuring up images of rival warriors on horseback solemnly stacking their arms before opposing lines of blue and gray. It was false, of course, but throughout the 1860s it was widely repeated, colorfully illumined, and distributed to an apparently accepting public by the publishers of popular prints. America's engravers and lithographers are probably responsible for perpetuating the legend of the apple orchard surrender—of vivifying the myth with what is now an all-but-forgotten body of crowded and colorful prints.

Grant called the story "one of those little fictions based on a slight foundation of fact." As memoir writers on both sides later recounted, on surrender day Lee's forces were occupying a hillside that embraced an apple grove. Grant's autobiography described a dirt road that ran diagonally up the hillside, over which so many rebel supply wagons had traveled that their wheels had cut through the protruding roots of one apple tree, creating a makeshift embankment. Lee was sitting on this ridge, his back against the apple tree, when he finally decided that the time had come to surrender the Army of Northern Virginia—or so Grant was told. At first, Lee had in fact proposed an outdoor meeting with Grant, but to discuss "peace" rather

than surrender. Lee even rode out along "the old stage road to Richmond, between the picket lines of the two armies" to keep the rendezvous, but Grant did not show up. This little-known incident of April 8, 1865, may also have contributed to the misconception that Lee had surrendered to Grant outdoors.[11]

Onlooker William W. Blackford, once an aide to Jeb Stuart, remembered a slightly different scene: an apple orchard guarded by "a line of sentinels," where Lee could be found on surrender day pacing "backwards and forwards . . . looking like a caged lion." He was in "one of his savage moods that day," Blackford recalled, "and when these moods were on him, it was safer to keep out of his way." Inside the McLean parlor he would be quiet to the point of sullenness, and when he left, an observer noted, Lee reddened visibly with "a deep crimson flush, that rising from his neck overspread his face and even tinged his forehead." Once outside, he clapped his hands together vigorously, and then, when his horse did not appear, he called harshly for an orderly. The Lee who displayed such disquietude contrasts sharply with the idealized image later projected universally in prints and literature, an image Blackford described as "the embodiment of all that was grand and noble in man." In prints, Lee was again the Bayard—the perfect knight, exuding gallantry in defeat.[12]

Lee, in his glorious new full-dress uniform, was the picture of stoic nobility in Appomattox prints; he looked all the more glorious next to Grant, who garbed himself for the occasion in what he described as a "rough traveling suit, the uniform of a private with the stripes of a Lieutenant-General." The truth was that Grant's stock of fancy uniforms had not yet arrived at Appomattox, whereas Lee had decided to dress up so that he would look appropriately formal in case Grant took him prisoner. The resulting collision of styles—the simplicity of the victor, the grandeur of the vanquished—was pointedly reflected in many prints of Appomattox and grew into an American legend.[13]

After signing Grant's peace terms, Lee rode tearfully back to his camp, cheered all along the way by his loyal, loving troops. Returning to the apple orchard, he took up a position under one of the trees in the grove and solemnly began receiving his officers. Lee's return to the orchard supplied another element of reality for the eager image makers. Yet another was provided the next day, when Grant decided "I would like to see General Lee again." This time the two met on horseback and chatted for half an hour near the former Confederate headquarters, as staff officers hovered at a respectful distance. It was an anticlimactic meeting, to be sure, but it is likely that reports of this second Grant-Lee encounter served further to stimulate the burgeoning belief that Lee had actually surrendered in such a setting. That belief quickly took hold at the scene. No sooner had Lee evacuated the site than the tree beneath which he had made his farewells to his staff was uprooted and "carried off by relic hunters." For years, "apple-tree jewelry" was "profusely distributed" as purportedly authentic souvenirs of the surrender.[14]

To printmakers for whom the atmosphere of the McLean parlor was too mundane, the apple orchard alternative provided a perfect excuse to dramatize the otherwise unremarkable surrender scene. To such artists, a war that had been fought on the field had to be surrendered on the field, in much the way the British had capitulated to George Washington. Some printmakers may actually have believed the apple orchard myth. Others may have adopted it because it offered a superior artistic setting for their panoramic prints. Whatever the motive or inspiration, for years the majority of Appomattox prints portrayed Lee's surrender to Grant in an outdoor setting.

It was in such scenes that Lee was finally introduced in separate-sheet prints to the Northern and Southern public—in glorified depictions of a fabricated setting,

in which Lee's heroic demeanor belied defeat. Pierre S. Duval's 1866 lithograph, for example, suggested that the two generals had ridden together on horseback through the forest before their fateful meeting at the McLean house (plate 4). A bit more stationary in composition, but no less inaccurate, was the lithograph by James Queen for John Dainty of Philadelphia (fig. 40).[15] It also showed the surrender taking place outdoors, but at least with the principals dismounted and surveying the impressive scenery on foot. Duval and Queen were not the only printmakers to produce these fanciful scenes of the drama at Appomattox. Chicago's Kurz and Allison Art Studio, for example, published an extremely crowded print that suggested that the entire Army of the Potomac and the Army of Northern Virginia had witnessed the scene (fig. 41).

The only surviving evidence indicating that any printmaker completely understood the chronology of events at Appomattox on April 9 and 10, 1865, is a lithograph by one-time Currier and Ives artist Louis Maurer that shows Grant and Lee meeting on horseback, but with a caption specifically declaring that the encounter had taken place the day after the surrender (fig. 42). The lithograph was modeled after a beautiful watercolor by Otto Boetticher, a Prussian-born military artist and Union soldier (plate 5). Maurer's adaptation of Boetticher's picture remains one of the least-known, yet best-realized, Appomattox prints. It portrayed the two great adversaries planning for peace as grandly as they had waged war.

Maurer's lithograph was a further signal that Appomattox had heralded not only a new era in American history, but also a new age of printmaking, a highlight of which would be the promulgation of the sympathetic image of the Lost Cause by Northern artists for a rediscovered Southern audience. In that commercial campaign yet to come, Robert E. Lee would emerge the undisputed hero.

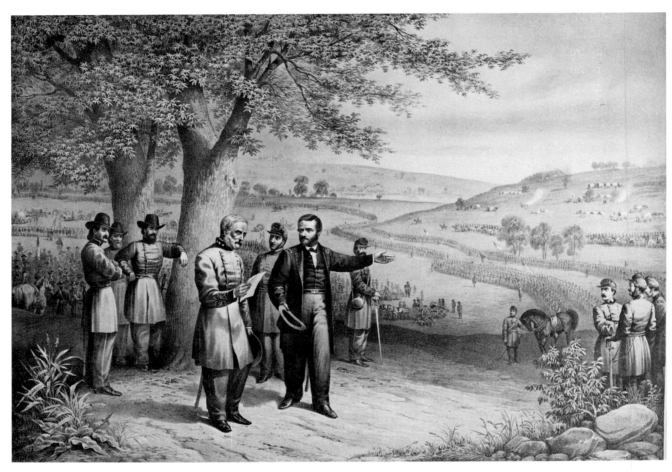

Figure 40.
James F. Queen, *The Surrender of General Lee / and His Entire Army to Lieut. General Grant April 9th 1865*. Published by John Dainty and Goff Brothers, Philadelphia, 1866. Lithograph with tintstone, 21¾ x 27¼ inches. In a highly imaginary interpretation of the purported outdoor surrender, Lee studies what the viewer is meant to assume are surrender terms, as Grant gestures to the armies encamped in the distance. Lee aide A. L. Long remembered that the legendary apple tree under which the two generals allegedly stood was "half a mile from the point where the meeting of Lee and Grant took place, yet widespread currency has been given to the story that the surrender took place under its shade" (Long, *Memoirs of General Lee*, 422). (*Louis A. Warren Lincoln Library and Museum*)

Figure 41.
[Louis] Kurz and [Alexander] Allison, *Capitulation & Surrender of Robt. E. Lee & His Army at Appomattox C.H., Va. to Lt. Genl. U.S. Grant.* Chicago, n.d. Chromolithograph, 15½ x 22 inches. This symbolic scene shows both Union and Confederate armies crowded into an orchard out-side Appomattox Court House to witness Lee's surrender to Grant. Note the prototypical tattered and wounded Confederates at left juxtoposed with the hearty Union troops behind Grant. Lee is shown presenting his sword to the conqueror, an-other Appomattox myth. Although Grant later wrote that he was impressed by this "sword of considerable value," he characterized "the much talked of surrender of Lee's sword and my handing it back" as the "purest romance" (Grant, *Personal Memoirs*, 2:490, 494). The Lee portrait shows him much the way a Southern general remembered him that day at Appomattox: "He looked . . . weary and careworn, but in this supreme hour was the same self-pos-sessed, dignified gentleman that I had always known" (General H. J. Hunt, quoted in Long, *Memoirs of General Lee*, 426). (*Louis A. Warren Lincoln Library and Museum*)

Figure 42.
Louis Maurer, after Otto Boetticher, *Grant and Lee / (Meeting Near Appomattox Courthouse, Va., April 10th 1865, the day after the surrender of Lee's Army) / From the Original Picture by Lieut. Col. Otto Boetticher / in the Possession of General Chas G. Halpine.* Published by Paul Boetticher and by Hatch and Company, New York, 1866. Lithograph, 13⅞ x 26 inches. The artist here depicts a meeting in an open field, but Lee's aide, Colonel Charles Marshall, believed "it was then he met General Grant under that famous apple tree, because I saw some federal soldiers cutting down the tree the next day" (Maurice, *An Aide-de-Camp of Lee*, 274–75). As Grant remembered this incident, he rode out toward Confederate lines the day after the surrender, accompanied by a bugler and a staff officer carrying a white flag. He was halted by Confederate pickets, but, seeing who it was, "Lee soon mounted his horse . . . and met me. We had there between the lines, sitting on horseback, a very pleasant conversation of over half an hour, in the course of which Lee expressed it as his earnest hope . . . that we would not be called upon to cause more loss and sacrifice of life" (Grant, *Personal Memoirs*, 2:497). Grant promised nothing, and the two parted; they would not meet again until Grant was president. (*Louis A. Warren Lincoln Library and Museum*)

8 / The Belle of Richmond

When the war ended, if Lee was already a hero in the South and was gaining respect in the North, Jefferson Davis was little more than a caricature to most Americans, North and South. As the life of the Confederacy ebbed, an ever-increasing internal clamor grew against the "President, General Davis." The North, in turn, was eager and able to poke fun at the rebel leader in cartoons—and had been doing so since the war began (fig. 43). Despite this wealth of savage caricature during the war, many thoughtful Northerners could not but concede, however grudgingly, Davis's courage, integrity, and fidelity to his cause. Thus few were ready for the Davis image that appeared as a consequence of the fall of Richmond and the Confederate leader's escape and capture.

The bare facts of the escape and capture seemed simple enough. On April 2, 1865, General Lee's messenger informed President Davis, who was in his pew at Richmond's St. Paul's Episcopal Church, that the city had to be evacuated. Davis calmly ordered the removal of the government, along with its documents and funds, to Danville, Virginia; the Confederate president was not ready to give up. With his family and his cabinet, he followed the government to Danville. Shortly thereafter they moved by train to Greensboro, North Carolina, where they found themselves somewhat less than welcome. Though Davis wanted to fight on, he found little support. He fled further, into Georgia. There he held a last cabinet meeting and, somewhere along the way, he absorbed the momentous fact of Lincoln's murder. Early in May the government in Washington put a price of $100,000 on his head. Davis continued his flight into backwoods country, parted from his family, was reunited with them, seemed indecisive, became exhausted. On May 10, some fifty miles from the Florida border, Union cavalry caught up with his party. A soldier who later claimed to have

been the first to sight the Confederate chief explained, "I knew him from his pictures."[1]

Many people did, for Jefferson Davis had perhaps the most recognizable face of any Confederate by 1865. But now, as a consequence of the circumstances of his capture, an avalanche of new Davis pictures—all of them caricatures—blanketed the land, accompanied by newspaper headlines, detailed articles, accusations, defenses, and, especially in the North, laughter. The commotion centered on the charge that at the moment of his capture the president of the Confederacy was wearing his wife's raincoat and had her shawl over his head and shoulders.

Jeff Davis Caught At Last. Hoop Skirts & Southern Chivalry, published by John L. Magee in Philadelphia, was one of many cartoons presenting the new Davis image (fig. 44). The Confederate president, dressed as a hoop-skirted old lady with a dagger in one hand and a water pail in the other, protests: "I think the United States Government could find something better to do, than to be hunting down Women and children." The two women behind him, presumably Mrs. Davis masquerading as a daughter and a daughter masquerading as a granddaughter, complain that the Yankees will not let "poor Grandma" or "poor mother" go to the well for a bucket of water. One jeering Union soldier lifts the old lady's bonnet-like shawl, and another, her skirt. At the top of the design is the bold proclamation: "The only true Picture of the Capture of Jefferson Davis, from the account furnished by Col. Prichard of the 4th Mich. Cavalry."

Jefferson Davis himself described his capture differently in his 1881 book, *The Rise and Fall of the Confederate Government*:

> My horse remained saddled and my pistols in the holsters, and I lay down, fully dressed, to rest. Nothing occurred to rouse me until just before dawn, when my coachman, a free colored

Figure 43.
[Printmaker unknown], *The Last and Best Portrait of Jeff Davis. Drawn from Life by A. Sour Apple Tree*. N.p., n.d. Lithograph, 15½ x 9⅝ inches. The image of the president of the Confederacy dangling from a rope was a popular one throughout the North during the Civil War. Separately published cartoons, intended for display, only underlined a sentiment that was also expressed in the press, popular songs, plays, pamphlets, books, patriotic envelopes, and various novelties. (*The Boston Athenaeum*)

Figure 44.
J[ohn]. L. Magee, *Jeff Davis Caught At Last. Hoop Skirts & Southern Chivalry.* Philadelphia, 1865. Lithograph, 10 x 14⁹/₁₆ inches. In this brutal cartoon, typical of the graphic satires of the Davis capture issued in the North in 1865, the fugitive chief executive is mocked as a "bearded lady," calling to mind a well-known feature of the sideshow world of P. T. Barnum. A soldier at left recites a version of the nursery rhyme, "Jack and Jill," a sly reference to reports that at the time of his capture Davis was carrying a pail to fetch water. (*Louis A. Warren Lincoln Library and Museum*)

man, who faithfully clung to our fortunes, came and told me there was firing over the branch, just behind our encampment. I stepped out of my wife's tent and saw some horsemen, whom I immediately recognized as cavalry, deploying around the encampment. I turned back and told my wife these were not the expected marauders, but regular troopers. She implored me to leave her at once. I hesitated, from unwillingness to do so, and lost a few precious moments before yielding to her importunity. My horse and arms were near the road on which I expected to leave, and down which the cavalry approached; it was therefore impracticable to reach them. I was compelled to start in the opposite direction. As it was quite dark in the tent, I picked up what was supposed to be my "raglan," a water-proof, light overcoat, without sleeves; it was subsequently found to be my wife's, so very like my own as to be mistaken for it; as I started, my wife thoughtfully threw over my head and shoulders a shawl. I had gone perhaps fifteen or twenty yards when a trooper galloped up and ordered me to halt and surrender, to which I gave a defiant answer, and, dropping the shawl and raglan from my shoulders, advanced toward him; he leveled his carbine at me, but I expected, if he fired, he would miss me, and my intention was in that event to put my hand under his foot, tumble him off on the other side, spring into his saddle, and attempt to escape. My wife, who had been watching, when she saw the soldier aim his carbine at me, ran forward and threw her arms around me. Success depended on instantaneous action, and, recognizing that the opportunity had been lost, I turned back, and, the morning being damp and chilly, passed on to a fire beyond the tent.[2]

Davis's autobiography, written eight years later, included some variations of the capture scene that de-serve attention. One of these suggested that as he stepped out of his tent to escape, "a servant-woman started with me carrying a bucket as if going to the spring for water." In this version, when he was stopped by a soldier, Davis threw "off a shawl which my wife had put over my shoulders."[3]

What emerges from Davis's accounts is that, among other things, the president did in fact try to slip away from the Union troops. The attempt was not altogether unrealistic, for Davis's *Rise and Fall* pointed out that "during the confusion, while attention was concentrated upon myself . . . one of my aides, Colonel J. Taylor Wood, with Lieutenant Barnwell, walked off unobserved."[4]

Apparently Davis also attempted to walk away casually, with a female slave as a supporting character in the drama. She carried a water bucket—or perhaps he did. However rapidly Davis had decided to attempt an escape, and however many "precious moments" he and his wife Varina spent before the decision was made, there was time enough for her to think of the ruse of going with a servant for water. There was also time enough for Davis to don a raincoat—which turned out to be Mrs. Davis's raglan.

We do not know precisely how different male and female raglans were, although Mrs. Davis's coat apparently survives, having later been sent to Washington as evidence on the orders of Lincoln's secretary of war, Edwin M. Stanton. The coat could be worn thrown over the shoulders, and Varina Davis, who was tall and large framed, wore a large size. We do not know for sure, either, how dark it was in the tent, and there is conflicting testimony on the point. But we need not doubt that Davis, an honorable man, believed his own account to be true. Most of his biographers have believed it, too.

More important than the raglan is Davis's claim that "as I started, my wife thoughtfully threw over my head and shoulders a shawl."[5] Men did sometimes wear shawls—Abraham Lincoln did—but not

over their heads. Most likely, Davis was barely conscious of what he was wearing as he attempted to steal away with his wife's raincoat over his shoulders, her shawl over his head and shoulders, and a servant woman with a water bucket by his side. In the semidarkness his mind had to be focused on escape. "I had gone perhaps fifteen or twenty yards," Davis recalled, when a mounted trooper "galloped up." The drama was nearly over. Disguise was abandoned—or was it disguise? —and, to quote Davis further, "dropping the shawl and raglan" from "his shoulders," he tried to attack and unhorse the trooper. In the narrative from *Rise and Fall*, when the shawl is mentioned, it is described as being draped over "head and shoulders." When it is dropped, in the following sentence, the raglan and shawl together come off the "shoulders." Was a painful memory being opaqued over?[6]

The mid-May front-page headline of the *New York Herald* was blunt:

JEFF. DAVIS. Details of his Capture. His Camp Surprised at Daylight on the 10th Instant. He Disguises Himself in His Wife's Clothing, and, Like His Accomplice [John Wilkes] Booth, Takes to the Woods. He is Pursued and Forced to a Stand. He shows Fight and Flourishes a Dagger in the Style of the Assassin of the President. His Wife Warns the Soldiers Not to "Provoke the President for He Might Hurt 'Em." He Fails to Imitate Booth and Die in the Last Ditch. His Ignominious Surrender.[7]

"The Belle of Richmond" became the butt of the victors' laughter. His "last shift" was depicted repeatedly; the pun was too enticing for printmakers to resist. Davis was consistently pictured in women's clothing, sometimes in a coat, a dress, or a skirt, but most often in that era's most conspicuous item of female attire, a hoopskirt.

The hoopskirt idea may well have originated with an "enterprising reporter" who discovered that such an item in fact had been "captured" in the Davis camp— naturally enough, as there were women in Davis's entourage. Cartoonists added other details. The shawl generally became a bonnet. Davis was often depicted carrying a water pail in one hand and a Bowie knife or "Arkansas toothpick" in the other. Many of the details were added from the account of Davis's capture given by General J. H. Wilson, whom Davis subsequently accused of having "uttered many falsehoods in regard to my capture." Wilson was not an eyewitness, but his report to Secretary Stanton was widely copied and quoted in the Northern press.[8]

The cartoons depicting Davis's capture projected traditional sectional and class hostilities, but their chief focus was on sexuality. In mid-nineteenth-century America, notwithstanding the occasional appearance of disguised female soldiers in the Civil War, the idea of the woman warrior was beyond the culture's ken. Only a very few people even knew of androgyny or transvestism. The context of Civil War violence emphasized manliness, and men of the era looked upon "petticoat government" with mirthful disdain. Male and female roles were well defined and, in many areas, rigid. Those roles were illustrated by printmakers like Volck and artists like W. D. Washington as images of the brave fighting soldier and his antithesis, the domesticated female—the self-sacrificing binder of male wounds, the keeper of the hearth, the mourner.[9]

The effect of the 1865 cartoons was to emasculate Davis. The pictorial source for many of them was undoubtedly the woodcut illustration of Davis's capture on the cover of *Frank Leslie's Illustrated Newspaper* of June 3, 1865 (fig. 45). The impatient public did not have to wait long for separate-sheet cartoons. Like most of these, *The Chas-ed "Old Lady" of the C.S.A.*, by "Burgoo Zac" of Cincinnati, transformed the simple morning dress shown in the illustration into an exaggerated hoopskirt (fig. 46). And a soldier lifts Davis's skirt with a sword, a symbol of maleness, in a gesture that would be repeated often in these cartoons.

Figure 45.
[Printmaker unknown], *Capture of Jefferson Davis, at Irwinsville, Ga.* Published in *Frank Leslie's Illustrated Newspaper*, June 3, 1865. Wood engraving, 9⅛ x 9½ inches. Quoting a *New York Tribune* correspondent, *Leslie's* stated that Davis was dressed "in petticoats, morning dress and a woollen cloak, with a hood closely drawn over the head and a pail on her arm." Mrs. Davis, it was reported, had asked a suspicious Union corporal "to allow her mother to go to the spring for a pail of water." The corporal then discovered that the morning dress was "not quite long enough to conceal a pair of boots." *Leslie's* depicts the image of Davis at his capture at perhaps its most feminine. (*Louis A. Warren Lincoln Library and Museum*)

Figure 46.
Burgoo Zac, *The Chas-ed "Old Lady" of the C.S.A.* Published by Oscar H. Harpel, Cincinnati, 1865. Lithograph, 9¾ x 16⅛ inches. This cartoon not only includes a black person, presumably a servant of Davis's, but also makes reference to the fact that the soldier who claimed to have been the first to spot Davis was a Norwegian-born tanner. Thus the man on the right speaks with an accent, in this case, German: "Mein gott, tis *ole mutter* vears a pig gavalier poots So-o." The print bears a copyright date of June 5, 1865, a mere four weeks after Davis's capture—a clear indication of the considerable speed with which these cartoons were published. (*Library of Congress*)

Other cartoons, including Magee's *Jeff Davis Caught at Last*, made reference to Davis's ungranted request to his captors that his family be permitted to continue on their journey. In Wilson's report Davis was said to have expressed "great indignation at the energy with which he was pursued, saying that he had believed our government more magnanimous than to hunt down women and children."[10] So cartoons depicted *Jeff. Davis "As Women and Children."* Indeed, the sole threat in many of these pictures comes from Mrs. Davis, who warns: "Do not provoke 'the President,' he might hurt some one." But viewers knew this to be a jest, for the knife in Davis's hand only occasionally suggested resistance. It was there, sometimes bloody, to condemn one who was supposed to have conspired in the murder of Abraham Lincoln. But viewers understood that a cowardly Davis gave up without a fight.

Davis himself claimed that he had wanted to fight. His 1889 autobiography, which failed to mention the unheroic raglan, did recount in some detail his hope of assaulting the trooper who captured him. According to his earlier account, that action was prevented when Mrs. Davis ran forward and threw her arms around her husband. "Success depended on instantaneous action," Davis said, and the moment was lost. There is a problem with this story. Davis admitted that he was "perhaps fifteen or twenty yards" from the tent when he was captured. Unless Varina left the tent with him, her inhibiting embrace could not have occurred. Perhaps she only screamed at the sight of a firearm being leveled at her husband, and the sound froze the president into inaction. It is also possible that, as he recalled his capture in later years, Davis exaggerated what in his day would have been called his manly bravery.[11]

In any case, Northern-made cartoons in 1865 were loath to concede much courage to the enemy chief. These works, picturing their cowardly subject in hoopskirts, sometimes moved from ambiguous to explicit sexuality—so explicit that they seem to call into question old assumptions about Victorian mores. *The Head of the Confederacy on a New Base*, for example, resembled a rape or castration scene (fig. 47). Another print, *Jeff's Last Skedaddle* (fig. 48), described "How Jeff in His Extremity Put His Naval Affairs and Ram-Parts Under Petticoat Protection." In it, a half-dressed young female is trying to stop the pursuing Union troopers, who are charging with unsheathed swords erect. "Please gentlemen," the good-looking lass pleads, "don't disturb the privacy of Ladies before they have time to dress." The sexual frankness is probably a clue that such art was not customarily found in "respectable" homes.[12]

The question of sexual identity dominated these works, but other motifs appeared as well. Allusions to Confederate gold were common, for at the start of the removal from Richmond what was left of the Confederate treasury had been removed too. The supposed, but really nonexistent, millions in specie excited too many imaginations, North and South, to be ignored. "Southern chivalry," too, was castigated by the cartoons in plain Yankee language, verbal and pictorial, that embodied both sectional and class hostility. And the prints celebrated the end of the Confederate States of America. In one 1865 Currier and Ives lithograph entitled *A "So Called President" in Petticoats*, a proper Southern gentleman reproaches a blue-coated soldier, "Aint you ashamed to treat the President so?" The reply is: "President!! Who is he President of." The central character remains an unresisting figure whose dress is being lifted by a soldier's sword.

If the end of the Civil War and the capture of Jefferson Davis held any further meanings, the 1865 caricatures rarely indicate it. Black people, for example, appear in only a few works, even as supporting actors in this American drama. In Washington, G. Querner portrayed blacks celebrating and ridiculing a caged Davis, at whom the somber ghost of John Brown points an accusing finger (fig. 49). Davis, of course, is in dress and bonnet, but the blacks are drawn as gross minstrel-show stereotypes. Similarly depicted "dark-

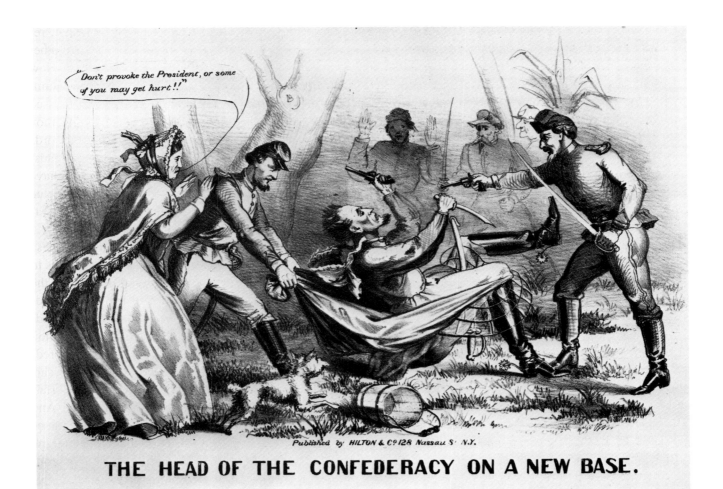

THE HEAD OF THE CONFEDERACY ON A NEW BASE.

Figure 47.
Hilton and Company, *The Head of the Confederacy on a New Base.* New York, 1865. Lithograph, 9 x 14 inches. Ambiguous sexuality is a major recurring theme in the cartoons of the Davis capture. The Union soldiers' assault portrayed in this example carried boldly sexual overtones for period viewers with earthy tastes. Surprisingly overt, it shows the victim's skirt pulled back and an officer in assaulting position in front of Davis's spread legs. Davis's sword protrudes between his legs as a striking symbol of incongruous manliness. (*Louis A. Warren Lincoln Library and Museum*)

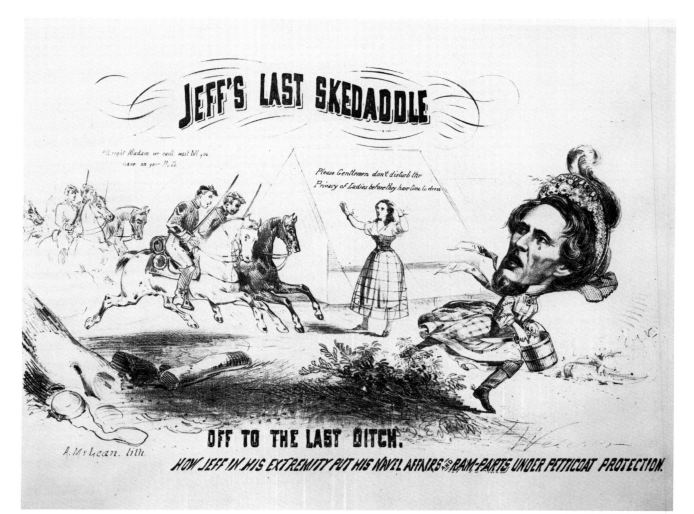

Figure 48.
A. McLean, after T. Welcker, *Jeff's Last Skedaddle*. N.p., ca. 1865. Lithograph, 17 x 11¼ inches. "Skedaddle" was Civil War slang for "retreat" or "flight," having replaced the prewar slang "absquatulate." Such street language was appropriate to cartoon prints, which rarely made the pretenses to "art" that more formal engravings and lithographs did. The head of Davis here rests awkwardly on the escaping body because Welcker obviously did not trust himself to adapt a recognizable likeness to his immediate pictorial needs—he had to copy a portrait photograph exactly. (*Louis A. Warren Lincoln Library and Museum*)

Figure 49.
G. Querner, *John Brown Exhibiting His Hangman*. Washington, D.C., 1865. Lithograph, 16⅜ x 12¼ inches. Jefferson Davis, of course, was in no way responsible for the hanging of John Brown, an act of Virginia state authorities before the Civil War. But Brown's martyrdom made him a potent symbol of the righteousness so long denied by the South. Ironically, the black beneficiaries of Brown's sacrifice are depicted here as comic and vulgar minstrel figures in a fashion common in nineteenth-century cartoons. (*Courtesy The Library Company of Philadelphia*)

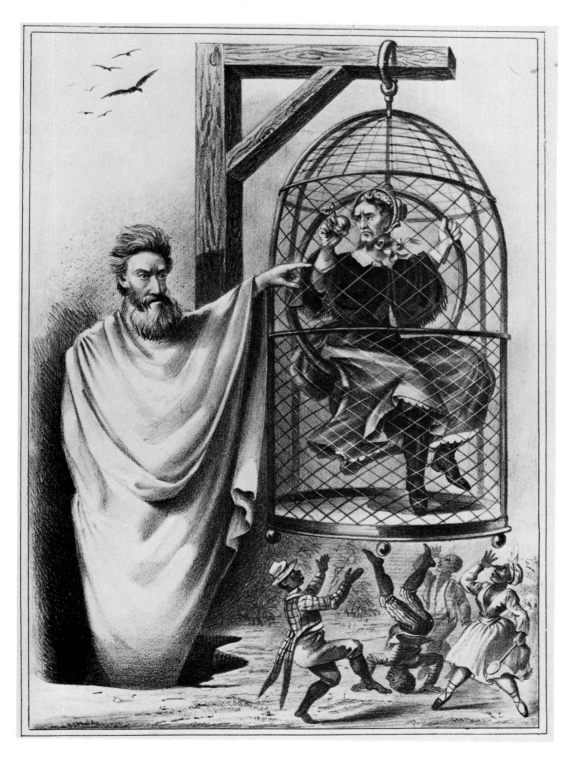

ies" appear in Burgoo Zac's cartoon, *The Chas-ed "Old Lady" of the C.S.A.* (see fig. 46). The inventive Zac was also capable of going beyond such portrayals. In his *Finding the Last Ditch* (fig. 50), a Union soldier pitches the hoop-skirted and bonnetted Davis to the devil, as "stolen gold" and the "assassin's" knife fall too. In the background there is a black man celebrating, his chains broken. And the long caption includes a statement about "Everybody getting their 'Rights.'"

After four years of war Americans needed to laugh again, and so hoopskirts were everywhere. Printmakers were businessmen and presumably gave the Northern public the product they thought it wanted. The unanimity, rapidity, and avidness with which they focused their attention on *The Capture of an Unprotected Female* (the title of another 1865 Currier and Ives work) indicate that the printmakers touched an important nerve of American culture, at least in its Northern aspect.

The possibility of Davis's being hanged was discussed in the press, and cartoons depicting the deed occasionally appeared as late as 1865 (see fig. 43), but they were overwhelmed by the hoopskirted image. Blue-coated soldiers had sung for four years about hanging "Jeff Davis from a sour apple tree," and cartoonists had frequently and wishfully pictured Davis so; nevertheless, when he was actually captured, what Lincoln called "the better angels of our nature" prevailed. Though Davis was kept in prison—in chains for five days and under poor conditions for four and a half months—after two years he was freed to go home and write his two-volume history of the Confederacy. He had lost the war, and for much of the North his real punishment was his emasculation.

A culture advanced enough to eschew revenge on the chief of the defeated enemy—but, some would say, primitive enough to lust after revenge for the hundreds of thousands dead and for their own martyred chief—could find some release in devastating ridicule. Print-

makers played a substantial role in the ridiculing process, along with journalists. Newspapers were cheap and reached a broad audience but were quickly discarded. Prints, however, were usually put on walls and retained for years. But cartoon prints, if we can judge from their scurrilous content and crude artistry, were likely displayed in saloons, perhaps most often on outdoor walls or fences, and in rare instances even in lower-class homes. Their irreverent use by the least literate classes helps explain the difficulty of finding written descriptions of how and where separate-sheet cartoons were utilized.

The early cartoons and newspaper accounts of Davis's capture inspired jokes, stories, pamphlets, poems, and sheet music. Northerners sang cheerily of "Jeff in Petticoats" (fig. 51). "A Song for the Times," its publisher billed the work, and indeed it was.

"She's the Bearded Lady!" exclaimed the Union soldier lifting Davis's bonnet in *Jeff Davis Caught at Last* (see fig. 44). The same cartoon asked the question, "Where is Barnum?" As if P. T. Barnum needed such prompting. He wasted little time installing in his famous American Museum in New York a tableau that included a life-size statue of Davis, complete with hoopskirts and surrounded by figures of the soldiers who captured him.

In Barnum's museum the cartoons thus almost came alive. Indeed, there seems to have been a close relationship between Barnum's world and the world of the separate-sheet cartoon. Figures depicted in advertisements for Barnum's museum sometimes showed up in these cartoon prints. Theirs was a realm perhaps best described as the demimonde of art and symbol.

Some proper people no doubt thought it the work of a just God when fire destroyed Barnum's museum on July 13, 1865. Tens of thousands of New Yorkers watched the spectacle that outdid Barnum, with both relics and animals burning. A few things were saved: some wax figures, small animals, rare coins, the fat

Figure 50.
Burgoo Zac, *Finding the Last Ditch.* Published by Oscar H. Harpel, Cincinnati, 1865. Lithograph, 14½ x 10 inches. An unusual and original capture scene because it reduces the typically crowded scene to four symbolic characters, the print features: Davis, "C.S.A." patched to his tattered trousers, dropping his knife and his "stolen gold," symbols of assassination and dishonesty; the comparatively robust "U.S." soldier about to hurl "the 'Head' of Secession into the Ground"; the Devil, poised to receive Davis on his pitchfork; and the liberated slave, rather compassionately drawn, lifting in jubilation his newly unshackled arms. The cartoon is unusual in format as well, for the great majority of separate-sheet cartoons were horizontal, rather than vertical, pictures. (*Library of Congress*)

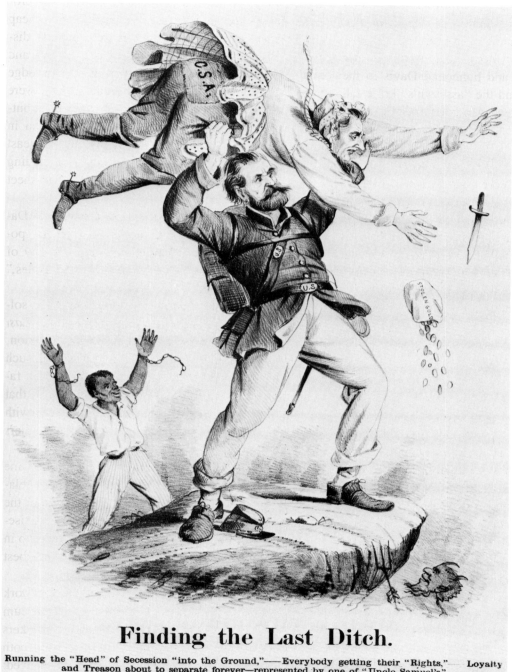

Finding the Last Ditch.

Running the "Head" of Secession "into the Ground,"——Everybody getting their "Rights," Loyalty and Treason about to separate forever—represented by one of "Uncle Samuel's" Noble Veterans and the "Sternest" Rebel of 'em all.

Entered according to Act of Congress, in the year 1865, by OSCAR H. HARPEL, (Pike's Opera House, Cincinnati) in the Clerk's Office of the District Court for the Southern District of Ohio.
DESIGNED BY BURGOO ZAC.

Figure 51.
H[enry]. C. Eno, "Jeff in Petticoats. A Song for the Times." Published by William A. Pond, New York, 1865. Lithographed sheet music cover, 10 x 8¼ inches. The chorus sang of "Jeffy D! you 'Flow'r of chivalree,' Oh royal Jeffy D! your Empire's but a tin-clad skirt, oh, charming Jeffy D." The verses focused on Davis's attempt to escape with stolen gold while disguised in the obligatory crinolines and stays. (*Louis A. Warren Lincoln Library and Museum*)

lady, the learned seal—and the statue of Jefferson Davis. Onlookers caught the figure as it was thrown from a window and then hung it on a lamp post on Fulton Street, petticoats and all.[13] In a way, this symbolic hanging was, for Davis and for a proud Southern culture, worse than the real hanging he escaped. Emasculation was perhaps the worst punishment in nineteenth-century America's male-dominated culture.

Barnum was resourceful. He would rebuild his entertainment empire and revive the hoopskirted Davis. Years later, the former Confederate secretary of the navy, Stephen R. Mallory, bemoaned the display: "Many thousands of children, whose wandering eyes beheld it, will grow to maturity and pass into the grave, retaining the ideas thus created as the truth of history."[14] In time the tableau did come down, but the idea behind it never did entirely, certainly not in the North and perhaps not even in the South.

Barnum had tried to purchase the actual Davis petticoats for $500 from Secretary of War Edwin Stanton. George Templeton Strong, an entrepreneur himself and an astute observer of society, noted in his diary: "Barnum is a shrewd businessman. He could make money out of those petticoats if he paid $20,000 for the privilege of exhibiting them." Strong, Barnum, and the printmakers all understood what the North wanted. And if Stanton could not supply the hoopskirts, that did not matter. For, as the blunt Barnum explained in a different context, "My dear sir, the bigger the humbug, the better the people will like it."[15]

The question remains, how big was this particular humbug? It is clear that Davis had been captured in his wife's raglan and fringed shawl (with a figured band containing "red-orange, light-blue, green, and gold colors") and with a water pail in his hand or in that of an accompanying servant.[16] By 1877, when he reasoned in a private letter that "there was no impropriety in using disguise to escape capture, but there was no time to have assumed one," the former Confederate

president had considerably clouded reality in his own mind. Two diaries of eyewitnesses, one a Rebel, the other a Yankee, noted his disguise; the former expressed deep regret about it, but the latter deemed it a "fit ending."[17]

Yet it is also clear that Davis was a brave man and a man of integrity, and the portrait of him that emerged in 1865 was unfair. What happened in the early morning of May 10, 1865, would have mattered little but for the needs of the time. The atmosphere was right for Northerners to believe the worst. On May 14 and 15, the diary of former Democrat Gideon Welles, first Lincoln's secretary of the navy and then Andrew Johnson's, noted: "Intelligence was received this morning of the capture of Jefferson Davis in southern Georgia. I met Stanton this Sunday P.M. at Seward's, who says Davis was taken disguised in women's clothes. A tame and ignoble letting down of a traitor."[18] This statement was never corrected in subsequent entries in the diary. On May 13, General Wilson had telegraphed Stanton: "The captors report that he hastily put on one of Mrs. Davis' dresses and started for the woods." On the following day he amplified matters but shed no further light: "The device adopted by Davis was even more ignoble than I reported at first."[19] Hoopskirts were looming on the horizon, but Stanton wanted evidence. B. D. Pritchard, the colonel of one of the two units that had seized the former president, was ordered to "procure the disguise worn by Davis at the time of his capture and proceed to Washington and report to the Secretary of War." The colonel "received from Mrs. Davis a lady's water-proof cloak." Both she and soldiers present at the capture identified the garment. However, Pritchard had to return "on the morning following" to obtain "the balance of the disguise . . . which consisted of a shawl, which was identified and admitted to be the one by Mrs. Davis." Whatever her reasons, Varina Davis was slow to part with all the "evidence." Her instincts were correct. Soon a wood-

cut of the offending garments, based on an Alexander Gardner photograph, appeared in *Harper's Weekly*.[20]

Varina Davis, who better than any other person except her husband knew what really happened on that fateful morning, explained in a letter to Democratic politician Francis P. Blair, less than a month later, that she had pleaded with Davis "to let me throw over him a large waterproof which had often served him in sickness during the summer season for a dressing gown, and which I hoped might so cover his person that in the gray of the morning he would not be recognized." In explaining matters thus to a friend—even as her husband was being universally depicted in hoopskirts—she did not identify herself as the owner of the raglan, but instead gave the impression that Davis habitually wore the rainwear. Her letter went on to say: "As he strode off, I threw over his head a little black shawl which was round my own shoulders, seeing that he could not find his hat." Though Mrs. Davis admitted that she had pleaded with her husband to disguise himself and that he accepted a "large waterproof," the shawl itself became part of the attire only because Davis's own hat was misplaced.[21] In her own mind and for the benefit of her imprisoned husband, the opaquing process had begun.

A quarter of a century later, Varina Davis declared with some heat, while still denying the hoopskirt charge, that "any disguise" would have been "legitimate" for Davis. Her retrospective reasoning had been invoked throughout the South from 1865 on. Stories of heroes who were supposed to have escaped danger by wearing female attire, including Charles II and Bonnie Prince Charlie, were trotted out. Tales were told of King Alfred dressed as a cowherd and Richard the Lion-Hearted disguised as a pilgrim to escape danger.[22] Most Southerners came to deny the charges of any female attire, and they were joined by a few Northerners. But such tales have lives of their own. By 1890 a resigned Mrs. Davis simply announced, "I have long since ceased to combat falsehood . . . borne upon the wings of hate and vilification." Still, she could not resist delivering some counterblows.[23]

She knew how much pain her husband suffered from the universal smirks aroused by his new image. Davis himself had written of the hoopskirts as "the staple of so many malignant diatribes and pictorials" and of "wood cuts . . . said to have been made in New York." And he added that "in my case and our time, truth is crushed beneath malice and falsehood." In *Rise and Fall* he spoke "of the story and its variations" as "all the spawn of a malignity that shames the civilization of the age." While he was writing his memoirs, he recalled bitterly in a public letter the time "when the invention of malignants was taxed to its utmost to fabricate stories to defame and degrade me in the estimation of mankind; when time-servers at home as well as abroad joined in the cry with which the ignoble ever pursue the victim." "I will postpone, to some other time and more appropriate place any further notice of the story," Davis explained in his book, and postpone it he did until the day he died. One biographer, Robert McElroy, summed up matters thus: "For the rest of his life Davis resented the thought that friend and enemy could believe him guilty of seeking safety by a method so 'unbecoming a soldier and a gentleman.' "[24]

McElroy went further, adding that "probably no single incident of his career caused him such poignant anguish." This estimate came from a man who chronicled a life replete with tragedies. Yet the judgment may well have been accurate. The rumors were painful to Davis only in part because of his idea of "Southern honor" and his humiliation in the context of a Victorian definition of manhood. The story also hurt because at some level of consciousness both Varina and Jefferson Davis knew that there was a kernel of truth to it.

What neither of them understood fully was the popular impact of *The Belle of Richmond, Jeff's Last Shift, The True Story of the Capture, A "So Called President" in Petticoats, Jeff's Last Skedaddle, The Head of the Confederacy on a New Base, The Capture of an*

Unprotected Female, and all the other cartoons. If the Davises could not understand, it is possible that Stanton did. In any case, he locked up in the War Department "Shawl, waterproof and spurs worn by Jeff. Davis on the day of his capture, May 10, 1865." A second notation, also in Stanton's hand, commanded: "Deliver only to order of Secretary of War, or General E. D. Townsend A.[Assistant] A.[Attorney] Gen. E.D.S." The box remained unopened in the War Department until the twentieth century.[25]

Two years in confinement at Fortress Monroe were not, for most Northern sensibilities, punishment commensurate with Davis's crime. Hoopskirts were more appropriate. And so with Stanton's quiet help the vilification continued and Davis served as the scapegoat for his perceived sins and those of his people. Not only was hatred concentrated on him but, even worse, laughter as well. Laughter is good medicine, as folk wisdom has it, and the new Davis image—the comic emasculated character "running through bush and through briar, in the cumbrous disguise of hooped skirts," to quote George Templeton Strong's description—helped sublimate the North's hatred. It must have played some role in Reconstruction, the atmosphere of which was now colored by ribald laughter rather than the mere desire for revenge.[26]

In 1865 Sergeant-Major Robert H. Kellogg of Connecticut published an account of his experiences at Andersonville, the most horrid symbol of the rebellion to the North—so odious that its commandant became the only Confederate to be executed for war crimes after the fighting ended. The book ended with the capture of Davis not far from Andersonville and the surmise that his self-inflicted "unmanning" had much to do with the vicinity *and* "his guilty soul." The capture "will hold him up to ridicule for all time to come," Kellogg was certain. The book had a double frontispiece: one wood engraving showed the misery at Andersonville; the companion piece, the capture of "the responsible party." In the book's design, the "unman-

ning" of the enemy chief balanced the horror of Andersonville, which was also well known to Northern audiences from popular prints.[27]

"If I alone could bear all the suffering of the country, and relieve it from further calamity, I trust our Heavenly father would give me strength to be a willing sacrifice," Davis wrote to his wife from Fortress Monroe in the dismal fall of 1865.[28] He wanted a trial, he was willing to accept death, he was strong enough to face any *manly* punishment. But what the North inflicted on him instead was too painful to bear with equanimity.

In 1890, defending her husband and the theoretical legitimacy of disguise, Varina concluded hypothetically that "I would have availed myself of a Scotch cap and cloak, or any other expedient."[29] The reference was unwitting testimony to the potency and longevity of the kind of tales that had so painfully beset both her husband and his Union counterpart. On his way to Washington in 1861, Abraham Lincoln had been informed that an attempt would be made to assassinate him in Baltimore. He abandoned his regular schedule and took a night train through the city incognito, wearing a large overcoat and exchanging his familiar stovepipe hat for a recently received gift of a "brown Kossuth hat." Lincoln arrived in Washington safely. Soon a reporter announced on the front page of the *New York Times* that the president-elect had worn "a Scotch plaid cap and a very long military cloak." Cartoons, articles, songs, and poems had mocked the embarrassed Lincoln, inspiring Adalbert Volck's cartoon for *War Sketches*.[30]

Four years and 620,000 dead later, there was a much deeper need for laughter. The comic image of a cowardly Lincoln had made it a little easier for Southerners to go to war in 1861, armed with defiant songs about Scotch caps and cloaks. The laughable image of a cowardly Davis in 1865 made it a little easier for the North to be forbearing toward the defeated enemy. The quantity of Davis petticoat prints—a search so far has

turned up thirty-two independently published examples, five from Currier and Ives alone—suggests their much larger role in influencing public opinion than the few 1861 Lincoln cartoons. By 1865 the growth of the idealized Lincoln image in the North was paralleled by the creation of the sexually ambiguous image of Jefferson Davis. The simultaneous emergence of the two images testified to the inexorable link between the fates of the two presidents.

Though much was written, in the century after the capture of Davis and the end of the rebellion, about the awful vengeance the North wreaked upon the defeated South, it should be reasonably clear that, on the whole, Lincoln's advice had been followed: "let 'em up easy." A proper perspective on the mood of the Reconstruction North requires some reflection on how other victors have dealt with the vanquished throughout history—particularly after brother-against-brother wars. Compared to English dealings with the Irish or the Scots, or to the residual bitterness and bloodshed that followed the French Revolution, or to the Russian and Chinese civil wars in our own century, Americans seem to have done better after their war, and the image of Davis in hoopskirts illustrates one of the tools that permitted them to do so.

Part II

The Lost Cause, 1865–1907

Representing nothing on God's earth now,
 And naught in the waters below it,
As the pledge of a nation that passed away,
 Keep it dear friend, and show it.

Show it to those who will lend an ear
 To the tale this trifle will tell,
Of Liberty born of a patriot's dream,
 Of a storm-cradled nation that fell.
—P. C. Carlton, "Confederate State's Money"

9 / The Dividing Line

The Confederate image blossomed from the unlikely soil of defeat and subjugation, but it required cultivation by Northern craftsmen. While the Confederacy existed as a vital cause, popular prints had done little to depict or shape it. Northern publishers temporarily abandoned the Southern market, and Southern publishers proved ill-equipped to take up the slack. As Bell I. Wiley has observed, the region "did not have the background for a quick cultural awakening." When the wartime blockade curtailed trade, Confederates, who had long been dependent on Northern and European imports, learned to do without the cultural amenities to which they were accustomed. For four years, their focus increasingly narrowed to mere survival. By the time the war drew to a close, many faced what one observer described as the "entire ruin and destruction" of their homes and property.

Amidst this deprivation there arose an ironic yearning to ennoble defeat and to celebrate the very leaders who had proved powerless to prevent the conquest. The South had to learn to live with defeat and the memory of human loss unprecedented in American history. Somehow Southerners had to accept and draw spiritual strength from the tragedy. This cultural condition inspired a vigorous cultural and commercial response, but the commercial one, at least, was somewhat belated.[1]

Northern printmakers did not immediately market Lost Cause images in the South. Only one fully sympathetic print of a Confederate scene produced in 1865 survives. Even commerce acknowledged the need for a respectable interval between the burial of the Confederacy and the pictorial resurrection of its martyrs and heroes. The respect shown to Robert E. Lee in the Appomattox prints hinted at future directions; so, in an indirect way, did the cartoonists' choice of ridicule rather than malevolence in their depictions of Jefferson Davis's fall. But some time did have to pass. In 1866, Northern printmakers slowly began supplying portraits of Confederate heroes to the South. To judge by the number of different subjects, production rose through 1870, which proved a watershed year for the Confederate image.

The "influences of war were not wholly negative" for the South, as Wiley has pointed out, "for the thrill, shock, and suffering of those tragic times provided a heritage" that Southerners felt compelled to preserve. Popular prints, especially portrait engravings and lithographs of Confederate civilian and military heroes, became popular in homes, schools, and veterans' lodges as the visual records that accompanied a sentimental renaissance of the Lost Cause.[2]

This nostalgia is more than a little curious. After all, the Confederate leaders were defeated, and history is notorious for celebrating victors and forgetting the vanquished. But popular prints embody history in extremely popular forms. For the masses of ordinary Southerners, the idea that they had followed losers was unattractive, to say the least. The enormity of Southern sacrifice—one-third of her males were mobilized for war and one-fourth of these, 250,000 men and boys, died—underscores the unacceptability of forgetting the Confederate leaders. If those men were forgettable, then the 250,000 had died in vain. All the widows and orphans had suffered poverty in vain. The amputees and cripples had been disfigured in vain. Mississippi had spent 20 percent of its 1866 state revenues on artificial limbs because of a political error. The uselessness of such sacrifice was unthinkable, and so the Confederate heroes came back as icons.

They came back in heroic portraits drawn and printed in the North. The explanation for this development should be obvious. Printmakers seeking the broadest possible audience produced prints that appealed to various tastes and prejudices. Traditionally indifferent to ideology, printmakers had always tailored products for both Democrats and Republicans, for Catholics as well as Protestants. Now Yankee engravers and lithographers were producing Confederate images. The

printmakers of New York, Boston, Philadelphia, and Chicago reentered the previously forbidden market after 1865 with titles such as *Our Southern Heroes* that might have been deemed treasonous only a year earlier. In printmaking, commerce quickly conquered sectionalism.

Printmakers proved unabashedly adept at playing both sides of the Reconstruction street, vying with equal vigor for Northern and Southern audiences with prints that celebrated the virtues and heroes of each region. It was not uncommon for portraits of Lincoln and Davis or Grant and Lee to come off the same press at virtually the same time. But, aside from the newsworthy Appomattox scenes, these old enemies never appeared together in the same print—proof that customers purchased them as icons to be revered, not as historical curiosities to be collected.

The printmakers' cause after 1865 was profit, not patriotism. The same publishers supplying Lost Cause images to the white South sought to create images for the black South, too. In the highly competitive world of American printmaking, such seemingly incongruous production did not suggest divided loyalties—only a keen sense of marketing that knew few political restrictions. Lithographer Thomas Kelly of Philadelphia and New York, for example, entered the postwar competition with prints of both Lincoln's and Davis's cabinets (see figs. 102 and 103). He issued lithographs of the Lincoln family as well, along with a lithographed tribute to the Fifteenth Amendment, which declared that voting rights could not be denied "on account of race, color, or previous condition of servitude." At the same time, Kelly was publishing portraits of Robert E. Lee. With the war ended and barriers to trade lifted, such ideological virtuosity became commonplace.

Boston's Louis Prang was one such virtuoso printmaker. Immediately following the war, he focused on "generals who served under the Union flag during the Great Rebellion." Later he thrived in the expanded Reconstruction market and missed few opportunities to respond to the different demands of his varied audiences.

A rare pictorial opportunity arose in April 1870, when the first black ever to be elected to the United States Senate assumed the Mississippi seat once held by Jefferson Davis. Thomas Nast captured one aspect of the emotionally charged transition with a full-page *Harper's Weekly* woodcut entitled *Time Works Wonders*, which portrayed a horrified Davis as Iago, cringing from the sight of black Senator Hiram Revels at his old desk and uttering the appropriate lines from Shakespeare's *Othello*: "For that I do suspect the lusty Moor hath Leap'd into my seat: the thought whereof doth like a poisonous mineral gnarl at my innards."[3]

Nast's caricature, like most such efforts in the picture press, was published for its news and satiric value, with no thought to a more permanent life. Prang's response, however, was quite different. Acknowledging on the pages of *Prang's Chromos* the ironic fact that Revels now occupied the seat "held once by the head and front of the great slaveholders' rebellion," the printmaker characterized the turn of events as "an object of great interest" and introduced a chromolithograph of the new senator in response to "a great national want, grown partly out of admiration, partly out of curiosity."[4]

He also cleverly forwarded a copy of the print to the nation's leading spokesman for freed blacks, Frederick Douglass, hoping for an endorsement that would help him market the print to the newest of Southern audiences. He was not disappointed. Noting that blacks heretofore had been portrayed as "monkeys," Douglass responded enthusiastically, writing: "Heretofore, colored Americans have thought little of adorning their parlors with pictures. They have had to do with the stern, and I may say, the ugly realities of life. . . . Every colored householder in the land should have one of these portraits in his parlor, and should explain it to

his children, as the dividing line between the darkness and despair that overhung our past, and the light and hope that now beams upon our future as people."[5]

Prang was anything but a one-issue publisher and at the very time he was breaking new ground with his "dividing line" chromo of Hiram Revels, he was circulating a portrait of Stonewall Jackson lithographed by Dominique Fabronious. Prang's 1871 catalog also offered lithographed *cartes-de-visite*—photographs the size of visiting cards usually collected in parlor albums—of Jefferson Davis, Alexander Stephens, Robert E. Lee, Stonewall Jackson, and Albert Sidney Johnston as well as portraits of the predictable Northern heroes like John Brown, Benjamin F. Butler, Abraham Lincoln, and Ulysses S. Grant. Yet Prang was not above advertising a scene of minstrel life drawn in such a derogatory fashion that, had he seen it, Frederick Douglass would almost certainly have been horrified by the reversion to the "monkey" image he so reviled.[6]

Printmakers tried to provide images for everyone. One who called himself "Am. Harcq.," for example, issued a lithograph in 1866 entitled *The Heroes of the South* (fig. 52); significantly, it was copyrighted in New York City, where such a title might have seemed downright treasonous a year before. And it was another New York print publisher, William Pate, who flooded the South with that emblematic Lost Cause image, *The Burial of Latane* (see fig. 1).

John A. O'Neill, a future mayor of Hoboken, New Jersey, also emerged as a leading purveyor of Confederate imagery, beginning in 1866 with what were advertised as "splendid steel portraits" of nineteen political and military celebrities, including Davis, Lee, Jackson, and Beauregard, for a two-volume Southern history of the war written by Edward A. Pollard, the Civil War editor of the *Richmond Examiner*, and published by C. B. Richardson in New York City. With this head start as an engraver of Lost Cause portraiture,

O'Neill went on to depict Lee and his lieutenants in a separate-sheet display print and to produce another book engraving that publisher Richardson used for two Lee-related volumes—both, again, issued in the North.[7]

John Chester Buttre, a contemporary of O'Neill's, was an even more successful engraver who periodically issued catalogs indicating that he sold both his own works and those of his rivals. For thirty years after the end of the war, Buttre's offerings included portraiture not only of Lincoln, Grant, and the principal Confederate icons—Davis, Jackson, and Lee—but also Joseph E. Johnston, Beauregard, and Stephens, all engraved by New Yorkers Goffin, Jackman, Hall, and Ritchie. Philadelphia engraver William Sartain, perhaps best known for a fine engraving of the Lincoln family, also turned his attention to the South after the war. Although he had served in the Union army, Sartain now portrayed his erstwhile enemies in a series of superb postwar mezzotints whose subjects included Lee, Jackson, Beauregard, and Davis.[8]

Perhaps the most vivid example of the new freedom in the marketplace can be found in a postwar catalog of "new . . . cheap and popular prints" from Currier and Ives. Included among its 903 subjects, each priced at twenty cents, were eleven portraits of Civil War personalities. Only four—Lincoln, Grant, Sherman, and McClellan—were Union, whereas a surprising seven were Confederate—Davis, Lee, Jackson, Joseph E. Johnston, Beauregard, Forrest, and Breckinridge. For black Southerners, who had no interest in Confederate heroes but who briefly enjoyed some power in the Reconstruction South, Currier and Ives also published a portrait lithograph of Oscar J. Dunn, the black lieutenant governor of Louisiana. (Dunn, born a slave, became a captain in Louisiana's black Union troops and was elected to the state's second-highest office in 1868.) Further startling evidence of Currier and Ives's postwar marketing versatility came in the firm's offer-

THE HEROES OF THE SOUTH.

Figure 52.
Am. Harcq., *The Heroes of the South*. New York, 1866. Lithograph. Northern printmakers began soon after the war to provide the neutralized South with heroic images of its once-fierce generals. This lithograph, which appeared the year after Appomattox—the first year, significantly, in which a number of such tributes came off the Northern presses—featured Lee and Beauregard as the central figures, positioned on either side of a Confederate battle flag. The chronologically impossible group scene includes martyrs "A. B." Stuart and "S." Jackson as well as soldier-politicians "J. C. Breckenridge" and "W. Hampton." There was, of course, no way such an assemblage could have gathered in uniform at one time during the war, but Southerners determined to adorn their parlors with Lost Cause memorabilia no doubt appreciated the comprehensive image of so many Confederate immortals frozen forever in a mythically triumphant parade. (*Library of Congress*)

ing of "patriotic scenes," which included the following titles, listed one right after another: *Lee at "Stonewall's" Grave*; *John Brown—Leaving Prison*; *Assassination of Lincoln*; *The Death-bed of Lincoln*; *Freedom to the Slaves*; *Tomb of Lincoln*; *Death Bed of Lee*; *Lee Lying in State*; *Death of "Stonewall" Jackson*; and *The Lost Cause*.[9]

America's printmakers traditionally appealed to the heroic, but sentimentalism played a role in their works as well. Several prints of the Lost Cause focused on its "lost" quality—pictures meant to evoke pity and not defiance. Currier and Ives's 1871 Lost Cause print (plate 6) was such a portrayal of defeat, showing a stooped Confederate veteran returning from war to his ramshackle cabin and a gloomy family cemetery. A spectral Confederate battle flag rises like a holy emblem from the trees. Though the picture emphasized defeat and loss, it was nevertheless a potent image for Southerners. Such symbolism had little appeal in the North, and Northerners were less likely to feel the pity such sentimental prints were meant to evoke. Most Northerners were surely more likely to feel the Confederates got what they deserved for trying to destroy the sacred Union.

Currier and Ives's crude lithograph was an imaginative conception, rather than a copy of a portrait photograph, although the degree of originality in the print is unclear. Cincinnati's Henry Mosler had painted a Lost Cause canvas in 1868, also showing a stooped soldier in front of his crumbling cabin. No print based on it survives, but there is a handsome chromolithograph of Mosler's 1873 painting of the same soldier leaving his happy cabin for the war (plate 7). The theme had obvious appeal in prints aimed at a popular audience in a sentimental era.

An exceedingly rare Southern-made print of the Lost Cause era also stressed sentimentalism. W. E. Omsley's engraving after a painting by W. Sanders, also entitled *The Lost Cause*, offered a crudely symbolic view of the outcome of the war (fig. 53). A flag-waving figure representing "Union" dominates the composition, rendered passively enough perhaps to suggest reconciliation rather than retribution; the living Union contrasts with the lifeless figure lying at her feet and clutching a scroll labeled "secession." It is difficult to imagine an age in which Americans would consider displaying such art in their homes. But readers of *Huckleberry Finn* who recall the maudlin tastes of Emmeline Grangerford in her Missouri home will perhaps understand. In the emotional Lost Cause era, bathetic art found a receptive audience in the onetime Confederate states, at the same time that black-bordered Lincoln mourning prints were reaching a substantial market in the North.

Another symbol of the lostness of the cause was the now-worthless Confederate money. Lewis L. Simons's *The Lost Cause* (fig. 54) featured a poem called "Confederate States Money," written by North Carolina author P. C. Carlton. The verses melodramatically traced the demise of Confederate currency, using it as a metaphor for the death of the Confederacy itself:

> But our boys thought little of price or pay.
> Or of bills that were overdue
> We knew if it bought our bread to-day.
> T'was the best our poor Country could do.
> Keep it, tells all our history o'er
> From the birth of the dreams to its last;
> Modest, and born of the Angel Hope
> Like our hope of success, *It Passed*.

Simons's print featured several examples of the worthless money, but it also carried some signs of defiant strength as well. At the core of the scene is a Confederate flag, and surrounding it are medallion portraits of Lee, Davis, and Jackson in one group and Joseph E. Johnston and Beauregard in another. Border designs also celebrated the undimmed memory of the cause: the palmetto of South Carolina, the truculent Virginia seal, an ironclad battle on the seas, and the charred ruin of Fort Sumter. The poetry admitted that the cause

Figure 53.
W. E. Omsley, after W. Sanders, *The Lost Cause.* New Orleans, 1868. Engraving, 15 x 11¾ inches. This primitively allegorical evocation of Lost Cause mythology is so laden with symbols that it was accompanied by a lengthy subscript that attempted to explain the scene as "A design to represent the late great war . . . in which the struggle, its causes and results are shown. The two divisions are represented in the feminine order . . . the struggle . . . shown by the broken condition of the implements of war. Second, the causes are shown by the Church and the Negro. Third, the result is shown by the prostrate form of the Southern Lady (the South) and the forsaken banner." (*Louisiana Historical Association Collection, Tulane University Library*)

Figure 54.
Lewis L. Simons, *The Lost Cause*. N.p., n.d. Lithograph, 20¾ x 26⅞ inches. On its most obvious level, this is an almost cynically humorous evocation of the destruction of the Southern economy, especially its now-worthless Confederate currency. But the print managed also to provide a compensating dose of Lost Cause nostalgia with its medallion portraits of Southern heroes, its emblematic border portraiture of Confederate triumphs, and its stirring poetical tribute to "the faith that was in us . . . strong indeed." In at least one known copy of this print, actual Confederate bills were pasted over their lithographic representations. (*Library of Congress*)

had "passed," and the currency constituted a painful reminder of the economic consequences of defeat, but Simons's print also reflected sprightly pride and defiance as well.

The rather mixed message and its preoccupation with a subject often of great interest in America—money—made this print quite popular in its day. Charles E. Moore copyrighted an "oleograph" version of it in Milwaukee in 1879, with the title *Confederate Note Memorial*, and P. H. Ferguson produced an 1896 chromolithograph of it. In 1902 Gray Ellis of Washington, D.C., published a variant as well.[10]

Few Lost Cause prints spelled out their meanings as specifically as Simons's or the Omsley engraving. Most, after all, were straightforward portrait likenesses and doubtless had a range of meanings that appealed in different ways to different viewers. Presumably, they had no appeal at all to blacks, carpetbaggers, scalawags, or Federal officeholders like James Longstreet —Southerners who might conceivably have hung a

portrait of Ulysses S. Grant in their cabin, library, or office. There was always another South for whom the Confederacy was a quite forgettable experience. For probably a majority of Southerners, however, these pictures had a genuine appeal, but it varied in intensity and specific meaning from person to person. A few seem to have dwelt gloomily on tragedy and defeat, and some, at the opposite extreme, saw a reactionary and bitter defiance in the symbols of the Lost Cause. Most, perhaps, saw regional identity, sectional pride, strength to live with loss, or a realistic recognition of defeat without either total resignation or rejection of what Confederate heroes had fought for.

It may have been a tragic sort of pride that Southerners derived from the prints of the Lost Cause, but these pictures generally avoided an abject, prostrate, or gloomy defeatism. Their message may not have promised hope for the future, but they affirmed a reassuring identity from the past.

10 / Cromwell in Gray

The nineteenth century may well have been closer in spirit to the Age of Reformation than to the modern age of ecumenism and humanism. Although by mid-century sentimentalism had made softening inroads in the puritanism of this nation's founders, a fondness lingered in many American breasts for saints of sterner stripe. Stonewall Jackson exuded this atavistic religious appeal, and it was powerful enough to attract reluctant admirers in Civil War Philadelphia and even in antislavery New England. The anomaly of openly expressed admiration for an enemy general was noted even in Great Britain by the young John Dalberg-Acton, later Lord Acton and a famous historian. Undoubtedly carried away by his enthusiasm for the Southern cause, he observed in the fall of 1862: "In the Northern cities Stonewall Jackson is the national hero."[1]

He was a hero who conjured up another era. Some nineteenth-century Americans found it almost impossible to speak of Stonewall Jackson without invoking the imagery of an older civil war, a bitterly religious one between puritans and cavaliers—the English Civil War. "A typical Roundhead," one officer called Jackson, using the slang characterization of the English puritans. Richard Taylor, the well-read son of President Zachary Taylor, served with Jackson in the Shenandoah Valley campaign of 1862. After appealing one of Jackson's stern rulings against a fellow officer, Taylor observed Jackson "absorbed in prayer. Yet in that moment I saw an ambition boundless as Cromwell's, and as merciless. . . . [H]e loathed it, perhaps feared it; but he could not escape it. . . . He fought it with prayer, constant and earnest—Apollyon and Christian in ceaseless combat."[2] Less sympathetic witnesses, like those who gossiped in Mary Boykin Chesnut's salon in Richmond, resorted to the same imagery. As recorded by Mrs. Chesnut, Brigadier General Alexander Robert Lawton expressed a frank view of the great Confederate leader:

I think there is a popular delusion about the amount of praying that he did. He certainly preferred a fight on Sunday to a sermon. . . . Failing to manage a fight, he loved next best a long Presbyterian sermon Calvinistic to the core.

He had no sympathy with human infirmity. He was a one-idea'd man. . . .

He classed all who were weak and weary, who fainted by the wayside, as men wanting in patriotism.

If a man's face was white as cotton and his pulse so low that you could not feel it, he merely looked upon him impatiently as an inefficient soldier and rode off, out of patience. He was the true type of all great soldiers. . . . He could order men to their death as a matter of course. . . . He gave orders rapidly and distinctly and rode away. Never allowing answer nor remonstrance.

"Look there. See that place. Take it." When you failed, you were apt to be put under arrest. When you reported the place *taken*, he only said "Good."

Jackson was a stern disciplinarian indeed. One of his staff members later described Jackson's refusal to remit the harsh sentence of a court martial: "In this case General Jackson was as hard as nails; in the performance of a duty he always was. I never knew him in such a case to temper justice with mercy; his very words were merciless." He arrested officers frequently and ordered soldiers executed for offenses as slight as stealing apples. But he was no hypocrite. He definitely preferred not to fight on Sundays and, when he was forced to, as at Kernstown in 1862, surely no godly soldier ever went through more sincere agonies of conscience. Afterward Jackson told his wife that it was "the best that I could do under the circumstances, though very distasteful to my feelings. . . . I believed that so far as our troops were concerned, necessity and mercy both called for the battle. . . . Arms is a profes-

sion that, if its principles are adhered to for success, requires an officer to do what he fears may be wrong."[3]

Mrs. Chesnut may have come closest to explaining the seemingly conflicting mixture of piety and ruthlessness in Jackson when she pointed out: "There cannot be a Christian soldier. Kill or be killed, that is their trade, or they are a failure. Stonewall was a fanatic. The exact character we wanted. . . . He knew: to achieve our liberty, to win our battles, men must die. The religion of mercy, love your neighbor before yourself . . . why, that eliminates war and the great captains." Mrs. Chesnut was right about the fanatically clear logic of Stonewall Jackson's military thinking. His chief of staff for a time, the Reverend Robert L. Dabney, a Presbyterian minister and the general's intimate friend, recalled frankly that the "character of his thinking was illustrated by the declaration which he made upon assuming this command, that it was the true policy of the South to take no prisoners in this war. He affirmed that this would be in the end truest humanity, because it would shorten the contest, and prove economical of the blood of both parties."[4]

Fanatic or not, even to Mrs. Chesnut Jackson was "the Confederate hero par excellence." Surely General Lawton and others in Mrs. Chesnut's salon did not dissent from the widespread appreciation of the Jackson mystique. Even while debunking reports of soldiers' supposed love for Jackson, Lawton called him "the true type of all great soldiers." He was, to Lawton, one of the archetypal "restless, discontented spirits," the kind who "move the world."[5]

Equating Jackson with Cromwell may sound harsh to modern ears, but in evangelical Civil War America, the description cut two ways, arousing both fear and admiration. Jackson himself may have shared this ambivalent feeling when he watched John Brown hang at Harpers Ferry in 1859, as that wonderfully ironic commentator on America's Civil War, Edmund Wilson, observed:

Thomas Jackson (not yet called "Stonewall") seems indeed to have had some fellow feeling with Brown when he presided as major of militia at Brown's hanging. . . . He had prayed for the mad Brown's soul the night before the execution, and when it was over had written his wife that the fanatic "had behaved with unflinching firmness. . . . I was much impressed with the thought that before me stood a man in the full vigor of health, who must in a few moments enter eternity. I sent up the petition that he might be saved. Awful was the thought that he might in a few minutes receive the sentence, 'Depart, ye wicked, into ever-lasting fire!' I hope that he was prepared to die, but I am doubtful. He refused to have a minister with him."

Jackson would not always be so understanding of his Northern foes, and mere gallantry on the other side could not inspire such a response. After a rearguard action in the Shenandoah campaign, for example, a Confederate officer reported the successful repulsion of a gallant Union cavalry attack and said he regretted that most of the cavalrymen had been killed in the action. Jackson asked, "Why do you say you saw those Federal soldiers fall with regret?" The officer explained that their bravery merited a better fate. "No," said Jackson coldly, "shoot them all: I do not wish them to be brave."[6]

But the one-dimensional "Roundhead" soon became more than a Cromwell in gray. At midpoint in the war he became the South's first great martyr. When the great Confederate warrior died in May 1863, of wounds mistakenly inflicted by his own troops during a nighttime reconnaissance, Northerners greeted the news with predictable expressions of relief—but with surprising words of admiration as well. John W. Forney, an influential Philadelphia Republican, editor of the proadministration *Washington Daily Morning Chronicle*, a political associate of President Lincoln's

—and later a strong voice for sectional reconciliation—paid Jackson the tribute of a relieved eulogy. On May 13, 1863, the newspaper reported Jackson's death in this way:

> Stonewall Jackson is dead. While we are only too glad to be rid, in any way, of so terrible a foe, our sense of relief is not unmingled with emotions of sorrow and sympathy at the death of so brave a man. Every man who possesses the slightest particle of magnanimity must admire the qualities for which Stonewall Jackson was celebrated—his heroism, his bravery, his sublime devotion, his purity of character. He is not the first instance of a good man devoting himself to a bad cause. From the beginning of the world we have seen such men—men of narrow minds, but strong passions and tremendous will. Religious enthusiasts of all religions and creeds have often devoted themselves with conscientious and determined energy to a wicked cause, or have, by their excesses, degraded a good cause to the level of a bad one. Mohamet, Cyril, Philip of Spain, Loyola, Xavier, Bloody Mary, several of the Popes of Rome, Robespierre, George IV., and Jo Smith are familiar instances of enthusiasm, fanaticism, and obstinacy combined with that curious obliquity of the reasoning powers which is one of the most wonderful and puzzling characteristics of the human mind. Jackson belonged to this class of men.[7]

The language the editorial used in discussing Jackson was hardly exceptional, but it is notable for the response it evoked in one of its readers. Abraham Lincoln sat down after reading the paper and wrote Forney, "I wish to lose no time in thanking you for the excellent and manly article in the Chronicle on 'Stonewall Jackson.' "[8]

Although a magnanimous man, President Lincoln rarely said anything kind about his Confederate adversaries. Even Robert E. Lee inspired in Lincoln only derisive doggerel, in which he referred to the Confederate general somewhat disrespectfully as "Bobby" Lee. Stonewall Jackson, after his martyrdom, evoked a different response from Lincoln and others in the North. And the North was where the printmakers were.

In the South, of course, Jackson's death merely intensified a long-standing demand for prints of the first great Confederate hero. The Confederacy managed to produce a few pictures of Jackson, but not in separate-sheet prints. *Carte-de-visite* photographs were available for parlor albums, two newspaper woodcuts appeared, and an early biography published in Richmond boasted a lithographed portrait as the frontispiece.

Probably the first Southern print portrait of Stonewall Jackson was the humble woodcut engraving on the cover of the premier issue of the *Southern Illustrated News* on September 13, 1862—which appeared, it might be said, not a minute too soon. Confusion over the physical appearance of the country's heroes was rife in the Confederacy and was by no means alleviated by *carte-de-visite* photographs. As late as January 1863, the *Southern Literary Messenger* printed an article saying that General Jackson "wears short sidewhiskers." Little wonder that they had been flabbergasted by the *Southern Illustrated News* portrait by Torsch (fig. 55). "The likeness of Stonewall Jackson," the *Messenger*'s editors noted, "is said to be very good. He is a softer looking man than we had expected to see; shows very little iron in his bland physiognomy." The likeness was said to be good by the *Southern Illustrated News* itself, which pointed out in the biographical sketch that accompanied the engraving, "Major General Thomas Jonathan Jackson, or as he is familiarly known, '*Stonewall*' JACKSON, now engrosses as much of public attention as any other man engaged in the present struggle for Southern independence." Hence the editors' choice of Jackson for the paper's maiden edition and the insertion of this hyperbolic blurb to introduce the quite unrecognizable likeness:

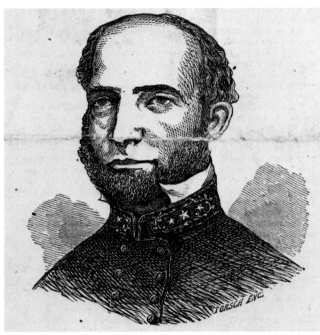

Figure 55.
[John W.] Torsch, [*Stonewall Jackson*]. Published in the *Southern Illustrated News*, September 13, 1862. Signed, lower right, "Torsch Eng." Wood engraving, 4½ x 3 inches. Despite its promise of honesty in portraiture and its vow not "to make one engraved head serve as a portrait" of others, the *Southern Illustrated News* put its worst foot forward with its first picture of the hero of the Valley Campaign. Perhaps because erroneous information led to the engraver's copying the wrong photograph, this woodcut bore no resemblance at all to Stonewall Jackson. The *News* usually did better in the future. (*Rare Book Division, The New York Public Library, Astor, Lenox, and Tilden Foundations*)

Our First engraving: We present in this issue of our paper an engraving of General "STONEWALL JACKSON" which has been examined by near relatives and friends of the distinguished hero all of whom pronounce it an admirable and truthful likeness.

The real truth was that it was nothing of the kind—merely a hastily sketched portrait, rather clumsily transferred to wood by Torsch and bearing almost no resemblance at all to the general.[9]

Curiosity about Jackson intensified after the general's death, which brought immediate outpourings of grief in the South. In Richmond, where the government had all but shut down when news of Jackson's death reached the city, the largest crowd in its history met the martyr's remains at the railway depot and marched in procession to the governor's mansion, where the body lay in state. The next day, May 12, 1863, another throng accompanied the funeral procession. When the body arrived in Lexington later that week for burial, yet another immense crowd was on hand to show its respect.

The "bland" woodcut engraving must now have seemed grossly unequal to Jackson's newly exalted status. As historian Emory M. Thomas put it, "Alive, Jackson was an eccentric genius, part Southern Calvinist and part killer. Dead, this Cromwell reincarnate took first place in the pantheon of heroes in a nation of cavaliers." Besides, many Southerners had seen Jackson now—in death or in photographs—and they knew he bore little or no resemblance to the Torsch engraving.[10]

In August 1863 the *Southern Illustrated News* published its second front-page portrait of the martyred commander (fig. 56)—making him the first Confederate general to be so honored twice. The pages of subsequent editions of the newspaper continued to reflect Jackson's growing popularity. According to one adver-

tisement, for example, the *Stonewall Song Book* sold 5,000 copies at seventy-five cents apiece within a year.[11]

Only a few weeks after his death, the publishers of the *News*, Ayres and Wade of Richmond, launched a major project: a full-scale "Life of Stonewall Jackson, the hero of the Present War for Independence," to be written by John Esten Cooke. With Cooke's work there began to emerge a distinctly Southern image of Stonewall Jackson, which would obscure some of the traits that Northerners grudgingly admired in him. Cooke, a member of General Jeb Stuart's staff and a writer who interpreted and glorified many leaders of the Lost Cause for Northern and Southern readers alike, wrote some of the earliest Confederate works on Jackson. In "Stonewall Jackson and the Old Stonewall Brigade," written for the *Southern Illustrated News* in February 1863, Cooke readily admitted many of Jackson's eccentricities, from lemon-sucking to a love of cold baths. "He is unquestionably peculiar, original, and and [*sic*] *sui generis* in character and bearing," Cooke wrote. He described Jackson as "a true 'soldier of the Cross,'" but Cooke did not lay much stress on the Cromwellian aspects of Jackson's character for a readership that the young Virginia writer doubtless imagined to have a taste for the cavalier. Cooke mentioned Presbyterianism only in a discussion of Jackson's battlefield fatalism:

> He is a devoted member of the Presbyterian Church—a church which has always embraced the doctrine of predestination, in its utmost scriptural latitude, and is no doubt strongly impressed with the truth of this tenet. Believing fervently in an overruling providence, and trusting in the goodness of an omnipotent creator, he gives himself no concern, except to the performance of his duty. The issues of life and death are in a mightier hand than man's; and to that

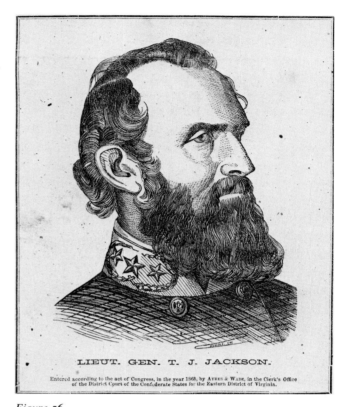

Figure 56.
Hurdle, *Lieut. Gen. T. J. Jackson*. Published in the *Southern Illustrated News*, August 29, 1863. Copyrighted by Ayres and Wade, Richmond. Wood engraving, 6¼ x 4¾ inches. Jackson's Old Testament ruggedness somehow looked best in woodcuts. This man who saw the world in black and white did not require the subtler shadings of lithography or mezzotint to communicate his flinty personality. (*Rare Book Division, The New York Public Library, Astor, Lenox, and Tilden Foundations*)

omnipotent power—to the "Sovereign Eternal Unchangeable Invisible"—he is content to leave the decision whether he shall live or die.

Cooke softened Jackson's puritanism even more in his 1863 biography, written shortly after the general's death—a biography that carried the second *Southern Illustrated News* woodcut on its orange paper cover. Though a devoted Presbyterian, Cooke wrote then, Jackson was "no sectarian. So great a spirit could not be tinged with bigotry; and a gentleman of high character, long serving on his staff, assured the present writer that he was wholly free from any trace of illiberality or dogmatism in his religious creed." Cooke insisted that "the General is adored by his troops," and such admiration is easier to imagine for Cooke's Jackson than for the Jackson who comes to us from other sources. In other words, North and South began to diverge in their interpretations of this unlikely hero.[12]

A different view of Jackson, also Confederate in origin, was embodied in a rival book. This competing volume aimed at being the first full-length biography of Jackson and was to be written by his chief of staff, R. L. Dabney, with the blessings of the Jackson family. To lure buyers to Cooke's book instead, the publishers of the South's leading picture weekly proudly announced that its volume would also feature "a splendidly executed LITHOGRAPHIC LIKENESS, from a photo by D. T. Cowell at Minnis." Copies of the original camera study were to be made available to the public as well. As the *News* announced: "With a desire to supply the great demand for the picture of General Jackson we have made the necessary arrangements with Mr. Cowell at Minnis' Gallery on Main Street, who will, immediately after the publication of our Book, furnish any person desiring it, with a photographic likeness of the lamented hero." That was in May. By June, house advertisements in the *News* were heralding the forthcoming book version as "the great work of the Age."[13]

Some critics, however, did not so receive it. In July, one observer labeled the project a "catch penny" piece of "literary hack-work," in an assault that was probably engineered by Reverend Dabney's supporters. Another critic, writing in Dabney's own church organ, the *Central Presbyterian*, denounced Cooke as a "self-appointed upstart." Ayres and Wade particularly resented criticism of the well-advertised lithographic illustration. The paper noted angrily on July 4 that "some of our good friends have insinuated that the picture of General Jackson, which we have carried to accompany our Book, is not a *bona fide* likeness of the lamented hero." The confusion may have been instigated by jealousy or perhaps by the public's familiarity with the earlier Torsch image of Jackson that had been carried by the journal, or perhaps by an unbearded prewar photograph of Jackson that had broad circulation well into the Civil War. Whatever the origins, Ayres and Wade responded with the claim that they personally had secured a letter of introduction for photographer Cowell to carry to Jackson at camp, and that Jackson had actually sat at Fredericksburg:

> To relieve all doubt in regard to this matter, we beg to announce that the picture was taken for us by Mr. D. T. Cowell. . . . Through the kindness of a friend we were enabled to procure for Mr. Cowell a letter of introduction to Gen. Jackson, who, immediately upon the arrival of the artist at his headquarters at Fredericksburg consented to sit for the picture. Three different photographs were taken at the time, one of which was spoiled by the shaking of the instrument. Of the other two, it is needless for us to speak. The *habitues* of the Minnis Gallery know full well the style of pictures taken by that first class establishment.[14]

The *Southern Illustrated News* believed it had proven that the likeness was genuine and the Ernest Crehen adaptation unquestionably true to its source. Ayres and Wade continued to advertise their book all summer,

particularly in the *News* edition of August 29, which featured not only the new woodcut of the late general but another long excerpt from Cooke. "The central figure of the war," the article began, "is, beyond all question, that of Robert E. Lee. His, the calm, broad military intellect that reduced the chaos after Donelson to form and order." But Jackson, it continued, "is the motive power that executes, with the rapidity of lightning, all that Lee can plan." This article serves as a useful reminder that Robert E. Lee was already a Confederate favorite and may have overshadowed the rather peculiar figure of Jackson—especially in Southern hearts—almost from the start. Cooke, after all, might have called Jackson the "Greatest of Generals," but in the same sketch he noted that Jackson himself said, "*Lee I would follow blindfold*."[15] It is not at all clear that, as Thomas Connelly and Emory Thomas would have it, Jackson's image ever seriously threatened the primacy of Robert E. Lee's.

Jackson was a genuine hero nonetheless, and the Cooke book apparently did quite well. It sold 3,000 copies the day it was published and, if one believes the newspaper advertisements that updated sales figures almost weekly, 10,000 copies had been purchased by early September 1863. The book was popular enough to appeal to publishing pirates in both Europe and the North. Controversy over the Southern-made Jackson pictures subsided. On August 14 the *Richmond Whig* enthusiastically declared the highlight of the book to be its "two very striking and correct engravings."[16]

Cooke began his book on a defensive note, saying in the introduction that a "religious paper has made an incredibly violent and insulting attack upon the work and the author, while the former was in press and the latter absent in the field." After thus wrapping himself in the flag, Cooke otherwise spoke calmly of Dabney's proposed book, admitting that the competing author had been "a friend of the deceased leader, and especially competent to describe the religious phase of his character." In truth, Cooke was probably relieved to be able to leave religion to the Reverend Dabney. Cooke realized the nature of Jackson's religious views clearly enough, but he apparently did not like them. He was quite willing to say the general was "eccentric," "a martinet" of "stern soul." In fact, he finally characterized Jackson's generalship in rather chilling terms: "[H]ard fighting was the strong point of this General. If Jackson was famous for anything at all, it was for an inborn and ineradicable tendency to stubborn, unyielding combat, against any odds. . . . He had little of the fiery dash of Rupert, at the head of his cavaliers—but the very bulldog pertinacity and iron nerve of Cromwell—sworn to conquer or die."[17]

Cooke had little taste for Jackson's Cromwellian traits. It was far easier for this Virginia romantic to contemplate Turner Ashby, "this splendid type of Southern chivalry," "the chevalier upon his milk-white horse," "the peerless partisan of Virginia." Jackson's unimposing appearance on his "old raw-boned sorrel, gaunt and grim" could not be ignored by Cooke, but the general's religion and personal behavior could be softened. Cooke said that Jackson was "immensely popular," that he liked children, that though he was "*an intense man*," he was not "ill-tempered, in the proper meaning of the phrase," that behind the sternness there lay a "childlike heart." The "great Lieutenant-General was as humble, simple and confiding as a child." "So great a spirit," Cooke insisted, "could not be tinged with bigotry."[18]

Thus the image began to veer away from the living Stonewall, the tough professional soldier who, in the words of General Lawton, "did not value human life where he had an object to accomplish." During Jackson's lifetime, this same observer had noted, "there was much fudge in the talk of his soldiers' love for him. . . . They feared him and obeyed him to the death. Faith they had in him, stronger than death. . . . I doubt if he had their love." But dead he seemed also far less forbidding than the man who, in life, commanded respect but rarely love. General Lawton add-

ed, "And now that they begin to see a few more years of Stonewall Jackson would have freed us from the yoke of the hateful Yankees, they deify him." A cult figure was born in the South; a machine had been transformed into a martyr. The last remaining obstacle to a universal Southern embrace of his image—the very Calvinist sternness that appealed to the North—was now being obscured in the mist of Southern mourning. Only then did the playfully cynical Mrs. Chesnut take a "photo book" she had acquired earlier "to pillory all celebrities," and lovingly add a likeness of Jackson.[19]

The long-awaited *Life and Campaigns of Lieut.-Gen. Thomas J. Jackson*, by Reverend Dabney, appeared in America only in 1866. Dabney rendered a subject as tough-minded as the crusty and uncompromisingly unreconstructed Presbyterian minister himself. His Jackson was a rugged Confederate who "never had a furlough; was never off duty for a day, whether sick or well; never visited his family; and never slept a night outside the lines of his own command." Here was the first appearance in print of the "shoot them all" anecdote, explained by Dabney in a way sure to displease romantic Southerners like Cooke: "He meant to suggest reasonings which show that such sentiments of chivalrous forbearance, though amiable, are erroneous." Dabney revealed Jackson's systematic theorizing on the uselessness of prisoners of war in a conflict like the Civil War, and he drew a sharp contrast between the cheerfulness and humor of Jeb Stuart and Jackson's serious and diffident nature.[20]

Such views may well have been true to Jackson's real nature, for Dabney knew him much better than Cooke did, and Dabney's contentions certainly meshed with some of the earliest descriptions of Jackson. In 1863, when Jackson died, early biographers and eulogists like Charles Hallock had been forced to admit that this "soldier of the Cross" had been a "taciturn, praying professor" at the Virginia Military Institute

before the war and far too "stern in the performance of his duty" and "stiff and uninteresting" to be liked by the cadets. Hallock devoted only four lines to Jackson's family, but characterized his hero as "the high-souled, heroic man, falling like Sidney and Hampden." James B. Ramsey, a Presbyterian minister in Lynchburg, Virginia, naturally defended his fellow churchman as "the farthest possible remove from being a bigot" but revealed that Jackson "never, during the two years of his service, left the camp—never saw his home and for thirteen months at a time was separated from his beloved wife." Ramsey compared Jackson to other examples of "eminence secured by holiness. Joseph in Egypt, Hezekiah . . . Daniel . . . Paul . . . Edward VI . . . Andrew Melville in Scotland, a Gustavus Adolphus in Sweden; . . . a Gardener and Havelock among soldiers." VMI superintendent Francis H. Smith, like Mrs. Chesnut, knew that "the spirit of war is antagonistic to the genius and spirit of religion" and was therefore relieved to be able to recommend to his young charges "a christian hero" like Jackson, but Smith had to admit that Jackson was "strict, and at times stern in his discipline, though ever polite and kind," and hence "was not always a popular professor."[21]

An unpopular hero was unfeasible, of course; so early eulogists generally said that Jackson changed, and they balanced the image of the stiff professor with a more admirable Civil War general. Hallock hit upon the ingenious idea that Jackson, who died of pneumonia after he was wounded, in fact "laid down his life for his men" because he had contracted pneumonia by lending his cape to a sleeping staff officer the night before Chancellorsville. Ramsey could not "forbear to add that Gen. Jackson was eminently a happy man, cheerful and free from anxious eare [*sic*]: that he was just as kind, as gentle and as tender, as he was stern and inexorable in his requirements when duty and the interests of his country demanded, and as he was

lion-like in battle." No one was ever much inclined to make Jackson the supreme hero of the war, even early on. Hallock compared him to George Washington and quoted from an English newspaper that referred to Robert E. Lee and Jackson as equals, if different in style. Ramsey ended his eulogy of the dead hero with a relieved reference to the living one: "Blessed be his name that he has not left us without some at least who partake of his spirit, and that the noble chief of our armies, our beloved and honored and magnanimous Lee is strong in the fear of God." The Confederacy was still a viable proposition when Jackson died, and dead heroes were not really useful. Live ones were needed as well, and Lee quickly garnered the preponderant share of praise.[22]

The transfer of allegiance did not happen immediately, and it did not occur everywhere. The *Atlanta Daily Intelligencer*, for example, asked at Jackson's death, "Oh, who can take his place in our armies? Who can fill his place in our hearts?" The question typified the plight of the Confederacy in mid-1863. It may have had some great heroes, but it needed more immediately if it were to survive. So Robert E. Lee was given the benefit of the doubt even by those who responded more emotionally to Jackson's appeal. South Carolina's Emma LeConte recalled, just after Appomattox:

> How well I remember the death of Stonewall Jackson! I can never forget my feelings when I heard of it. We had heard he was very low, but I did not dream he could die. . . . How I loved him! He was my hero. I then admired Lee as grand, magnificent, but Jackson came nearer my heart. There was mourning deep and true throughout the land when that news came.
>
> Since then Lee has had the hero-worship, all—both his and Jackson's—though the dead hero will always be shrined in every Southern heart.[23]

In fact, he elicited so much hero worship that Cooke declared Lee the supreme captain even in his 1863 life of Jackson. A solution to the South's problems with Jackson's noncavalier image was to make him but a dutiful hammer in the hands of the great forger of Confederate independence—the great cavalier, Robert E. Lee. Confederate eulogists were willing to compare Jackson to Hampden and Sidney and to Adolphus, Gardener, and Havelock, but none mentioned Oliver Cromwell except Cooke, who did so only in half-praise, depicting Jackson as a man of "great simplicity," a fighter, an "aggressor." The "central figure in this war" was a role reserved for Robert E. Lee. The difficulty for many Southerners—excepting Presbyterians of Jackson's ilk—can be seen in Henry W. R. Jackson's *Confederate Monitor and Patriot's Friend*, published in 1862 before Jackson's death. Throughout the journalistic sketches excerpted in this long pamphlet, one finds arguments that the Civil War was caused by "the sectional and abolition dogmas of puritanical factions" and that the Confederates were fighting "crop-eared Puritans." Quoting from the *Richmond Whig*, finally, Henry W. R. Jackson characterized the Yankee war effort by historical analogy:

> While history teems with evidence of this inevitable tendency of a war of invasion, we present an example in which its consequences have been inflicted by a people of the same race with ourselves and coinciding in general character with our Yankee invaders.
>
> Cromwell's invasion of Ireland was conducted on precisely the same plans, and with identically the same purposes which actuate our foes.

Confederates were never altogether at ease with their Cromwellian hero because the popular mythology of the day depicted them at war with Northern Cromwells![24]

The solution to the Southern problem with Jackson's

image came, ironically, from a Northerner, a man almost certainly attracted to Jackson because of common puritanical roots, the New England poet John Greenleaf Whittier. Other Northerners like John W. Forney had been fascinated by the figure who prayed by night and waged fierce battle by day, and Jackson's religious fervor even warmed the heart of the abolitionist Whittier. Critic Edmund Wilson erred when he dismissed "Barbara Frietchie," Whittier's poem about an incident in Lee's invasion of Maryland in 1862, as a piece of "patriotic journalism" bordering on "versifying claptrap."[25] For Stonewall Jackson figured in Whittier's poem, and his character, as was often the case, evoked a response more complex than chauvinistic flag-waving.

Waving the Stars and Stripes, of course, constituted the essence of Frietchie's legendary fame. She, so Whittier had been informed, chose to thrust the American flag out the upstairs window of her house in Frederick, Maryland, while Stonewall Jackson's troops marched through the town. The poem celebrates her patriotism, but it also pays quiet tribute to Jackson, who orders his men, their muskets trained on the window, to hold fire. The best-remembered lines recalled Frietchie's famous dare:

> "Shoot, if you must, this old gray head,
> But spare your country's flag," she said.

But the next stanzas, less often quoted, celebrated Jackson's forbearance:

> A shade of sadness, a blush of shame,
> Over the face of the leader came;
>
> The nobler nature within him stirred
> To life at that woman's deed and word:
>
> "Who touches a hair of yon gray head
> Dies like a dog! March on!" he said.

Whittier clearly meant the poem in part as a tribute to Jackson. It appeared in the *Atlantic Monthly* in October 1863, five months after Jackson's death and more than a year after the supposed incident in Maryland.[26] The New England poet spread his tribute as broadly as an ardent abolitionist could in the midst of a war against slavery:

> Barbara Frietchie's work is o'er,
> And the rebel rides on his raids no more.
>
> Honor to her! and let a tear
> Fall for her sake on Stonewall's bier.

Ulysses S. Grant summed up Jackson's essential nature in a way that helps explain Whittier's appreciation of the Confederate leader when he said, "He impressed one always as a man of the Cromwell stamp, a Puritan—much more of the New Englander than the Virginian."[27]

As late as 1896, Northern printmakers were still taking advantage of Whittier's evenhandedness. When the National Publishing Company of Cleveland, Ohio, published a lithograph entitled *Barbara Frietchie* (plate 8), they included an explanation in the caption that would give the print appeal in Northern and Southern parlors alike:

> During the great Civil War, the women on both sides displayed the devotion, sincerity and zeal so characteristic of their sex.
> Among all stands one old woman, Barbara Frietchie, of Frederick, Maryland, whose name will ever be remembered North and South. The North will remember her gallantry when men faltered; the South, one whose name is associated with their idol, Stonewall Jackson.

The printmakers thus made a shrewd appeal not only to adherents of the Lost Cause but also to the segment of

the public that likely bought the most prints for the home—women.

The irony of Whittier's work was that it depicted Jackson in a chivalrous act. Some of the general's close admirers, such as Dabney, admitted that Jackson readily eschewed chivalry for its inutility in war, but the Northern poet unknowingly paved the way to the Southernization of Jackson's image by making him fit more comfortably into the cavalier tradition. This in turn eased the later work of Northern printmakers who were eager to produce lithographs and engravings acceptable to Southern taste after the war.

Even during the Civil War, Jackson's appeal in the North had been unusually strong, but never strong enough to generate a separate-sheet lithograph or engraving. Northerners were curious enough about the Confederate hero to exhaust quickly the first edition of Markinfield Addey's *"Stonewall Jackson,"* published in New York by Charles T. Evans in 1863. Advertised as a biography of "The Brave Soldier, Consummate General, and Devoted Christian," the book received some favorable notices, all of which seem to have emphasized "the PRIVATE VIRTUES of a BRAVE AND CONSCIENTIOUS MAN." Addey's book, because it competed with an edition of John Esten Cooke's biography pirated in New York by Charles B. Richardson (another sign of curiosity about the Confederate hero), also boasted of its freedom "from sectional bitterness." It was "not disfigured with any of those offensive inferences which it is difficult for a rebel writer to avoid." The publisher scored an important point, for the United States Army banned the sale of the Cooke biography in the Department of the Ohio.[28]

Northerners who wanted to know what the man behind the Shenandoah Valley campaign looked like could buy *carte-de-visite* photographs of him (as he looked before the war, with long sideburns and no beard). No doubt these same photographs were still on the market after Whittier immortalized Jackson's "no-

ble" soul in 1863. And his image was readily available in barely loyal Baltimore. Marylanders could purchase "Riding a Raid" (fig. 57), a piece of sheet music published by Baltimore's George Willig in 1863, which sported on its cover the usual beardless Jackson portrait, reversed and labeled *Old Stonewall*. Whittier, incidentally, may have been familiar with this music, as he wrote in "Barbara Frietchie" that Jackson "rides on his raids no more." The same pose later inspired a memorial print from England, designed as a premium for subscribers to London's *Illustrated News of the World*, as well as a cruder English print that bore little resemblence to even the younger Jackson (fig. 58). By 1864 Blelock and Company, printmakers from New Orleans who moved to New York after the city's fall to Federal forces, were producing " 'Stonewall' Jackson's Prayer," sheet music with a lithographed portrait of Jackson (by Henry C. Eno of New York) as the bearded general he had been during his greatest Civil War exploits. The improved accuracy ended with the portrait, however, for the words of the song referred to Jackson's infant son (he had only a daughter).[29]

Seriously disloyal Baltimoreans who were subscribers to Adalbert J. Volck's series of Copperhead etchings received *Scene in Stonewall Jackson's Camp* (fig. 59), an effective print that revealed Volck's masterfully propagandistic understanding of visual materials. The artist began with the beardless portrait of Jackson, apparently well known in some Baltimore circles, but updated his original drawing (fig. 60) when he obtained a more recent bearded model for his Jackson print. As a bearded patriarch, Jackson better fit Volck's curious scene, which had an air of early piety about it, the cloaked and rather baggy-clothed spectators not looking at all like a group of Civil War soldiers gathered about their general.

Religious though Jackson was, Volck's print nevertheless constituted early mythmaking. General Jackson certainly encouraged prayer in his camps, but,

Figure 57.
A. Hoen and Company, "Old Stonewall." Portrait on cover of sheet music entitled "Riding a Raid." Published by George Willig, Baltimore, 1863. Lithograph, approx. 5 x 3½ inches. Based on a much-copied pre-war Jackson photograph of uncertain origin, this lithograph adapted the uniform details from a retouched version. They had been added later to the photograph but seem to correspond to no authentic uniform of Jackson's—including the Confederate one he wore as a bearded general in 1863. The pro-Union Boston printmaker Louis Prang issued his own lithographic adaptation of the photograph, which, because it showed Jackson beardless, has led some observers to conclude it may have been issued during the war. But there is no proof that Prang or any other Northern printmaker published a separate-sheet portrait of this or any other Confederate general while the war raged. (*Library of Congress*)

Figure 58.
Bacon and Company, *General "Stonewall" Jackson. / From a Photograph by Brady.* London, ca. 1862–63. Lithograph, 11¾ x 8⅝ inches. Even though it was based on the same prewar photographic model adapted for prints by Hoen (see fig. 57) and at least one other London printmaker, engraver D. J. Pound, Bacon's lithograph exaggerated Jackson's sidewhiskers, removed the cleft from his chin, and lightened his hair. The result was a rather jolly-looking Jackson wholly unlike the subject and wholly unlike any other print portrait of the general. (*Louis A. Warren Lincoln Library and Museum*)

GENERAL "STONEWALL" JACKSON.

FROM A PHOTOGRAPH BY BRADY.

Figure 59.
Adalbert Johann Volck, [*Scene in Stonewall Jackson's Camp*]. Baltimore, ca. 1863. Etching, 6⅝ x 9⅝ inches. Volck claimed to have sketched General Jackson from life, but he made many unverified and unverifiable claims that usually presented himself as a daringly disloyal Marylander. Because most of Volck's pro-Confederate works predated the end of the war, the artist always portrayed his Confederate soldiers in shoes rather than as barefoot victims of Yankee material superiority, as they were later seen in the mythology of the Lost Cause. Before the cause was lost, Confederate propagandists resented the idea that their government was unable to provide shoes for its soldiers. (*Library of Congress*)

Figure 60.
Adalbert J. Volck, *Scene in Stonewall Jackson's Camp.* Pen over pencil on buff paper, 6 ⁵/₁₆ x 8 ¾ inches. [Baltimore], n.d. In this original sketch for one of Volck's more successful prints (see fig. 59), the artist first drew a likeness based on the well-known beardless Jackson portrait. A pencil outline for the beard that would appear in the final etching is visible and looks at first glance like a long, droopy moustache. The existence of this early portrait of a clean-shaven Jackson suggests that Volck's claims to have sketched Jackson at the front may have been invented. (*M.* *and M. Karolik Collection. Courtesy Museum of Fine Arts, Boston)*

being a shy and taciturn man, he rarely if ever led it himself. A Maryland soldier who served under Jackson told Louisa Wright this story:

> It was Genl. Jackson's custom every afternoon to have a meeting for prayer, in a large tent. He sent over an invitation to the members of our Battalion to be present, saying he would like very much to have us come. One afternoon I went over to the prayer meeting tent and as I approached nearer I heard some one praying aloud—in earnest supplication—and the words of the petition, in their beautiful simplicity were like those of a little child. I did not know at first who it was. When the prayer was ended I perceived it was Genl. Jackson. After the prayer there was a pause and Dr. Lacey, his Chaplain, told him that the young men present would like to hear a few words from him. But his modesty was such that he could not be induced to speak a word.[30]

John Chester Buttre, a well-known New York engraver, early recognized the power of Volck's concept—and stole it. In 1866 he published *Prayer in "Stonewall" Jackson's Camp* (fig. 61), after a drawing by Peter Kramer. But Kramer had done very little original work; he retained Volck's overall design, canopy of trees, and backdrop of tents and merely added portrait likenesses of various generals. A. P. Hill, in the left foreground, was a replacement for one of Volck's less successful figures in the original etching—a seated, praying common soldier with a pipe in his pocket, a figure who looked rather like an exhausted derelict. Kramer also added a striking likeness of Richard S. Ewell, placing him to Jackson's left, and he turned Volck's figure on Jackson's immediate left so that he faced Jackson. This made Jackson more clearly the focus of the print than he had been in Volck's work. A few more portrait heads were added in the background, and Kramer made an important concession to

Northern Reconstruction tastes by altering Volck's degradingly simian features on Jackson's black servant, Jim Lewis.

The Buttre engraving was a striking illustration of how fast yesterday's treason could become today's acceptable heroism—especially to Northern printmakers now competing for the newly reopened Southern market. For most printmakers, the motivating spirit was now entirely commercial rather than political or patriotic. In 1867 Haasis and Lubrecht of New York, for example, issued a large colored woodcut entitled *Our Fallen Braves* (fig. 62), which featured a portrait of Jackson in the center, bordered by smaller portraits of other Confederate generals who died in battle. The same New York firm just two years earlier had published *Our Fallen Heroes* (fig. 63), similar in size and format but featuring a central portrait of Abraham Lincoln surrounded by various smaller vignette likenesses of Union generals killed in the war. Like the major lithographic firms that produced political portraits for *both* parties in presidential campaign years, Haasis and Lubrecht ignored their own sectional or patriotic sentiments and offered prints that appealed to former Yankees and former Butternuts alike.

Buttre apparently calculated his audience's sympathies with precision. As late as 1884, his engraving of *Prayer in "Stonewall" Jackson's Camp* was on sale for $1.50. Ten years later, the demand for Jackson images was still strong. Buttre's 1894 catalog offered six different Jackson engravings, not only the products of Buttre's own establishment, but also engravings by New York competitors. These included George Edward Perine, a New Jersey-born engraver who had executed several portraits of Abraham Lincoln; William G. Jackman, an English-born line, stipple, and mezzotint engraver active in New York since 1841; and the firm of H. B. Hall and Sons, founded by Henry Bryan Hall, Sr., another English-born, English-trained artist. All these engravers were principally engaged in the creation of book plate engravings. The existence

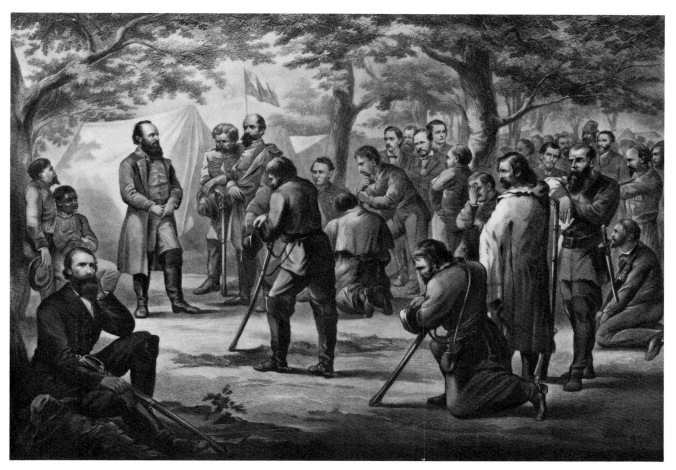

Figure 61.
J[ohn]. C[hester]. Buttre, after P[eter]. Kramer, *Prayer in "Stonewall" Jackson's Camp.* New York, 1866. Engraving, 21 x 27 inches. Buttre acknowledged a debt to Kramer's drawing in the caption but ignored its true source, Adalbert Volck. Kramer did add portrait likenesses of A. P. Hill, Richard S. Ewell, A. J. Pendleton, Dr. Hunter McGuire, Henry Kyd Douglas, William Allen, J. Smith, and William J. Hawks. Though in many ways Kramer improved the etching, he spoiled the flag in the left background, now unrecognizable as a Confederate banner. Buttre offered the engraving in his 1884 and 1894 catalogs at $1.50. (*Eleanor S. Brockenbrough Library, Museum of the Confederacy*)

of their Jackson works in Buttre's catalog of separate-sheet prints indicates that the overstock from such book projects was sometimes sold independently. And in this marketplace, apparently, Jackson was an enduringly popular subject.[31]

Print tributes to Jackson from many Northern publishers headed south after the war. To illustrate all of them here would be impressive but repetitious, as nearly all owed a debt to three principal photographic models. But throughout the 1860s and 1870s, they were plentiful.

The familiar Jackson three-quarters profile, for example, once used for the engravings on Confederate currency, recurred after the war in both straightforward and mirror-image adaptations by several Northern printmakers. A. B. Walter used it for an 1866 engraving, Miles Strobridge adapted it for an 1877 chromolithograph, and William Sartain for a postwar mezzotint. Walter was from New York, Strobridge from Cincinnati, and Sartain from Philadelphia, but they all gravitated to the Jackson profile photograph as the ideal model. And not only was the pose destined for the parlor wall, but also for the parlor piano: as adapted by J. L. Peters, it was the cover portrait for a Jackson songbook, some of whose selections were "Stonewall Jackson's Way," "Stonewall's Death," and "Stonewall Requiem."

An early monument to Jackson's palatability to Northern printmakers was William Sartain's *Lieut. Gen. Thomas J. Jackson and His Family* (fig. 64), a mezzotint engraving published in 1866 by Bradley and Company of Philadelphia. Jackson was the only Southern general to receive the ultimate visual compliment from Northern printmakers—depiction as a solid family man.

The family was a sacred institution in Victorian America, and public men, especially generals, without families might be perceived as warriors unredeemed by any softer virtues. Depiction in the bosom of one's family suggested that a man's life contained a gentler, more religious, more cultured, less competitive side. Demand for family images must have been great among the print-buying public, for printmakers went to extraordinary lengths to discover what the often obscure family members looked like and to portray family gatherings in parlors or on porches—whether the busy public men ever really gathered in such places with their families or not.[32]

The real Stonewall Jackson, like Abraham Lincoln and many other public figures who were similarly depicted, in fact had almost no time for his family. As Dabney and other early chroniclers of the general's life revealed, he never took home leave during the Civil War, nor did he indulge the feelings of fellow officers for their families. In the fall of 1861, for example, Jackson denied a pass to an officer whose wife was terminally ill, saying to him, "Man, man, do you love your wife more than your country?" There was more than a routine disclaimer in Mrs. Jackson's description of her last visit with her husband: "General Jackson did not permit the presence of his family to interfere in any way with his military duties."[33] Jackson loved his family, but duty generally took him elsewhere. He did not see his only child until she was five months old.

Sartain's scene, like many other family prints, contained inaccuracies. Jackson's daughter, for example, was less than six months old at the time of her father's death and is obviously too old in the print. The Sartain print is somewhat demilitarized, for, despite the title, Jackson does not wear the high general's collar he in fact showed in all of his photographs. But the print carries a correct title. It depicted Jackson *and his family*, and not Jackson's *home*, for he never saw his family in his home. Rather, Mary Anna came with their daughter Julia to visit Jackson in winter quarters in April 1863. The ladies stayed at the house of a local family named Yerby.

Jackson was the only Confederate general portrayed

Figure 64.
William Sartain, *Lieut. Gen. Thomas J. Jackson and His Family*. Published by Bradley and Company, Philadelphia, [1866]. Mezzotint engraving, 13¾ x 19⅛ inches. For this group portrait, Jackson's hand rests, appropriately for this ar-dent Presbyterian, on an open Bible. But the Southern icons decorating this imaginary parlor—a portrait of Robert E. Lee and busts of John C. Calhoun and George Washington—probably never saw the inside of Jackson's real parlor while Jackson was in it. The picture of Lee, for example, was based on a Vannerson photograph, taken several months after Stonewall Jackson's death. In reality Jackson spent precious little time in such surroundings outside of prints. Writing in 1861, his wife, Mary Anna Jackson, reported that her home was growing "more lonely and painful to me from day to day" (Jones, *Heroines of Dixie*, 23). (*Anne S. K. Brown Military Collection, Brown University*)

Figure 65.
[Printmaker unknown], [*Stonewall Jackson and His Family*]. N.p., n.d. Lithograph. The portraits of General and Mrs. Jackson in this print appear to be based on the same photographic models William Sartain used for his family scene, but the portrait of the child his troops had nicknamed "Little Miss Stonewall" is different and better in this anonymous and rare lithograph. Moreover, the absence of the fine parlor setting Sartain used gives this print the primitive simplicity that always seemed to suit Jackson's Cromwellian image. (*Courtesy of Stonewall Jackson House Collection, Historic Lexington Foundation*)

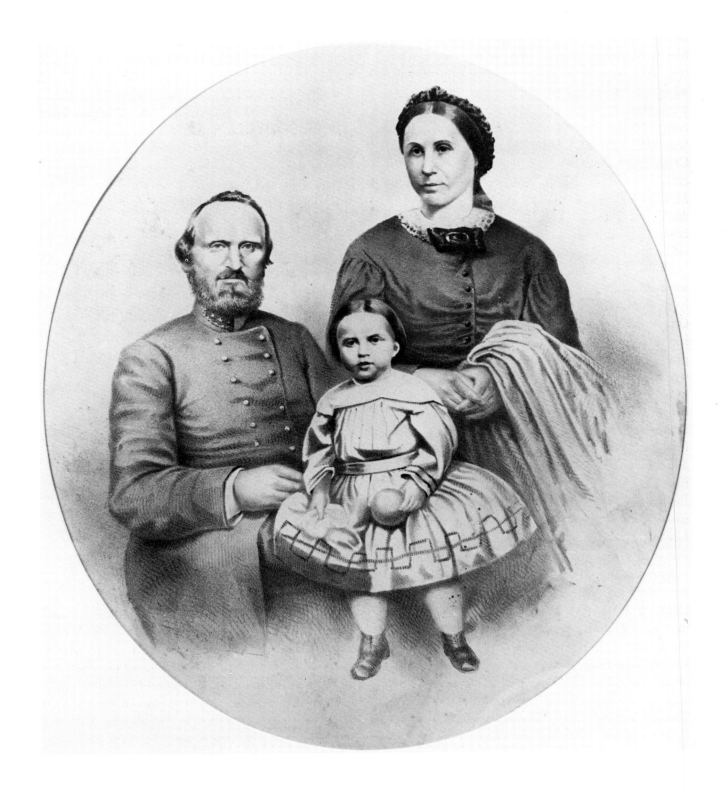

in a family print, and that honor was twice extended him. In a rare oval lithograph of the Jackson family (fig. 65), Mrs. Jackson dominates the scene out of all proportion to her warrior husband, but it remains a compelling print—with an unusually charming and candid child portrait. In sheet music, too, Jackson was featured in the Confederate imprint, "My Wife and Child Song. Poetry by the Late, Lamented Hero, General 'Stonewall' Jackson." Actually, one Henry Root Jackson had written the poetry, but Stonewall Jackson's identification with family virtue was strong enough to prompt the publishers' erroneous conclusion.[34]

Unlike Lee and other more cavalier warriors, Jackson seemed to bring to mind the idea, not only of family, but of home. Two prints showed Jackson homes. One by B. Haymond, issued in 1885, depicted Jackson's birthplace in Clarksburg (located in West Virginia at the time of the print, but a part of Virginia when Jackson was born). This strange print showed the little house jammed, a humble anachronism, between two Italianate brick buildings that had later grown up around it. More atmospheric was the 1889 chromolithograph, *Stonewall Jackson and His Boyhood Home, Situated on the West Fork River, Lewis Co. W. Va.* (plate 9). The residence might have seemed too grand for Jackson, who had a humbler image than Lee, but it was shown in ruins—unlike the handsome ancestral Lee home, Stratford Hall, as featured in *The Lees of Virginia* (see plate 3).

One reason for Jackson's close identification with the important Victorian image of home—unique among Confederate generals in lithographs and engravings—may have been that family was more compatible with the puritan ideal than the cavalier. Cavalier heroes like Robert E. Lee were associated with the idea of ancestry or genealogy, but they were never shown in domestic scenes with their wives and children. Yet depicting Jackson with his wife and daughter made him seem less like a Cromwell, for Cromwell was a general and a

military dictator who represented the antithesis of private family virtues. Whereas the family prints may not have pushed Jackson's image toward the cavalier ideal, they did—like the prayer-in-camp prints that ignored his antisocial awkwardness and the "Barbara Frietchie" image that stressed his chivalrousness—improve his image for Southerners by softening its hard Cromwellian outlines.

While the Jacksons were at the Yerby house, Mary Anna persuaded her husband to have his photograph taken. It is unclear why a photographer came to the Yerby house seeking a sitting from the general, but the visit may well have been prompted by Ayres and Wade's desire for a model for the *Southern Illustrated News*. The resulting portrait became the most popular model for later prints, and what Mrs. Jackson said about it is therefore important:

> It was during these last happy days that he sat for the last picture that was taken of him—the three-quarters view of his face and head—the favorite picture with his old soldiers, as it is the most soldierly-looking; but, to my mind, not so pleasing as the full face view which was taken in the spring of 1862, at Winchester, and which has more of the beaming sunlight of his *home-look*. . . . After arranging his hair myself, which was unusually long for him, and curled in large ringlets, he sat in the hall of the house, where a strong wind blew in his face, causing him to frown, and giving a sternness to his countenance that was not natural.[35]

The difference Mrs. Jackson noted is difficult for modern eyes to detect, but printmakers, if they really had a choice among photographic models, may have seen it. Most Jackson print portraits, including the traditional military equestrian ones, used this 1863 photograph as a model. An interesting early example is the Kelly and Sons lithograph published in Philadelphia (fig. 66). Here the equestrian figure, turned to look back at his

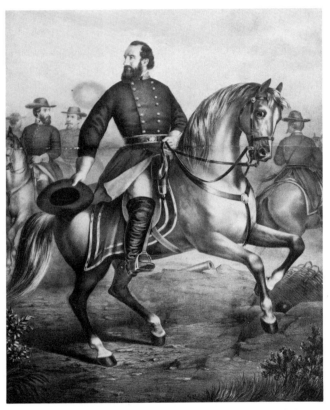

Figure 66.
J. L. Giles, *Genl. (Stonewall) Jackson.* Printed by William C. Robertson, New York. Published by J. Kelly and Sons, Philadelphia and New York, [1866]. Lithograph, 22⅞ x 18 inches. Giles also lithographed a small Jackson portrait for George E. Perine. Equestrian portraits of Jackson, like this one, owed more to European traditions of battle art than to knowledge of the general's life, for he was a notoriously silly-looking horseman who rode an undistinguished horse, "Little Sorrel." As John Esten Cooke noted, although the "popular idea of a great General is an individual . . . who prances by upon a mettled charger," Jackson looked quite undistinguished in his "discolored" uniform, a "sun-embrowned coat" and a "yellowed" old cap, its peak pulled low over his eyes. What distinguished him from "a nobody," wrote Cooke, was "the glittering eye . . . in whose blaze was the evidence of a slumbering volcano below" (*Southern Illustrated News,* August 29, 1863). Interested viewers should compare the Giles steed with the stuffed Little Sorrel in the Virginia Military Institute Museum. (*Eleanor S. Brockenbrough Library, Museum of the Confederacy*)

troops, is not turned enough to make the three-quarters portrait sit realistically atop its shoulders.

If Mrs. Jackson was correct, and the military image of her husband triumphed over Jackson's "home-look" in prints of the post–Civil War era, then the Northern printmakers were true to an impulse that admired the fierceness of this Cromwellian soldier. Certainly military themes dominated many of the early prints, especially A. L. Weise and Company's *Gen'l Stonewall Jackson at the Battle of Chancellorsville* (fig. 67). And the military aspect triumphed even over the facts in Currier and Ives's 1872 lithograph, *The Death of "Stonewall" Jackson* (fig. 68). In that print Jackson was shown dying in a tent, surrounded by uniformed officers, his saber and his Bible grouped in the foreground as perfect symbols of this Christian soldier. In truth, Jackson died in the home of a family named Chandler, and Mary Anna and Julia were present.[36]

Depiction as a general on horseback had its unavoidably Cromwellian overtones, but Stonewall Jackson was, after all, a mounted general in real life. What these equestrian military portraits did for Jackson's image was to purge much of its eccentricity. Early Confederate accounts agreed that Jackson cut a fairly ridiculous figure on horseback. Hallock said he "was not an elegant rider. He sat stifly [*sic*] in the saddle, with arms akimbo and legs rigidly straightened before him, and toes pointing Zenith-ward." His hat was "shocking." Cooke contrasted Jackson's appearance with the "popular idea of a great General . . . all covered in gold lace and decorations, who prances by upon a mettled Charger." The Confederate general wore a "sun-browned coat of grey cloth . . . almost out at elbows" and "rode in a peculiar fashion, leaning forward somewhat, and apparently unconscious that he was in the saddle." The *New York Tribune* agreed that "on horseback he by no means looked the hero of a tableaux." Part of the problem was the horse itself. As staff officer Henry Kyd Douglas said, "General Jackson never had a handsome horse in the army, nothing

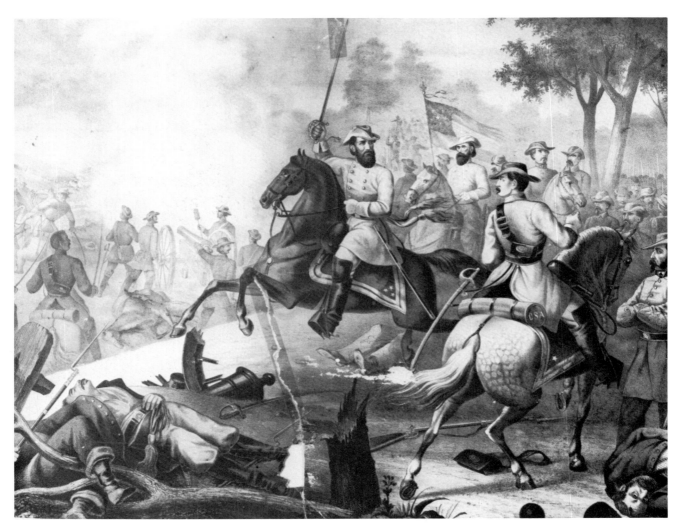

Figure 67.
A. L. Weise and Company, *Gen'l Stonewall Jackson at the Battle of Chancellorsville.* Published by Joseph Hoover, Philadelphia, 1867. Lithograph, 18 x 24 inches. The traditional heroic conventions of battle art conspire almost to obliterate any traces of Jackson's individual character in this rare early print. Far too large for his horse, Jackson also seems far too effortless a rider in this depiction, while the face, as drawn, barely constitutes a portrait likeness and the soft hat defies the widespread knowledge that he usually wore a small kepi. Tradition is evident in this and many other prints of Confederate subjects in the essentially pyramidal design of the central figures, the usual artistic compositional scheme for celebrating a single great general (see Lalumia, "Realism and Anti-Aristocratic Sentiment in Victorian Depictions of the Crimean War," 48). Observing him, A. L. Long thought Jackson "very poorly mounted on an old sorrel horse, and in his musty suit . . . anything but a striking figure." Yet when leading troops in battle, Long said, "he looked truly heroic and appeared a man made by nature to lead armies to victory" (Long, *Memoirs of Lee*, 263). (*Casemate Museum*)

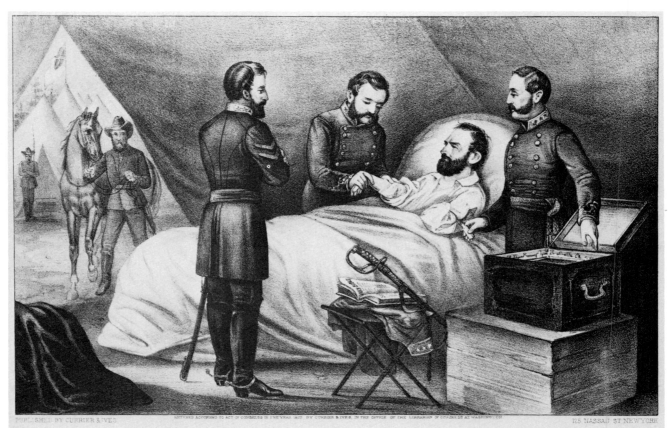

PUBLISHED BY CURRIER & IVES ENTERED ACCORDING TO ACT OF CONGRESS IN THE YEAR 1872 BY CURRIER & IVES, IN THE OFFICE OF THE LIBRARIAN OF CONGRESS AT WASHING. DC. 125 NASSAU ST NEW YORK

THE DEATH OF "STONEWALL" JACKSON.

GENERAL THOMAS JONATHAN JACKSON, born in Clarksburg Harrison County Va. Jan.y 21.st 1824. Wounded in both arms at Chancellorsville Va. May 2.nd 1863 by the Fire of a South Carolina Regiment who mistook his escort for Federal Cavalry; his left arm was amputated the same evening and he died at Guinea's station on the Richmond and Fredericksburg Rail Road, May 10.th 1863.

Figure 68.
Currier and Ives, *The Death of "Stonewall" Jackson*. New York, 1872. Hand-colored lithograph, 12½ x 7⅛ inches. Popular prints typically veered between wild inaccuracy and scrupulous attention to detail, and this lithograph featured doses of both. In fact, Jackson's death scene looked nothing like this. For one thing, he died in what his widow recalled as a "small, humble abode," not a tent; for another, Mrs. Jackson was present—or at least no further away than the next room—and thus surely deserved notice in the print. Nor is it likely that Jackson's mount was in as close proximity as this print suggests, despite the understandable artistic compulsion to include the symbolic riderless horse. The overall effect is to militarize Jackson's death. Perhaps that explains why, on the other hand, the print is accurate in portraying such "military" details as the general's recently amputated left arm (the lithographers could just as easily have hidden Jackson's extremities beneath the covers). And the flag shown in the background is not of the stars-and-bars variety most familiar to Americans when this print was issued, but the second flag of the Confederacy, the very one prescribed on May 1, 1863, less than two weeks before Jackson's death (Mary Anna Jackson, quoted in Jones, *Heroines of Dixie*, 219–20). (*Louis A. Warren Lincoln Library and Museum*)

to compare to General Lee's 'Traveler,' or Stuart's 'My Maryland,' or Ashby's white or black stallions. 'Little Sorrel' was a plebeian-looking little beast, not a chestnut, . . . a natural pacer with little action and no style."[37]

The conventions of military portraiture rode roughshod over such realities, with the result that Jackson, once his eccentric dress and horsemanship were obscured, could appear as a rather cavalier-looking soldier. Kurz and Allison's large lithograph of the general, for example, is notable for its depiction of his plumed hat, a swashbuckling element of costume more appropriately associated with the flashy Jeb Stuart or Cooke's knightly Turner Ashby.

Almost all the printmakers flattered Jackson after 1863. The flattery is most obvious in these traditionally heroic equestrian portraits, which defied the fairly common knowledge of his awkward posture on horseback. But the essential point of flattery was true of all Jackson portraits. As one perceptive Confederate veteran put it in 1867: "I have never seen a photograph, an engraving or a painting of Jackson that did not unmistakably represent him, but I have never yet seen a good likeness of him. They all bear the test of analysis[,] every individual feature is good, and one artist has his profile perfect. But none of them have succeeded in catching Jackson's *tout ensemble*, none of them have yet painted his awkwardness."[38]

It would be a commonplace observation to find only that popular prints flattered their subject. More important is that the flattery moved Jackson's Cromwellian image toward an image more compatible with the South's cavalier tradition. The customary effect of these prints was to clean up Jackson's image, improving his uniform, his horsemanship, and his whole physical impression.

One of the results of this image making was that Jackson, when depicted with Lee, appeared not as a contrast but as a similarly inspiring Confederate hero.

In iconography, as in life, Lee and Jackson were closely associated—in group portraits of Confederate generals, for example. Those published in the North after the war to appeal to Southern audiences typically featured Lee and Jackson in close proximity, usually as the most prominent members of the group. Several printmakers immortalized the two generals' final meeting as a particularly dramatic watershed in Southern history. To the artists, the meeting seemed the perfect expression of knightly compatibility, destined within hours to be shattered by the death of one—a death, some later said, that doomed the South's chances for winning its independence.

The two generals met just before dark on the southeast angle of the Chancellorsville and Catharine Forge roads. The conference lasted long enough for Lee to be seen with a map spread out before him, reading by flickering candlelight as he asked Jackson, "How can we get at those people [the Yankees]?"[39] Artists romanticized the scene and often made it considerably grander in scale. One such depiction (plate 10) showed Lee and Jackson on horseback in broad daylight, each leading contingents of soldiers complete with flag-bearers and drummers—hardly the kind of encounter that could have been kept secret from nearby Union forces. But the most enduringly popular evocation of the fateful meeting was the inspiration of a foreign-born artist, E. B. D. Fabrino Julio, who did not arrive in America until the year the rebellion began. The Julio painting, executed in 1869, was first adapted as an engraving by Frederick Halpin (plate 11). Later came an 1879 chromolithograph by Turnbull Brothers and a 1906 version by the Jamestown Photographic Corporation.

For a time, the Lee and Jackson images seemed inextricably interwoven. Lee's portrait was displayed in the imaginary room where William Sartain's Jackson sat with his family, for example (see fig. 64). And while Edward Sachse's 1869 lithograph of Stonewall

Figure 69.
J. G. S., *Grave of Stonewall Jackson at Lexington Va. From a Sketch by a General Officer of the C.S.A. made during the War.* Published by E[dward]. Sachse and Company, Baltimore, n.d. Chromolithograph, 12⅝ x 9¼ inches. The grave at right is no doubt that of Jackson's first daughter, who died in 1858. Missing is the grave of Jackson's first wife, omitted by the printmaker perhaps as a courtesy to his widow. As for the Confederate soldier with his rifle at rest, he is notable for his tattered trousers and bandaged bare feet, curious especially when one looks at his rather nice uniform jacket. In reality the Confederacy managed to shoe most of its soldiers, but barefoot Johnny Rebs were part of the cherished postwar view that the Confederacy was not really defeated, but merely overwhelmed by the vastly superior numbers and resources of the North. (*Anne S. K. Brown Military Collection, Brown University*)

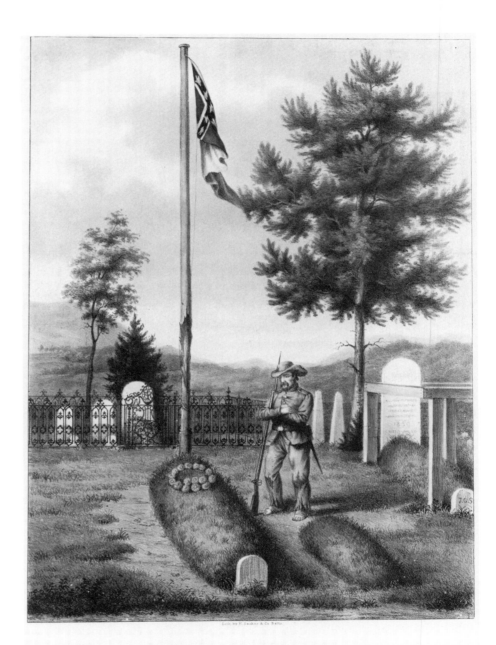

Lith. by E. Sachse & Co. Balto.

GRAVE OF STONEWALL JACKSON
AT LEXINGTON V.ª

From a Sketch by a General Officer of the C.S.A.
made during the War.

"His Spirit wraps yon dusky mountain,
His memory sparkles o'er each fountain
The meanest rill, the mightiest river,
Rolls, mingling with his fame for ever."

Figure 70.
Currier and Ives, *The Grave of Stonewall Jackson. Lexington, Virginia.* New York, 1870. Hand-colored lithograph, 12⁷⁄₁₆ x 7⅞ inches. Despite the common symbol of the weeping willow tree, frequently seen in mourning prints, this lithograph was unusual. Robert E. Lee was depicted in civilian rather than military dress. And the print more than likely mourned Lee, who died in the year of its publication, as well as Jackson. Note that Lee is never identified by name in the lithograph—proof that his likeness was by 1870 already recognizable by the mass of Americans. (*Louis A. Warren Lincoln Library and Museum*)

Jackson's grave (fig. 69), allegedly based on a soldier's sketch, gave prominence only to the burial site, a lithograph published by Currier and Ives just three years later and also entitled *The Grave of Stonewall Jackson* (fig. 70), signaled a major change in iconographical emphasis by submerging the Jackson image and instead depicting Lee as an aged civilian visiting the tomb of his late lieutenant. Adalbert Volck produced the source for a print of almost exactly the same scene as one of a series of pictures commissioned to aid the campaign for a Jackson monument (fig. 71). The message was clear: if Jackson was ever Lee's equal as a symbol, by the 1870s he was on the way to subordination and Robert E. Lee was emerging in his place.

Stonewall Jackson may well have been, as the *Southern Literary Messenger* proclaimed him, a true "idol of the people" in 1863—while the Confederacy still lived, before the cause was lost, and when the major need was military efficiency.[40] But military efficiency likewise demanded living leaders for the cause, not mere memories of them, and from Jackson's death in 1863 on, Robert E. Lee was as prominent as Jackson. Although the Cromwell in gray fared unusually well in the Northern imagination, he would not long, if ever, be first in the hearts of Southerners, for too many of them fancied they were fighting Northern Cromwells. A distinct tendency to soften the Cromwellian outlines of Jackson's image had the ironic effect of making him superfluous as a hero, even as it made him more respectable. When it came to embodying a sentimentally chivalric image, no one could outshine Robert E. Lee.

Figure 71.
Charles or Augustus Tholey, after Adalbert J. Volck, *General Lee's Last Visit to Stonewall Jackson's Grave.* Published by Louis Eckhardt and Brothers, Philadelphia, 1872. Chromolithograph, 19 x 24⅛ inches. Volck visited the site and painted the cemetery as he saw it. Therefore, he did not need to fall back on the convention of a weeping willow tree, the standard mourning symbol used by fast-working commercial printmakers like Currier and Ives. Lee seems too slender and, by comparison with the trees, too tall, but the print nevertheless creates an affecting scene. The existence of other prints of Lee at Jackson's grave, including one issued by Currier and Ives in 1870 and another issued by William E. Lloyd of Savannah in 1869, suggests that it was a potent and popular Lost Cause image. (*Library of Congress*)

11 / That Grand Man Loved by All

In the summer of 1867, two years after Appomattox, a noticeably older Robert E. Lee took his first extended vacation since the end of the war. For two years he had been laboring as president of struggling Washington College in Lexington, Virginia. Although he had hoped for a postwar life as a gentleman farmer, his wife's estate at Arlington had been confiscated by the Federal government and, in an act of vindictive irony, its grounds converted into a Union military cemetery. Lee foresaw perfectly its fate, going so far as to warn his wife's cousin to "get all your . . . pictures &c" out of the house. Subsequently Lee rejected employment offers from commercial enterprises, fearing they might misuse his potent name to sell products and services. But with his wife an invalid and their daughters still unmarried and living at home, the general faced genuine financial problems. Then came the offer from Washington College: limited duties, no classes to teach, a free house on campus, and $2,500 a year. Lee seized the opportunity.[1]

After months of uninterrupted work, during which he helped design a modern curriculum and attracted generous new funding for the college, Lee decided it was time to get out into the open air for a much-needed respite from his routine. Together with his beloved daughter Mildred—Lee astride Traveller and she riding the general's "quiet" backup war horse, Lucy Long—he headed south from Lexington into the remote Peaks of Otter, the picturesque mountains in the Blue Ridge range. It was on this tranquil journey that Robert E. Lee literally came face to face with his own growing fame and the increasingly pervasive presence of the Lee image.

On one of their first days out, as Mildred later remembered, they came upon some small, dirty-faced children playing at the foot of a hill along the roadside. Lee, who adored children, paused to speak to them "in his gentle playful way," teasing them that it might do well for them to take soap and water to their faces. The children merely stared back "with open-eyed astonishment, and then scampered off up the hill." The Lees thought no more about them and continued their ride. But a few minutes later, rounding the same hill, they encountered their little friends again, racing out of a small cabin and now freshly scrubbed, their hair neatly combed, and wearing clean, pressed clothes. One little girl among them explained excitedly: "We know you are General Lee! We have got your picture."[2]

Later in their vacation, Lee and Mildred found themselves on an open road in a heavy downpour and sought shelter in the nearest cabin. "The woman of the house looked dark and glum," Mildred recalled, "on seeing the pools of water forming from my dress onto her freshly scoured floor." When Lee followed her inside, "with his muddy boots" leaving tracks in their wake, her expression became even "more forbidding and gloomy than before." Lee saved the day with a typical show of Southern gallantry, apologizing grandiloquently for marring the beauty of "her nice white floor," and the woman—although clearly unaware of the identity of her celebrated guests—melted and invited them into her parlor to wait out the rainshower. Entering the room, the Lees were treated to another display of the growing importance of Lost Cause images. Adorning the parlor wall, Mildred remembered, were "colored prints of Lee, Jackson, Davis, and Johnston." Robert E. Lee took a seat—perhaps directly beneath an engraved or lithographed portrait of himself.[3]

Not until the rain had let up and Lee had excused himself to fetch the horses did Mildred confess her father's identity to the flabbergasted country woman. The hostess moaned over and over again, "What will Joe say? What will Joe say?" Joe, her husband, had fought under Lee with the Army of Northern Virginia, and now he was missing this rare opportunity to welcome his hero to his own home. In a sense, however, he and his wife had already done so by placing a picture of Lee, alongside images of other war heroes,

137

in this most hallowed place in their house—the parlor wall, the spot above or beside the family hearth once reserved for religious icons, and now increasingly the province of the heroes of contemporary culture. Print historian Robert Philippe has claimed that political portraits were "the heirs of the sacred picture" in that they "testified to convictions" and provided "reassurance of ways of being" to those who displayed them. Lost Cause portraits were something more. In the South they were badges of a sectional identity that once again approached religious significance. They were eloquent testimony to the stubborn survival of Confederate nationalism, which ironically found its full symbolic expression only after the war and with the help of Northern artistic talent and graphic technology.[4]

Undoubtedly Lee was beginning to comprehend the powerful grip his image had begun to exert over the Southern public. Everywhere he went, he faced outpourings of public adulation. On another vacation to White Sulphur Springs that July, one Maryland belle caught a glimpse of the "tall and majestic figure" and was overcome to find herself "in the presence of General Robert E. Lee, the hero of our dreams." Clearly, the dream had outlived the cause. The lady described in this way her feelings on confronting the Lee image in the flesh:

> The man who stood before us, the embodiment of a Lost Cause, was the realized King Arthur. The soul that looked out of his eyes was as honest and fearless as when it first looked on life. One saw the character, as clear as crystal, without complications or seals, and the heart, as tender as that of ideal womanhood. The years which have passed since that time have dimmed many enthusiasms and destroyed many illusions, but have caused no blush at the memory of the swift thrill of recognition and reverence which ran like an electric flash through one's body.[5]

For many men and women in the onetime Confederate states—particularly the veterans of his battles and their wives and children—Robert E. Lee had attained an even more exalted status in defeat and civilian life than he had enjoyed as supreme military commander. It was not only that Lee had transformed himself from soldier to educator, from a leader compelled to sacrifice young lives to a leader dedicated to improving them. It was, too, that the South, although changing and seeking a new ideal, also took comfort in an old one. The new Lee fit the prescription perfectly; he embodied memories of battlefield gallantry as well as hopes for a peaceful postwar life. Significantly, this transformed Lee in mufti also earned growing respect in the North, where nearly all the prints of Robert E. Lee would be produced. Lee's metamorphosis from military threat into benign elder statesman no doubt made it increasingly acceptable for publishers in New York, Philadelphia, or Chicago to issue celebratory Lee images by the thousands.

The cause had been effectively lost with Lee's surrender to Grant in April 1865. In the weeks that followed, Joseph E. Johnston maintained his hopeless struggle against William T. Sherman; Jefferson Davis fled southward, claiming still to be leading a government-in-exile; and onetime fire-eater Edmund Ruffin dramatically killed himself with his rifle, recording, in his last diary entry, his "unmitigating hatred to Yankee rule . . . and the perfidious malignant and vile Yankee race." It was not lost on both Southerners and Northerners that, in marked contrast, Robert E. Lee simply went home.[6]

Home was then a rented house in downtown Richmond. Only a few blocks from the former White House of the Confederacy, it had barely escaped destruction in the fires that swept the city during its siege by Union forces. It was to this simple dwelling that Lee rode alone, a "splendid specimen of a soldier and a gentleman" who was welcomed by neighbors with moving displays of respect and affection.[7]

The full cultural impact of Lee's decision to lay down his arms and reenter society was not immediately appreciated, but it was fully recorded visually. Lee went home to his Franklin Street residence on April 15, 1865, the day Abraham Lincoln died in Washington. On that same day a famous visitor to Richmond, one who had hoped to be elsewhere, found himself lingering in the city, unsure what to do next. He was Mathew Brady, the veteran photographic impresario who, years earlier, had made the photo of Lee (see fig. 29) that became the model for the first engraved portraits for the picture weeklies. Brady was at the end of a long and financially ruinous effort as manager and chief promoter (he was by then too troubled by bad eyesight to operate his camera personally) of a mobile battlefield studio that had traveled into the war theaters to make a photographic record of the rebellion. Now he wanted one more sitting with Robert E. Lee.

"It was supposed," Brady later told the *New York World*, "that after his defeat it would be preposterous to ask him to sit, but I thought that to be the time for the historical picture." Brady asked an intermediary to approach Lee and the general agreed to be photographed. On April 16, Brady posed Lee both alone and with two staff officers (see fig. 39) on the back porch of his home. In time, several of these poses would be adapted by printmakers. For the moment, however, the pictures themselves served as painful reminders to his countrymen of the toll the war had exacted from Robert E. Lee. Yet as ravaged as he appeared, the general reportedly had some of the photographs made for his own use and over the years was known to give away signed copies. With typical Victorian modesty, Lee later said of the poses, "They are all bad alike to me, but there are some more awful than these daily brought to my notice."[8]

Lee's offhand appraisal is important not only for ranking his photographs, but also for calling attention to the rate at which Lee images were then being produced. The constraints that inhibited the production of Lee portraiture during the war had vanished. In prints such as the Tholey brothers' richly colored lithograph for John Calvin Smith of Philadelphia (plate 12), the defeated commander was sentimentally reunited with Confederate military celebrities in symbolic scenes that, although they certainly never occurred on the field, must have seemed ideal decorations for homes, clubhouses, or veterans' hospitals. The Tholeys, who were successful lithographers of advertising prints and trade cards, also issued a companion print of *Grant and His Generals*, another indication of the purely commercial impetus behind the production of portrait prints.

In real life, Lee resumed wearing civilian clothes almost immediately after the surrender, but he was nearly always portrayed in prints in his Confederate uniform, although seldom in battle. Northern printmakers in the late 1860s might well have been sensitive to prints that suggested the suffering inflicted on the Union by the brilliant Confederate general. Southern print buyers, too, might have been squeamish about purchasing too-graphic reminders of the 20 percent casualty rates suffered by Robert E. Lee's armies. Indeed, a healthy impulse, exemplified by a few Southerners, was to try to forget the whole experience. In 1887, autograph collector Lida Thackeray of Nashville requested a signature from W. W. Jackson, who had served as a Confederate officer. He wrote back: "I reply to your letter merely to acknowledge its receipt. . . . I am one of the many thousand soldiers, who discharged their whole duty during the war—have preserved no records and do not talk about the events of the war now but am making an honest effort to forget so fratricidal and unnecessary a conflict precipitated by hot-headed but non-fighting politicians."[9]

For others, however, forgetting would have implied that Confederate soldiers had died in vain, and looking back became a necessity for emotional survival. There were occasional reminders of casualties in the prints, but fortunately for postbellum Southerners the con-

ventions of battle art in the European and white American tradition did not permit showing how heroes died. Blood, except for dabs on bandages of superficial wounds, was hard to find in these pictures, and disfigurement was even rarer, unless it was hidden by an empty sleeve or trouser leg. As French military painter Edouard Detaille wrote in the 1870s: "One impression that one could never render is that of disfigured cadavers, wounded men without arms or legs, this sort of museum of anatomy. Never should one permit oneself, I believe, to present those to the public." Prints showing Lee leading a charge (figs. 72, 73) were the exception rather than the rule. Most engravers and lithographers placed Lee on an iconographical pedestal—the gentle knight forever gazing out at unseen dragons, in much the way a Washington College faculty member saw him, as a Southern Saint George. In that guise he was even more acceptable to both Northern suppliers and Southern audiences.[10]

An exceedingly combative image of Lee would have been at odds with his own policies of sectional reconciliation. Addressing the issue shortly after his surrender, Lee remarked: "I believe I may say, looking into my own heart, and speaking as in the presence of God, that I have never known one moment of bitterness and resentment." His advice to all former soldiers was to demonstrate similar control. To bitter veterans who threatened to start new lives abroad as Confederate emigrés, Lee counseled staying on, pointing out, "the south requires the aid of her sons now more than at any period in her history." He urged even the most embittered zealots to stay in the region and rebuild it, even if it required taking the detested Union oaths of allegiance he felt were superfluous and demeaning. When one former officer's well-known father remonstrated with him for taking the oath to the Union, the soldier explained that Lee personally had so advised. "That alters the case," the father replied. "Whatever General Lee says is all right, I don't care what it is." The same man later said to the general himself: "You certainly play Washington to perfection." To more and more Southerners searching for the restoration of lost pride and dignity, it must have seemed an apt comparison.[11]

Of course, Washington had retired in victory and was later called upon to serve his country again as president. Lee knew there would be no similar honors for him. But he could not have more skillfully enhanced his image than he did in August 1865 by going quietly to Lexington to take the reins of the school named for his wife's ancestor. In a frequently quoted passage, he explained his new commitment, his reasons for undertaking it, and his expectations: "I have a self-imposed task which I must accomplish. I have led the young men of the South in battle. I have seen them die in the field; I shall devote my remaining energies to training young men to do their duty in life."[12]

His new role was "to educate Southern youth into a spirit of loyalty to the new conditions and the transformation of the social fabric." It was particularly "incumbent upon those charged with the instruction of the young," Lee professed, "to set them an example of submission to authority." Lee devoted himself to setting just such an example. As his former military secretary, Charles Marshall, wrote, Lee "set to work to use his great influence to reconcile all the people of the South to the hard consequences of their defeat, to inspire them with hope, to lead them to accept, freely and frankly, the government that had been established by the result of the war." Marshall, at least, felt that "the advice and example of General Lee did more to incline the scale in favour of a frank and manly adoption of that course of conduct which tended to the restoration of peace and harmony than all the Federal garrisons in all the military districts."[13]

This conciliatory image was best captured by that most ardently pro-Confederate artist, Adalbert Volck, in a small painting of Lee in his college study (plate 13) that served as a model for a chromolithograph (fig.

Figure 72.
Dubois Tesslin, after L. M. D. Guillaume, [*Robert E. Lee*]. Printed by Goupil et cie, Paris, published in New York by M[ichael]. Knoedler, ca. 1884. Mezzotint engraving, 25½ x 21 inches. According to Lee aide A. L. Long, Traveller was "as calm as his master under fire" (Long, *Memoirs of Robert E. Lee*, 132–33). But this European print depicts the horse literally foaming at the mouth during an apparent charge, while Lee, in an uncharacteristic black beaver hat, looks calm to the point of distraction—a distortion attributable to the engraving's dependence on the bland-looking photographic model by Minnis and Cowell (see fig. 33). The battered soldier at the lower left—a type inserted often in Lost Cause prints—looks genuinely inspired, while the quintessential Southern rider, Jeb Stuart, is visible in the background. Printmaker Tesslin produced a companion engraving for Goupil of a Guillaume equestrian portrait of Jackson. Each was listed for five dollars in the 1884 general catalog of the Knoedler Company, Goupil's longtime New York copublisher. (*Eleanor S. Brockenbrough Library, Museum of the Confederacy*)

Figure 73.
Charles Shober, *Gen. Robert E. Lee*. Published by Shober and Carqueville, Chicago, 1891. Lithograph, 19¾ x 14 inches. In this dramatic evocation of the equestrian Lee, the general is portrayed galloping past his beleaguered troops in an apparent effort to inspire them to victory. The horse foams, but he looks more like the celebrated Traveller than Tesslin's portrayal. Audiences were familiar with the horse through the distribution of period photographs and prints. Traveller died of lockjaw soon after Lee's death; some years later he was disinterred and his skeleton exhibited at Washington and Lee University. Not until this century, when the campus practice of autographing the horse's bones had gotten out of hand, was the skeleton mercifully taken down and reburied. (*Library of Congress*)

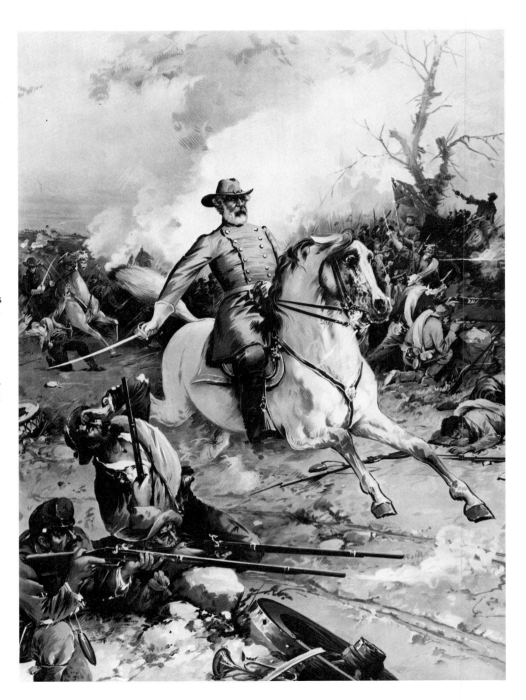

74) by the successful Baltimore printmaking firm of Edward Sachse. This was one of the three pictures Volck was apparently commissioned to produce for the Jackson Monument Association. The artist claimed that he traveled from Baltimore to Lexington in 1870 to paint Lee from life during a one-hour sitting in Lee's office in the basement of the Washington College chapel. He completed the painting back in Baltimore, probably not until 1873, with a local judge posing as the model for Lee's torso. But Volck clearly also turned to photographic sources to buttress his alleged brief life encounter with his subject. The finished painting closely resembles one of the Brady poses made in Richmond in April 1865.[14]

Moreover, the only proof that Volck might have been in Lexington to work on the commission is the set of pencil sketches he made for another picture in the series, *General Lee's Last Visit to Stonewall Jackson's Grave* (see fig. 71). One of these sketches is clearly dated June 1872, almost two years after Robert E. Lee's death. Volck could have checked the details of Lee's study then, as well; college officials kept everything as Lee had left it for years afterward. Once again, it is possible that Volck distorted the story of the origins of his work. Whatever its precise origins, the image portrayed a wholly domesticated Lee, and the considerable rarity of the chromolithograph today suggests that although Lee's transformation into a civilian doubtless enhanced his image in some circles of the South and made him more palatable to the North, it was not an image most of his Southern admirers wanted to display. As the reigning symbol of the Lost Cause, Lee was most acceptable when portrayed in full military regalia, even though, in his public life, he had indeed become the black-suited educator Volck accurately portrayed.[15]

Lee still had enemies in the North, of course. When he heard that the general had assumed a college presidency, William Lloyd Garrison wondered whether Lu-

cifer had "regained his position in heaven." The idea of Lee "at the head of a patriotic institution, teaching loyalty to the . . . Union he so lately attempted to destroy" seemed outrageous to the old abolitionist. A Boston newspaper echoed his concerns, suggesting that an "arch traitor" like Lee would inevitably teach "more treason" to his students. The surprising thing was not that such vitriol surfaced, but that so little of it did. Lee endured his share of attacks, of course, but compared to Jefferson Davis in this early postwar period, he seemed almost universally beloved. Naturally, the political leaders of secession bore more of the blame than the military men who could plead that duty and obedience to authority shaped their course. This factor helped Lee and all of his lieutenants, but it did not stifle all criticism.[16]

Some criticism evaporated as Lee made good on his pledge to promote sectional reconciliation. As a contemporary described this "new" Robert E. Lee, his "whole soul was engaged in the work of reconstruction, and he lost no opportunity to promote it socially." By 1868 a Lee Society was organized in, of all unlikely places, Poughkeepsie, New York. That same year even witnessed scattered Democratic calls for his nomination to the presidency of the United States—an honor that could not have been bestowed, because Lee had not regained his citizenship and therefore was ineligible to serve. The thought of such a campaign must nonetheless have amused Lee. The Republicans were set to nominate his old conqueror, Ulysses S. Grant, inspiring the Democratic *New York Herald* to predict a result quite different from that at Appomattox, explaining that Lee "is a better soldier than any of those they have thought upon and a greater man." Ironically, the *Herald* echoed the sentiments of the many Southerners who believed in their hearts that Lee had never really lost, but had merely been overpowered by superior numbers. Lee was rarely blamed for his military defeats; such absolution was at the core of his post-

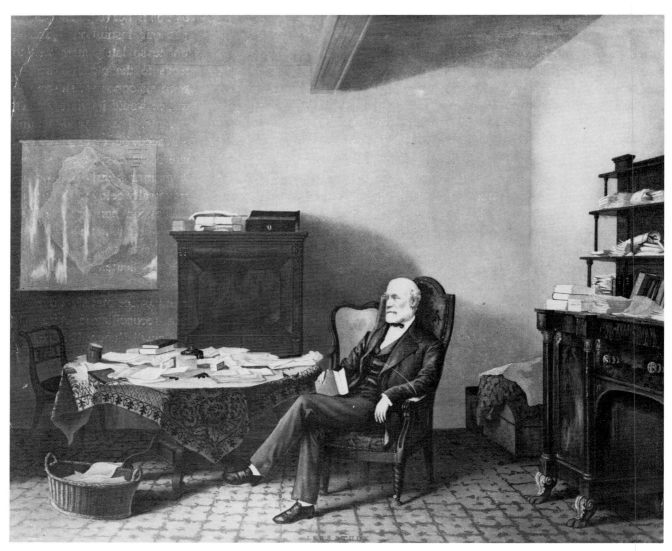

Figure 74.
E[dward]. Sachse and Company, after Adalbert Johann Volck, *Lee In His Study*. Baltimore, ca. 1873. Lithograph, 18 x 21¾ inches. Meticulously copied from Volck's original (see plate 13) by one of Baltimore's leading printmakers, this popular print gave Lee's admirers access to an admirably accurate postwar likeness of their hero as nonmilitary educator. Evidently audiences preferred graphic evocations of Lee's glory days in uniform—this print's relative scarcity suggests it was not especially popular with Southern print buyers. (*Library of Congress*)

war emergence as a Southern god. As the *Herald* editorialized, "with half as many men as Grant he would have beaten him from the field in Virginia, and he affords the best promise of any soldier for beating him again."[17]

The Lee image was in ascendancy. That Christmas, President Andrew Johnson issued a proclamation of amnesty that put an official stamp on reconciliation. Although Lee's citizenship would never be restored—his papers were misfiled and remained lost for a century—he did make it to the White House: in May 1869 he visited President Grant there, the first time the two generals had met since the surrender, except in prints.

A tangled web of circumstances, including the dearth of accurate photographic models and the decline of Southern printmaking, had stifled the production of Lee images during the war, whereas a happy confluence of circumstances after the war inspired it. Northern publishers were poised to churn out pictures for the Southern print-buying audience they were eager to recapture. New Lee photographs were becoming available. As he entered a premature old age, Lee found himself in the collective embrace of millions of adoring Southern admirers. As one of his students explained, "we likened him to Agamemnon." Lee was "the chivalrous warrior of Christ, the Knight who loved God and country, honours and protects pure womanhood, practices courtesy and magnanimity of spirit, and prefers self respect to ill-gotten wealth."[18]

Lee appealed strongly to Southerners who sought reassurance that the war had been noble and its leaders perfect. He thus exerted unprecedented influence over his own generation and the succeeding ones, potential print buyers for whom expatriates and political leaders now seemed comparatively unattractive. That influence was heightened by veterans, whose stories of Lee's heroism assumed greater proportions as the years went on. As art historian Jessie J. Poesch has explained: "In the South these veterans—colonels and drummer-boys alike, the drummer-boys lasting the longest—represented living history, and memories of the war were kept alive and transmitted as oral history. Printed images and paintings (Lee was most frequently painted, both during his later years and posthumously) of the heroes of the war reinforced this oral tradition." To such old soldiers Lee could be used, as Thomas Connelly has described the phenomenon, as "a balm to soothe defeat. Lee's character served as the rebuttal to the American dream, and to the gnawing question of how a righteous cause could lose. Lee would be held up as proof that good men do not always succeed." General William Nelson Pendleton, who devoted himself to preserving Lee's memory, thought Lee's defeat at Appomattox no more disillusioning than Christ's at Gethsemane. Both their names were sacred, and both had shown that it was possible to lose and still be sanctified by succeeding generations.[19]

Lee must have been aware of this sea change in the popular heart. There were the experiences of his 1867 vacation and the flattering editorials of 1868. In 1869 Lee again confronted the growing importance of his image in a reunified America. That summer New York publisher C. B. Richardson decided to reissue Lee's father's book, *Memoirs of the War of '76 in the Southern States*, and he asked the son to write a new introduction and to supply a portrait of himself for adaptation as a book illustration. It was clear that Richardson, who also offered to publish Lee's memoirs should he write them, believed that the additions would heighten sales. Lee, who had long avoided even mentioning his disgraced father, had hoped to write his own memoirs. Failing health and the time-consuming college schedule had thus far prevented him from doing so, and it is conceivable that he saw Richardson's offer to write a prefatory essay as an opportunity, not only to air his personal view of military duty, but to reinvigorate his fading connection to "Light Horse" Harry of the Revolution.

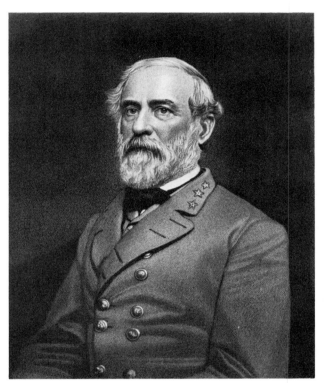

Figures 75, 76.
H. Dunensing, *very truly yrs / M[ary]. [Custis] Lee* [facsimile signature]. Steel engraving, oval, 5⅜ x 4⅜ inches. [J. A.] O'Neill, after Vannerson, *I am very truly yours/ R. E. Lee* [facsimile signature]. Steel engraving, 5⅜ by 4⅜ inches. Both published by Richardson and Company, New York, 1869. There was no mistaking the disparity in appearance between the stern, somber Mary Custis Lee and her magnificent-looking husband. That disparity was accentuated both by Mrs. Lee's invalidism and by what many thought was a carelessness about her appearance almost to the point of sloth. Wittily contemplating the effect on Virginia society should this "martyr to rheumatism" die before her husband, the wartime society belle Constance Cary predicted, "wouldn't these Richmond women *campaign* for Cousin Robert? In the meantime," she added, "Cousin Robert holds all admiring females at arm's length" (quoted in Woodward, *Mary Chesnut's Civil War,* 569). (*Courtesy Harold Holzer*)

The result was strangely unremarkable. A marvelous letter writer, Lee proved an inhibited essayist whose memoirs, had they been written, probably would have been formal and unrevealing. But the publishing episode proved interesting in part because it offered another example of the willingness of Northern publishers to produce Lee images. At first the general was reluctant for Richardson to include his picture. Lee articulated one of his reasons in a letter to his wife on August 10, 1869: "[R]eceived by . . . mail a letter from Mr. Richardson, reiterating his request to insert my portrait in my father's Memoirs, saying that it was by the desire 'of many mutual friends' on the ground of its giving additional interest to the work, and increasing its sale. That may or may not be so; at any rate, I differ from them. Besides, there is no good portrait accessible to him, and the engraving in the 'Lee Family' I think would be an injury to any book."[20]

The engraving to which Lee referred was undoubtedly John A. O'Neill's portrait for a book Richardson had published a year earlier, Edward C. Mead's *Genealogical History of the Lee Family*. Richardson advertised it as "an elegant quarto volume, handsomely illustrated" with "beautiful steel portraits" of both Robert and Mary Custis Lee (figs. 75, 76). O'Neill, a New Jersey-born printmaker who later became chief engraver for the U.S. treasury under the Cleveland administration, had already produced a celebratory image of Lee as the central portrait for a group entitled *Generals of the South*. "The steel engravings in this work," Richardson's advertisement claimed for the 1868 Lee genealogy, "have been prepared from the original family portraits, which were furnished for the purpose and have never before been engraved." The book sold for six dollars; editions in special morocco binding were priced at ten dollars.[21]

O'Neill's companion engravings of Robert and Mary Lee represented the earliest known occasion on which the two were paired in print portraiture. This pairing occurred only in books. There are no known Lee family prints, despite the reasonable assumption that such portraits would have found an audience among Southerners who revered both the Lee and Washington traditions. George Washington, who had no natural family save his wife, had nonetheless been depicted as a family man in a widely distributed and copied image, but Lee, who had a large family, never was. A partial explanation for this void may be the fact that the Lees' family home had been seized. Victorian family prints almost always portrayed parents and children in their parlor. But except for a rented house in Richmond and a borrowed one in Lexington, the general had no parlor to call his own after the Civil War. That his parlor in Arlington had been confiscated by Yankees was a matter of bitter resentment on Mrs. Lee's part, and perhaps on the part of the whole South. To portray him in that setting would have been to deny the Lees their splendid Lexington exile.

Moreover, as the unique status (among Confederate generals) of Stonewall Jackson in family prints suggests, family was a puritan tradition. Lineage was a cavalier one, and there were numerous prints that stressed the Lee ancestors and descendants (see fig. 28 and plate 3). Pictorial acknowledgments of Lee's family—of his wife and daughters rather than his family tree or his soldier children—might have paled by comparison. And finally, printmakers might well have been discouraged by Mary Custis Lee's forbidding appearance. It is, in fact, apparent from O'Neill's 1868 engraving of Mary that her plainness could not be cosmeticized by printmakers. It is more difficult to understand what the family found wrong with the engraver's rather handsome portrait of the general.

Yet when Richardson proposed a Lee engraving for the reissue of "Light Horse" Harry's memoir, Lee at first demurred, then later acceded enough to ask his wife "whether you could send him a picture worth inserting," should he change his mind. He was waver-

ing. And by the following week the general had decided to turn the entire matter over to Mary. Writing to her again, he said: "As regards the portrait for Mr. Richardson, you must do as you please. I shall not write to him any more on the subject. Unless the portrait is good and pleasing it will be an injury to the book."[22]

Perhaps Lee thought it a little improper to overshadow his father in that great man's memoir. But it is also barely possible that some of his uneasiness about including his own portrait in a book about his father stemmed from the Confederate general's rather uncertain relationship with that hero of the Revolution. Besides the problem of Henry Lee's profligacy, there was Robert E. Lee's curious relationship to his father's political legacy. The son, as historian Charles Royster has argued, ultimately fought to destroy the Union his father had helped create. Furthermore, Henry Lee had been horrified by the savage civil war he saw in the Carolinas during the Revolution, and he cherished a love of Union and order ever after. Robert shared his father's distaste for guerrilla warfare, but he was not a deeply reflective man; he seemed unwilling to acknowledge the anomaly of pleading, as Royster puts it, "traditional attachment to Virginia" as an explanation for his role in making Virginia "one of the main victims of the war's devastation."[23]

It is difficult to ascertain what happened next in the episode of illustrating "Light Horse" Harry Lee's book. Apparently Mary Lee did agree to include a picture, because publisher Richardson's updated version of the elder Lee's book did feature an engraving of Robert, but it was the same portrait that had appeared in Mead's genealogy—the pose Lee thought would be an "injury" to the new book. Perhaps publisher Richardson convinced the Lees that the picture was adequate, or possibly he simply ignored their objections. Engravers charged a great deal of money for making plates, and it was far more economical for the publisher to reuse an existing one for which he had already paid. All explanations are unavoidably conjectural; no documentation has survived that might explain the reappearance of O'Neill's engraving. But whatever the reason—convenience or stubbornness—its inclusion over Lee's initial objections surely suggests the increasingly irresistible commercial appeal of his image.

Another early Lee image from the North was produced by Thomas Kelly, a young lithographer who had learned his trade from his father, John, in Philadelphia before establishing himself as a "dealer in prints and frames" in New York City in 1863. Although best remembered for creating Union portraits, in 1867 he issued a full-figure lithograph of Lee that placed the general, in military regalia, in a scene that seemed a more logical backdrop for civilian portraits (fig. 77).[24] The classical column, for example, was a symbol of republican statesmanship and had little meaning for a portrait of Lee.

There were further reminders that demand for Lee images was growing. In the fall of 1869 a Swiss painter named Frank Buscher came to Lexington to paint Lee in uniform.[25] Sculptor Edward Valentine came, too. During the war, which Valentine had spent in Berlin, the latest Vannerson photographs of the general were sent through the blockade to aid Valentine in producing a full-figure statuette. Now he trembled at the thought of approaching "this grand old idol of the south" in person. The sculptor had heard of Lee's "noble simplicity, of his gentle and kindly bearing," but confessed he could "never appreciate how these qualities could ever neutralize the inquietude which I felt until I was once in his company." To his surprise, Valentine found the general an ideal sitter. The sculptor "could observe no difference in General Lee's manner when he was sitting for me from that which was his ordinary bearing." Lee's sessions with Valentine were of lasting importance and indirectly inspired production of a Lee

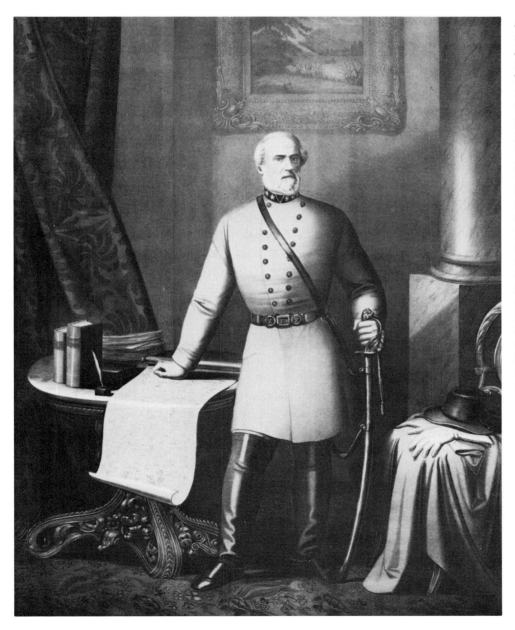

Figure 77.
Anton Hohenstein, *General Robert E. Lee*. Printed by Spohn and published by Thomas Kelly, Philadelphia, 1867. Lithograph, 24¼ x 18⅝ inches. This curious print portrait of Robert E. Lee presents a military Lee in a civilian setting, complete with a pillar of state. The rare image was clearly based in part on Frank Vizetelly's crude and, at the time, all but forgotten wartime sketch of Lee (see fig. 34), with Vannerson's photograph in reverse (see O'Neill adaptation, fig. 76) used as the source for the portrait of Lee's face. Hohenstein, one of the most prolific Philadelphia lithographers, worked for nearly all the city's publishers, specializing in images, not of Lee, but of Lincoln. (*Smithsonian Institution, Division of Political History*)

print portrait. But that did not come until later—after Lee's death.[26]

First Lee crowned his years of surging popularity with a final tour of the deep South during which he was greeted as a living saint, with crowds alternately cheering him and receiving him in awe-struck silence. This was no longer the magnificent-looking Lee of 1863 and 1864, but a plumper, balder, unsteadier version, old well beyond his sixty-two years and so gripped by his chronic angina that he was barely able to walk a hundred yards without suffering chest pains. But his admirers saw only the Lee they wanted to see. "He's mighty like his pictures," observers reportedly said everywhere he went. One of his young female cousins, seeing him on this tour for the first time, remarked: "We had heard of God, but here was General Lee!"[27]

Lee returned from this last campaign intending to resume his duties at Washington College, but his health deteriorated rapidly. In October 1870 he suffered a stroke, and after lingering a few weeks, he died at his home in Lexington. Lee was the first great Confederate to die after the war and the South mourned deeply—with displays of pictures as well as tears. In Richmond, public buildings and stores closed down, and bells tolled throughout the city, presenting a "scene of mourning hardly witnessed" anywhere in recent memory, according to a correspondent dispatched by the *New York Times*. As part of the demonstration of respect and grief on the day of his funeral, many townspeople displayed "pictures . . . of Gen. Lee, draped in crape with evergreen."[28]

In Louisville, "with all the public institutions in recess," and a "sabbath-like stillness" broken only by the continuous tolling of church bells, "the eye caught on every side long vistas of streets festooned with funeral drapery; pictures of the dead hero, decked with flowers and symbols of mourning could be seen at every turn, surrounded by groups of citizens speaking in subdued tones and bearing on their faces the impres-

sion of a sorrowful veneration, such perhaps as the faces of our fathers wore when Washington died." It was much the same throughout the South: black crape, draped portraits, and the sound of mourning music; timely funeral marches, their covers typically adorned with lithographed portraits of the late general (fig. 78), met all these needs at once.[29]

In New York there were no such demonstrations, but Currier and Ives recognized the universal news value of Lee's death and marked it with two prints: a modest deathbed scene (fig. 79) that failed to include his famous wife among those attending the general during his last moments; and a print depicting the decoration of Lee's casket (fig. 80). Some copies of the latter were distributed in the South by a Tennessee copublisher who imprinted his own name below that of Currier and Ives in the bottom margin of the lithograph. That Lee's death had removed all sectional barriers restricting universal admiration was evident in the lines the printmakers selected for the caption to the deathbed lithograph: "His deeds belong to history, while his life of devoted, unostentatious piety and firm and living trust in Jesus as his personal Redeemer, gives assurances that he has received the Christian crown of glory, and entered into that rest that remaineth for the people of God."

Such pictures of military, political, and cultural heroes extended the tradition of the religious icon prints of old. Now, however, they testified to faith in a secular or civil religion that mixed Christian symbology with images of military and, in Jefferson Davis's case, political leadership. The effect may well have been more potent than that of the partisan political prints that still appeared every four years at presidential election time. Increasingly, white Southerners found their identity as citizens bound up with idealized images of old Confederate heroes. The Confederate nation still existed as a mystical entity within the political boundaries of the United States.

The print tributes to Robert E. Lee came from points

Figure 78.
[Printmaker unknown], "In Memoriam / Genl. Robt. E. Lee / Funeral March." Sheet music cover, published by Charles B. Bayly, Baltimore, 1870. Lithograph, 6¼ x 4⅞ inches. Typical of the illustrated memorial music issued in tribute to Lee, Bayly's funeral march portrait featured as its centerpiece yet another adaptation of Minnis and Cowell's standard photographic model (see fig. 33), the most popular of all the sources for Lee engravings and lithographs. The music mourned the general, not the college president. (*Louis A. Warren Lincoln Library and Museum*)

PUBLISHED BY CURRIER & IVES ENTERED ACCORDING TO ACT OF CONGRESS IN THE YEAR 1870, BY CURRIER & IVES, IN THE OFFICE OF THE LIBRARIAN OF CONGRESS AT WASHINGTON 152 NASSAU ST. NEW YORK.

General Custis Lee. *Physician.* *Miss Mildred Lee.* *Clergyman.* *Miss Agnes Lee.*

DEATH OF GENERAL ROBERT E. LEE,
AT LEXINGTON, VA., OCTOBER 12TH, 1870,
Aged, 62 years, 8 months and 6 days.

Born, January 6th, 1808.—His deeds belong to history, while his life of devoted, unostentatious piety and firm and living trust in Jesus as his personal Redeemer, gives assurance that he has received the Christians crown of glory, and entered into that " rest that remaineth for the people of God."

Figure 79.
Currier and Ives, *Death of Robert E. Lee, At Lexington, Va., October 12th, 1870, Aged 62 years, 8 months, and 6 days.* New York, 1870. Lithograph, 7⅝ x 12¼ inches. Among the mourners depicted in this print are family members—a Lee son and two Lee daughters—and the obligatory physician and clergyman. Like many of Currier and Ives's more than fifty deathbed scenes, the Lee print suffered from several errors and questionable artistic decisions. No clergyman, for example, attended Lee when he died; the minister had left Lee's house the night before and was not called back. Daughter Agnes, shown seated here, was actually kneeling at Lee's side, fanning him, as he breathed his last. Most surprising of all, Mary Custis Lee was omitted from the scene, although she loyally attended him at his bedside. "Mother would be rolled in, in her chair," daughter Mildred testified, "and sit by his side—having the hardest part to act, that of being passive—when she would have given her life to do something" (Flood, *Lee,* 258). Possibly the printmakers had no available photographic model of Mrs. Lee, but this did not stop Currier and Ives in the cases of Lee's daughters. The artist simply turned their heads away from the viewer. (*Library of Congress*)

DECORATION OF THE CASKET OF GEN! LEE.

At Lexington Va. October 15th 1870

Figure 80.
Currier and Ives, *Decoration of the Casket of Genl. Lee At Lexington, Va. October 15th 1870*. New York, 1870. Lithograph, 8¾ x 12¾ inches. The fact that Currier and Ives—the most news-conscious and market-sensitive of all American printmakers—issued not one but two prints of Lee, in and after death, indicates the demand his passing likely exerted on all engravers and lithographers. The unidentified female mourner here probably represents the nearly universal grief of white Southern womanhood for the great cavalier. Beneath the credit line on this print is an additional caption that provides a rare insight into how such Northern-made efforts were distributed in the South: "J. C. and W. M. Burrow / Wholesale dealers and publishers of charts, books, photographs, prints, albums, &c. &c., No. 200, Main Street, Bristol, Tenn. / Agents Wanted / Catalogues sent free." (*Courtesy The Library Company of Philadelphia*)

north and south—although the production of portraiture such as Currier and Ives's print of Lee almost certainly was more a response to growing demand among Southerners than to any major softening of attitudes among Northerners. Yet, as the *New York Herald* described Lee's broadening appeal at the time: "We have long since ceased to look upon him as the Confederate leader, but have claimed him as one of ourselves . . . for Robert E. Lee was an American, and the great nation which gave him birth would be to-day unworthy of such a son if she regarded him lightly."[30]

Around the same time that Currier and Ives published their Lee memorial lithographs, P. Girardet used the Minnis and Cowell wartime photographic model (see fig. 33) for an engraving published in Paris by Goupil (fig. 81). By 1884 the engraving, along with the firm's equestrian portrait, was being offered in print catalogs in New York.[31]

Although the Minnis and Cowell photograph continued to inspire printmakers on both sides of the Atlantic, another pose emerged as a favorite model for engravers and lithographers portraying Lee. This was the 1864 photograph made by Julian Vannerson for sculptor Edward Valentine—the same pose that had been adapted as an illustration in the reissue of "Light Horse" Harry's memoirs (see fig. 76). Lee had worn an unaccustomed high collar for the sitting, in deference to the ladies, according to the recollections of his son, Custis. Ironically, he was often portrayed in prints in this collar style he seldom wore. Evidence of the photograph's appeal—and the accompanying first stirrings of resurrection for the Southern printmaking industry—came with the adaptation by B. B. Euston of Macon, Georgia, as a memorial tribute issued in 1870 (fig. 82). Vannerson's pose was also engraved six years later by William Edgar Marshall, best known for an extremely popular engraving of Abraham Lincoln. Commenting on Marshall's Lee engraving, the editors of the Southern Historical Society papers said, "While

we do not think the photograph from which the engraving is made quite equal to another of the thirty-two in our possession, we regard the engraving as a very admirable one in every respect." Lee was becoming a much-pictured man, and, for all his modesty, he had by the end of his life left behind a substantial legacy of photographs on which prints could be modeled.[32]

These prints bore witness to the fact that Lee, in death, had become a genuine icon. It helped that Lee died at the perfect time and place. He did not expire from wounds received on the battlefield—a martyr to violent secession, like Stonewall Jackson—but at the college where he had preached reconciliation and which would soon bear his name alongside Washington's. The moderate man won the war of images because his likenesses appealed to both the unreconstructed and the reconciliationists in the South. It no doubt helped production in the North as well that a majority of Southern states were by then redeemed. Even more to his benefit, Lee did not live too long after the war. He participated little in the years of rehashing and debating the advances and retreats he had led; he was never forced to defend himself against revisionist historians; he was never relegated to attending reunions with other enfeebled veteran officers. He never held a position of political power or prominence that forced him to make pronouncements on or formulate policies for the thorniest problems of Reconstruction and then be responsible for them to a large public.

Lee was spared all that. He lived just long enough to reconstruct his own image—but not so long that it could be tarnished or diminished. President Grant, his Northern counterpart, saw his own reputation soiled by political scandal in his later life. But Lee remained eternally above reproach and beyond criticism, looking for all time just as he had looked in the many Appomattox prints. Perhaps Mary Custis Lee put it best when she explained, "he could not have been more lamented or his fame brighter had he lived a thousand

Figure 81.
P. Girardet, [*Robert E. Lee*]. Published by Goupil et cie, Paris, and M. Knoedler, New York, ca. 1870. Lithograph, oval, 9³⁄₁₆ x 7⅝ inches. Further proof of Lee's growing attractiveness to European image-makers—especially in the postwar era, when such tributes could be shipped freely to Southern ports—this expressive print portrait was straightforwardly copied from Minnis and Cowell's photograph (see fig. 33), but with Lee's eyes beautifully illuminated and his expression beatified. (*Anne S. K. Brown Military Collection, Brown University*)

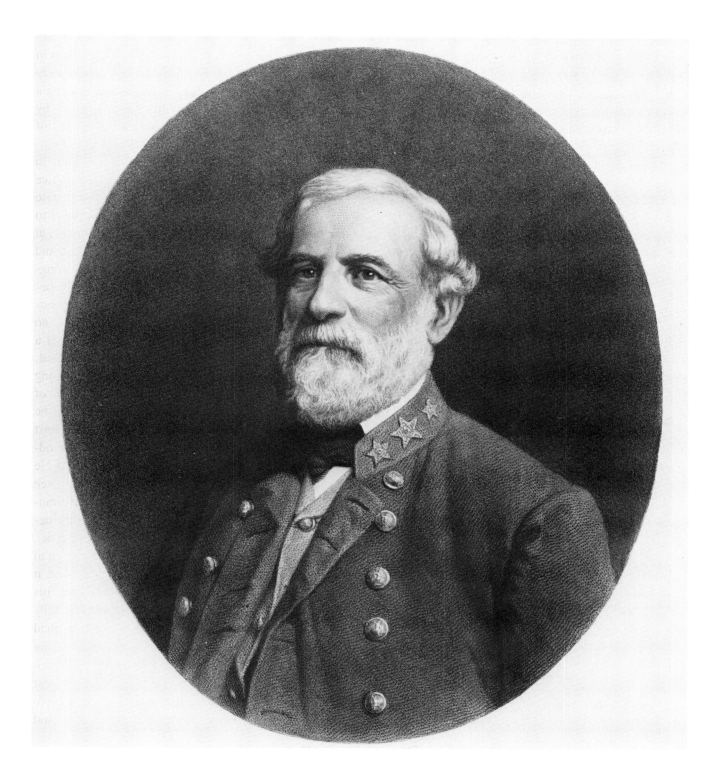

Figure 82.
B. B. Euston, *In Memoriam /
Genl. Robert E. Lee. / The
Pure Patriot. The Chivalrous
Soldier. / The Sincere Chris-
tian.* Executed at Georgia Prac-
tical Business College, Macon,
Ga. Published in Washington,
D.C., 1870. Lithograph, 24 x
20 inches. Included here partly
because of its unusual origins
as a sort of advertisement for
the skills of a business school
in Georgia, this symbol-laden
tribute to the late general en-
cased his portrait, copied from
Minnis and Cowell's photo-
graph (see fig. 33), in a cluster
of laurel and Confederate
flags. Twin obelisks, each
topped by a funeral urn, bear
the names of Lee's battle-
grounds. At bottom is the seal
and motto of the state of Vir-
ginia: "sic semper tyrannis."
(*Eleanor S. Brockenbrough Li-
brary, Museum of the
Confederacy*)

years," even if he "had won for our beloved South the independence to . . . which he devoted his life." She went on to observe shrewdly, if chillingly: "Had he been successful instead of the Hero of a Lost Cause he would not have been more beloved and honored. I am content and would not have him back if I could."[33]

Just one day after his death, the general's Lexington admirers signaled the accuracy of Mary Lee's assessment by forming a Lee Memorial Association, whose goal would be to raise the funds necessary to build an appropriate symbol of the South's love and admiration. The South was still far from prosperous, still struggling to rebuild its shattered economy, and such an ambitious fund-raising project had to be ingeniously crafted. Determined to raise money in small amounts from large numbers of Lee followers, the association commissioned two versions of a mezzotint engraving based on the Vannerson photograph and featuring facsimile signatures of association officials (fig. 83). The Lee Memorial Association portrait was the work of a Northerner, of course: Adam B. Walter, a lifelong resident of Philadelphia, who had studied and worked in partnership with printmaker Thomas B. Welch. Walter was familiar in the North for his popular engraving of the Lincoln family, perhaps the best-selling of all the engraved and lithographed parlor scenes that were rushed off the presses after Lincoln's assassination in 1865. Yet he had no compunctions about soon thereafter playing a role in the movement to memorialize Lee, the importance of which was attested to by a speaker at the unveiling of the resulting monument in 1883: "A considerable sum was realized from a steel engraving of Gen. Lee published by Bostwick and Company, of Cincinnati, and sold under the authority of the Association."[34]

As the Lee Memorial Association gathered momentum, devotees in Richmond who were eager to launch their own campaign for a Lee statue organized a rival group, the Lee Monument Association, with General Jubal A. Early—one of Lee's loyal lieutenants and a

bitterly unreconstructed rebel—as its president. Competition for limited Southern resources was keener than ever, and the new association hired professional fund-raising agents, staged lectures on Lee's life at which collection boxes were passed through the audience, and organized a cadre of volunteers to raise money in small and large amounts. The Lee Memorial Association was aghast, rebuking the new group for what it termed "malignant and scandalous behavior," but the Monument Association persevered. Like their fellow Lee admirers in Lexington, members of the Monument Association decided to commission a fund-raising print portrait, and they settled on an ingenious device to attract sentimental veterans and Lost Cause camp-followers alike: a print of Lee astride his beloved Traveller.[35]

In 1866 Lee had been approached by Lexington photographer Michael Miley, who was hired by Washington gallery operator Alexander Gardner to obtain a picture of the general on his famous horse. A twenty-five-year-old former Confederate soldier, Miley venerated Lee, and, being the sole full-time photographer in town, took pictures of him often. According to his son, Miley never knew "a man more willing to oblige" than the general. Unlike less important sitters, who sometimes grew impatient at the rigors of posing for photographers, Lee always urged Miley "to take his time, because he . . . had plenty of time and nothing to do." Lee's patience was tested by the request to sit astride Traveller; it was a steamy July day, and the horse was besieged by swarms of flies that kept him twitching and stamping—and continually ruining exposures. Miley finally gave up, but he asked Lee to try again when the weather cooled in September. The general consented once more, and this time the sitting worked to perfection. Lee donned a Confederate gray suit—an old uniform, its insignia long ago removed—along with a broad-brimmed hat and riding gloves, then mounted Traveller outside his campus home. "He is getting old like his master," Lee said of his horse when

Figure 83.

A[dam]. B. Walter, after Julian Vannerson, *R. E. Lee. / Genl. [facsimile signature] / Sold by authority of the Lee Memorial Association for the erection of a Monument / at the tomb of Genl. R. E. Lee / at the Washington & Lee University, Lexington, VA.* Published by Bradley and Company, New York, 1870. Engraving, oval, 17¾ x 14⅜ inches. In the competition to raise money in the impoverished South for memorials and monuments to Southern martyrs and heroes, prints were frequently used as premiums. As another fund-raising device for the Lee Memorial Association, Walter was commissioned to issue a companion engraving of Joseph E. Johnston. (*Louis A. Warren Lincoln Library and Museum*)

a cousin prepared to paint him, adding that he "looks to your pencil to hand him down to posterity." The Miley photograph (fig. 84) probably created just what Lee had hoped for: a portrait of general and horse, "just as we went through the four years of the war together." It later served as the model for innumerable adaptations in several media.[36]

In 1876 the Lee Monument Association commissioned its adaptation, a lithograph by the Baltimore firm of A. Hoen and Company (fig. 85). *Genl. Lee on Traveler* was made available to "any college, school, lodge, club, military or civic association" that sent ten dollars to the association. The editors of the influential Southern Historical Society papers endorsed the lithograph as "a really beautiful picture, which we hope will adorn a very large number of our Southern schools and homes."[37]

Not until 1883 did Stonewall Jackson's daughter unveil Edward Valentine's recumbent Lee statue at Lee's tomb on the campus of Washington and Lee College—the fruition of the Memorial Association's long years of work. Seven years later, Marius Jean Antonin Mercie's equestrian statue, funded by the competing Lee Monument Association, was unveiled before a crowd of more than a hundred thousand in Richmond. As an orator said at the unveiling of the Richmond monument, "A grateful people" had given "of their poverty gladly, that . . . future generations may see the counterfeit presentment of this man, this ideal and bright consummate flower of our civilization." Many of the Southerners who had contributed despite their poverty now owned, as a direct result, print portraits of Robert E. Lee.[38]

Visiting a Mobile, Alabama, home in the summer of 1871—only a year after Lee's death—a correspondent for the *Southern Magazine* observed: "Upon the walls were portraits of Gen. R. E. Lee, and Stonewall Jackson, and Jefferson Davis—indeed, the first two mentioned I see everywhere in the South, in private as well as in public houses—and other Rebels of distinction." In time, Lee's image dominated all. As Connelly has argued, between 1870 and 1885 Lee was effectively transformed, through the work of biographers, magazine writers, and Lee societies, into a regional god, "the ultimate demonstration of the superiority of their civilization." Between 1885 and 1907, the year of the Lee centennial, Lee's image evolved further into that of a *national* hero whose "grandeur of soul" was finally acknowledged almost everywhere and was "accepted almost wholesale by the nation."[39]

Admirers in the 1880s had innumerable Lee prints from which to choose. At least two full-figure Lee poses were available, for example. One version showed Lee in a Confederate camp (fig. 86). A romantic photograph taken by Vannerson in 1864—showing Lee in dress uniform, his waist encircled by a sash—became the model for a rival full-figure print (plate 14). In each case, inexplicably, the lithographer superimposed a head based on a different Lee photograph for the portrait.

Further evidence that prints provided a visual accompaniment to the transfiguration of Robert E. Lee could be found in the 1884 catalog of engravings issued in New York by John Chester Buttre. It listed eight different portraits of Lee, including a separate-sheet copy of O'Neill's engraving for the Henry Lee memoir. Lee's fame continued to grow, and ten years later the firm was offering nine Lee prints.[40]

Lee was now the figurative centerpiece for nearly every visual evocation of the Lost Cause, from the primitive 1904 picture by Americus Patterson of Gainesville, Texas (fig. 87), to the more sophisticated renderings created in the North and in Europe. In one compelling exception, a celebration of military leaders entitled *Our Heroes and Our Flags* (plate 15), Lee was portrayed at the right in a central grouping with Jackson and Beauregard; even here, his hand gestures suggest that he is instructing the other two. An explanation

Figure 84.
Michael Miley, [*Lee on Traveller*]. Photograph, Lexington, Va., September 1866. One of the best-known of all Lee photographs and one of the most popular models for artists and printmakers, it was taken outside the former general's home on the campus of Washington College. At around the same time, one of Lee's students saw him astride his famous horse for the first time—a sight that never failed to awe witnesses—and remembered: "Traveller moved as if proud of the burden he bore. To me the horse was beautiful and majestic. It was the only time I was impressed with the greatness and beauty and power and glory of the man. He sat erect in the saddle. The gloved hand held the bridle, the other hung gracefully at his side. He was every inch a king. It was only a moment, but the impression will last a lifetime. It is one of the joyous moments of life on which my memory loves to dwell" (W. H. Taylor, quoted in Flood, *Lee*, 249). (*Library of Congress*)

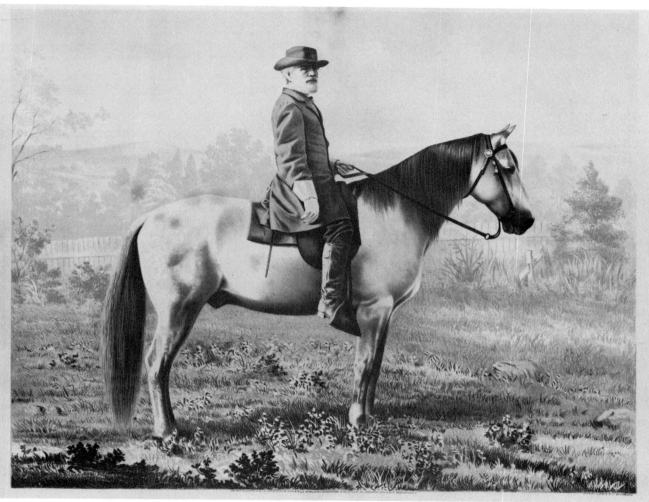

Figure 85.
A[ugust]. Hoen and Company, *"Genl. Lee on Traveler"* [*sic*]. Published for the Lee Monument Association, Richmond, 1876. Lithograph, 14¾ x 18½ inches. Sold to raise funds for the erection of a Lee statue in the former Confederate capital, Hoen's print was unerringly true to the Miley model, with little embellishment to the spare background save for an overall sharpening of detail.

Lee had purchased his beloved horse in the Virginia mountains in 1861, "and he has been my patient follower ever since," he recalled some years later, adding, "you must know the comfort he is to me in my present retirement." Asked once by an artist to describe him, Lee wrote this famous passage: "If I was an artist like you, I would draw a true picture of 'Traveller' representing his fine proportions, muscular fig-ure, deep chest and short back, strong haunches, flat legs, small head, broad forehead, delicate ears, quick eye, small feet, and black mane and tail. Such a picture would inspire a poet, whose genius could then depict his worth and describe his endurance of toil, hunger, thirst, heat, cold, and the dangers and suffering through which he has passed. He could dilate upon his sagacity and affection and his invariable re-sponse to every wish of his rider. He might even imagine his thoughts through the long nightmarches and days of battle through which he has passed. But I am no artist, and can only say he is a *Confederate gray*" (Lee to Martha ["Markie"] Williams, quoted in Long, *Memoirs of Robert E. Lee*, 131–32). (*Eleanor S. Brockenbrough Library, Museum of the Confederacy*)

Figure 86.
J[ohn]. C. McRae, *Gen. Robert E. Lee.* Published by Thomas Kelly, New York, 1867. Engraving, 23½ x 17½ inches. The engraver used as his principal model the torso from a full-length 1863 Minnis and Cowell photograph that was unique for showing Lee in battlefield regalia, wearing boots and gloves, and holding his hat in one hand and his sword in the other. The print-maker substituted a face from an earlier Minnis effort (see fig. 33) and added the camp-site background, including the headquarters tent and map-laden strategy table. (*Anne S. K. Brown Military Collection, Brown University*)

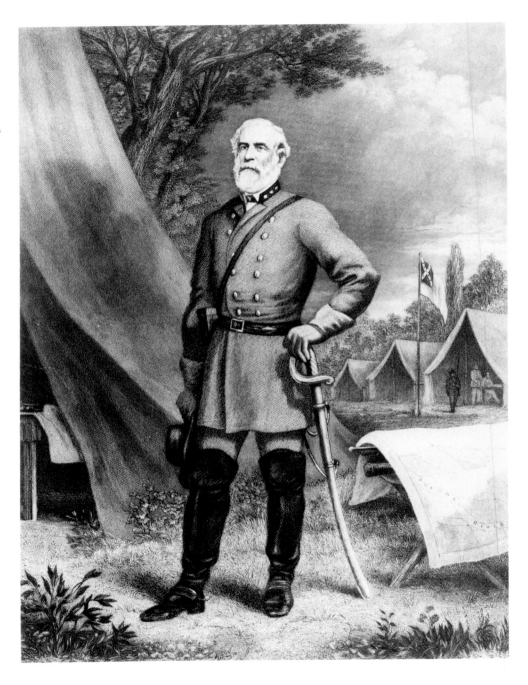

for the positioning of the three leaders can be found by tracing the lithograph to its photographic sources. The Lee portrait had been faithfully modeled after a seldom-adapted Vannerson profile that portrayed him facing to his right, just as he was depicted in the print. In another version of the group, frequently referred to as "The Three Generals," Johnston replaced Beauregard. As late as 1928, the *Confederate Veteran* was offering copies for $7.50.[41]

As the nineteenth century drew to a close, there was little diminution in demand for and production of Lee graphics, although methods and media were changing greatly. The year 1906 saw the Robert E. Lee Calendar Company of Raleigh offer, for one dollar, a *Lee Memorial Calendar* dedicated to "those who fought to make the Southland Free" and featuring an Osborn Art Company lithograph of a watercolor portrait by Dixie Washington Leach. The advent of photomechanical processes that revolutionized newspaper and magazine illustration may have diminished for some the appeal of display prints by making them too plentiful and thus cheapening them. But calendar art no doubt provided a useful substitute, and products such as the Osborn Art Company lithograph of Lee provided a means to display his portraits at home far into the twentieth century.

The year 1906 also brought a handsome Lee etching (fig. 88), issued by the John A. Lowell Bank Note Company of Boston as a premium for membership in the Confederate Memorial Literary Society. It won praise as "a fine etched portrait" in a review published by the *New York Sun*. "The artist has succeeded in making the head very lifelike," the newspaper explained. "It is not the more familiar presentment of Lee, with the face marked by responsibilities and sadness over a losing fight, but that of an earlier Lee, bright and handsome and animated." Lee's daughter, Mary, was quoted as describing the print as "the most perfectly satisfactory likeness of my father I have ever seen."[42]

There were still more prints to come. In 1907—one hundred years after Robert E. Lee's birth—a Washington, D.C., printmaker named A. B. Graham issued a group portrait of Confederate generals (fig. 89), in which Lee was not only placed prominently in the foreground, but so positioned that nearly all the others in the scene seemed to be looking directly at him. Thanks to a surviving advertising sheet, the vigorous post-1900 trade in Lee prints is vividly revealed. The flyer advertised a gravure print of which no original copies have been discovered, although a later offering in the *Confederate Veteran* included a reproduction (fig. 90). In the tradition of the endpaper endorsements published in books of the 1860s and 1870s, the publishers had collected letters of praise for their work and now published a litany of them for prospective customers. Several show not only how Lee prints were advertised, but also how they were used.[43]

"I have your Photogravure of General Robert E. Lee," wrote General Stephen D. Lee in one such tribute. "It is now framed and hangs over my desk where I do all my work." Noting that she possessed many such pictures, Lee's daughter, Mary, called the print "the best full-face likeness" she had ever seen. "It is a fine picture," agreed General William L. Cabel, "and I shall have it framed and placed in my parlor where the young people of my country can see it and call to mind his many virtues." And General L. L. Lomax added: "It is decidedly the best likeness I have ever seen and I intend to have it framed for my own house."[44]

It is wonderfully illustrative of the origins of Lost Cause prints that this photogravure had been published, not in the South, but in the Bronx, in New York City. Priced at one dollar, it was promoted as a "picture for the Home of every Southerner." As a spokesman for the Robert E. Lee Camp no. 1 of the United Confederate Veterans told the publishers: "Members of this Camp consider it a splendid likeness of our old Commander and prize it very highly. We will frame it and

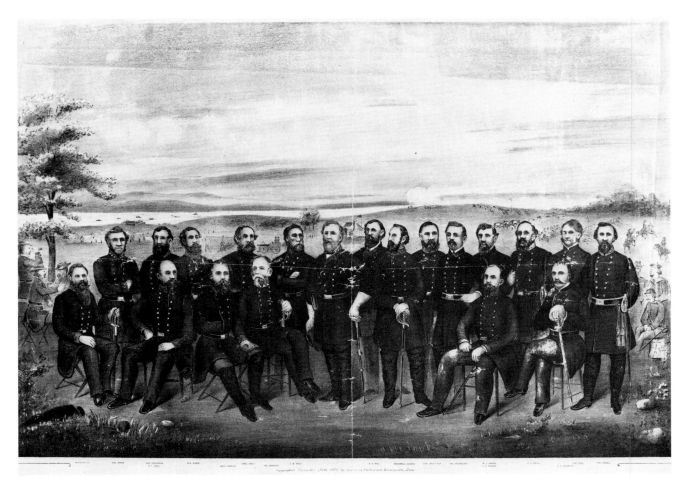

Figure 87.
Americus Patterson, *Lee and His Generals*. Gainesville, Tex., 1904. Hand-colored lithograph, 18⅝ x 27 inches. A crude and mysteriously de-rived group portrait, notable chiefly because it is the only known original Lost Cause print made in Texas. The source of most of its portraiture can be traced to photo-graphs. But the central portrait of Lee appears to be wholly in-vented and, perhaps not sur-prisingly, does not look much like him. Interestingly, the Confederate generals here are wearing blue uniforms. (*Library of Congress*)

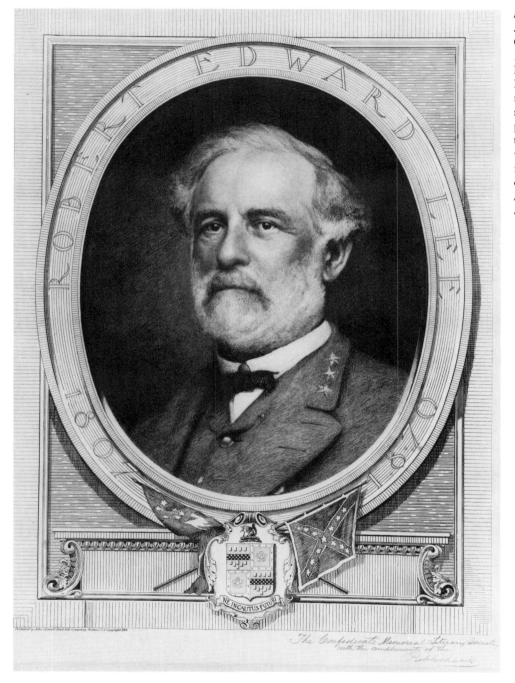

Figure 88.
John A. Lowell Bank Note Company, *Robert Edward Lee / 1807–1870.* Boston, 1906. Etching, 21½ x 16⅛ inches. Issued for the Confederate Memorial Literary Society, this straightforward adaptation of a pose from the post-Appomattox Brady sitting (see fig. 39) was extensively reviewed, and it was lavishly praised by one of Lee's daughters. (*Eleanor S. Brockenbrough Library, Museum of the Confederacy*)

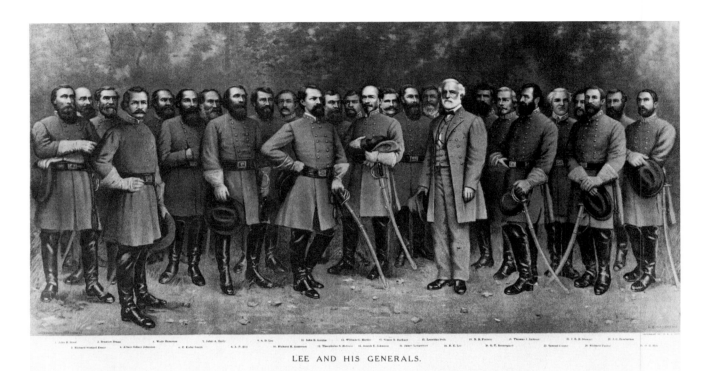

LEE AND HIS GENERALS.

Figure 89.
A. B. Graham Company, after G. B. Matthews, *Lee and His Generals*. Published by W. B. Matthews, Washington, D.C., 1907. Photogravure, 11⅛ x 22⅜ inches. Issued the year of Lee's hundredth birthday, the appearance of this impressive photogravure pointed convincingly to the enduring appeal of his perpetual military image. Based on one of the poses from Mathew Brady's milestone sitting a few days after Appomattox, the Lee portrait dominated the other twenty-five, including those generals in the back row who appear to have no feet. (*University of Georgia Library*)

Handsome Photogravure of General R. E. Lee

Rarely has been seen a more pleasing likeness of the great Confederate commander than is shown in the photogravure here offered. His daughter, Miss Mary Custis Lee, says it is the best full-face likeness of him. The picture is slightly larger than the print here given and is in size especially suitable to frame for a library table or desk—a gift that would be appreciated by any one.

This photogravure originally sold at one dollar. It is now offered at 75 cents, prepaid. Order promptly, for the stock is very limited.

FINE ENGRAVING OF PRESIDENT DAVIS

Many inquiries have come for a large picture of the only President of the Confederacy for presentation to schools and for Camps and Chapter rooms. Nothing could be more suitable than the large half-tone engraving now offered by the VETERAN at one dollar, postpaid. This picture, in size some 13 by 15½ inches, shows Mr. Davis as he was just before taking on the responsibilities of his office, when in the fullness of his manly beauty, the face serene but strong. Order from

The Confederate Veteran, Nashville, Tenn.

Figure 90.
Advertisement for the Ambrose Lee Publishing Company's photogravure of Robert E. Lee, from The *Confederate Veteran*, October 1917. The date of the offering indicates that the "high class photogravure" enjoyed distribution for at least eleven years—in 1906 the New York Public Library received an earlier promotional sheet for the print. The *Veteran* copy notes that, in the World War I era, the price had been reduced from one dollar to seventy-five cents. Although no copies of the original have been found, this advertisement, with its small illustration, gives some idea how the gravure portrait looked. (*Louis A. Warren Lincoln Library and Museum*)

place it upon our Camp wall, where, for all time that we may last, it will be a reminder of the noble face of that grand man loved by all."[45]

From the early Appomattox prints celebrating his dignified acceptance of defeat, through the display portraits of the 1870s and 1880s that marked his elevation to the status of icon, to the calendars and gravure images of the early twentieth century, Robert E. Lee was visually venerated by his people, his "noble face" preserved in a body of celebratory engravings and lithographs that testified to his unique place in the Southern heart. The Lee image survived reconstruction and reconciliation, and it endured well into the new century. Even as the United States plunged into the Great Depression at the end of 1929, the *Confederate Veteran*, although it conceded that "pictures of Confederate leaders have become very scarce, and some are not now procurable at all, especially in good engravings," could still offer two display prints of Robert E. Lee, a steel engraving for two dollars and a photogravure in sepia for one dollar.[46]

On his final tour of the Deep South, Lee had appeared genuinely surprised by the size and enthusiasm of the crowds that gathered to greet him at every railroad station and dock, and he is reported to have said: "Why should they come to see me? I am only a poor old Confederate." An orator speaking in Richmond a generation later—the day Lee's birthday became a legal holiday in Virginia—answered the question by declaring that the general's name now belonged next to "that of Washington himself—on the roll of those immortal few 'that were not born to die.' "[47]

Robert E. Lee had been born to lead, and he had fulfilled his destiny, at least in the eyes of the Southern people—eyes that gazed for decades upon the heroic, sentimental print portraits of "that grand man loved by all." They remembered Lee much the way Lee's father, "Light Horse" Harry, had remembered George Washington in one of the most famous eulogies ever spoken. Throughout the South, and particularly in the iconography of the Lost Cause, Robert E. Lee had emerged as first in war, first in peace, and first in the hearts of his countrymen.

As the captured Confederate president began his trek northward from Georgia to prison, he passed many paroled soldiers from his defeated armies. Davis's Yankee captors could not resist the pleasure of boasting occasionally about their prize, and at times the Rebels seemed not to mind. In reply to Northern shouts of "Hang him! Shoot him!" came the acquiescent Southern twangs: "The damned Mississippi Mule." The bloody years of war had made Davis increasingly unpopular with his own people. He had grown to be something of a scapegoat for their looming defeat, and now the cause was lost. "We've got no use for him," the Rebs yelled at their former enemies. Many years later Davis's biographer, Allen Tate, wrote: "Jefferson Davis died on May 11th, 1865."[1]

The North repeatedly called for Davis's death in newspapers, pamphlets, books, speeches, songs—and in popular prints. The Confederate president with a noose around his neck, dangling from a tree, was a commonplace image in the North from 1861 to 1865. On rare occasions some degree of artistry was attained in this orchard of sour apple trees. William M. Davis produced a *trompe l'oeil* painting in 1861 based on the most popular likeness of the Confederate president, which had appeared, among other places, on the five-cent Confederate stamp. The center of the artist's work is a tattered lithograph in an old pine frame, with its caption "Hon. Jeff. Davis" fully visible. The lithograph is torn, one corner curls down, and disrespectful signs are pasted over it. But what makes the work successful is the illusion of shattered glass over the print. The painting was photographed in 1862 and distributed as a *carte-de-visite* entitled *The Neglected Picture* (fig. 91).

The title prophesied a time when such Confederate portraits would be left uncared for and unheeded, passed over by history. But it was executed in a year when history seemed to be on the side of the Confederacy. In 1862 the Confederate armies were frequently victorious, and William Gladstone, then the British chancellor of the exchequer, publicly declared that "Jefferson Davis and other leaders of the South have made an army; they are making, it appears, a navy; and they have made what is more than either, they have made a nation." Gladstone's friend, Lord Acton, went further and pointed to a future in which "the people of the North might willingly acknowledge in Mr. Jefferson Davis the successor of Washington."[2]

Nor did the Union cause look altogether promising as late as the summer of 1864, when the original of *The Neglected Picture* was displayed at the Philadelphia Sanitary Fair, which 12,000 people attended daily, including, on one day, Abraham Lincoln. If Lincoln himself saw any portraits of Davis save the one on the Confederate five-dollar bill that he carried in his wallet at the end of the war, he never commented on them, but it seems certain that he would not have liked the common images showing Davis's hanging.[3] Lincoln had no taste for executions and wanted to see Davis escape the country after the war. He understood how martyrs are made. But Lincoln died before the Confederate president was captured. Almost overnight the cowardly image of the hoopskirted Davis overwhelmed that of the dangerous rebel chief. Then his fortunes turned once again, but more slowly and less drastically. Jefferson Davis, once a heroic figure in Southern graphics and later a comically emasculated one in Northern cartoons, finally reemerged in prints made for Southern audiences as a hero of the Lost Cause.

Ironically, the principal agents of Davis's final transformation were Edwin M. Stanton and a twenty-six-year-old brigadier general of volunteers, Nelson A. Miles. Miles was put in charge of the Confederate president at Fortress Monroe, where Davis was imprisoned for two years after his capture. The young general from New England locked Davis in a damp, moldy

"The Neglected Picture." (Over.)

Entered according to Act of Congress, in the year 1862, by Wm. M. Davis, in the Clerk's Office of the District Court of the United States for the Southern District of New-York.

Figure 91.
[Photographer unknown], after William M. Davis, *The Neglected Picture.* New York, 1862. Photograph. In this *carte-de-visite* of a *trompe l'oeil* painting, the shattered image of the Confederate president—a torn lithograph slipping from its frame, glass broken, and disrespectful signs pasted on the broken glass—symbolized the way much of the North wished to see Davis. The superimposed label of "Justice & Co. Dealers in 'Cordage'" on the right and the reference to the "undertaker" on the left were both reminders of the most common wartime Northern image of Davis as a likely candidate for execution. The formal ancestors of modern-day graffiti are discernible in this surprisingly modern work of art. (*Courtesy Harold Holzer*)

casemate and subjected him to constant, humiliating surveillance of even his most private functions. The guards' feet tramped unceasingly night and day, lights were left burning constantly, and no communications were permitted from the guards or the outside world. Masses of soldiers and a wide moat with drawbridges guarded the prison. The *New York Herald* reported that the enemy chief was "in a living tomb." "No more will Jefferson Davis be known among the masses of men. . . . His life has been a cheat. His last free act was an effort to unsex himself and deceive the world. He is . . . buried alive."[4]

In the North, at least one printmaker tried to exploit the situation. Gibson and Company of Cincinnati produced the cartoon *Jeff. Davis in Prison* (fig. 92), showing guards recalling the "rotten sowbelly and moldy hardtacks" of Southern prisons. Meanwhile their prisoner haughtily refuses the plain soldiers' food he is given, saying, "I have not been accustomed to such living, and will not put up with it." But the North much preferred the hoopskirted Davis to the one suffering in prison, and the Gibson print is the only one known to have depicted such a scene.

Chains are visible around Davis's ankles in the Gibson cartoon, and indeed, on the second day of his confinement at Fortress Monroe, Davis was shackled on General Miles's orders. Frail though the prisoner was, he resisted the indignity, showing "unnatural strength," according to the officer in charge. Davis proved willing even to die. He knocked down the blacksmith who was sent to affix the chains. The startled smith leaped to his feet and raised his hammer to retaliate, but the officer of the day intervened. Sturdy soldiers were summoned and the shackling was completed. One hundred and twenty years later, historian Burke Davis summed up matters thus: "From the moment he had struggled against Edwin Stanton's brutal blacksmith at Fort Monroe, Jefferson Davis had become a martyr of the Lost Cause, a role he never lost."[5]

JEFF. DAVIS IN PRISON.

Figure 92.
F. H., *Jeff. Davis in Prison.* Published by Gibson and Company, Cincinnati, 1865. Lithograph, approx. 10 x 14 inches. The artist makes a case for the justice of Davis's imprisonment at Fortress Monroe by re- minding viewers of a cause célèbre in the North, the alleg- edly intolerable conditions of wartime Southern prisons, for which the Confederate presi- dent was widely held responsi- ble by Union men. Davis is shown as a despicable aristo- crat receiving reasonable treat- ment, even if he is humiliated by chains. The stereotypical black man completes the de- sign. But in Mrs. Davis's later opinion, her husband entered prison with "his stately firm and knightly bearing" un- bowed. He "seemed a man of another and higher race, upon whom 'shame would not dare to set' " (Davis, *Jefferson Da- vis, Ex-President,* 2:648). (*Li- brary of Congress*)

Newspapers quickly reported the shackling incident, and within five days the chains were removed. Davis's treatment slowly improved. He found a friend in the prison doctor and when, because of that friendship, the physician was removed from his post, his successor became a friend, too. After a time the lights in his casemate were snuffed out at night. The guards who observed all his movements were removed from his cell, and Davis was allowed to take walks on the ramparts. He began to correspond with his wife, and in time their prison letters formed remarkable testimony to their deep affection for each other.

Davis left the dank cell for the officers' quarters four and a half months after entering the bowels of this "American Bastille," as it was styled at the time, in the Democratic party tradition of denouncing military arrests of civilians during the Civil War. Then, in May 1866, his wife, her sister, and the Davises' baby daughter Winnie came to stay at the fort. The prisoner received newspapers and other reading materials, and encouragement from both North and South. His mail included a note from Mary Custis Lee: "If you knew how many prayers & tears had been sent to Heaven for you & yours, you could realize that you were not forgotten." But even this letter contained a reminder of hoopskirts and chains. "Oh why did you delay & fall into the hands of those whose only desire is to humiliate & destroy you?"[6]

Eventually General Miles was replaced by a more benign jailer and Davis was given the freedom of the fort. By then his treatment had become a symbol of the struggles over Reconstruction. The government in Washington could not vengefully pin on him explicit responsibility for the cruelties of wartime Southern prisons, nor could they prove complicity in Lincoln's assassination. A court test concerning the constitutionality of secession—something Davis would have welcomed—promised little profit to the victorious North and was delayed. Signs increasingly pointed to the prisoner's release.

John J. Craven, Davis's first doctor at Fortress Monroe, played a key role in the former president's parole and restoration to popularity. A book entitled *Prison Life of Jefferson Davis*, created by Craven's friend Charles G. Halpine from the doctor's diaries and from the writer's own imagination, appeared in the summer of 1866.[7] The book portrayed Davis as an upright man who had given all he possessed for his convictions and who deserved to be free. Though in failing health and incarcerated in the strongest fortress on the continent, accused of horrid crimes he did not commit, subjected to humiliations that shamed the United States and modern civilization, the defeated rebel, in Craven's view, had retained his honor before God and the American people.[8] The book furnished sympathetic glimpses of Davis's purported views on history, literature, art, Lincoln (whom he was said to have respected), and the current state of the country. It chronicled Davis's life in prison with wonderful detail. But the most spectacular part described the shackling and valiant resistance of the prisoner:

"Kill me! Kill me!" he cried, passionately, throwing his arms wide open and exposing his breast, "rather than inflict on me, and on my People through me, this insult worse than death."

"Do your duty, blacksmith," said the officer. . . .

At these words the blacksmith advanced with the shackles . . . but, as if with the vehemence and strength which frenzy can impart, even to the weakest invalid, Mr. Davis suddenly seized his assailant and hurled him half way across the room.

On this Captain Titlow turned, and seeing that Davis had backed against the wall for further resistance, began to remonstrate. . . .

"I am a prisoner of war," fiercely retorted Davis; "I have been a soldier in the armies of America, and I know how to die. Only kill me,

and my last breath shall be a blessing on your head. But while I have life and strength to resist, for myself and for my people, this thing shall not be done."[9]

Later Davis recounted to his doctor, according to the Craven book, how "I seized a soldier's musket and attempted to wrench it from his grasp, hoping that in the scuffle and surprise, some one of his comrades would shoot or bayonet me." The image was vivid: the proud president of the Confederate States of America seeking to lay down his life on the altar of the Lost Cause.[10]

Even Varina Davis, in her later memoir of her husband's life, felt obliged to question "the dramatic account published in Dr. Craven's book."[11] Davis himself wrote revealing marginalia in his own copy of the book. On the pages describing the shackling his comments ranged from "coloring laid on" through "not true," "false," "fiction perverting fact," to the vehement declaration of "gross misrepresentation no part of the affair truthfully reported; my resistance resulted from a sense of right & duty; though desperately it was calmly, quietly made."[12] Whatever actually occurred on that day and during the rest of his two years of imprisonment we will never know fully. But at Fortress Monroe, Davis did symbolically recover his manhood.

Exactly two years and a day after his capture in Georgia, Davis left the fortress. He and his family sailed up the James River toward Richmond. Along the way people carrying flowers gathered at little landings to honor their president. When he reached the former Confederate capital, crowds were waiting at the wharf and along roads, men with hats in hand and ladies waving handkerchiefs from windows. Mr. and Mrs. Davis stayed in the same room in the Spotswood Hotel that they had occupied in 1861, when they had come to preside over a Confederacy that was supposed to last forever.

The former prisoner went to a Richmond court to receive his official freedom. Gerrit Smith, the great abolitionist, and Horace Greeley, the reform-minded editor of the *New York Tribune*, led the list of names of bail signators. Davis exited the courtroom to a wildly roaring crowd and rode in an open carriage back toward the Spotswood, but only with some difficulty because of the milling throngs. Upon arrival at the hotel, however, he was greeted by a silent crowd. Then a deep voice boomed: "Hats off, Virginians!" And, in the words of Davis's secretary Burton Harrison, "Five thousand uncovered men did homage to him who had suffered for them."[13]

The printmakers were not slow to recognize this opportunity, with a Southern lithographer leading the way. As soon as Richmond's Charles L. Ludwig, formerly of Hoyer and Ludwig, was able to obtain a new photograph of Davis, he published *The Bail Bond of Mr. Jefferson Davis, Late President of the Confederate States, With all the Original Signatures Thereto* (fig. 93). The North, from 1863 through the end of Reconstruction, revered a similarly wordy icon, the text of the Emancipation Proclamation, often embellished by Yankee printmakers with Lincoln's portrait and other decorations. This proclamation was a mundane legal document that appears dreadfully dull to most readers today, but it carried enough symbolic weight in the nineteenth century to make it a popular subject for prints. From Jefferson Davis's bail bond, Ludwig created an analogous print for the white South, turning another mundane legal document, with the signatures of mostly unknown individuals below it—and those often illegible—into a lithograph of great emotional value.

The bail bond print certified the martyrdom of the "Late President of the Confederate States," but the little portrait featured on it did not show the face that Southerners had known during the war. Instead, Ludwig, using a new photograph, had captured the face of a martyr. Davis at the time of his release from prison, according to the *Richmond Enquirer*, showed "the rav-

Figure 93.
Ch[arles]. L. Ludwig, *The Bail Bond of Mr. Jefferson Davis, Late President of the Confederate States With all the Original Signatures Thereto*. Richmond, [1867]. Lithograph, 23½ x 16⅛ inches. Davis's bail bond became a martyr's icon after his release from Fortress Monroe. This facsimile featured a new Davis portrait, based on a photograph taken on July 19, 1867, in Canada, where the former president went to join his family after his release. The historical and reverential meaning of such images is much clearer than their practical use at the time; it is somewhat difficult to imagine such a print as a framed decoration in a Southern parlor. *(Eleanor S. Brockenbrough Library, Museum of the Confederacy)*

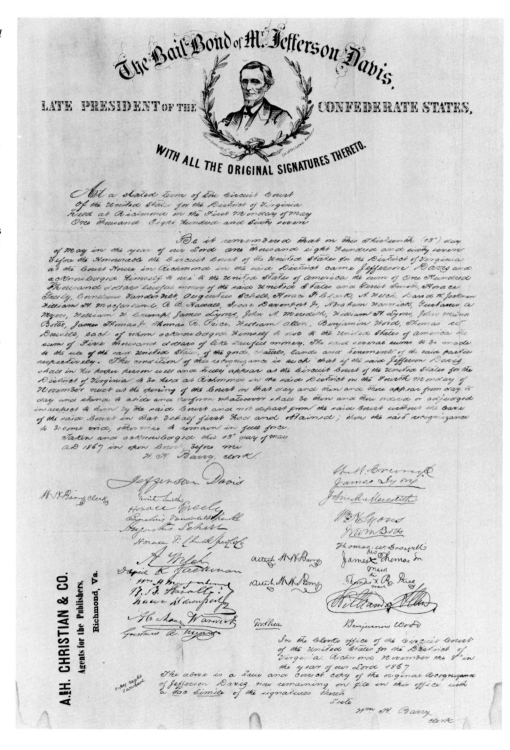

ages made by sorrow and suffering." "But his countenance," the newspaper went on, "although haggard and care-worn, still preserves the proud expression and the mingled look of sweetness and dignity for which it was ever remarkable. His hair is considerably silvered, but his eye still beams with all the fire that characterized it in the old time, and he seems every inch a king."[14] The fact that Davis was out of prison only on bail and could be reincarcerated at any time added poignancy to the Ludwig print.

Not until 1869 was the government in Washington ready to drop all charges against the former Confederate leader. Nor were Northern printmakers ready to surrender at once to the changing demands of the Davis print market and forget the hoopskirted image or the "sour apple tree" entirely. Currier and Ives greeted Davis's release with a lithographed cartoon showing Horace Greeley—who had not only signed the bail bond but, before that, had campaigned for Davis's release in the pages of his influential newspaper—opening a jail cell to receive the affectionate embrace of the freed prisoner. The familiar tree and an ironic title adorned the print: *Jeff D. Hung on a "Sour Apple Tree," or Treason Made Odious.*

The Davis connection dogged Greeley to the end of his life. When he ran for president against Ulysses S. Grant in 1872, another Currier and Ives print showed Greeley asking black men to vote for him. But behind him stood Davis with a whip in one hand and chains in the other. "No Mr. Greeley," says one of the freedmen, "we can't vote for you for behind you we see Jeff Davis and behind him is the old lash and bondage." Greeley was the central figure of this campaign lithograph and Davis only a supporting character. Yet the image of Davis as an unrepentant and unforgiven embodiment of the Confederate cause reflected the way many Northerners would always see him.

Only one known print from 1865 portrayed Davis altogether favorably. This anomalous lithograph, entitled *The Last Act of the Drama of Secession* (fig. 94),

provided a sentimental depiction of Davis's farewell to his despondent aides as he fled to the Deep South. The print came from the southern Ohio city of Cincinnati—which gives the only possible clue to the reason for its publication. Perhaps, that close to Kentucky, there was some market for sympathetic renderings of Jefferson Davis's flight.

One other print from the North accorded Davis a measure of dignity while criticizing him for spurning a last offer of reconciliation from President Lincoln (fig. 95). Lithographed by Kimmell and Forster in New York in 1865, it was one of a series of prints comprising an allegorical political history of the Civil War. *The Last Offer of Reconciliation* quietly made the point that Jefferson Davis, whom the vast majority of Northerners preferred to see as a humiliated wretch, had in fact been a president who was in some official ways at least the equal of Lincoln. In this way the print might have had an unconscious positive effect on Davis's image. But Davis's reputation had not revived anywhere yet. Some years would pass before the sea change in popular feeling toward Davis in the South inspired more openly sympathetic portrayals by the Northern printmakers.

The new Davis image (seen, for example, in Northern depictions of his inauguration as Confederate president [fig. 96]) was vigorously portrayed into the twentieth century. Historian Frank Vandiver has described Davis as a "Leader without Legend," but that is true only if one looks at the subject from a national perspective. Southern historian Grady McWhiney described him as the "Unforgiven," but that was a Southern description of Northern bias.[15] In the South there is much evidence, including his later portrayals in popular prints, to indicate that hearts often forgave Davis his faults and embraced his legend for long years after the war, after his death, and into a new age.

In *Jefferson Davis Gets His Citizenship Back*, Robert Penn Warren put it this way: "Davis had come out of the war with popularity diminished almost to the

THE LAST ACT OF THE DRAMA OF SECESSION.

Figure 94.
Gibson and Company, *The Last Act of the Drama of Secession*. Cincinnati, 1865. Lithograph, 12⁷/₁₂ x 17 inches. Of the more than two dozen Northern-made lithographs depicting Davis's flight and capture, this is the only one to portray it altogether sympathetically. An eyewitness wrote of the Confederate chief during his last hours of freedom: "Mr. Davis' great resources of mind and heart shone out most brilliantly. He was calm, self-poised; giving way to no petulance of temper at discomfort; advising, consoling, laying aside all thought of self for our unhappy and despairing people, and uttering words of consolation." (Capt. Micajah Clark, quoted in Davis, *The Long Surrender*, 127–28). (*Library of Congress*)

Figure 95.
Kimmell and Forster, *The Last Offer of Reconciliation / In Remembrance of Prest. Lincoln / "The Door is Open to All."* Published by Henry and William Vought, New York, [1865]. Lithograph, 16⅞ x 24¼ inches. In this print, one of a series telling the story of the Civil War allegorically, Lincoln makes a generous offer of rapprochement. He appears ready to lead Jefferson Davis to a temple of liberty whose columns are being wrapped in bunting bearing the names of the states by the bête noire of the Confederacy's twilight, William T. Sherman. The point of the print was Lincoln's generosity and Southern intransigence, but, like the Appomattox prints, this one may have had the effect of lending some stature and dignity to the Confederate leader. (*Louis A. Warren Lincoln Library and Museum*)

Figure 96.
A. Hoen, after James Massalon, *The Starting Point of the Great War Between the States. / Inauguration of Jefferson Davis*. Published by Matthew Tierney, Washington, D.C. 1887. Lithograph, 30½ x 23¾ inches. The second postwar print to depict the swearing in of Jefferson Davis at Montgomery on February 18, 1861 (the first was a Miles Strobridge chromolithograph, published in Cincinnati in 1878), this impressive panorama purported to record the scene seconds after the oath taking—1:00 P.M., as the Capitol clock shows—with the new president and vice president leading spectators in prayer. As William L. Yancey put it, "the man and the hour" had met. An eyewitness to the spectacle called it "a great day for Montgomery." She remembered joining a "mass of people in front of the portico," although this print suggests only a modest crowd. She also recalled—and in this case the print portrays—"the balconies and every front window . . . filled with ladies." After the swearing in, "the ladies threw down small bunches of flowers," some of which Vice President Stephens "gathered up and held in his hand" (Eleanor Noyes Jackson, quoted in Jones, *Heroines of Dixie*, 12–13). (*Chicago Historical Society*)

ALEX. H. STEPHENS, WM. L. YANCEY, JEFF. DAVIS, HOWELL COBB,

THE STARTING POINT OF THE GREAT WAR BETWEEN THE STATES.
INAUGURATION OF JEFFERSON DAVIS

vanishing point, but when, free on bail, he emerged from the courthouse in Richmond, the rebel yell burst forth for the first time since the last few Southern bayonets had glittered in a futile charge." On the Chesnut plantation in 1865, old Aunt Harriet had been "radiant" when news of the Confederate president's capture arrived: "And why don't they hang Jeff Davis and clear the deck for peace. I want this row over." But when more detailed descriptions of Davis's capture came, one of Aunt Harriet's neighbors, the Reverend Richard S. Trapier, exclaimed: "Look here—taken [in] woman's clothes . . . rubbish—stuff of nonsense. If Jeff Davis has not the pluck of true man, then there is no courage left on this earth." He went on with great emotion: "I will pray for President Davis till I die. I will do it to my last gasp. My chief is a prisoner, but I am proud of him still. He is a spectacle to gods and men. He will bear himself as a soldier, a patriot, a statesman, a Christian gentleman. He is the martyr of our cause." And Mary Chesnut's diary notes, "I replied by my tears."[16]

Davis's ordeal as a prisoner was not lost on the white South, preoccupied though it was with Reconstruction. When Davis was given his freedom at last, it was clear to the cheering South that he would remain, in the words of Allen Tate, the poet who became his biographer, " 'President' until he died." And Tate explained why: "He lay in Fortress Monroe, charged with treason, for two years, much of the time in chains, separated from his family and friends. He became the sacrifice of the Southern people to the passions of the Northern mobs."[17] Davis never wavered, and he replied to his captors and tormentors, so Dr. Craven's *Prison Life* claimed, with words equivalent to: "Father forgive them for they know not what they do." Both North and South had their martyrs after the horrors of civil war. Davis was made a living martyr. It was as though time had stopped at Fortress Monroe. Historian Charles Reagan Wilson has written: "Reading the eulo-

gies [offered to Davis upon his death in 1889], one almost concludes that he must have been tried for treason, convicted, and probably crucified."[18]

The iconographical result was predictable. Portraits were produced in substantial numbers, mostly in the North. A photograph of Davis taken at the Brady gallery before the war provided the model for his best-known image both during the war and after (fig. 97). One of its earliest print adaptations appeared on the Confederate postage stamp engraved by Hoyer.

The same likeness cropped up in numerous prints. In New Orleans, which fell into Union hands in 1862, Blelock and Company published a handsome colored lithograph of Davis at an unspecified date (plate 16). William Blelock issued at least two editions of this print.[19] Similar, though not quite as handsome, likenesses came from New York's Jones and Clark Company and from Chicago's Kurz and Allison (fig. 98). Using another Brady pose from the same sitting, both Currier and Ives (fig. 99) and William Sartain produced appealing prints.

If we can trust the report of pioneer photographic historian Francis Trevelyan Miller, Jefferson Davis posed for only one wartime photograph (fig. 100)— in sharp contrast to the nearly eighty pictures of his Northern counterpart.[20] Though it was probably available to engravers and lithographers—and chronologically was more accurate than the Brady poses—this photograph nevertheless attracted fewer imitations by printmakers. An exception was a chromolithograph with no date or publisher identified, which depicts a vigorous middle-aged man with chiseled features, seemingly younger than his Brady-based likenesses and showing no white at all in his beard (plate 17). The white did appear in Davis's beard and hair in later prints, as shown by another lithograph of uncertain provenance that features on the only surviving copy the legend "Defender of Southern Rights," drawn by hand at a later date; even in this picture, a degree

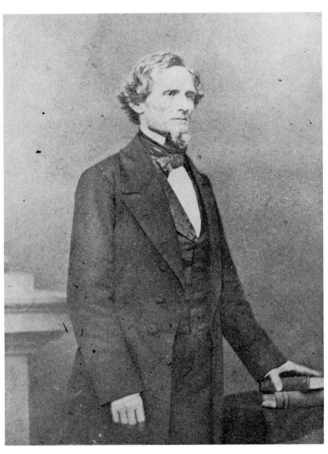

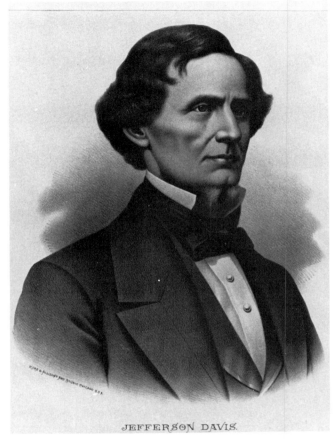

Figure 97.
Mathew Brady Gallery, [*Jefferson Davis*]. Photograph. Washington, D.C., ca. 1859–60. (*Louis A. Warren Lincoln Library and Museum*)

Figure 98.
Kurz and Allison, *Jefferson Davis*. Chicago, n.d. Lithograph, 23 x 18½ inches. In 1880 Austrian-born Louis Kurz formed a partnership with Alexander Allison in Chicago, and over the next twenty-three years the two seemed to specialize in Civil War image making. They produced, mostly for Northern audiences, a large number of battle scenes and portraits, the former marked at times by military naiveté and historical unreliability. Their Davis reflected the man a reporter described as "clad in a neat garb of the old-time Southerner," whose "easy, courtly grace" was typical of "gentlemen of the old regime" (*Southern Bivouac* 2 [August 1886]: 138). (*Gettysburg National Military Park*)

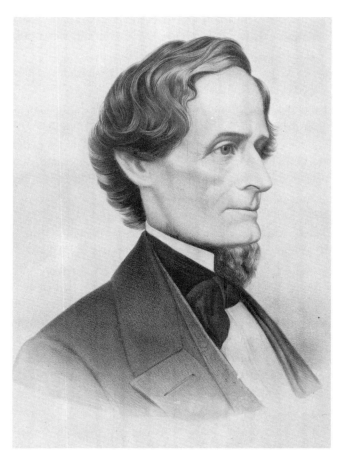

Figure 99.
Currier and Ives, *Jefferson Davis*. New York, n.d. Lithograph, 13⅝ x 9⅛ inches. A prewar Brady photograph of Davis as U.S. senator served as a model for this postwar lithograph. Davis, who in reality bore himself as a dignified aristocrat and somewhat reserved gentleman, was here made to look undistinguished and affable. (*Virginia Historical Society*)

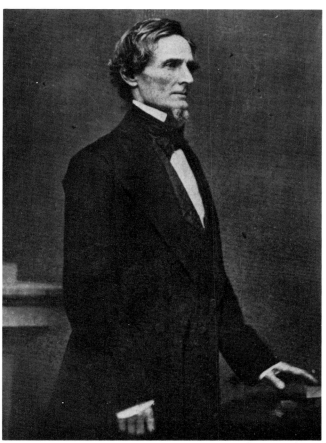

Figure 100.
[Photographer unknown], [*Jefferson Davis*]. Richmond, n.d. (*Louis A. Warren Lincoln Library and Museum*)

of relative youthfulness remains. The chief explanation for this is that the face makes a quarter turn only, avoiding an emphasis on Davis's aged and hollow cheeks. Thus these potentially authentic presidential images failed to show the physical price the war extracted from the leader of the Confederacy.

Postwar group portraits included Davis as well. The "authentic" president appeared, for example, in *Jefferson Davis and the Confederate Generals* (fig. 101). This photoengraving from the later 1880s documents the iconographical rise of Davis's reputation in the generation after the war. The president is seated in the front—one is tempted to say, clearly in charge, although Lee stands only a little way back in the center. As the Confederate defeat receded further into the past, what remained was the memory of sacrifice and glory. There was glory enough for all, or nearly so, but Davis towered above all Southern idols except Lee as the nineteenth century came to an end. The Confederate president had bickered with his generals during the war, and much of this contention persisted in public after the war until, one by one, they all died, but these disagreements did not matter to the makers of prints or their buyers. In that world of imagination the Lost Cause united all.

Another group portrait, *Jefferson Davis and His Cabinet with General Lee*, by Thomas Kelly of New York (fig. 102), testified to the emotional detachment of the commerce-minded printmakers. Kelly's Southern customers may not have known that this image had its Union twin, with Lincoln and his cabinet shown meeting in precisely the same poses (fig. 103). And fewer still, probably, were the customers in North or South who realized that the ultimate inspiration for both prints was yet another cabinet scene: the immensely popular A. H. Ritchie engraving of Lincoln's first reading of the Emancipation Proclamation (fig. 104).

Davis's official political or military "family" was the only family most printmakers allowed him. Yet the

Confederate president was a warm family man. His first wife Sarah, the daughter of Zachary Taylor, died within weeks of their marriage and Davis remained a widower for a decade. When he married again, it was for life. He and Varina Howell Davis had six children and enjoyed an unusually close relationship despite their many trials. Davis ended his incomplete autobiography by mentioning their youngest child, Winnie: "Born in the last year of the war, she became familiarly known as 'the daughter of the Confederacy.'" Photographs were taken of the children, of Davis and his wife, and of three generations of the Davises together. They made touching sentimental images and might well have provided models for popular prints to exploit the Victorian vogue for domestic images. Lincoln, whose family life was perhaps more troubled than Davis's, and who was never photographed with his wife, nevertheless became the subject of a large number of family prints.[21]

With but one known exception, Davis was denied this immortalization as a family man in popular prints. Perhaps it was because Southern culture preferred him as a martyr who was thrown into chains and torn from his wife and children, even from his little baby, and who suffered alone for the sins of his people. The South needed such a martyr, not a contentedly comfortable family man. Besides, family images could soften, almost feminize, men. Southerners who had been affronted by the "belle of Richmond" would not have been comfortable with further manifestations softening the leader's image. It is remarkable that the Northern printmakers seem to have sensed this so clearly.

The interesting exception, which showed Davis as a very old man shortly before his death, was Kurz and Allison's rare print of the Davis family (fig. 105). Its existence may be explained in part by the printmakers' unrivalled interest in domestic scenes, for Kurz and Allison issued similar family prints of Abraham Lincoln, Ulysses S. Grant, James A. Garfield, and Benja-

Figure 101.
F. Gutekunst, after Faas, Jr., *Jefferson Davis and the Confederate Generals*. Copyright by Dr. J. Olney Banning and Son, Philadelphia, 1890. Phototype, 19½ x 16¼ inches. The contentious generals of the C.S.A. flank their commander in chief in a dignified grouping. Behind Davis are (from left) A. P. Hill, John Bell Hood, J. E. B. Stuart, and Stonewall Jackson, who stands next to Robert E. Lee, forming a semicircle. On the right side a slightly separated group includes James Longstreet, Joseph E. Johnston, and P. G. T. Beauregard, generals who troubled Davis during and after the war. But Lee overlaps his lieutenant, Longstreet, thus ensuring the unity of the composition, and Jubal Early, whom Davis called "that excellent general," completes the design. (*Gettysburg National Military Park*)

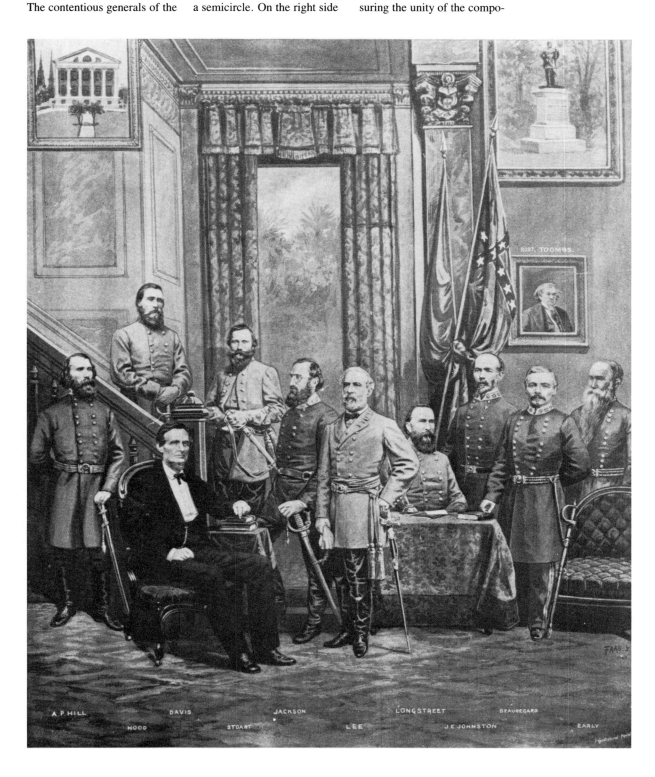

JEFFERSON DAVIS AND HIS CABINET

With General Lee in the Council Chamber at Richmond

Figure 102.
Thomas Kelly, *Jefferson Davis and His Cabinet with General Lee in the Council Chambers at Richmond*. New York, 1866. Lithograph, 18⅜ x 27½ inches. Copyright renewed by Americus Patterson, Gainesville, Tex., 1897. An oversized Davis dominates this awkward lithograph, which is quite like Kelly's Lincoln cabinet scene (see fig. 103), except for the heads of the figures and a few details. Thus the Confederate president holds in his hand a document that in Lincoln's hand had been the Emancipation Proclamation. The background and accessories remain almost the same, including the familiar table and chandelier of the White House cabinet room. (*Library of Congress*)

Figure 103.
Thomas Kelly, *President Lincoln and His Cabinet. With General Grant in the Council Chamber of the Whitehouse.* New York, 1866. Lithograph, 18½ x 27¾ inches. *(Louis A. Warren Lincoln Library and Museum)*

Figure 104.
Alexander Hay Ritchie, after
Francis B. Carpenter, *The First
Reading of the Emancipation
Proclamation before the Cabi-
net.* Published by Derby and
Miller, New York, 1866. Mez-
zotint engraving, 20¾ x 32⅜
inches. *(Louis A. Warren Lin-
coln Library and Museum)*

min Harrison. The iconographical significance of this print may be less great than its significance as proof of Kurz and Allison's series-mindedness. The Chicago lithograph firm, when it hit on a good print idea, stuck to it, as the many copies of the firm's numerous Civil War battle scenes—all in distinctively rigid format— prove.

If Davis could not be allowed much of an icono- graphic family, he was at least allowed to grow old in prints, unlike most Confederate heroes. There were many lithographs, engravings, and, later, photoen- gravings of the former president as elder statesman— some inspired by pure commercialism, such as one used as an insurance advertisement (fig. 106).

There are few embellishments on these prints. They show only what, to many Southerners, had become a beloved face. By contrast, one of the now-familiar Lincoln print portraits, by John Sartain, included in one corner a symbolic broken chain.[22] In this case, the artist's judgment was sound: the white North did need reminders of black suffering and the Emancipation Proclamation. The white South, on the other hand, did not need to be reminded of Davis's shackles. Central as his prison experience was to the Davis image, there are no known separate-sheet prints showing Davis's mar- tyrdom in prison, although good models were certainly available—a fine Alfred Waud sketch, for one, or the frontispiece of Dr. Craven's book. There was no need for prison scenes or symbolic chains in the pictures that were hung on the walls of Southern homes. For in the Lost Cause brotherhood of white Southernness, every Davis portrait carried the unseen chains of a proud but defeated people.

In May 1886 Jefferson Davis returned to Montgom- ery, Alabama, the city where he had taken an oath as president of the Confederate States of America a quar- ter of a century before. Old and "in feeble condition," he was the special guest at a ceremony to lay the cornerstone of a monument to the Confederate dead.

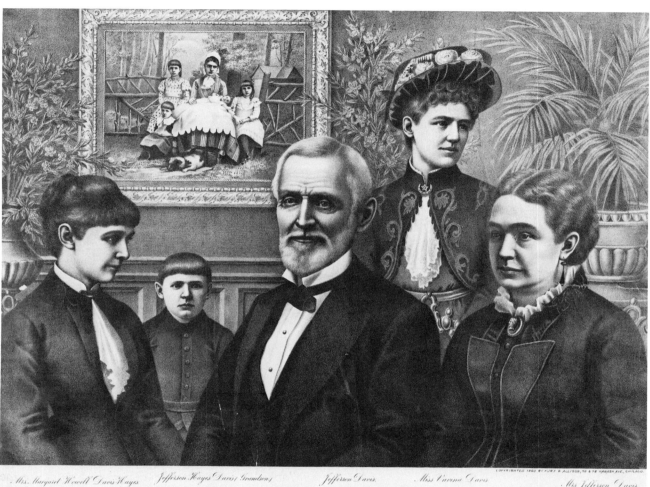

Mrs. Margaret Howell Davis Hayes Jefferson Hayes Davis (Grandson) Jefferson Davis. Miss Varina Davis Mrs. Jefferson Davis

JEFFERSON DAVIS AND FAMILY.

Figure 105.
Kurz and Allison, *Jefferson Davis and Family*. Chicago, 1890. Lithograph, 16⁹⁄₁₆ x 23⅛ inches. The only known Davis family print, this lithograph is based primarily on contempo- rary photographs. Davis is flanked by his two surviving daughters: Maggie is at the viewer's left, next to her son; Winnie, "the daughter of the Confederacy," is on the right, standing behind her father and her mother, Varina Davis. Davis's own likeness stems from a photograph taken in 1888 by Washburn in New Or- leans. Daughter Maggie sent a copy of the photo, with her "best wishes," to the officer in charge of Davis's shackling at Fortress Monroe. (*Library of Congress*)

Figure 106.
Budden and Son, *Jefferson Davis* [facsimile signature] *Compliments of Maj. J. H. Morgan, Special Agent Manhattan Life Insurance Co.* Atlanta, ca. 1880–85. Photoengraving, 18¼ by 12⅛ inches. A premium for the Southern office of a Northern company, this portrait was obviously designed as a Lost Cause gift to be used by the firm's local agent, who might have been aided as well by the fact that he bore the name of a war hero, the cavalry raider General John Hunt Morgan. Davis was realistically portrayed here, much like the elder statesman who, a reporter noted, had grown "a full beard and moustache" that "conceal the ravages made by sorrow," so that he still looked "every inch a king" (Davis, *The Long Surrender*, 221). (*Eleanor S. Brockenbrough Library, Museum of the Confederacy*)

PUBLISHED BY BUDDEN & SON. ATLANTA

Jefferson Davis

COMPLIMENTS OF
MAJ. J. H. MORGAN, Special Agent
MANHATTAN LIFE INSURANCE CO.,
Southern Office, ATLANTA, GA., Rooms 8 and 9, Gould Building.
NEW YORK.

Figure 107.
[Printmaker unknown], *Jefferson Davis*. Published by I. S. Johnson and Company, Boston, 1890. Lithograph with tintstone, 14⅛ x 10 inches.

Jefferson Davis was a purely Southern hero. Lee, who prized the Union, disliked slavery, and preached reconciliation, eventually became an American hero—for many, the Southern counterpart of Abraham Lincoln. In this striking fin-de-siècle likeness, Davis, here given a squarer face than his own lean visage, could be mistaken for Robert E. Lee. A closer look, however, reveals the different part of his hair, the closer trim of his beard, and, of course, the facsimile signature at the bottom. (*Library of Congress*)

His welcome was overwhelming. As *Frank Leslie's Illustrated Newspaper* reported: "Houses were illuminated, fireworks brightened the heavens, artillery boomed, and a dozen bands played while the shouts of thousands mingled with the roar and added to its volume" in "an ovation . . . said never to have been equalled or eclipsed in that city." Despite a "pouring rain," it was also a city "gayly decorated," and one principal feature was a show of portraits. "Pictures of Confederate generals were fastened to the outside of walls." Davis stayed in the same room of the Exchange Hotel that he had occupied in 1861. The corridor leading to the room was an "arch" of American flags, and over the door hung a picture of Lee between two more flags. The United States was assimilating the Confederacy into its culture, as it had assimilated so much else.²³

Deeply moved though he was by his reception, Davis wanted nothing of assimilation. He spoke of "a land where liberty dies not." He moved on from Montgomery to Atlanta and then Savannah in a glorious tour. "All the South is aflame," another New York reporter wrote, "and where this triumphant march is to stop I cannot predict." Davis spoke of state sovereignty. People saw a very old man, filled with love for things lost. "Is it a lost cause now? Never . . . a thousand times, no! Truth crushed to earth will rise again . . . can never die."²⁴

Davis died in 1889, and his funeral in New Orleans was a huge event that further reawakened Southern sectionalism. A year later Boston printmaker I. S. Johnson memorialized the former Confederate president in a stunning portrait print (fig. 107). In 1893 Davis's reinterment in Richmond created another great Southern convulsion. His truth was marching on, and his portraits marched with it.

Robert Penn Warren would write: "As a symbol of irrepressible principle, as the vicarious sufferer for his people, as the image of honor, Davis entered the hearts of his countrymen, to be called from city to city the eternal President of the City of the Soul into which the human disorder of the Confederate States of America had been mystically converted."²⁵ But the countrymen of Jefferson Davis were more than Americans. They were Southerners, who had repeated with Davis, as if in prayer, "Is it a lost cause now? Never."

Jefferson Davis's bitter enemies, Joseph E. Johnston and P. G. T. Beauregard, were the two generals besides Lee and Jackson who figured most prominently in prints of the Lost Cause. If the Confederate president had gotten his way, during the war or after, no doubt their pictures would have been turned to the wall. Yet they hung in many Southern homes—symbols, in a way, of Davis's unfavorable standing with some old Confederates.

Internecine strife, important as it was in Confederate military history—and though it constituted, in part, an explanation of Confederate defeat—was less important in the production of images after the war. Like the unsophisticated farmers Robert E. Lee encountered on his 1867 vacation, most Southerners, particularly as the decades advanced, would have been happy to see pictures of diverse Confederate heroes in their homes, including Davis, Johnston, Lee, Jackson, and others. The war of Confederate memoirs in which old generals tried to blame others for their defeats, like the often acrimonious politics of high command during the war itself, took place at a somewhat rarefied level, above the arena of popular domestic icons. The printmakers produced an abundance of group portraits of Confederate leaders that blithely ignored their internal struggles and aimed instead for inclusiveness. It is unlikely to have occurred to a printmaker that Johnston, Beauregard, and Davis hardly belonged in a harmonious group portrait. And such an idea was probably even less likely to occur to the print's simple purchaser. The existence of numerous group prints supplied a unity to Confederate command that never in fact existed. Almost every high-ranking general was individualistic enough to endanger command harmony, yet important enough to merit treatment in portrait prints.

If any further proof be needed of historian Thomas Connelly's assertion that Virginians played a larger role in shaping the Lost Cause than they did in shaping the cause itself, then the relative prominence of Joseph E. Johnston in postwar Confederate prints should surely suffice. Nothing in Johnston's Civil War career quite explains his prominent role as an icon afterward. He certainly held several important commands, but bad luck—bad judgment perhaps—and bad relations with Jefferson Davis kept him from the sort of successful career conventionally celebrated in prints.

Had it not been for Davis and Beauregard, Johnston might have been the horseman in the early Hoyer and Ludwig lithograph inspired by the first Battle of Bull Run. The expectations of the Confederate people, as well as Davis's own apparent reluctance to contradict the stories that the president personally led troops in the battle, surely robbed Johnston of some well-deserved early glory. Beauregard's personal flamboyance and prominent field role also helped diminish whatever share of the accolades Johnston might legitimately have garnered.

The wounds Johnston incurred at Seven Pines on May 31, 1862, came close to sidelining him for the rest of the war. They were not all that serious—he recovered physically by November of that year—but during his convalescence he had been succeeded by Robert E. Lee, whose battlefield brilliance shone too quickly and too brightly to allow General Johnston to return to his old command.

President Davis instead found work for him in the West, but this reassignment was the seed ground of bitterest enmity. By early 1863 one opinionated war department official would say with acerbity, but not without truth, that Johnston "never treats the Government with confidence, hardly with respect."[1] Johnston did not exercise or comprehend the power Davis intended for the Western command, and the general became as superfluous as he imagined Davis intended him to be. To powerlessness was soon added the insult of blame for the defeat at Vicksburg. Soon Johnston was in league, consciously or unconsciously, with

the president's avowed political enemies. Nevertheless, seniority and a dearth of Confederate military talent forced Davis to appoint Johnston commander of the Army of Tennessee in December 1863. Misunderstanding and rancorous disputes followed the next spring and summer, when Johnston conducted a skillful series of retreats toward Atlanta before William T. Sherman's forces. On July 17, 1864, President Davis finally relieved Johnston of command in favor of the pugnacious John Bell Hood, who promptly lost the Army of Tennessee as an effective fighting force. In February 1865 Robert E. Lee urged Johnston's appointment to command the Confederate forces fighting Sherman in the Carolinas. Davis complied. "It is too late now," Johnston remonstrated, "and he has only put me in command to disgrace me."[2] On April 26, 1865, Johnston surrendered to Sherman at the Bennett house near Durham, North Carolina.

By giving up, General Johnston gained a little of the lustre that surrender seemed ironically but inevitably to confer; irreconcilables did not fare as well in prints as repentant rebels did, at least not at first. Johnston, like Lee, was allowed by Currier and Ives to share some of the victor's limelight in *The Surrender of Genl. Joe Johnston Near Greensboro N.C. April 26th 1865* (fig. 108). The Confederate general was accorded a somewhat stiff dignity, especially by contrast with Sherman's rather candid pose, in this flawed and mediocre lithograph by the giants of American popular printmaking.

Most of the print's faults seem attributable to Currier and Ives's customary headline chasing. The background, drawn with only moderate skill (the Union orderly's tiny horse could almost be a merry-go-round pony), is distinctly out of perspective and might have been sketched by another hand than the one that executed the Sherman and Johnston portraits. Those were above average for Currier and Ives, in particular the Sherman portrait (especially from the knees up).

The Johnston portrait was too fat by far for that lean little gamecock and was also out of date. The Confederate general had gray hair and a distinctly worried look in his wartime photographs. Currier and Ives used, instead, a Mexican War era image as their model. The artist had to doctor the general's antebellum uniform, which after all had been issued by the army he opposed throughout the Civil War. The printmaker obviously consulted few other sources, as Johnston's coat lacked the paired buttons shown in other Civil War portraits. The lack of research is also conspicuous in the anonymous landscape and in the failure to attempt any picture of the Bennett house, where the surrender took place. (The house was famous enough later to inspire a print without the generals in it.) As usual, Currier and Ives were pursuing ephemeral profits with such prints and felt little burdened by any responsibility to live up to the standards of historical painting.

The Bennett house surrender itself was an anticlimax and therefore never inspired other engravings or lithographs of the Johnston-Sherman meeting—a far cry from the plethora of commemorative graphics inspired by Appomattox. Besides, William T. Sherman lacked presidential ambitions, whereas Grant's political hopes had doubtless helped stimulate the production of Appomattox prints. Actually, on April 26 Sherman and Johnston were meeting at the Bennett house for the third time in ten days. Sherman's original surrender terms had been rejected by the United States War Department for touching too many political matters, and the incident proved controversial enough that Sherman was doubtless relieved not to see any additional Bennett house prints to remind the American people of the hard-bitten general's political naiveté. Johnston's surrender, no matter what the terms, simply was not the event Lee's was. As Sherman expressed it in his smoothly written memoirs, news of Lee's surrender, which reached Sherman's army on April 12, "created a perfect *furore* of rejoicing, and we all re-

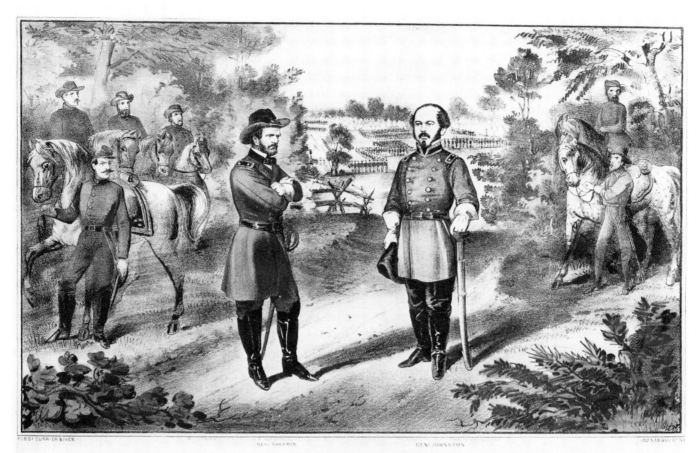

THE SURRENDER OF GEN! JOE JOHNSTON NEAR GREENSBORO N.C. APRIL, 26TH 1865.

Figure 108.
Currier and Ives, *The Surrender of Genl. Joe Johnston Near Greensboro N.C. April 26th 1865*. New York, [1865]. Hand-colored lithograph, 7¹¹/16 x 12⁵/16. The artists at Currier and Ives seem to have known nothing about this event beyond the fact that Johnston surrendered to Sherman. Therefore they relied almost exclusively on myth (note that the Confederate aide at the right rear wears a cavalier plume in his hat) and on artistic conventions (which suggested the neat rows of ceremonial troops depicted in the background). (*Louis A. Warren Lincoln Library and Museum*)

garded the war as over, for I knew well that General Johnston had no army with which to oppose mine."[3]

Johnston's rank, if not his actual battlefield performance, was exalted enough to generate some portraits during the Civil War. The *Southern Illustrated News* published a fairly accurate, if somewhat murky, woodcut based on a Vannerson photograph, and a London lithographer published a handsome oval portrait modeled on the prewar photograph that Currier and Ives would still be using in 1865 (fig. 109).

Knoedler and Goupil copublished another engraved portrait, reversed from the photograph and of uncertain date, and A. G. Campbell of New York also issued a handsome engraving (plate 18). William Sartain's similar oval portrait was one among several postwar mezzotints of Confederate heroes that the Philadelphia engraver published in the same format.

Group portraits confirm Johnston's high station as a hero of the Lost Cause. In such groupings, proximity to Robert E. Lee seems to be the principal measure of importance, and by that standard Johnston fared well. In three of them, for example, Johnston forms one part of a focal triad with Lee and Jackson. Lee always held the center, but Johnston ranked more or less with Jackson in Tholey's *Lee and His Generals* (see plate 12) and in the A. B. Graham Company's *Lee and His Generals* (see fig. 89), published in 1867 and 1907 respectively. Johnston even managed to retain or improve his pictorial importance in Frederick Bourquin's transformation (see fig. 7) of a Goupil group scene (plate 2), from a Davis-Beauregard-Johnston to a Davis-Lee-Johnston triad.

In other words, Johnston not only maintained his status as a Confederate hero, but he might actually have improved it as the years passed after the war. One of the reasons was his early, self-serving salvo in the famous *Narrative of Military Operations*, published in 1874, which beat most similar reputation-savers to the market by more than five years. There was, however, a wide gulf separating those who comprehended detailed military history from those less sophisticated Southerners who merely felt some fealty to the same cause Johnston had served.

The *Narrative* was a temporary help, but over the long run it could not salvage Johnston's military reputation. For, if it could be said that he never lost a battle in the Civil War, it could as accurately be said that he never won one, either. Bull Run's laurels he had shared with Beauregard (and Davis, for a while), and Kennesaw Mountain rendered only a fleeting tactical advantage, followed by continued retreat before Sherman.

A clue to the surprising iconographic success of such a curiously unaggressive military figure can be found in a Johnston mezzotint, engraved by A. B. Walter and printed by Bradley and Company in 1873, then distributed as a fund raiser for the Lee Memorial Association by Cincinnati's W. W. Bostwick and Company. The association was not only dedicated to promoting Lee's reputation; it was, as Thomas Connelly has suggested, also protective of Virginia's reputation. Johnston's background helped his fame surpass a maddeningly passive military performance: he was a Virginia cavalier somewhat in the mold of Robert E. Lee, the greatest hero of the Confederacy and the Lost Cause. Johnston's father had served under "Light Horse" Harry Lee in the American Revolution, and his mother was Patrick Henry's niece. Joseph was to marry the daughter of a member of Andrew Jackson's cabinet. He went to West Point and became a professional soldier, serving in three wars in which he suffered some nine wounds.

Despite his wounds, Johnston lived until 1891. After the war, his record was not as aristocratically impeccable as Lee's. Johnston left Virginia for Savannah and embraced a commercial career in the insurance business, an opportunity similar to the ones Lee rejected. Before Lee died, Johnston posed with him in Savannah for two famous photographs that tend to obscure Johnston's jealousy of Lee during the war. In 1877 he returned to Virginia, was elected to Congress

Figure 109.
Day and Son, *Genl. Joseph E. Johnston.* [England], n.d. Lithograph, 4⁵⁄₁₆ x 3⁷⁄₁₆ inches. Unlike successful politicians, American soldiers had few occasions to sit for photographs. Men like Johnston, Jackson, and Lee had posed for the camera in the Mexican War era and then rarely again until the Civil War. This English lithograph preserved Johnston's Mexican War appearance. By contrast, during the Civil War Johnston was a grizzled veteran of several military campaigns, and he looked it. (*Virginia Historical Society*)

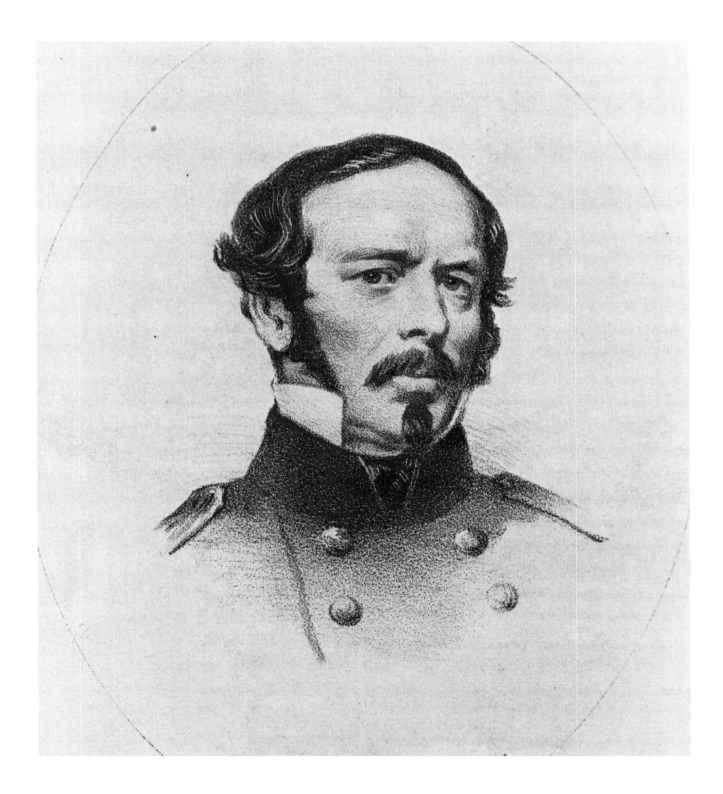

from Richmond the next year, and eventually moved to Washington, D.C., where he died. His skills as a general, bolstered retrospectively by his skills as a memoir writer and enhanced by his proper Virginia background, served this deeply flawed Confederate well, or so it appeared in Lost Cause prints.

Johnston's rival for Bull Run fame, Pierre Gustave Toutant Beauregard, was the Confederacy's first genuine military hero, and the impetus of that early surge of popularity was almost enough to overcome later problems with his reputation: his penchant for grandiose but impractical plans, his bitter feud with President Davis, and his failure to gain the highest commands in the South for any substantial periods. Early success also helped obscure certain facts that could never aid a heroic reputation in North or South, including a Gallic name, a French accent, and adherence to the Roman Catholic faith. Where religion was concerned, at least, the Confederate South seems to have been more tolerant than the North. For one reason or another, the Union never produced a Catholic hero of the Civil War as important as Beauregard. And Abraham Lincoln's cabinet, unlike Jefferson Davis's, contained no Jews. Dixie's color line tended to draw whites of all faiths and backgrounds closer together, perhaps, even as it more firmly excluded blacks.

Command at the bombardment of Fort Sumter, followed rapidly by field command at Bull Run, combined with a handsome and somewhat exotic appearance to make Beauregard the Confederacy's most celebrated military hero of 1861. After the battle at Bull Run, promotion to full general made him the fifth ranking Confederate officer, but in the hearts of the people he was surely first at that moment.[4] Although no separate-sheet lithograph or engraving of Beauregard bearing a Confederate imprint has been identified, wartime sheet music certainly spread his fame and his countenance. Beauregard's popularity in this genre was aided by the fact that he achieved fame before the Confederacy lost New Orleans and there-

with much of its ability to publish sheet music with handsome lithographed covers. And, of course, it did not hurt his cause with the New Orleans sheet music industry that he came from Louisiana. It was no doubt with special zeal that New Orleans's P. P. Werlein and Halsey published the "Beauregard Bull Run Quick Step," with a lithographed equestrian portrait by Wehrmann, and A. E. Blackmar and bro[thers] published "The Beauregard Manassas Quick-Step," with a portrait on the cover drawn by the Confederacy's black artist, Jules Lion. Blackmar, who also ran an operation in Augusta, Georgia, issued "The Beauregard Manassas Quick-Step" there, with a lithographed cover portrait by B. Duncan and Company.

In fact, Beauregard briefly became the Confederacy's only presidential contender besides Jefferson Davis. As the first Battle of Bull Run was fought well before the November 5 election that would change the provisional government to a permanent one, some people urged Beauregard to run against Davis. But he was probably no more popular at this point than the provisional president, who, incidentally, could match Beauregard's impressive showing on sheet music covers with various Jefferson Davis grand marches (although only two known examples bore lithographed portraits on their covers).[5]

Early in 1862, Beauregard moved west to become second-in-command to Albert Sidney Johnston. The Creole general played an important role in the sanguinary battle of Shiloh, which resulted in the first really heavy casualties of the Civil War and forced an eventual Confederate retreat. He received his first widespread criticism for his conduct of that battle after his superior, General Johnston, died on the field. Jefferson Davis was itching to remove him and finally did so in the summer of 1862. In September Beauregard went to Charleston, South Carolina—the site of his and the Confederacy's first great triumph at Fort Sumter—to supervise the defenses there.

Despite the lack of glamour and the decidedly sec-

ond-rate importance of the assignment, Beauregard's successful defenses of Charleston in the spring and summer renewed the momentum of his fame and probably spurred publication of one of the most arresting portraits ever published in the *Southern Illustrated News* (see fig. 9); it also resulted in yet another illustrated sheet-music cover, "Beauregard's Charleston Quickstep," with music by L. Shreiner and a lithographed portrait by E. Crehen. J. F. Weeks printed the composition for J. C. Schreiner and Son of Macon and Savannah, Georgia. The remote geographic location of these music publishers may have made them especially appreciative of coastal defense and willing to celebrate events other than those on the Virginia front.

In the spring of 1864, Beauregard was assigned to defend the southern approaches toward Richmond. He successfully protected Petersburg from Union forces led by the inept General Benjamin F. Butler and later became part of Lee's army when the Virginian moved to Petersburg to meet the Army of the Potomac's latest southern approach. Beauregard returned to the West in the fall and finally ended the war with his old friend Joseph E. Johnston in North Carolina. Jefferson Davis's continuing hatred had excluded Beauregard from the more important commands for two years.

This deliberate exclusion diminished Beauregard's chances for fame during the war but hurt him less afterward than would have been the case, perhaps, had Davis's own reputation not fallen so precipitously. To have quarreled with President Davis did not prove to be the badge of shame that similar quarrels with President Lincoln bestowed on some Northern generals. Naturally Beauregard, with his distinctly continental surname, enjoyed a following in European prints that would otherwise have been surprising, given his relative obscurity as a military commander after the spring of 1862. Both a French and an English separate-sheet print of him exist. At least two American separate-sheet prints were made, doubtless after the war; one is in William Sartain's series and the other is a handsome

line-and-stipple engraving by H. F. Baker (fig. 110). Beauregard appeared grayer and tireder-looking in a French lithograph, *Général G. T. Beauregard* (fig. 111). A decidedly heroic battlefield scene published in Philadelphia in 1867 (fig. 112) recalled the early glories of Beauregard's flamboyant career.

Group portraits more accurately reflected the fall of Beauregard's wartime heroic reputation. The early Goupil depiction of Jefferson Davis and his generals (see plate 2) showed Beauregard next to the president in the front row. Years later, when Bourquin revised the print (see fig. 7), Beauregard was shunted to the back row and replaced in the foreground by Lee. But for a year, at least, from July 1861 to July 1862, the great Creole could lay claim to a fame exceeding even Lee's. Their competition for reputation may have been conscious, at least on Beauregard's part. The two men followed different courses after the war, with Beauregard becoming a successful railroad entrepreneur and businessman while Lee opted for the paltry salary, but near-clergyman status, of a college president. In 1885 Beauregard's ghostwriter and chief literary champion, Alfred Roman, wrote his hero cynically about their forthcoming article, which was critical of Lee: "[S]hall we not forcefully touch upon the anointed of the Lord —the immortal Virginian—the greatest warrior of all the centuries next to Grant? You shall be mauled! Happily it will be you, not I."[6]

In truth, Beauregard had long ago been mauled in military reputation by Robert E. Lee. The remarkable aspect of Beauregard's image was its staying power, despite Jefferson Davis's success in relegating him to rather obscure commands. As late as 1896, the Southern Lithograph Company—located, despite its name, in New York—featured Beauregard with Stonewall Jackson and Robert E. Lee as the central portraits of *Our Heroes and Our Flag* (see plate 15). Probably without knowing it, the lithographers chose as a photographic model an appropriate Beauregard portrait from his black-haired Sumter and Manassas glory days.

Figure 110.
H. F. Baker, *Gen. Beauregard, C.S.A.* N.p., n.d. Engraving, 6 x 5⅛ inches. Using a photograph taken before Beauregard's hair turned salt-and-pepper gray, Baker captured Beauregard's handsome appearance rather than the fierceness of the woodcut portrait in the *Southern Illustrated News* (see fig. 9). Line and stipple offered a more subtle range than the rough wood engraving, which seemed best for men of the Stonewall Jackson stripe with straightforward images. (*Eleanor S. Brockenbrough Library, Museum of the Confederacy*)

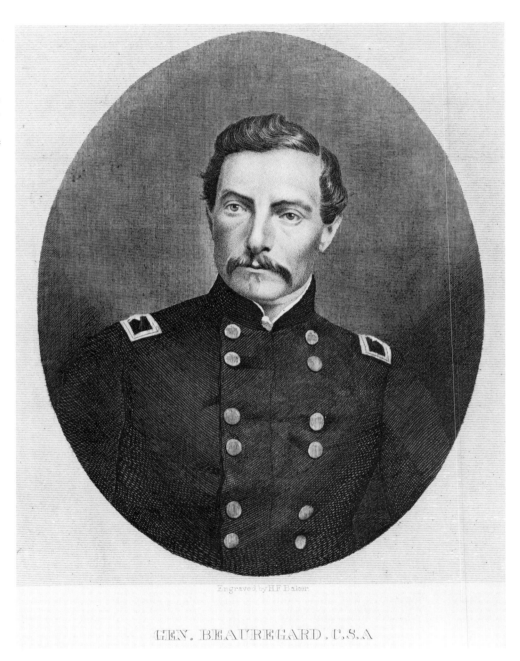

Engraved by H.F. Baker

GEN. BEAUREGARD, C.S.A

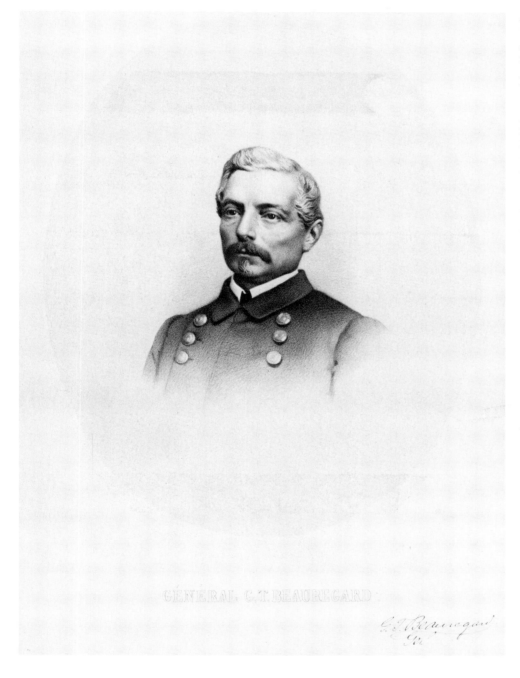

GÉNÉRAL G. T. BEAUREGARD

Figure 111.
[Printmaker unknown], *Général G. T. Beauregard* [with facsimile signature]. Lithograph. Arthur Fremantle, who toured the Confederacy in 1863, said of General Beauregard: "He would be very youthful in appearance were it not for the colour of his hair, which is much greyer than his earlier photographs represent. Some persons account for the sudden manner in which his hair turned grey by allusions to his cares and anxieties during the last two years; but the real and less romantic reason is to be found in the rigidity of the Yankee blockade, which interrupts the arrival of articles of toilette." Though widely referred to in characterizations of the Creole general, this quip, it should be noted, came from an Englishman and embodied a national stereotype in its belittling suggestion of hair-dyeing vanity. (*Anne S. K. Brown Military Collection, Brown University*)

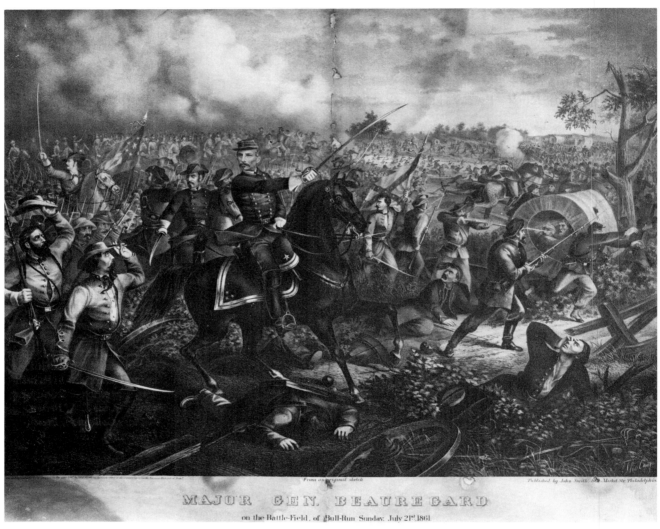

Figure 112.
Tholey, *Major Gen. Beauregard on the Battle-Field of Bull-Run Sunday, July 21st. 1861*. Published by John Smith, Philadelphia, 1867. Lithograph. This print depicts the final rout of Union forces in the first great battle of the Civil War. During the war, hasty prints of Confederate victories appeared in the North, salable because of their news value. And by the 1880s Southern victories were depicted in series of prints collected, no doubt, in number and valued in part for the inclusiveness of their historical record. But a print showing a Confederate victory, published in 1867 in the North, was a rarity and must have sold almost exclusively in the South. (*Confederate Memorial Hall, New Orleans*)

Only Beauregard and Johnston shared some real iconographic importance with Lee and Jackson. There are, of course, other scattered portraits of various Confederate generals: for example, Albert Sidney Johnston, by Perine (published by James A. Hummel in Louisiana in 1867); John C. Breckinridge, by Kurz and Allison; John Hunt Morgan, by Kurz and Allison; A. P. Hill, by J. L. Giles; and Richard S. Ewell, by an unknown engraver. These prints provide a few insights into the Lost Cause and, it must be admitted, many mysteries. There was nothing mysterious, though, about the scarcity of portraits of General James Longstreet. It seems a near-miracle that two survive: one, a handsome lithograph by J. L. Giles for George E. Perine of New York (fig. 113); and the other, a fine engraving made in France by Goupil et cie. Longstreet was a general of prominence and probably deserved more iconographic attention than Nathan Bedford Forrest, who also enjoyed the honor of at least two lithographic portrayals. But production of Lost Cause prints was determined by postwar myth as much as wartime performance, and there was good reason to shunt Longstreet aside for other heroes.

For one brief period after Stonewall Jackson's death, Longstreet held a command of great importance that might have led to his assuming Jackson's former status as second only to Lee. Indeed, he held important commands throughout the war. Until the very end, Longstreet was among those who urged continued resistance. But once the war was over, he quickly embraced "practical reconstruction and reconciliation," as he told a New Orleans newspaper in 1867. The "sword," Longstreet explained, "has decided in favor of the North," and Northern principles, therefore, "cease to be principles and become law." He became a Grant political appointee and an avowed Republican in 1869. From then on, the great majority of white Southerners shunned him. The Giles and Perine lithograph might well have been produced before that date, for after-

ward Longstreet was regarded as a traitor to the Lost Cause. He may have been more acceptable in some Northern circles or in Europe, but he was not useful to Northern printmakers seeking Confederate heroes to sell in the South.[7]

Nathan Bedford Forrest, on the other hand, was pictured both by Perine and Giles, who produced Longstreet's only American-made portrait, and also by the giant of the popular-print industry, Currier and Ives (fig. 114). Forrest doubtless owed his surprising prominence not only to real military genius and to a tough record as a battler for the Lost Cause (he was a founder of the Ku Klux Klan), but also to the fact that, gifted with a talent for pungent and earthy phrase-making, he had the common touch. Born in Tennessee, Forrest was the son of a blacksmith and rose to wealth as a slave trader and planter. He could read only with difficulty, as Yale-educated General Richard Taylor noted, but he spoke the idiom of the people. And he spoke a distinctly unromantic and noncavalier tongue; he was famous less for gallantry than for getting there first with the most men. Though his men rode horses, Forrest shrewdly broke the link with knightly cavalrymen of the past by using his men exclusively as mounted infantry who rode to battle but fought on foot once they got there.[8]

Forrest's image serves as a reminder of the ever-present competing strand of distinctly noncavalier image making. There was nothing cavalier in this man's reputation, which was marred by the charge that he allowed the murder of black prisoners of war at Fort Pillow. The existence of Forrest prints stands as a warning against overemphasis on the cavalier theme and a reminder that Southerners, even the sectionally self-conscious ones, never constituted a monolith of gentility.

It is instructive to consider not only the various subjects who were treated in prints but also those who were not, though by all logic they should have been.

Figure 113.
J. L. Giles, *Gen. James Long-street*. Lithograph with tint-stone, 12 x 9⅞ inches. Published by Geo[rge]. E. Perine, New York, n.d. For a brief period during the Civil War—between Chancellorsville and Gettysburg—Longstreet stood in Stonewall Jackson's place as second only to Lee. He soon fell from that exalted height, but not precipitously, and his military record did not deserve the near iconographic oblivion that Longstreet suffered. This lone American print was probably published before the former general became a Republican office holder. Its rarity testifies to the pictorial fate of Southerners who appeared too eager for sectional reconciliation. (*Virginia Historical Society*)

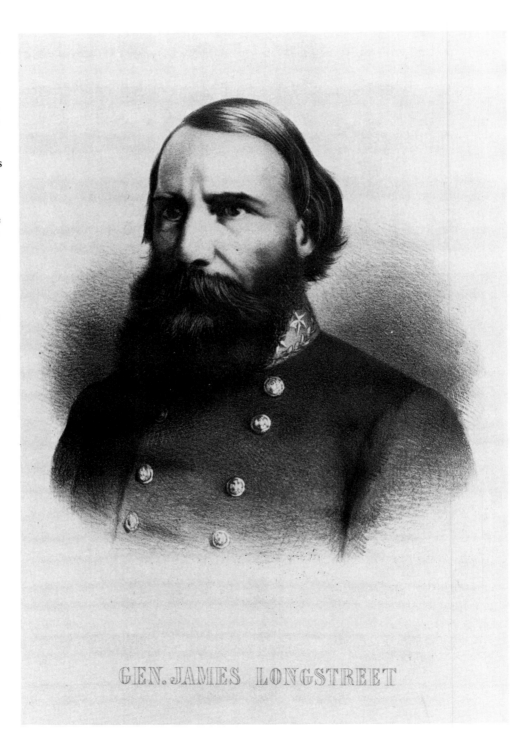

GEN. JAMES LONGSTREET

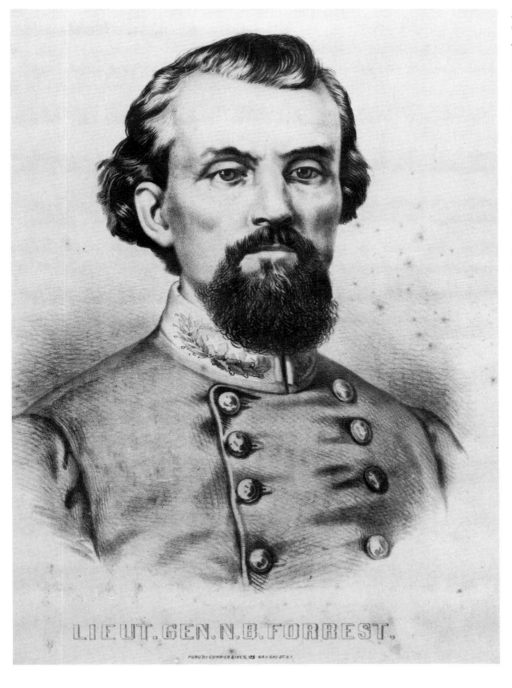

LIEUT. GEN. N. B. FORREST.

PUB'D BY CURRIER & IVES, 125 NASSAU ST. N.Y.

Figure 114.
Currier and Ives, *Lieut. Gen. N. B. Forrest.* New York, n.d. Lithograph, approx. 12 x 8 inches. The Confederacy's great cavalrymen—J. E. B. Stuart, Nathan Bedford Forrest, John Hunt Morgan, and John Singleton Mosby—fared indifferently in prints. The cavalier myth seems to have been of little help to them, despite the fact that knights were presumably mounted warriors. Forrest, famous for the unheroic military dictum to get there first with the most men, surely could not have owed his portrayal in a Currier and Ives print to any cavalier image. (*Perkins Library, Duke University*)

J. W. RANDOLPH RICHMOND Vª
LITH BY E OFF FN

Figure 115.
E[rnest]. Crehen, "Riding a Raid." Sheet music cover, published by J. W. Randolph, Richmond, n.d. Lithograph, 7⅜ x 9⅝ inches. The song behind this striking cover celebrated Jeb Stuart with this verse: "Now each cavalier that loves Honor and Right, / Let him follow the feather of Stuart tonight." Crehen was a competent portraitist, but only a fair portrayer of horseflesh. Stuart's mount in this lithograph bears some resemblance to the improbable horse on which Jefferson Davis was mounted in the Hoyer and Ludwig lithograph depicting the president's entry on the field of Bull Run. (*Library of Congress*)

The most obvious of the latter would be, of course, J. E. B. Stuart, whose wartime cavalier appeal led to the production of a rare Confederate imprint (see fig. 17) and two fine illustrated sheet-music covers, one of them a very cavalier equestrian portrait (fig. 115). But Stuart's death in battle in 1864 failed to prompt the Lost Cause image making that might have been expected. Whereas Stonewall Jackson emerged as puritan martyr, no corresponding cavalier martyr attained icon status. Perhaps martyrdom simply is not a cavalier ideal.

Stuart seemed an ideal, even a self-conscious choice as a cavalier symbol. "All I ask of fate is that I may be killed leading a cavalry charge," he once said, but on the field Stuart was a better and more realistic cavalryman than his words implied. He never led a big cavalry charge during the Civil War, and, though he never adopted Forrest's forward-looking tactics, Stuart most often prudently retreated when his horsemen faced infantry, rather than other mounted men, in substantial numbers. He played a traditional role that was somewhat at odds with the realities of cavalry combat in an era of rifled firearms, acting the gay cavalier and maintaining a colorful camp with a retinue of foreign-born officers, artists, and entertainers suggestive of a medieval court's freaks and musicians. Writer John Esten Cooke was a cousin of Stuart's wife and was available to write colorful copy about this Confederate hero. Stuart's portrait appeared early in both the *Illustrated London News* and the *Southern Illustrated News*.[9]

Nevertheless, whatever cultural, economic, political, and artistic forces worked to generate images, they all failed Jeb Stuart, who, many Southerners thought, had failed Lee at Gettysburg. There is not a single known postwar separate-sheet print of this famous cavalryman.

Stuart's case provides further proof that the Virginia conspiracy to capture Civil War history, as described by Thomas Connelly, was a decidedly incomplete and

unsystematic one. Stuart was a Virginian of very respectable family, but Kentucky hero John Hunt Morgan enjoyed portrayal in a Kurz and Allison print while Stuart went unnoticed in the visual medium. Likewise, Virginia's great raider, John Singleton Mosby, whose exploits inspired more legends than those of any other Confederate hero, somehow failed to be portrayed in any known postwar separate-sheet lithograph or engraving. Mosby was like Stonewall Jackson in his ability to wring reluctant praise from his Union opponents. They called a section of Virginia "Mosby's Confederacy" out of grudging respect for his power there. Herman Melville wrote a poem about one of Mosby's exploits that was published as early as 1866. And the "gray ghost" affected cavalier dress à la Stuart: cloak lined in scarlet, hat with ostrich feather plume, yellow sash, and patent leather cavalry boots. But there the cavalier image ended. Mosby led a group of ragamuffins who were not always regarded as regular soldiers by the Union. He said in later years that his outlook on war, "not acquired by reading the Waverly novels," most closely resembled that of Grant, Sherman, and Stonewall Jackson. And, like Forrest, his career was marred by atrocity charges.

Nevertheless, his exploits were so exceptional that they should have been memorialized in some prints. Photographic models appear to have been available, and Richmond's Ayres and Wade published a fine oval

woodcut likeness of Mosby in their 1864 book, *The War and Its Heroes*. They realized that the "exploits of Major Mosby would furnish material for a volume which would resemble rather a romance than a true statement of actual occurrences." Mosby prints in one tradition of Confederate heroism or another might well have appeared had his postwar activities not doomed him to Longstreet's fate. In 1872 he supported the Republican Grant for president, and five years later he accepted appointive office from the Republican Hayes administration. No myth could overcome the reality of membership in the Republican party in the postwar South. There would be no prints of John Singleton Mosby.[10]

As potent as Virginia and the cavalier image became, they were far from omnipotent and by no means dictated the future status of all Confederate heroes. If proper Virginia background helped Joseph E. Johnston's image, despite his unaggressive military record, it curiously failed the gallant Jeb Stuart, his spectacular triumphs notwithstanding. And an antithetical cavalryman like Nathan Bedford Forrest fared better in prints than some more cavalier Virginia heroes. But some element of defiant pride was necessary in any Lost Cause hero. The cause of ardent reconciliationists like Mosby and Longstreet was lost in the postwar South.

14 / Radical Nostalgia:
The Soldier-Artists of the Confederacy

Nostalgia seems an unlikely quality to find in army veterans, yet they are a notoriously nostalgic lot, old generals and privates alike. "Telling war stories," after all, is common slang for reminiscing about times gone by. Although some veterans try to forget their military life, many others do not. Artists who have served as soldiers seem to be no exception—at least they rarely were in the nineteenth century. One legacy of these soldier-artists was the evolution of nostalgic conventions in battle art.

Nostalgia, it is worth noting, is selective memory, and throughout the nineteenth century art showed a markedly selective approach to warfare. Edouard Detaille, one of the greatest military artists of the late nineteenth century, provides an illuminating example. He knew, as his biographer tells us, that to excel at painting military subjects he must heed both the advice of Diderot to "Follow the armies, go, see, and paint," and the wisdom of Charlet that "The true military painter must sketch everything under fire." Yet witnessing war made all of them realize that verisimilitude could be carried only so far.

Detaille followed the advice and the wisdom. Despite being exempt from service because his mother was a widow and his brother was already under the colors, the young artist followed the French armies in the Franco-Prussian War as a member of a general's staff. He saw much combat, but he refused to paint casualties accurately. His artistic memory was, in a word, selective.[1]

Detaille was an artist of another lost cause—France's defeat by Prussia—so it is perhaps not surprising that the Confederacy had its artistic chroniclers too, nostalgic veterans like Detaille who knew the real look of war but never showed the whole picture. In fact, artists proved to be among the most unreconstructed of rebels. They exerted substantial influence on the Confederate image, though they were few in

number. The failure to woo Maryland into the Southern camp and the early loss of New Orleans deprived the Confederacy of its artistic centers as well as its graphic ones. Of the twenty Southern painters discussed in Jessie Poesch's *Art of the Old South*, who were alive during the Civil War and for whom detailed information is available, over half of them (eleven) worked in New Orleans or Baltimore. Half had been born in Europe, and the Union blockade cut the fledgling slave republic off from this important source for new artists.

Most of the artists in Poesch's study were too old to fight in the Civil War. But of those four under forty-six years of age for whom information is available, one served in the Confederate army, one fled to Paris from Baltimore, one had enjoyed a successful career in New York for a decade before the war and fought for the North despite his Virginia origins, and one remained a civilian throughout the war. However, the last-mentioned, W. D. Washington, painted the most famous patriotic picture executed in the Confederacy, *The Burial of Latane*. One of the older artists discussed by Poesch died while experimenting with a "chemical compound" for the Confederacy. And another, who lived in Italy, probably prompted his son to enlist when he said that he would have returned himself to fight for his native Virginia were he not too old and deaf. There may have been few camp artists among the native chroniclers of the cause, but the artistic spirit seemed definitely ready to serve.[2]

It could be said that in all of Southern history the largest infusion of artistic talent into the region came during the brief four years of the Confederacy. But that talent was brought by the Northern armies and the Northern illustrated newspapers that covered their exploits. Of all the artists who executed works in Virginia in the three centuries before 1900, one in twenty were Union soldiers or artist-correspondents for illustrated newspapers chronicling the Civil War. These included

some of the greatest artists ever to paint Virginia sub-
jects: Winslow Homer, Albert Bierstadt, and Sanford
Robinson Gifford. They included the Prince de Join-
ville of France, who dabbled in watercolors and ob-
served the American war as a member of Union Gen-
eral George B. McClellan's staff. And they included
David Gilmour Blythe, the heavy-handed allegorical
painter from Pittsburgh.[3]

The Virginia scenes painted by the more famous of
these men have been noted and studied, but there is
another large body of works, many of which became
the models for popular lithographs and engravings,
that has been overlooked—the works of the Yankee
soldier-artists. Lieutenants, captains, colonels, ma-
jors, and even privates, they painted numerous South-
ern scenes showing the sites of Union encampments
during the Civil War. As subjects for prints in the
home, these may appear at first glance rather unheroic;
the hospitals, prisoner of war camps, log huts of inac-
tive winter quarters, and training camps in obscure
Virginia locations that they depicted are all mostly
forgotten to history. These works, of course, were not
icons; they were picture postcards, so to speak, drawn
to show the folks back home in New England or New
York or Pennsylvania the setting of a soldier's life. Or
perhaps they were mementos carried home by the vet-
erans themselves, to be hauled out of trunks in later
years to show the children who asked their fathers,
"Where were you during the war?" Although improb-
able as subjects for prints, they were nonetheless pro-
duced with surprising frequency, ephemeral windows
on a transitory existence.

As revealing images of the Confederacy, these prints
do not amount to much. At most, they may give a little
glimpse of the dreary desolation of Virginia battle-
grounds, where whole forests were leveled by huge
armies in need of clear fields for artillery and rifle fire,
logs for firewood, and huts for winter encampments.
Yet so scarce are Confederate images printed during

the Civil War that some Southern repositories collect
them as "views" of their state.

Many of the prints were published in Maryland,
no doubt because Baltimore printmakers, who were
close to the Virginia front and to the many Union
camps and garrisons in Maryland, could most quickly
and cheaply obtain the artists' views necessary as mod-
els and could likewise efficiently distribute the fin-
ished prints. Baltimore's Edward Sachse and Com-
pany, for example, lithographed a great number of
camp scenes. Max Rosenthal of neighboring Philadel-
phia also specialized in such work and visited about
150 Union camps in 1862–63, making sketches for
lithographs by his brother Louis.[4] Boston lithographer
John Henry Bufford published several views of the
Southern camps of Massachusetts troops.

Among the little-known Union soldier-artists of this
genre was the talented Otto Boetticher, who created
Confederate images of some importance. Born around
1816, probably in Prussia, Boetticher established a
studio in New York City in 1851. He served as an
officer of the Sixty-eighth New York Volunteers during
the Civil War. In 1862 he was captured by Confederate
forces and imprisoned briefly at Libby Prison in Rich-
mond before being moved to the prison in Salisbury,
North Carolina. From a watercolor by Boetticher, now
lost, Sarony, Major, and Knapp lithographed in colors
a rather serene depiction of Union prisoners—proba-
bly officers (plate 19). Published in 1863, the print
was a far cry from the more customary and perhaps
slightly more realistic prison camp atrocity pictures
that enjoyed a vogue in the North from this time until
well after the Civil War. Boetticher's scene showed
such well-nourished, relaxed, and happily occupied
soldiers, in such sanitary surroundings, that Goupil
et cie of Paris and London—two European capitals
more likely to produce pro-Confederate than pro-
Union prints—adapted the image as a print. Boetticher
produced the model for yet another prison print based

on his subsequent experiences in Salisbury, a famous picture not because of its Confederate prison context but because the Union prisoners in it are playing baseball. Boetticher's print was perhaps the first depiction of the future national pastime.

None of Boetticher's work suggests that his experience as a prisoner of war particularly embittered him toward the Confederacy. This is especially true in his 1866 watercolor of Grant and Lee, which served as the basis for the fine lithograph by Louis Maurer (see fig. 42). The focus of the print was the handsome figure of Ulysses S. Grant, but Robert E. Lee, though somewhat upstaged, was allowed full dignity in his pose. As with most Appomattox depictions, this one was primarily a Grant print and was an image of surrender that few Southerners, if any, would have opted to display on their walls. But it showed the quick willingness of Northern artists, even one who experienced war firsthand, to treat "rebels" fairly.

Virginia's own artists were a loyal group, but there were not many of them. Of thirty-six Virginia artists aged sixteen to forty-five at the outbreak of the war, sixteen served in the Confederate army, one served in the Union army, and three spent the war years in Europe or the North, where opportunities for artists were far greater. The occupations of the remaining fifteen are unknown, though it is fairly unlikely they served in the Confederate armed forces. Of those who did serve, six were placed in the engineers or the topographical bureau, where their artistic skills were no doubt put to good, if uninspiring, use.[5]

Among the infantrymen and artillerymen, however, were three young artists destined to garner considerable fame as Confederate soldier-artists; all played important roles in creating the generation of Lost Cause prints. The essence of their artistic endeavor might best be characterized by adapting the idiom of Northern "bloody shirt" orators of the postwar period. Those Republicans were telling Union veterans to "vote the way they shot"—against the South. Confederate soldier-artists, conversely, painted the way *they* shot—against the North. And their audience appreciated their work precisely for that animus. Several years after the war one of these artists, Conrad Wise Chapman, sent an old army comrade photographs of his sketches from their campaign; the artist's friend was delighted and begged for more: "Send me photographs of all your war sketches. I will value them highly, both as productions of your talent and labor and as mementos of that blissful time for the return of which I most devoutly pray, when it was lawful to kill Yankees."[6] In 1885 an anonymous admirer from Lynchburg, Virginia, the son of a Confederate soldier, told another soldier-artist, Allen C. Redwood: "I am proud that at least one writer and artist defends his old State and that his heart is still as true as when he wore the Gray and 'toted' his musket with his almost idolized Commander[.] Some like [George Washington] Cable and Mark Twain have bowed the knee to the Northern Calf, but Jackson's foot cavalry are as true now as when he was with them, true every time."[7]

The separate-sheet prints derived from the works of Redwood and Chapman, as well as from a third artist, the immensely successful illustrator and sculptor William Ludwell Sheppard, allow us only a small and fragmentary look at their *oeuvre*. Surveying the rest of their work and putting the prints in intellectual and artistic context reveal an ideology of the Lost Cause based on Southern rights, honor, white supremacy, and—rather than full admission of defeat—the assertion that the Confederacy was overpowered by a flood of Yankee men and materiel. Most modern Southern critics have seen in their works a "marvelous visual record of the soldier's life behind the lines and at the front during the War Between the States," but even more than historical recording, a Lost Cause ideology pervaded the artistic vision of the famous Confederate soldier-artists.[8]

In the strange career of Conrad Wise Chapman, the man's artistic proclivities are more easily explained than his ardent Confederate sympathies. He was the son of prominent Virginia-born artist, illustrator, and etcher John Gadsby Chapman, who moved to Europe in 1848. The boy, who was named for his father's friend, Virginia Governor Henry Alexander Wise, lived in Europe from age six to nineteen, from 1850 on in the legendary artistic environment of Rome. Yet when news of the Civil War reached Italy, the younger Chapman returned to enlist. Although the senior Chapman apparently told his son pointedly that he would return to America to fight if he were not quite so aged or hard of hearing, Conrad's departure nevertheless displeased his parents, who spent the rest of the war attempting unsuccessfully to protect their son from harm by requesting his transfer to other regiments.[9]

On September 30, 1861, Conrad Wise Chapman enlisted as a private in the Third Kentucky Infantry. Nicknamed "Old Rome" by his fascinated comrades-in-arms, he made numerous sketches of camp life, including the model for the later etching, *Third Kentucky Confederate Infantry—at Corinth—May 11, 1862*, and a chromolithograph of the same scene (plate 20), which, although executed in London, nevertheless became one of the most famous prints ever published of a Confederate camp scene.[10]

The print evolved from a skilled oil sketch showing three men playing cards on a red blanket, in the foreground of a Confederate camp softly dappled by the shadows of trees. The sketch accurately captured the atmosphere of a Confederate camp, if we can believe Carlton McCarthy, who served with the Richmond Howitzers and who observed after the war: "The 'Boys in Blue' generally preferred to camp in the open fields. The Confederates took to the woods, and so the Confederate camp was not as orderly or as systematically arranged but the more picturesque of the two."[11] Comparisons with the "postcard lithographs" of Union

camps confirm McCarthy's judgment. Those prints show a more regimented order in the Yankee camps, whereas Chapman's camp, especially in the preliminary sketch, is more picturesque, if somewhat less systematically arranged.

Like the subsequently created painting and etching, the chromolithograph opened the scene up a good deal to let light fall on the panorama in the middle ground of the print, eliminating some of the atmosphere of forest shelter in the original sketch. Chapman added a cooking scene in the right foreground, an eating scene in front of the tent in the middle ground, and a self-portrait (the man at left leaning on his musket) based on a photograph taken after Chapman returned to Italy in 1864. Aside from the loss of tree shade, many of the additions added interest without sacrificing accuracy. Card playing, the focus of the scene in all its variants, was a nearly universal vice of Confederate camp life. Robert E. Lee's order of November 1862 recorded that he was "pained to learn that the vice of gambling exists, and is becoming common in this army." It was already common in the Army of Northern Virginia and every other Confederate army, and from all reports it remained common. And most gambling involved card playing.[12]

Chapman's picture also serves as a visual reminder that the Confederacy rarely provided field kitchens or cooks for its soldiery. Most soldiers cooked for themselves, and, though chickens and eggs would later become scarce, in the spring of 1862 they were certainly not rare in any Confederate camp.[13]

Chapman's was a superior rendering of Confederate camp life, but this first-rate scene was more than merely an accurate picture of the camp life of ordinary Confederates, for which Chapman and his fellow artists are customarily celebrated. By the time his father etched the scene (sometime after 1864) and by the time the London printmakers produced their bright chromolithograph, Chapman had inserted two elements that fit

the Lost Cause myth and were not present in the original sketch. One was the ubiquitous bare feet in the right foreground; the other was the blacks. To be sure, Confederate camps, and Union ones as well, had black people in them, but it is doubtful that any of the black men ever slumbered contentedly—as the figure in the very center of the print is doing—while white soldiers cooked and ate. Most blacks in camp would have been cooking, serving, or cleaning up at such times and not posing, Sambo-like, in lazy ease with straw hats pulled down over their dozing eyes. Chapman's figure derived not from experience but from Negro stereotypes in white men's art. By 1871, when the chromolithograph was published, Chapman had allowed the intrusion of the myth of the Lost Cause into his otherwise evocative visual memoir of Confederate camp life.

It is a wonder Chapman could accurately remember anything of that life, for at the battle of Shiloh, fought April 6 and 7, 1862, he seriously wounded himself, apparently in the head, while loading his musket. He was taken to the rear and later nursed back to health in a private home. Unless his recovery was rapid, the whole Corinth camp scene may be invented, for Chapman would have had to return to camp in about one month's time in order to have recorded the scene in person. The self-inflicted bullet may have taken off part of his skull, or so his second wife reported many years later. One of his commanding officers later in the war, however, remembered that Chapman never complained of his injury and described it merely as a neck wound that did not affect the spinal column. Whatever the truth, it was serious enough to be considered the likely cause of the mental illness that after the war troubled the young veteran, off and on, for the rest of his life.[14]

After the accident, John Gadsby Chapman pulled enough strings with Henry A. Wise to get his son transferred to Virginia and to the unit commanded by his old friend. Young Chapman himself wrote three letters to Wise in the summer of 1862 pleading for the transfer, saying that he had wanted to join up in Virginia from the start but had encountered trouble getting there from Europe, as he had traveled through the North after the war had started and wound up in Kentucky instead.[15]

Brigadier General Wise brought about Chapman's transfer to the Forty-sixth Virginia Volunteers at the end of the summer. Later Chapman transferred again to the Fifty-ninth Virginia Volunteers. Both units were stationed near Richmond and apparently saw little action while Chapman was with them. But they did provide models for four more sketches, two camp scenes and two picket or guard scenes, that were turned into etchings by his father after the war. These Virginia prints are less famous than Chapman's other war pictures. *The Fifty-Ninth Virginia Infantry—Wise's Brigade, Diascund Bridge—May 1863* (fig. 116), another forest camp scene, lacked the candid interest of the cooking, eating, and card playing in the Corinth print. It carefully included a stereotypical lazy Negro at left. Most of the other figures are apparently portrait likenesses, and good ones, too, if we can believe Chapman's fellow soldier William Barksdale Tabb, who wrote in 1867: "Of the figures in the foreground, Lou: Turner is very good, but, in the kindness of your heart, you have flattered me. You have made me more as I should have been than as I am: you have not shown the figure of a man six feet two inches, weighing one hundred and twenty five pounds." Tabb was a colonel by the time pictured in the print; he must be the figure on horseback in the foreground.[16]

From September 1863 to March 1864 Chapman was detailed to make paintings of the fortifications of the harbor at Charleston, South Carolina, apparently to document P. G. T. Beauregard's survey of the fortifications there. The resulting paintings, some of which also provided models for etchings by John Gadsby Chapman, had a low-horizoned, static, and arid quality evocative of an atypical and unspectacular aspect of the Confederate experience—seacoast fortification

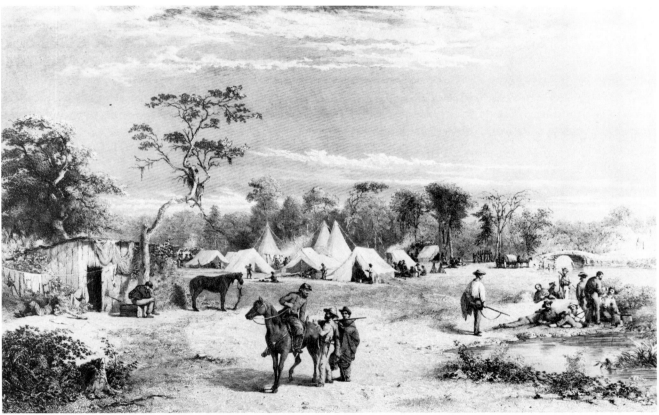

Figure 116.
John Gadsby Chapman, after Conrad Wise Chapman, *The Fifty-Ninth Virginia Infantry—Wise's Brigade / Diascund Bridge—May 1863*. Etching, 9½ x 13½ inches. The medium, and perhaps the way John Gadsby Chapman worked in it, gave the prints based on Conrad Wise Chapman's war sketches a static quality not usually present in the originals. The etchings, nevertheless, represented skilled work; they are rare not only for their subject matter but also for their quality. (*The Boston Athenaeum*)

duty.[17] But they may well be the most famous of all Confederate works of art, for the simple reason that they were early acquisitions of the Museum of the Confederacy in Richmond, where they have been displayed periodically for almost a century.

Chapman's works inspired more different prints than those of any other Confederate soldier-artist, but most of the etchings are quite rare and therefore little known today, and the unfortunate circumstances of his later life robbed him of some of the fame that would surely have come his way otherwise.

In 1864 he returned to Europe because his mother was ill. He fully intended to return to active duty, but by the time he got back to America, to Texas this time, the war was over. Chapman then went to Mexico, a refuge for die-hard Confederates, and served there with former generals John Bankhead Magruder and H. B. Lyon, who enlisted to aid Emperor Maximilian. When the emperor fell, Chapman was again without employment and entered the shiftless, penniless life he would follow the rest of his days. He liked war and he knew how to paint, but he seems to have been too mentally clouded ever to reach the promise so many saw in him. Chapman apparently had been prolific. "You ought to have collected materials enough to have made your fame & fortune," Wise observed. Another veteran wrote Chapman after the war, "I look upon you as the future truthful delineator of our struggle for life & liberty. . . . Work on—& some day—if not now—you will reap your reward."[18]

Under different circumstances, Chapman might have become a Southern Edouard Detaille. Both were artists and veterans of lost causes. But Chapman was never granted the abundant patronage that the French nation doled out to Detaille to raise morale for revenge against the Germans. One wealthy South Carolinian in Liverpool did commission Chapman to paint the legendary scene of the naming of "Stonewall" Jackson by General Bernard E. Bee at Bull Run and the wounding of Jackson at Chancellorsville, but the patron was ruined financially before Chapman got beyond the stage of mere research for the paintings.[19]

Truth to tell, it is not clear that the painter could have sustained the necessary effort. M. and N. Hanhart, who published the chromolithograph of Chapman's Corinth camp scene, promised a companion print in their advertisements, but it never came to pass, for by 1871, the year of the chromo's publication, Chapman had traveled to France and there had gone mad. He loved battle so much that he could not resist observing the Franco-Prussian War; some skilled oil sketches of Paris during the siege or commune showed promise. But he had been "flighty" for some time. Chapman's old Confederate comrades had seen in it only an artist's absent-minded preoccupation with a world other than the practical. He was apparently so scatterbrained that he lost most of his Civil War sketches. After his departure from France, he complained of the black devils, cut the moon out of a dark landscape called *All Quiet Along the Potomac Tonight*, wore ribbons in his hair, burned his sketches, and eventually threatened to kill himself and others. A London alienist diagnosed "monomania" and Chapman was dispatched to a private asylum in hopes of a cure. In three years he was released, much improved.[20]

Chapman married. After his wife's death, he left Europe for Mexico and married again. He painted some, but basically lived a hand-to-mouth existence. He continued to hate Yankees; when he got word of the outbreak of the Spanish-American War, he left Mexico, not so much to serve the hated United States as to serve the Old Dominion. Virginia, however, rejected the white-haired painter as a volunteer.[21]

Chapman remained in Hampton, Virginia, dreaming of painting Bernard Bee and Stonewall Jackson at Bull Run. He made sketches, obtained uniforms for models, and tried to scrape together enough money to hire men on horseback to sit for him. In a sort of haze, he

smoked Virginia cheroots, endured headaches, worried about unpaid bills, and argued with his black neighbors. For cash, he watercolored engravings of George Washington sent to him from a New York dealer and tinted photographs with oils. In some moods, Chapman could take an ironically humorous view of his own life, recognizing his inability to make money or sustain major work projects. But especially during quarrels with blacks, he saw himself as an unfairly neglected "Virginia gentleman." Chapman died of pneumonia on December 10, 1910, and was buried in the St. John's Church cemetery in Hampton. The exact location of his grave is unknown.[22]

The Confederacy's other two famous soldier-artists were more successful in the practical world, but the spirit of their work was not much different from Chapman's radical nostalgia. Allen Christian Redwood, though he gained considerable fame as an artist-illustrator, was responsible for only one separate-sheet Confederate print and must therefore receive briefer treatment here. Born June 19, 1844, in Lancaster County, Virginia, Redwood—significantly—was educated in Baltimore and New York before the war. He returned to Virginia after the fall of Fort Sumter and joined the Middlesex Southrons, a unit later absorbed into the Fifty-fifth Virginia. Campaigning with the great Stonewall Jackson, Redwood was slightly wounded and then wracked with disease. He gave up soft duty in the commissary department to return to the front—to Chancellorsville and then to Pickett's Charge, where he was again wounded. After recovering from his wound, he joined the First Maryland Cavalry early in 1864, saw much more fighting, and was finally captured just before Appomattox. He swore the oath of allegiance to the United States and was released in July.

Redwood took up residence in Baltimore, opened an art studio, did work for lithographers, and began to illustrate the memoirs of former Confederates. Balti-

more was a hotbed of Lost Cause sentiment, and Redwood's membership in the Maryland Academy of Art must have brought him into contact with fellow members Adalbert Volck and Innes Randolph, author of the poem "I'm a Good Old Rebel." In 1879 he moved to New York and began to write and illustrate articles for *Scribner's Monthly*. This connection led to his contributing over fifty pictures to the famous *Battles and Leaders* series.[23] This work, in turn, led to further invitations to illustrate books and articles of Confederate reminiscences. He thus kept in touch with old veterans and proved to be as nostalgic as any of them. Both his articles and his pictures endeared him to the old soldiers. The flavor of their response to his work is best captured in an 1885 letter to Redwood from an anonymous admirer in Lynchburg, Virginia, commenting on the artist's recent article in *Century*:

> Your article coming after so many of the so called Recollections of a Private is like reaching a cool spring after a hot and dusty march, that writer with his, "damnable iterations" of "you uns" and "we uns," must have made a specialty of captured "Tar Heels," from the Potomac to Danville I have not found the Virginian, white or colored, who used such expressions, I expect to read next in some of his papers that the best ladies of [the] South smoked corn cob pipes and used snuff, his articles are so much like Harpers Weekly during the war.[24]

Accuracy was what these letters always praised, and their writers had an eye for details that might escape the modern reader. It is certainly true, as this letter suggests, that North Carolinians were regarded as ungrammatical hicks by many Virginians. Yet despite its ring of authenticity and its craving for accurate depictions of the Civil War, this letter was more a product of the realm of myth than history. For its author was only "the son of a Confederate soldier." He knew the Lost

Cause, not the cause itself, and therefore he had no direct way of knowing whether Redwood rendered the Confederate military experience accurately or not.

Despite his Northern address, Redwood remained in the intellectual company of unreconstructed rebels. A lifelong bachelor, he had one well-documented romantic interest—the divorced daughter of Albert Taylor Bledsoe, a University of Virginia professor and one-time acting assistant secretary of war in the Confederacy whose postwar service to the Confederacy was the editing (and much of the writing) of the *Southern Review* in Baltimore. A sense of Redwood's political universe is aptly conveyed in a letter from M. T. Ducross, written to Redwood from New Orleans in 1866. The writer expressed his expectation that Redwood would soon be picking up his old musket again to "fight the radical mob in Baltimore." "If you do," Ducross went on, "please strike some blows for me & should you do[,] do strike hard & often—last July on the 30th we had a similar work to do in New Orleans, & we have done it like men." Ducross was referring to the bloody New Orleans race riot of 1866 in which thirty-seven Negroes were killed.[25]

In the later works of Redwood and his fellow soldier-artists, such intransigence was transformed into pictures that seemed inspired only by harmless nostalgia. The lithograph entitled *Charge of Maryland Infantry (C.S.), Gettysburg July 3rd. 1863* (fig. 117) was probably based on a watercolor sketch, which was in turn executed as a model for an illustration in *Battles and Leaders* in 1886. One of the admirers of Redwood's illustration complimented the artist on striking an accurate balance, for since Gettysburg it had been "Picket this & Picket that [and] I am tired of the whole thing." Portraying a fierce Confederate assault by units other than Pickett's famous brigade on Gettysburg's third day showed that other brigades deserved mention as well. Redwood certainly strove for accuracy, visiting the field in 1876 to sketch the terrain. But print-

making made its demands as well. The watercolor shows only two men in the flag group in the left foreground, but the preliminary sketch for the print and the lithograph itself show three. The casualty in the foreground was not heroically sprawling in the original watercolor; rather, he was curled up in almost fetal resignation. The wounded man at the right had no beard in the original. These alterations, some of them almost certainly more for compositional effect than substantive message, do not in themselves prove the work to be in any sense a piece of mythmaking. Yet it was, for the focus on the exploits of the Confederate troops from Maryland in the postwar prints was a considerable distortion of Confederate reality.[26]

To be sure, the Maryland Line fought fiercely for the Confederate cause, but true Confederates at the time, especially Virginians, regarded them with suspicion and a little disdain. The Confederate War Department ruled that Marylanders were aliens exempt from Confederate conscription, which caused considerable bitterness on the part of hapless Virginians. Jealousy and contempt were aimed not just at draft evaders, but even at wounded Maryland veterans. In Richmond's Chimborazo Hospital, Confederate authorities for a time removed all wounded Marylanders. Even when allowed to stay in Richmond's sickbeds, they gained treatment and food from the hospital matron only amidst bitter criticism from Virginia patients and authorities.[27]

The prominence of the Maryland Line in Confederate lithographs was not a result of personal artistic authenticity, either. Redwood served in the unit—but later, in 1864, and in the cavalry. He was not serving in the Maryland Line at Gettysburg.

The Maryland Line owes its considerable prominence mainly to the dedicated labors of General Bradley T. Johnson, its commander during the Civil War. Johnson had paid—in 1867, "when money was plenty" —to have William Ludwell Sheppard's painting, *The*

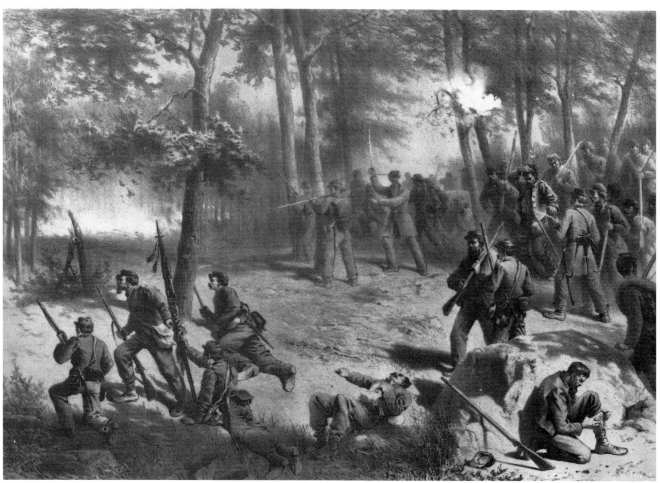

Figure 117.
[Printmaker unknown], after Allen C. Redwood, *Charge of Maryland Infantry (C.S.) / Gettysburg July 3rd. 1863.*

N.p., n.d. Lithograph, 14¼ x 19³⁄₁₆ inches. Just beyond the woods pictured by Redwood was a clearing into which some 300 men of the Second Mary-

land Infantry burst. They suffered 188 casualties in the disastrous assault, but somehow Redwood fails to render adequately a sense of the impend-

ing tragedy. (*Maryland Historical Society*)

Charge of the First Maryland Regiment at the Death of Ashby, lithographed by Baltimore's A. Hoen and Company (fig. 118). Then he gave "a copy to every man who was there, or his son." The origins of the Redwood lithograph are not so clear, but the energetic General Johnson had been Redwood's commanding officer, and it is not unreasonable to assume that Johnson had a hand in commissioning the Gettysburg print as well.[28]

Sheppard had never been a member of the unit, but he had been a Confederate soldier and he was enjoying an even more successful career as an artist-illustrator than Redwood—one less confined to Confederate subjects and to the desires of reminiscent former rebels. Nevertheless, the overall content of his work suggests that Sheppard, too, was a key visual architect of the Lost Cause as much as he was a chronicler of the ways of the common Confederate soldier.

Sheppard had belonged to anything but a common unit. The Richmond Howitzers were an elite battery of which William Ludwell Sheppard, the artist son of the treasurer of the Richmond, Fredericksburg, and Potomac Railroad, might be called a fairly typical member. Wisely, the Confederacy eventually assigned him to the topographical department of the Army of Northern Virginia, where his rare artistic talent could be put to good use. After the war, perhaps because of his mature and suave manner, Sheppard quickly drew assignments from Northern publishers to illustrate articles and books, sometimes with pictures of Northern subjects. The range of subjects he covered was considerable, but a substantial portion naturally dealt with his native South. His principal reputation as a soldier-artist rests on the illustrations for Carlton McCarthy's useful *Detailed Minutiae of Soldier Life in the Army of Northern Virginia*; the pictures were repeatedly praised for their accuracy and for their focus on the comradely and human-interest side of soldier life, rather than the heroic and sanguinary.[29]

The prints for which he was responsible present a different perspective, but neither the *Detailed Minutiae* nor the prints give a complete picture. *The Charge of the First Maryland Regiment* had its origins, not in Sheppard's eyewitness experience, but in Bradley T. Johnson's deep pockets. There are several portrait likenesses in the print, and the painter showed a certain brave adherence to historical or artistic authenticity, noted in humorous fashion by General Johnson himself, who told Redwood, "The drawing is very unsatisfactory for it places the Colo[nel] [Johnson himself] in the middle distance very small & vague."[30]

In fact, both Sheppard's and Redwood's Maryland Line prints owed as much to the conventions of battlefield art as to personal historical experience. Both prints focused on the passing of the flag from a wounded color-bearer to another man thrusting forward in the attack. It is quite true that the casualty rate among color-bearers was notoriously high, and that the passing of the colors in the charge of the First Maryland was important. But surely flag-bearers did not always fall so artistically; sometimes they must have dropped the flag when shot; some of them must have been killed instantly or disfigured in revolting ways by large-caliber ammunition. These lithographed Maryland color-bearers owe more to picturesque imagination than to battlefield reports.[31]

Sheppard's later print, *Virginia 1864* (fig. 119), represented his own unit, the Richmond Howitzers, but at a time when he presumably was not in service with them. Though old veterans felt "present at that very time" when they looked at Sheppard's picture, it probably was not a product of direct observation. The print nevertheless proved popular enough to be reprinted for distribution by an insurance company. And Sheppard's other print subjects were even more popular. His individual likenesses of a Confederate infantryman, artilleryman, and cavalryman are still reproduced for popular distribution.[32]

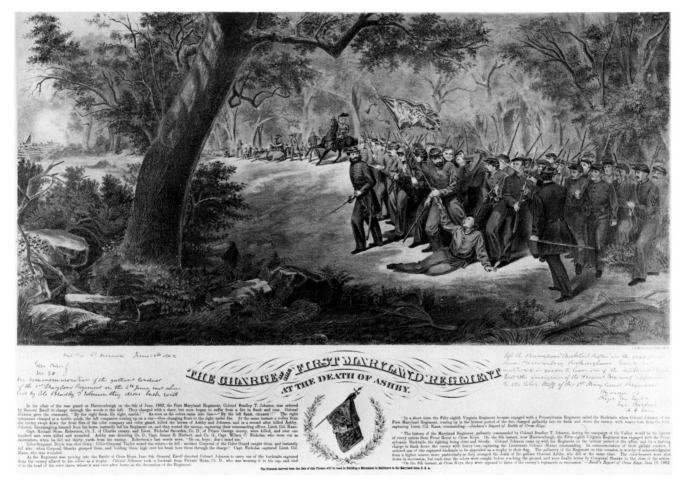

Figure 118.
G. A. Muller, after a painting by William Ludwell Sheppard, *The Charge of the First Maryland Regiment / at the Death of Ashby.* Printed by A. Hoen and Company, Baltimore, 1867. Lithograph, 18¼ x 25 inches (with text). Three color-bearers were shot down before Corporal Shanks, presumably the soldier pictured here, seized the colors. Sheppard's original painting hung in the Confederate Soldiers' Home in Pikesville, Maryland. Proceeds from the sale of this lithograph were to "be used in building a Monument in Baltimore to the Maryland Line, C.S.A.," but such a monument was never built. (*Louis A. Warren Lincoln Library and Museum*)

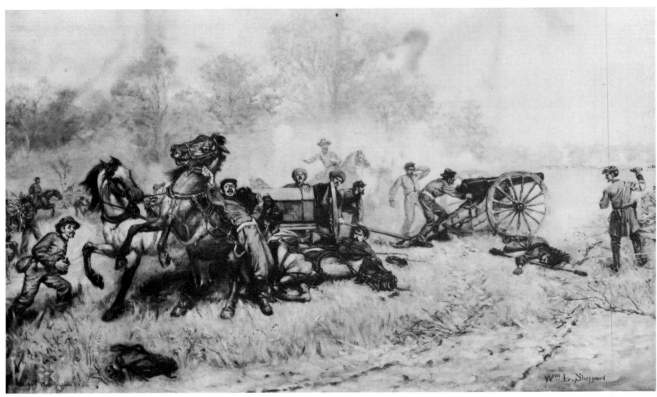

Figure 119.
Boston Photogravure Company, after a painting by William Ludwell Sheppard, *Virginia 1864.* N.p., 1888. Photoengraving, 15 x 24⅜ inches. Usually a six-horse team was necessary to pull the heavy cannons of the Civil War, but Sheppard's print shows only four horses. There is confusion enough in the scene, anyway; the unusually wild-eyed soldiers, along with the plunging horses, suggest defeat. From the officer at right, seemingly distracted by the dead cannoneer, to the mounted officer in the center who seems to be urging calm, from the gunner holding his head to the artilleryman pinned beneath the dead horse, the scene is populated with soldiers who to some degree defy the traditions of heroic battle art. The Virginia State Insurance Company nevertheless liked the print well enough to distribute it as a premium. (*Eleanor S. Brockenbrough Library, Museum of the Confederacy*)

In sum, Sheppard's work was as wedded to the myth of the Lost Cause as any. In fact, as illustrator of a memorial volume on Jefferson Davis, he was a principal visual architect of the myth. His illustrations reveal the telltale collateral themes that have consistently made artistic renderings of Confederate subjects emblems of a broad political ideology and not mere items of detailed antiquarian reminiscence. Among the subjects of Sheppard's illustrations are: Jefferson Davis standing up manfully to surrender to mounted Union soldiers; Stonewall Jackson praying on his knees (an unlikely pose for a Presbyterian); a loyal old slave carrying the master's wounded Confederate soldier son from the battlefield; a white man weeping at the deathbed of a faithful old slave; a scene of young Negroes playing raw practical jokes on old ones; a comical Negro denied voting by another comical Negro, who tells him "yo' cain' vote in dis' precink jess caze yo' slep' heah lass' night"; a little white girl delivering a Christmas present "from the Big House" to the slave quarters; and a portrait of a white plantation mistress reading to the slave children gathered about her.[33]

In other words, those artists who gloried in the Confederate experience consistently romanticized slavery and endorsed white supremacy—consciously, artistically, and almost automatically. Of course, consciousness of the emblematic nature of Confederate prints is easier to prove in their producers than in their buyers.

The two themes—Confederate experience and white supremacy—nevertheless constantly appear in tandem. When Colonel Tabb reported to Conrad Wise Chapman on the Virginia artistic developments of interest in 1867, he told him about "Ned Valentine [sculptor Edward Valentine] . . . getting up some fine busts of Jackson, Stuart, Beauregard, &c &c—besides several humorous busts & statuettes of negroes—illustrating their difficulty in plodding along the road to learning in the Freedmen's schools. One he calls the 'Nation's Ward'—the other a little negro boy goes to sleep at his lessons is admirable."[34]

When the works of these Confederate artists were revived in recent years, discussion focused on their accurate rendering of the common soldier's experience. Terms like "reportorial," "visual record," "keen observer," "authenticity," and "realism" litter the pages of modern criticism of the works of Chapman, Redwood, and Sheppard. These terms are useful and apt when comparing the soldier-artists' works with the hasty Civil War scenes of Currier and Ives and the Kelloggs of Hartford, or with the ridiculous fantasies of battle art churned out after the war by Chicago's Kurz and Allison. And reportorial accuracy was a self-conscious mark of the soldier-artists' works *vis à vis* the cavalier myth of the South. Allen C. Redwood, in particular, articulated these artists' vision of the commonness of the Confederate common soldier. In an article written in 1878 on "Johnny Reb at Play," Redwood said that "the subject of this memoir has come to figure as a melodramatic, not to say tragic, character. There could be no greater mistake. In the easy intercourse of his more familiar relations, he was in the largest sense a humorist." He noted: "There were three classes of men whom Johnny especially regarded as fair game when his frugal mind was on pleasure bent: civilians, the non-combatant staff and cavalry-men; for, despite that well-known foible of his character which consisted in the claim to cavalier descent, the typical Johnny was essentially a man of his legs." Likewise, Sheppard once boasted of his illustrations for McCarthy's *Detailed Minutiae* that there was "no such record of the life of the Confederate soldier by one who saw it" and that the pictures were "attempts to reproduce the daily life . . . apart from the great engagements that have been treated so often."[35]

Still, eyewitness accuracy in a vaguely anticavalier tradition is at most only half the story. Valentine's busts of Confederate heroes are still on display, but one never sees on display the anti-Negro, anti-Freedman's Bureau statuettes—however benign they appeared to the whites of the Lost Cause era—that went hand-in-

hand with them in Valentine's imagination. Likewise, the military themes in the works of the soldier-artists have been deemed worthy of some modern interest, but much of the rest of their work has remained buried.

One must examine an artist's overall body of work to uncover the underlying ideological structures of his vision. To do so with the Confederacy's soldier-artists is to discover the myth of the Lost Cause, not the innocently detailed memory of bygone days in camps and trenches. Theirs was not a sentimental journey into memory. It was a radical nostalgia.

Conclusion: In Memoriam

Although it was based on a painting by an artist born too late to be a soldier in the war, the print (fig. 120) that honored the charge of the Virginia Military Institute cadets at New Market on May 15, 1864, is among the most important works of Lost Cause art. The young Confederates had attacked in a thunderstorm, adding an elemental violence to the wild charge depicted by B. W. Clinedinst.

For all its simplicity as a piece of heroic battle art, it was an excellent rendering of Lost Cause idealism. Although the Confederates prevailed on that day in 1864, they were in a sense playing their last trump, for their leaders could not realistically contemplate further struggle without the assurance that young officers would continue to emerge from this important Confederate military school, the so-called West Point of the Confederacy. Instead, there were ten cadets killed and forty-seven wounded in the assault, and the Confederacy should have lost hope. This attack was a symbolic dredging up of the last reservoirs of manpower—boy-power really.

The charge, a monument to the futile gallantry of the last days of the Confederate States of America, epitomized the lostness of the Lost Cause. The idea of sacrifice became an object of Southern veneration after the war, and the idea of the Lost Cause became an object of worship. It was utterly fitting and appropriate that the Virginia-born artist Clinedinst provided the original painting of the cadets as a huge backdrop for the altar at the chapel of the rebuilt Virginia Military Institute.

As the Confederate image took shape after the Civil War, it became part of a civil religion—what historian Charles Reagan Wilson called "The Religion of the Lost Cause." After Appomattox, even as the white South lay prostrate in poverty and confusion, its people went through a spiritual transformation that would help many of them cope with their defeat. Again and again the Reverend J. William Jones would begin his prayers before groups of Confederate veterans: "Oh God! Our God, our help in years gone by, our hope for years to come—God of Abraham, Isaac and Jacob, God of Israel, God of the centuries, God of our fathers, God of Jefferson Davis, Robert Edward Lee, and Stonewall Jackson. . . ." It was said that Jones worshipped "Lee and Jackson next to God."[1]

The Confederate image surely had a nearly sacred meaning in the South. In their day, these engravings and lithographs helped reconcile the survivors to the sacrifices of their failed crusade. Above all, the faithful clung to the memories of three great prophets of the Lost Cause: Robert E. Lee, Jefferson Davis, and Stonewall Jackson. (Currier and Ives brought the trinity together in a novelty picture that placed two of the portraits on vertical strips visible from right or left and presented the third portrait when the whole was viewed directly from the front.) As the years went by, "the basic outline of each man's role in the myth of the Crusading Christian Confederates" was delineated, as Charles Reagan Wilson has pointed out, with inspiring clarity.[2]

Robert E. Lee was the Christian knight, the great warrior of great gentleness. He was the "perfect man" who, as a symbol of reconciliation, outgrew the bounds of Southern allegiance to become, by the early twentieth century, a hero to all America. A critic—apparently a Northerner—of a postwar Lee engraving compared the Confederate general to George Washington, saying, "Virginia, if she cannot claim to be the mother of many artists, has more than once benefited art by furnishing the subject, the hero, and the inspiration." He went on to say that Lee's meaning for Americans transcended his gray uniform: "Although this uniform . . . indicates a definite historical period, we cannot help seeing in the air of the majestic face a something which that particular uniform never accompanied—the accomplished work of life, the chastening

Figure 120.
[Printmaker unknown], after
Benjamin West Clinedinst,
[*Charge of the VMI Cadets at
New Market*]. Signed, lower
left, "Copyright 1916 / Benja-
min West Clinedinst / N.A.
from 1880 VMI." N.p., 1916.
Aquatint, 15⅞ x 11⅝ inches.
Given its subject matter, the
shape of the print's borders
suggests an artillery shell—an
idea reinforced for modern
viewers by the ominous 1916
date of the work. In fact, the
shape was dictated by the
gothic window of a church, for
the original canvas, executed
by the artist in 1880, towers
behind the altar in the chapel at
the Virginia Military Institute.
(*Eleanor S. Brockenbrough Li-
brary, Museum of the Confed-
eracy*)

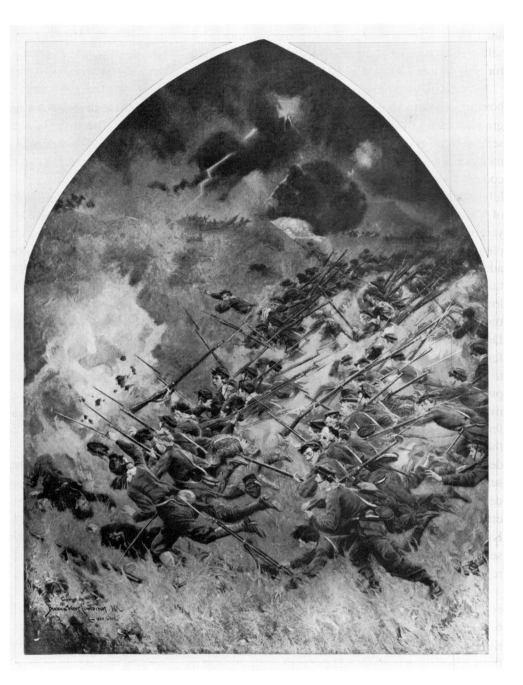

and visionary sadness of a *Lost Cause*, the grandeur of self-repression." As J. William Jones put it, Lee would forever be "*our* 'king of men.' "[3]

Jefferson Davis was the Christian martyr. In the bowels of Fortress Monroe, the unpopular and disgraced leader of the Confederate cause redeemed himself. As early as 1867 his worshipful former cabinet member, John H. Reagan, summarized the view of his countrymen in a letter to Davis: "Success might have left you, for this generation at least, the usual allotment of friends and enemies; but misfortune has embalmed you in the sincere and earnest affection of all our people. And you can at least enjoy this pleasing reflection, admidst the general wreck of liberty and of fortune, that you served a people and suffer for a people who love and venerate you more as your and their misfortunes and sorrows are greater." This letter, celebrating Davis's release from prison, concluded with Reagan's fervent assurance that he would continue to pray and to teach his "little children to pray" for the martyr-president. And many Southerners did pray for the man who, in the words of the Reverend Jones, "suffered in the room of his people, went to prison for them, had indignity put upon him, and was hated, slandered, maltreated and ostracized in the land he had served so faithfully—*all for them*."[4] In the twentieth century more stained-glass windows created for Southern churches commemorated Davis than Lee. The Knight had become the American and transcended the sectional bounds of the Lost Cause cult, but the martyr remained thoroughly and defiantly Southern.

Stonewall Jackson the puritan, the wrath of God, completed the trinity of Southern saints. This incarnation of the Old Testament prophet turned fearless warrior, the righteous leader, exemplified courage and blind faith in the face of death. Not only did he display these qualities in battle, but also as he lingered for days on his deathbed. Shot accidentally by one of his own men at Chancellorsville, Jackson lived long enough to prove beyond doubt that he died a Christian of the deepest faith. He died on the sabbath. "Let us cross over the river, and rest under the shade of the trees," were his salvific last words.

Yet even religious analogy fails to capture the full meaning of the symbols of the Lost Cause, for it was the civil aspect of this religion that was of greatest significance. Evangelical religion in the South remained healthy in its own right. The Southern association of religious symbols with the Confederacy was, above all, an index of high regard for the Confederate experiment. Confederate nationalism—as the unparalleled sacrifice of young white men proved—was hardly an inadequate, weak, or artificial sentiment. If the North had suffered a wartime casualty rate equal to the South's, 1,000,000 boys in blue would have died for Lincoln's cause instead of 360,000.

The nation that could call for such sacrifice and be answered so willingly was not destined to die and disappear with battlefield defeat. It lived on in the hearts of millions of Southerners. Some nineteenth-century national movements vanished after military defeat; some did not. Germany and Hungary survived the revolutions of 1848, the one to gain nation status in 1870, the other to reach a semi-independence in 1867. The Confederacy never regained national status in a political sense, but it waned ever so slowly in sentiment. This unredeemed nation within a nation existed, as all nations do perhaps, only in the hearts of some of its people. But it survived there all the same. The prints of the Lost Cause constitute tangible evidence of the strength and durability of Southern nationalism and pride. They were vivid reminders of what historian Bernard DeVoto called in the 1930s "the whisper of a Great Perhaps . . . the passionate *if* " that "sleeps uneasily in the grandsons' blood."[5]

For a half century that *if* survived, but like the tints in the lithographs and engravings, it grew paler and paler—until, as a poem on the cover of the *Confederate Veteran* expressed it:

Sorrow and pain and anger,
 Hatred and death are fled.
It is only glory lingers
 With the great immortal dead.[6]

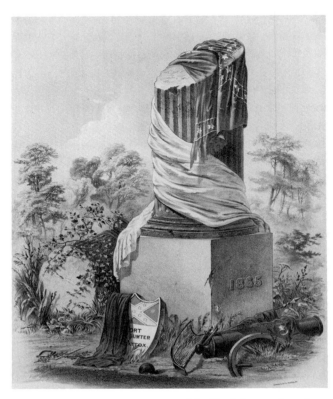

Figure 121.

C. A. David, *In Memoriam.* Published by Cosack and Company, Buffalo, N.Y., n.d. Lithograph, 17¼ x 12⅝ inches. A rare allegorical tribute to the Lost Cause, this print from the North is rich in symbols of mourning for the defeated South: the broken pillar of state, the emblem for a defeated country; the shield, the classical representation of battle (and in this case bearing the names of the first and last encounters, Fort Sumter and Appomattox); and the tattered flag of the Confederacy, draped over the column in the center of the scene. Note the other interesting features: the broken tools of war in the foreground; and the missing section of the pillar, visible half-buried in the brush at left. Without presenting a single portrait, and with only an indirect reference to its theme—the inscription "1865" on the base of the central column—the print managed to evoke a sense of loss and tragedy. (*Eleanor S. Brockenbrough Library, Museum of the Confederacy*)

Afterword

This book has examined how history shaped the prints that portrayed the fallen South and its heroes. It does not attempt to explain how the Lost Cause and its icons in turn affected the political and social history of the South and of the rest of the United States. Though promising beginnings have been made, the subject needs more careful evaluation to help us better understand the historical impact of the icons that played so central a role in the emotional movement known as the Lost Cause.[1]

For now, we will have to be content with introducing the prints of the Lost Cause as subjects for serious historical research. For a number of complicated reasons, these substantial and important visual records have been largely ignored until now. The principal problem is that popular prints have been regarded mostly as mere illustrations for books, not as primary source materials. This book, by contrast, presents the pictures themselves as the principal fruits of our archival research. Finding them and explaining their meanings and uses are our main tasks as print historians.

As our name for them—"prints of the Lost Cause" —implies, almost all of these pictures were produced after the Civil War was over, by Northern rather than Southern printmakers. But the subject of the prints was the Confederacy—its heroes, martyrs, and evocative emblems. As products of the Reconstruction era and its aftermath, these scenes and portraits of the Civil War later seemed inappropriate as illustrations of the era in which they were produced; they also fell into disuse as historians and book publishers increasingly sought original photographs and period art as illustrations of Confederate history. We found most curators eager to describe their photographic holdings but rather puzzled by our interest in the prints.

The Southern subject matter of and audience for these prints also affected their later reputation. Southerners formed the principal market for the pictures, but the South before air conditioning provided a hostile environment for the survival of paper products. Heat and high humidity exacted a heavy physical toll from the prints of the Lost Cause.

Moreover, despite a recent renaissance of interest, art cannot be said to have thrived in the Old South—as Northern production of the Lost Cause prints proves. Historian Bruce Chambers, as recently as 1984, referred to

> the almost total absence of collections of Southern art, whether formed privately or by museums. In almost every instance the collecting of particular kinds of art . . . has accompanied (if not preceded) their rediscovery and documentation by scholars. Each of the great museum collections in this country owes its unique character to the perspicacity and passions of individual collectors or curators. And yet in the South, there has been historically a curious absence of the collecting instinct which, even when it has surfaced, has tended to prefer anything but the art of its own region. . . . In museums Southern art is usually buried in storage, to be paraded out only to keep the local garden clubs and artists associations at bay.[2]

To be sure, most prints of the Lost Cause would hardly qualify for such collections anyway, as they are Southern in subject matter, sentiment, and audience, but not in provenance. Furthermore, Chambers was referring to the fine arts rather than the popular arts. Engravings and lithographs traditionally have been viewed as stepchildren by both Northern and Southern art museums, which pride themselves on their holdings in paintings and sculpture; by historical societies, which emphasize artifacts; and by rare book libraries, which naturally emphasize books and manuscripts.

The neglect of Lost Cause prints in scholarship is especially ironic because, as retrospective products of

the print industry with little special "news" value, such graphics were often the beneficiaries of greater care and more time-consuming craftsmanship than many of the hastily executed war scenes and political campaign portraits that capitalized on fleeting headlines. But the world of art has neglected these Lost Cause pictures almost completely. No gallery or museum has ever before put together a major exhibition on the Confederacy as depicted in popular prints. Curators and special-collections librarians attest to this, as do the frequently appalling conditions in which these Lost Cause prints are found today: tossed into bins or map cases, unframed and uncataloged, unrepaired, tattered, begrimed, and with pieces of old cardboard mats sticking to them—in no condition to be put on public display. Popular prints generally have only very recently begun to gain respectful scholarly treatment. The prints of the Lost Cause have not, until now, received any respect at all.

In fact, events of recent years have served to bury the prints of the Lost Cause ever deeper in archival oblivion. Whites resisting the modern civil rights movement sometimes waved Confederate battle flags and marched to the strains of "Dixie." Some saw in these symbols only the icons of an ignorant and aggressive racism, best forgotten forever. But as Thomas Connelly and Barbara Bellows have pointed out, many who hid behind them knew little of Confederate history.[3] The prints of the Lost Cause were direct ancestors of the more modern symbols, and we thought it would be useful to examine these earlier icons, products of an era when their meaning was far less distorted by the passage of time. Most important, however, our curiosity was aroused by their anomalous printing history in the North.

We cannot resist emphasizing the pioneering aspects of this study, but we would be dishonest and ungrateful were we to ignore the contributions of many others, North and South, whose help was essential in the preparation of this book: Charlene Alling, formerly of the Museum of the Confederacy in Richmond, as well as Tucker Hill and Malinda Wyatt, of the same institution; Sarah Bearrs, Virginius Hall, and Nelson Lankford at the Virginia Historical Society, Richmond; Richard Harrington at the Anne S. K. Brown Military Collection, Brown University; Pat McWhorter at the Historic New Orleans Collection; Wilbur E. Meneray at Tulane University in New Orleans; Sally Pierce at the Boston Athenaeum; Jenni Rodda, formerly of the Valentine Museum, Richmond; Lois Schultz at the Perkins Library, Duke University; and Ann Leslie Tuttle of the Virginia State Library. We are grateful, too, to Sandra M. Mongeon at the Museum of Fine Arts, Boston; Bernard Reilly of the Library of Congress; and Roberta Waddell at the New York Public Library.

A number of people read our manuscript in its early stages. James Gilreath of the Library of Congress's Rare Book Room and Wendy Wick Reaves of the National Portrait Gallery, Washington, D.C., provoked further study and considerable revision of the text. Other valuable readings came from Richard Nelson Current, emeritus professor of history at the University of North Carolina, Greensboro; Sylvia Neely of Indiana University-Purdue University at Fort Wayne; and Frank Vandiver, president of Texas A & M University. Catherine Clinton of Harvard University generously read a draft of chapter 8. Fred Voss of the National Portrait Gallery read and commented usefully on chapter 5.

We are indebted also to the staff of the Musselman Library at Gettysburg College, especially Kathleen Crapster, David T. Hedrick, Willis Hubbard, and Anna Jane Moyer, and to Tina Fair, secretary of the Civil War Institute at Gettysburg College and her student assistants: John Deeben, Tim Gelsinger, Karin Hagen-Fredericksen, and Debra Weber. Dozens of other librarians and National Park Service specialists helped us as well. Ann Murday of the Louis A. Warren Lincoln Library and Museum ably typed the text many

times without complaint. Pam Upton of the University of North Carolina Press gave us the best copyediting we have ever had.

To accompany the book, the authors assembled a traveling exhibition of prints, also called "The Confederate Image: Prints of the Lost Cause." The Lincoln National Life Insurance Company and Gettysburg College have cooperated closely to make both the exhibit and the book possible.

Gettysburg College, the first institution to host the exhibition, has always given us enthusiastic support. We thank especially: President Charles E. Glassick; former dean David B. Potts; Vice President Richard P. Allen and his staff; Bruce E. Bigelow; Carol Kefalas; James Agard, the curator of the Gettysburg College Art Gallery; and the members of the department of history—Bruce W. Bugbee, Basil L. Crapster, George H. Fick, Norman O. Forness, Charles H. Glatfelter, Jean Holder, and J. Roger Steman, chairman.

The Lincoln National Life Insurance Company, through its Corporate Public Involvement Committee, provided the seed grant for the exhibit. We thank the members of that committee and especially the chief executive officer of the company, Ian M. Rolland. David Allen, senior vice president, has also provided crucial support at every stage of our work. The Lincoln National Life Insurance Company also funded most of the authors' travel for research and all of the prodigious costs of photography.

We want also to acknowledge the support of the Pennsylvania Humanities Council, its executive director, Craig R. Eisendrath, and its assistant director, Carol Coren. Our consultants on the exhibit have been Richard Nelson Current, James Gilreath, Wendy Wick Reaves, and Frank E. Vandiver.

Finally, the authors are deeply grateful to those in our families who both endured and shared in the time-consuming work required to produce this volume.

Harold Holzer: My wife, Edith, has been both critic and inspiration, and I thank her for her patience, advice, and enthusiasm. My two daughters, Remy and Meg, respected my need to use the time I would otherwise have given them, and I will always be grateful to them for their understanding. And I owe a special debt of gratitude to the man for whom I work, Governor Mario M. Cuomo, for his veneration of history and encouragement to explore it.

Gabor S. Boritt: My wife, Liz, and our sons Norse, Jakob, and Daniel, all played a part in the creation of this book. If they did not always cheer the project on, they always cheered me up. I am grateful to them all.

We all owe special thanks to Lewis Bateman of the University of North Carolina Press, who approached the three authors after a lecture on Lincoln prints at Gettysburg College and invited us to turn our vague interest in a sequel on Confederate prints into a comprehensive volume and a traveling exhibit.

Notes

INTRODUCTION

1. Wilson, "Early-Lost Lamented Latane," 15; Dabney, *Richmond*, 175; *Confederate Veteran* 37 (May 1929): 161; Salmon, "Burial of Latane," 122; Vandiver, *Their Tattered Flags*, 210.

2. Wright, *A Southern Girl in '61*, 68; Cooke, quoted in Wheeler, *Sword over Richmond*, 272; Thomas, *Bold Dragoon*, 126, 229–30, 254–55.

3. Wright, *A Southern Girl in '61*, 68.

4. McGuire, *Diary of a Southern Refugee*, 143. The copy consulted by the authors is owned by the descendants of Mrs. Willoughby Newton and contains in its endpapers unsigned, penciled reminiscences on the creation of the Washington painting of the burial of Latane.

5. Thompson, "Burial of Latane," 475; "Burial of Latane," broadside poem in the Museum of the Confederacy, Richmond, Va.; the Latane story was occasionally exaggerated. Sallie A. Putnam described Mrs. Newton as burying "Letoni" on her knees, "in sight and hearing of the foe" (*Richmond during the War*, 141–42). For the artist's models, who were fixtures of Confederate Richmond's high society, see DeLeon, *Belles, Beaux and Brains*, 290–92. For more on Thompson and the *Messenger*, see Manierre, "Southern Response to Mrs. Stowe," 84.

6. Salmon, "Burial of Latane," 122, 124–27.

7. Turnbull Brothers (Baltimore) advertisement, reproduced in Salmon, "Burial of Latane," 127.

8. Advertising brochure, also by Turnbull Brothers, in the Museum of the Confederacy.

9. Lyne, "Restoration of Arlington Mansion," 185; Wilson, "Early-Lost Lamented Latane," 15.

10. Marzio, *Democratic Art*, 125, 117, 128; Beecher and Stowe, *New Housekeeper's Manual*, 84–85, 94.

11. Poesch, "Growth and Development of the Old South," 87.

CHAPTER 1

1. Jones, *Rebel War Clerk's Diary*, 1:13; Freeman, *South to Posterity*, 43.

2. On Southern letters, see especially Harwell, *More Confederate Imprints*, 1:xiv–xvi; Eaton, *History of the Southern Confederacy*, 217. On the alleged failure of Southern nationalism and its symbols, see Beringer et al., *Why the South Lost the Civil War*, 66, 76–77, and Woodward, "Gone With the Wind," 4.

3. "Sachse did quite a volume of prints—largely views of the south from points of interest, as well as military and naval prints"

(Peters, *America on Stone*, 349). On Blackmar, see Harwell, *Confederate Music*, 11.

4. Poesch, "Growth and Development of the Old South," 86–87.

5. Douglas, *I Rode with Stonewall*, 207–8.

6. Quoted in *Jefferson Davis and "Stonewall" Jackson*, 277.

7. Fremantle, *Three Months in the Southern States*, 201–2, 286.

8. McCarthy, *Detailed Minutiae*, 6.

9. Wilkinson, *Narrative of a Blockade-Runner*, 111, 130.

10. Massey, *Ersatz in the Confederacy*, 155; DeLeon, *Belles, Beaux and Brains*, 283; *Southern Literary Messenger* 32 (June 1861): 481; 34 (January 1862): 77.

11. Wiley, *Embattled Confederates*, 201–2; Massey, *Ersatz in the Confederacy*, 142.

12. The exception was Jules Lion of New Orleans, a French free-born black who drew the covers of "Beauregard Manassas Quick Step," "Missouri," "Orleans Cadets Quick Step," and "General Joseph E. Johnston Manassas Quick March" (see Poesch, *Art of the Old South*, 268). Lion sheet music is preserved at the Boston Athenaeum and the Historic New Orleans Collection.

13. Peters, *America on Stone*, 93. Beyer's subjects included Mount Vernon, Monticello, Harpers Ferry, and Hot Springs.

14. Wiley, *Embattled Confederates*, 68–69; Todd, *Confederate Finance*, 111; Dodge, "Domestic Economy in the Confederacy," 239.

15. Quoted in Green, *Confederate States Five-Cent Green Lithograph*, 1, 3.

16. Quoted in Dietz, *Postal Service of the Confederate States*, 97.

17. Green, *Typographs of the Confederate State of America*, 2–4, 8.

18. Dietz, *Postal Service of the Confederate States*, 96.

19. Dodge, "Domestic Economy in the Confederacy," 238, 240; *Southern Illustrated News*, July 25, 1863, p. 20.

CHAPTER 2

1. Quoted in Myers, *Children of Pride*, 919. The rare lithographed secession ordinances were located at the Museum of the Confederacy, Richmond, and the Historic New Orleans Collection. Jones's copy of the Savannah print may well be the one at Emory University, Atlanta.

2. Crandall, *Confederate Imprints*, 2:521, 523; Richard B.

Harwell lists two pieces called "Our First President's Quickstep" (*Confederate Music*, 135).

3. Peters, *America on Stone*, 268.

4. Thomas, *Abraham Lincoln*, 219–20, 434; Lalumia, "Realism and Anti-Aristocratic Sentiment," 36.

5. McWhiney, "Jefferson Davis and the Art of War," 101; Davis, *Jefferson Davis, Ex-President*, 2:392.

6. Myers, *Children of Pride*, 657, 665; Davis, *Jefferson Davis, Ex-President*, 1:360; Russell, *My Diary North and South*, 1:250.

7. Reagan, *Memoirs*, 109; Wright, *A Southern Girl in '61*, 55, 73.

8. Jones, *Rebel War Clerk's Diary*, 1:64; Myers, *Children of Pride*, 721, 727; Woodward and Muhlenfeld, *Private Mary Chesnut*, 105.

9. This crude lithograph, though available in several repositories, has not previously been identified as a Confederate imprint. Its generous bottom margin was almost always trimmed for framing in the nineteenth century. Only the copy in the manuscripts department, Perkins Library, Duke University, retained the words—faintly visible at the lower right—"Published by Hoy," before trimming took its toll of the remaining information.

10. Woodward and Muhlenfeld, *Private Mary Chesnut*, 102; Wright, *A Southern Girl in '61*, 73.

11. Jones, *Rebel War Clerk's Diary*, 1:65; Thomas, *Confederate State of Richmond*, 53. Davis had been chosen provisional president by a convention in Montgomery, but the convention also provided for a popular election for president the next November.

12. Alfriend, *Life of Jefferson Davis*, 305, 313; Clement Eaton, author of the best modern biography of Davis, terms Alfriend's book "adulatory" (*Jefferson Davis*, 317).

13. Johnston, *Narrative of Military Operations*, 54; Johnson and Buel, *Battles and Leaders*, 1:216.

14. Jones, *Rebel War Clerk's Diary*, 1:184

15. Strode, *Jefferson Davis*, 2:253, 256; Jones, *Rebel War Clerk's Diary*, 1:138, 139; Roland, *The Confederacy*, 93.

16. Jones, *Rebel War Clerk's Diary*, 1:140, 221.

17. Sideman and Friedman, *Europe Looks at the Civil War*, 33. For contrast, see Boritt et al., "The European Image of Abraham Lincoln," 153–83.

18. Hill, *Victory in Defeat*, 1–2.

CHAPTER 3

1. *Southern Literary Messenger* 24 (November–December 1862): 689; *Southern Illustrated News*, September 13, 1862, p. 4.

For appraisals of the *News*, see especially Coulter, *Confederate States of America*, 515; Vandiver, *Their Tattered Flags*, 209; Freeman, *South to Posterity*, 29; and Eaton, *History of the Southern Confederacy*, 219.

2. *Southern Literary Messenger* 34 (September–October 1862): 581.

3. *Southern Illustrated News*, September 13, 1862, p. 4.

4. Ibid., 4.

5. Ibid., 8.

6. Ibid., 8; Goldsborough, *Maryland Line in the Confederate Army*, 65–66; Wright, *Artists in Virginia before 1900*, 162.

7. *Hamlet*, act 3, sc. 4, lines 56, 58–61.

8. Ibid., lines 55, 54; *Southern Illustrated News*, October 18, 1862, pp. 8, 1–2.

9. Ibid., November 8, 1862, p. 3; Goldsborough, *Maryland Line in the Confederate Army*, 86–87.

10. *Southern Illustrated News*, November 22, 1862, p. 8; November 29, 1862, p. 3; December 13, 1862, p. 2; Porscher, *Resources of the Southern Fields and Forests*, 10–11.

11. *Southern Illustrated News*, September 27, 1862, p. 8; January 23, 1864, p. 24.

12. Ibid., August 8, 1863, p. 40.

13. Ibid., December 27, 1862, p. 3.

14. *Southern Literary Messenger* 35 (April 1863): 252.

15. *Southern Illustrated News*, August 11, 1863, pp. 1, 4.

16. Ibid., June 20, 1863, p. 8; July 4, 1863, pp. 8, 16; August 21, 1863, p. 7.

17. Ibid., July 25, 1863, p. 20; August 8, 1863, p. 40.

18. *Southern Literary Messenger* 34 (November–December 1862): 689.

CHAPTER 4

1. Quoted in Wright, *A Southern Girl in '61*, 106.

2. Mott, *History of American Magazines*, 2:112–13, 185; Roland, "The South at War," 340.

3. Cooke, *Old Stonewall Brigade*, 65–66.

4. Wright, *A Southern Girl in '61*, 150.

5. *Southern Literary Messenger* 34 (January 1862): 67.

6. Jones, *Rebel War Clerk's Diary*, 1:78, 128, 200; Pollard, *Observations in the North*, 2.

7. Jones, *Rebel War Clerk's Diary*, 1:193.

8. *Southern Literary Messenger* 34 (January 1862): 66; Roland, *The Confederacy*, 154, 173.

9. Jones, *Rebel War Clerk's Diary*, 1:193.

CHAPTER 5

1. Anderson, *Work of Adalbert Johann Volck*, viii.

2. "A Baltimore and a Holland Cartoonist Compared," *Baltimore Sun*, February 4, 1917, clipping in the Maryland Historical Society; *George Bellows and the War Series of 1918.*

3. Foley, "Adalbert Volck," 60–62; [Voss], *Adalbert Volck: Fifth Column Artist*; George C. Kiedel, "Adalbert J. Volck, Caricaturist, and His Family: Personal Reminiscences," *Catonsville Argus* (Md.), October 2, 1915. Throughout the autumn of 1915 the newspaper published a long series on Volck by Kiedel (hereafter referred to as Kiedel, *Argus*). All of the articles are in the Maryland Historical Society collection. See also Voss, "Adalbert Volck."

4. Kiedel, *Argus*, November 20, 1915. Volck's brother-in-law was a Lutheran minister. See Anderson, *Work of Adalbert Johann Volck*, vii.

5. Major William M. Pegram, quoted in Kiedel, *Argus*, October 9, 1915.

6. Halstead, "Heroic Illustrations," 504; *M & M Karolik Collection*, 85.

7. Varina Davis to A. J. Volck, September 5, 1967, in Kiedel, *Argus*, October 23, 1915.

8. Volck to Library of Congress, January 11, 1905, in Kiedel, *Argus*, October 16, 1915. The B.F.B. portfolio also appeared under the alternative title, *Ye Exploits of Ye Distinguished Attorney and General B.F.B.* (set in the Maryland Historical Society).

9. *Second and Third Issues of V. Blada's War Sketches*, "London" (Baltimore): n.p., 1864, advertising prospectus in the Maryland Historical Society.

10. Volck to Library of Congress, January 11, 1905, in Kiedel, *Argus*, October 16, 1915. Bibliographers disputed the claim for London as early as 1867; see Sabin and Eames, *Bibliotheque Americana*, 2:201.

11. James W. Foster to Mrs. F. H. Falkinberg, November 30, 1948, Volck Papers, Maryland Historical Society.

12. Volck to Library of Congress, January 11, 1905, in Kiedel, *Argus*, October 16, 1915; Halstead, "Heroic Illustrations," 504.

13. "Monument to Faithful Slaves," *Confederate Veteran* 36 (February 1928): 46.

14. Williams, *P. G. T. Beauregard*, 91.

15. Murrell, *American Graphic Humor*, 1:201; and Anderson, *Work of Adalbert Johann Volck*, vii.

16. *Baltimore American*, June 20, 1909; *Baltimore News and Post*, April 24, 1934; clippings in the Maryland Historical Society.

17. Halstead, "Heroic Illustrations," 500, 496; "Adalbert Volck," 51.

18. Kiedel, *Argus*, October 30, November 20, 1915.

CHAPTER 6

1. Thomas, *Confederate Nation*, 222, 224–25; *Southern Literary Messenger* 35 (June 1863): 374; (September 1863): 573; 34 (July–August 1862): 504; 35 (January 1863): 37.

2. Smyth, *Robert E. Lee*, 25–26; Long, *Memoirs of Robert E. Lee*, 18; Woodward, *Mary Chesnut's Civil War*, 116, 504.

3. Long, *Memoirs of Robert E. Lee*, 17–18; Robert E. Lee, introduction to Mead, *Genealogical History*, 9, 91; Connelly, *The Marble Man*, 193; Woodward, *Mary Chesnut's Civil War*, 521. Lee admitted, "I am a poor genealogist, and my family records have been destroyed or are beyond my reach" (quoted in Jones, *Personal Reminiscences*, 357).

4. Jones, *Rebel War Clerk's Diary*, 1:32

5. Smyth, *Robert E. Lee* 17, 19–20; Freeman, *R. E. Lee*, 1:82.

6. Smith, *Lee and Grant*, 27; Freeman, *R. E. Lee*, 1:109; *Southern Literary Messenger* 35 (January 1863): 35.

7. General Preston, quoted in Long, *Memoirs of Robert E. Lee*, 482.

8. Smith, *Lee and Grant*, 80; Smyth, *Robert E. Lee*, 45, 42–43, 48–49; Lee to Winfield Scott, April 20, 1861, quoted in Long, *Memoirs of Robert E. Lee*, 94.

9. Connelly, *The Marble Man*, 16–17; Pollard, *Southern History of the War*, 168; Stern, *Robert E. Lee*, 149.

10. *Southern Literary Messenger* 34 (February–March 1862): 197; 34 (July–August 1862): 504; John Esten Cooke in the *Southern Illustrated News*, August 29, 1863, p. 57; Woodward, *Mary Chesnut's Civil War*, 615.

11. Meredith, *Face of Robert E. Lee*, 13, 22; Lee, *Recollections and Letters*, 19; Bundy, *Painting in the South*, 76–77.

12. Woodward, *Mary Chesnut's Civil War*, 450; Mary Custis Lee to Robert E. Lee, May 9, 1861, quoted in Jones, *Heroines of Dixie*, 170, 26.

13. *Southern Illustrated News*, December 13, 1862, p. 2.

14. *Southern Illustrated News*, January 17, 1863, pp. 1–2.

15. Ibid.; Robert E. Lee, quoted in Smyth, *Robert E. Lee*, 83; Blackford, *War Years*, 109.

16. *Southern Illustrated News*, October 17, 1863, pp. 1–2; Meredith, *Face of Robert E. Lee*, 30–35.

17. Stern, *Robert E. Lee*, 166; Flood, *Lee*, 31, 223.

18. Stern, *Robert E. Lee*, 166; Meredith, *Face of Robert E. Lee*, 36.

19. Robert E. Lee to Mary Lee, April 29, 1863, November 30, 1864, and December 30, 1864, in Dowdey, *Wartime Papers of R. E. Lee*, 440, 873, 880.

20. *Illustrated London News*, June 4, 1864, p. 2; Meredith, *Face of Robert E. Lee*, 37–39; *War and Its Heroes*, 23–24.

CHAPTER 7

1. Badeau, "General Grant," 160.

2. Henry Lee, quoted in Maurice, *An Aide-de-Camp of Lee*, 257–58.

3. Long, *Memoirs of Robert E. Lee*, 436.

4. Jones, *Personal Reminiscences*, 307; Long, *Memoirs of Robert E. Lee*, 413; Lee, *Recollections and Letters*, 150–51.

5. *New York Herald*, April 14, 1865, p. 1.

6. Maurice, *An Aide-de-Camp of Lee*, 273; *Robert E. Lee: In Memoriam*, 23.

7. Adams, *Shall Cromwell Have a Statue?*, 35–44.

8. Conningham, *Currier and Ives Prints*, 255.

9. Barber, *U. S. Grant*, 52; *Appomattox Court House*, 90.

10. Grant, *Personal Memoirs*, 2:488.

11. Ibid., 2:486–88; Maurice, *An Aide-de-Camp of Lee*, 261–63.

12. Blackford, *War Years*, 292–95; General George Forsyth, quoted in Flood, *Lee*, 12.

13. Grant, *Personal Memoirs*, 2:490.

14. Blackford, *War Years*, 293–94; Grant, *Personal Memoirs*, 2:496–97; Long, *Memoirs of Robert E. Lee*, 2:422.

15. For identification of the print's artist, see Williams, *The Civil War*, 243; Wainwright, *Philadelphia in the Romantic Age of Lithography*, 81.

CHAPTER 8

1. Andrew Bee, as quoted in McElroy, *Jefferson Davis*, 2:511; Bee is also quoted in Wilson, "How Jefferson Davis Was Overtaken," 582–83.

2. Davis, *Rise and Fall*, 2:701–2. The above account is repeated verbatim in the posthumously published Davis, *A Short History*, 495–96.

3. Davis, "Autobiography of Jefferson Davis," in *Papers*, 1:lxiii.

4. Davis, *Rise and Fall*, 2:702. In fact Wood escaped by bribing his captor (Strode, *Jefferson Davis*, 3:221). See also note

17 for the Wood diary. There is a voluminous literature on the capture of Davis. The most recent historian to cover the subject is Burke Davis, *The Long Surrender*. The best guide to sources is Ballard, "A Long Shadow."

5. Davis, *Rise and Fall*, 2:701; Davis, "Autobiography," lxiii.

6. Davis, "Autobiography," lxiii. Davis's 1889 autobiography does not mention the raglan, only a dramatic "throwing off a shawl which my wife had put over my shoulders." The head is no longer mentioned (Davis, *Papers*, 1:lxiii). See also Rowland, *Jefferson Davis, Constitutionalist*, 7:443–45, 8:35, 53, 175–77.

7. *New York Herald*, May 15, 1865. The *New York Times*, May 15, 1865, reported much the same story, as did most of the Northern press. The *Atlantic Monthly* summed up a good part of what became the accepted version of events, reflected also by cartoons ([G.W. Lawton, Fourth Michigan Cavalry], " 'Running at the heads': Being an Authentic Account of the Capture of Jefferson Davis," *Atlantic Monthly* 16 [September 1865]: 342–47). This was the issue of the magazine that published James Russell Lowell's "Ode Recited at the Harvard Commemoration."

8. McElroy, *Jefferson Davis*, 1:514; J. H. Wilson to Edwin M. Stanton, May 13, 1865, in *New York Herald*, May 15, 1865; Davis, *Rise and Fall*, 2:703–5. For a sample of comments from the press see Quill, *Prelude to the Radicals*, 72–73.

9. Fredrickson, *The Inner Civil War*; Bruce, *Violence and Culture*; Wyatt-Brown, *Southern Honor*; Smith-Rosenberg, *Disorderly Conduct*.

10. Wilson to Stanton, May 13, 1865.

11. Davis, "Autobiography," lxiii; Davis, *Rise and Fall*, 1:701–2. See also note 8.

12. Historians have noted, incidentally, the existence of these cartoons but missed their sexual connotations, and therefore their meaning. McElroy illustrates the point by making an error in the subtitle of the McLean lithograph, *Jeff's Last Skedaddle*. The subtitle appears thus in McElroy: "How 'Jeff' in His Extremity Put His Naval Affairs and Ramparts Under Petticoat Protection" (*Jefferson Davis*, 2:704). In the original cartoon, however, Davis's "Ram-parts" were put under petticoat protection.

13. Harris, *Humbug*, 169.

14. Mallory, quoted in McElroy, *Jefferson Davis*, 2:515.

15. Nevins and Thomas, *Diary of George Templeton Strong*, 3:597; Harris, *Humbug*, 168.

16. The description of the shawl is from Keith A. Hardison, superintendent of "Beauvoir," Jefferson Davis Shrine, letter dated May 14, 1986.

17. Rowland, *Jefferson Davis, Constitutionalist*, 8:35; diary notation for May 10, 1865, John Taylor Wood Papers 2381, Southern Historical Collection, University of North Carolina;

Benjamin D. Pritchard diary, notation for May 10, 1865, facsimile reproduction in Fox, *Capture of Jefferson Davis*, 13.

18. Beale, *Diary of Gideon Welles*, 2:306.

19. Wilson to Stanton, May 13, May 14, 1865, *Official Records of the Union and Confederate Armies*, ser. 1, vol. 49, pt. 2, pp. 743, 760.

20. Benjamin Pritchard to Edwin M. Stanton, May 25, 1865, ibid., pt. 1, p. 538; Davis, *Jefferson Davis, Ex-President*, 2:648–49; *Harper's Weekly*, June 17, 1865, p. 373.

21. Mrs. Jefferson Davis to Francis P. Blair, June 6, 1865, Gist-Blair Papers, Library of Congress. In her memoir, however, Mrs. Davis follows her husband in mentioning nothing about her pleas for a disguise or Davis's inability to find his hat, and she notes that the raglan was hers.

22. Davis, *Jefferson Davis, Ex-President*, 2:641; McElroy, *Jefferson Davis*, 2:517–18. Nearly all the biographers of Davis provide ample selections from these defenses. For the most reasonable overviews see Dimick, "Capture of Jefferson Davis," and Bradley, "Was Jefferson Davis Disguised as a Woman When Captured?" But the common view is expressed in a footnote in Woodward, *Mary Chesnut's Civil War*, 819n: "It had been falsely reported that Davis was captured dressed as a woman."

23. Davis, *Jefferson Davis, Ex-President*, 2:641.

24. Rowland, *Jefferson Davis, Constitutionalist*, 7:443–44, 8:35–36; Davis, *Rise and Fall*, 2:702; Strode, ed., *Jefferson Davis: Private Letters*, 473; McElroy, *Jefferson Davis*, 2:518.

25. McElroy, *Jefferson Davis*, 2:516; Davis, *The Long Surrender*, 284.

26. Nevins and Thomas, *Diary of George Templeton Strong*, 3:598.

27. Kellogg, *Life and Death in Rebel Prisons*.

28. Strode, ed., *Jefferson Davis: Private Letters*, 178.

29. Davis, *Jefferson Davis, Ex-President*, 2:641.

30. Harper, *Lincoln and the Press*, 87–91. A convenient collection of four "Scotch cap and cloak" cartoons appears in Wilson, *Lincoln in Caricature*, 102–8.

CHAPTER 9

1. Wiley, *Embattled Confederates*, 219.

2. Ibid.

3. *Harper's Weekly*, April 9, 1870, p. 232.

4. *Chromolithographs of Louis Prang*, 37.

5. Ibid.

6. Ibid., 34–35, 38.

7. Advertisement in endpaper of Pollard, *Southern History of*

the War; Stauffer, *American Engravers upon Copper and Steel*, 1:193.

8. *Catalogue of Engravings for Sale by J. C. Buttre Company* (New York, 1884), 5, 31, 20, 30, 13, 44; (New York, 1894), 49, 103, 54, 28, 51, 11.

9. *Currier and Ives, A Catalogue Raisonné*, 2 vols. (Detroit: Gale Research Company, 1980), 1:xi.

10. Oleograph and chromolithographic versions can be found at the Atlanta Historical Society. The poem in the epigraph to Part II is from this print. See also a broadside copy in the Museum of the Confederacy. The words to the poem, printed as if on the verso of a ten-dollar Confederate note, vary slightly from those adapted for the Simons print. The poem is signed, "P.C.C./Statesville, N.C., May 24, 1880," and is accompanied by a "Reply" calling for reconciliation and brotherhood, written by Daniel L. Weymouth of Boston.

CHAPTER 10

1. Fears, *Writings of Lord Acton*, 340.

2. Grimsley, "Jackson," 17–19; Taylor, *Destruction and Reconstruction*, 89–91.

3. Woodward, *Mary Chesnut's Civil War*, 499–500; Douglas, *I Rode with Stonewall*, 214; Jackson, quoted in Vandiver, *Mighty Stonewall*, 205.

4. Woodward, *Mary Chesnut's Civil War*, 501–2; Dabney, *Life and Campaigns*, 192.

5. Woodward, *Mary Chesnut's Civil War*, 499.

6. Wilson, *Patriotic Gore*, 302; Dabney, *Life and Campaigns*, 397.

7. *Washington Daily Morning Chronicle*, May 13, 1863. Roy Bird Cook recognized some of the significance of this and reproduced the editorial in *Early Life of Stonewall Jackson*, 170–71.

8. Basler et al., *Collected Works of Abraham Lincoln*, 6:214.

9. *Southern Literary Messenger* 35 (January 1863): 36; 34 (July–August 1862): 512; *Southern Illustrated News*, September 13, 1862, pp. 1, 4.

10. Thomas, *The Confederate Nation*, 217.

11. *Southern Illustrated News*, August 29, 1863, p. 1; January 23, 1864, p. 23.

12. Cooke, *Old Stonewall Brigade*, 26, 28; Cooke, *Life of Stonewall Jackson*, 284. James I. Robertson, Jr., argues that Jackson's soldiers grew gradually to love him, after some initial unhappiness with his harsh discipline (*Stonewall Brigade*, 8–9, 23–26).

13. Connelly, *The Marble Man*, 19–20; *Southern Illustrated*

News, May 23, 1863, p. 8; June 20, 1863, p. 8.

14. *Southern Illustrated News*, July 4, 1863, pp. 4, 12, 16; September 5, 1863, p. 82; October 3, 1863, p. 104.

15. Cooke, *Old Stonewall Brigade*, 30.

16. Connelly and Bellows, *God and General Longstreet*, 55; *Southern Illustrated News*, December 13, 1862, p. 7; August 29, 1863, p. 57.

17. Cooke, *Life of Stonewall Jackson*, iii–iv, 17, 19, 183, 275.

18. Ibid., 65, 112, 224, 239, 277, 280, 183, 285.

19. Woodward, *Mary Chesnut's Civil War*, 499–500, 428.

20. Dabney, *Life and Campaigns*, vi, 737, 397, 637.

21. Hallock, *Biographical Sketch of "Stonewall" Jackson*, 8–9, 29; Ramsey, *True Eminence*, 4, 6; Smith, *Lt. Gen. Thos. J. Jackson*, 14, 6, 11.

22. Hallock, *Biographical Sketch of "Stonewall" Jackson*, 28, 5, 21; Ramsey, *True Eminence*, 17, 20. The pneumonia-cape story is a myth; see Vandiver, *Mighty Stonewall*, 530 (n. 29).

23. Connelly, *The Marble Man*, 19; Miers, *When the World Ended*, 96.

24. Cooke, *Life of Stonewall Jackson*, 277; Jackson, *Confederate Monitor and Patriot's Friend*, 11, 37, 60.

25. Wilson, *Patriotic Gore*, 470, 471.

26. Bennett, *Whittier*, 270–72.

27. Young, *Around the World with General Grant*, 2:212.

28. Addey, *"Stonewall Jackson"*; *The Brave Soldier, Consummate General, and Devoted Christian*, advertising broadside by Charles T. Evans for Addey's *"Stonewall Jackson,"* Library Company of Philadelphia; Cooke, *Old Stonewall Brigade*, 67–72, 58–59.

29. *" 'Stonewall' Jackson's Prayer,"* sheet music from Blelock and Company, 1864, Historic New Orleans Collection.

30. Wright, *A Southern Girl in '61*, 127–28.

31. *Catalogue of Engravings for Sale by J. C. Buttre and Company* (New York, 1884), 5, 30; (New York, 1894), 49; Groce and Wallace, *Dictionary of Artists in America*, 499, 343, 284.

32. Holzer et al., *The Lincoln Image*, 168–80.

33. Douglas, *I Rode with Stonewall*, 236; Jackson, *Letters of General Thomas J. Jackson*, 426.

34. "My Wife and Child Song," sheet music from George Dunn of Richmond, n.d., Boston Athenaeum.

35. Jackson, *Letters of General Thomas J. Jackson*, 427–28.

36. Vandiver, *Mighty Stonewall*, 488–94.

37. Hallock, *Biographical Sketch of "Stonewall" Jackson*, 11; Cooke, *Life of Stonewall Jackson*, 111–13; *Jefferson Davis and "Stonewall" Jackson*, 274; Douglas, *I Rode with Stonewall*, 206.

38. William Barksdale Tabb to Conrad Wise Chapman, September 15, 1867, Conrad Wise Chapman Papers, Virginia Historical Society, Richmond.

39. Vandiver, *Mighty Stonewall*, 463–65.

40. *Southern Literary Messenger* 35 (January 1863): 37.

CHAPTER 11

1. Robert E. Lee to Martha Custis Williams, April 7, 1866, in Craven, *"To Markie,"* 69.

2. Flood, *Lee*, 157; Lee, *Recollections and Letters*, 271.

3. Lee, *Recollections and Letters*, 272.

4. Ibid.; Philippe, *Political Graphics*, 172, 176.

5. Christina Bond, quoted in Flood, *Lee*, 161.

6. Thomas, *Confederate Nation*, 305.

7. Flood, *Lee*, 39; Jones, *Personal Reminiscences*, 275–76.

8. Frassanito, *Grant and Lee*, 416–18; Meredith, *Face of Robert E. Lee*, 61–63; Lee to Martha Custis Williams, June 20, 1865, and April 7, 1866, in Craven, *"To Markie,"* 62, 69–70.

9. W. W. Jackson to Lida Thackery, November 28, 1887, Historical Society of Pennsylvania, Philadelphia.

10. Peters, *America on Stone*, 383–84; Connelly, *The Marble Man*, 155; W. W. Jackson to Lida Thackeray, November 28, 1887, Historical Society of Pennsylvania, Philadelphia; Humbert, *Edouard Detaille*, 8 (translation by authors). See also Goetzmann and Goetzmann, *West of the Imagination*, 215–16, 221. American Indians and Eastern cultures, by contrast, showed much blood and dismemberment in their battle art.

11. Davis, *The Long Surrender*, 88–89; Freeman, *R. E. Lee*, 3:326.

12. Davis, *The Long Surrender*, 230.

13. Ibid.; Lee to Washington College Trustees, August 24, 1865, in Long, *Memoirs of Robert E. Lee*, 444; Maurice, *An Aide-de-Camp of Lee*, 164–65.

14. Anderson, *Work of Adalbert Johann Volck*, 146–47.

15. "Lee Portrait Here," *Baltimore News and Post*, April 24, 1934.

16. Flood, *Lee*, 182–83.

17. Ibid., 167, 151–52, 188–89.

18. Ibid., 154.

19. Poesch, "Growth and Development of the Old South," 88; Connelly, *The Marble Man*, 38.

20. Lee, *Recollections and Letters*, 365–66; Meredith, *Face of Robert E. Lee*, 47.

21. Endpapers to Lee, *Memoirs of War*; Stauffer, *American Engravers upon Copper and Steel*, 1:193.

22. Lee, *Recollections and Letters*, 365–66.

23. Royster, *Light Horse Harry Lee*, 109–11.

24. Delaney, *The Kellys*, 4–7.

25. Flood, *Lee*, 220–22.

26. Valentine, "Reminiscences of General Lee," in Riley, *General Robert E. Lee after Appomattox*, 150, 154.

27. Davis, *The Long Surrender*, 238–39.

28. *New York Times*, October 14, 1870, p. 1.

29. *Robert E. Lee: In Memoriam*, 35, 38.

30. *New York Herald*, quoted in Jones, *Personal Reminiscences*, 62.

31. *Gravures Lithographies et Photographies: Extrait du Catalogue General de Goupil et cie* (Paris: A Pillet Fils Aine, 1874), 2.

32. Meredith, *Face of Robert E. Lee*, 40–45; *Southern Historical Society Papers* 3 (February 1877): 92.

33. Connelly, *The Marble Man*, 37.

34. Ibid., 12; Fielding, *American Painters, Sculptors, and Engravers*, 390; Holzer et al., *The Lincoln Image*, 169–81; *Ceremonies Connected with the Inauguration of the Mausoleum and the Unveiling of the Recumbent Figure of General Robert E. Lee* (Richmond: West, Johnson and Company, 1883), 7.

35. Connelly, *The Marble Man*, 44–46.

36. Fishwick, *General Lee's Photographer*, 2, 3, 8, 27; Meredith, *Face of Robert E. Lee*, 68–69, 71; Rhinesmith, "Traveller," 42–43; Salmon and Salmon, "General Lee's Photographer," 88; Lee to Martha Custis Williams, January 1, 1868, in Craven, *"To Markie,"* 80. Some sources give 1868 as the date of the equestrian photograph.

37. McCauley, *A. Hoen on Stone*, 3; Peters, *America on Stone*, 219; Connelly, *The Marble Man*, 45–46; *Southern Historical Society Papers* 2 (August 1876): 108.

38. *New York Times*, May 30, 1890, p. 2; Captain John Hampden Chamberlayne, quoted in Taylor, *Four Years With General Lee*, 199.

39. Ernest Estercourt, "Letters From the South," *The Southern Magazine* 8 (April 1871): 599; Connelly, *The Marble Man*, 60, 66–67, 38, 114–15, 91.

40. *Catalogue of Engravings for Sale by J. C. Buttre and Company* (New York, 1884), 5; (New York, 1894), 54, 103.

41. *Confederate Veteran* 36 (June 1928): back cover.

42. *New York Sun*, March 30, 1906, p. 5.

43. *Confederate Veteran* 25 (October 1917): back cover.

44. Original advertisement in print collection, New York Public Library.

45. Ibid.

46. *Confederate Veteran* 37 (November 1929): back cover.

47. Davis, *The Long Surrender*, 238; Connelly, *The Marble Man*, 114.

CHAPTER 12

1. Lauren H. Ripeley, "Personal Reminiscences of the Flight and Capture of Jeff. Davis," typescript quoted in Davis, *The Long Surrender*, 149; see also " 'Running at the Heads,' " *Atlantic Monthly* 16 (September 1865): 346; Tate, *Jefferson Davis*, 300. The most commonly cited anecdote of the Davis trek is one in which a Union soldier yells at a Confederate: " 'Hey, Johnny Reb, . . . we've got your president!' 'And the devil's got yours,' was the swift reply" ([Clay], *A Belle of the Fifties*, 256). Ballard, "A Long Shadow," ably argues that even before Fortress Monroe, during the waning months of the Confederacy, Davis's popularity began to rise. The argument deserves further development.

2. William Gladstone, quoted in Crook, *The North, the South, and the Powers*, 227–28; Fears, *Writings of Lord Acton*, 1:340.

3. Stille, *Memorial of the Great Central Fair*, 114–18; *Harper's Weekly*, January 9, 1864, p. 29; April 16, 1864, p. 264; *The Daily Morning Drum Beat* (Brooklyn Fair newspaper), March 1, 1864, p. 4; March 2, 1864, p. 4; March 3, 1864, p. 4; Basler et al., *Collected Works of Abraham Lincoln*, 7:514; *New York Times*, March 29, 1986.

4. *New York Herald*, May 23, 1865.

5. Davis, *The Long Surrender*, 223. The first historian to note and exaggerate the transformation of the Davis reputation was Edward A. Pollard (*Life of Jefferson Davis*, 526–27). As for the shackling, the officer supervising it recalled the episode in a letter to his son (Jerome Titlow to son, July 4, 18—, in McElroy, *Jefferson Davis*, 2:527–30). See also *Official Records*, ser. 2, vol. 8, pp. 563–65, 572.

6. Mary C. Lee to Jefferson Davis, June 6, 1866 (the bulk of the letter was written soon after Davis's capture, but it was not sent until more than a year later), in Strode, ed., *Jefferson Davis: Private Letters*, 249.

7. Craven, *Prison Life of Jefferson Davis*. For discussion of the book's authorship, see Harrison, *Harrisons of Skimino*, 207; Barbee, "Dr. Craven's 'Prison Life of Jefferson Davis' "; Bradley, "Dr. Craven and the Prison Life of Jefferson Davis"; Hanchett, *Irish*, 142–50.

8. Hanchett, *Irish*, 146, contains a good summary of the book.

9. Craven, *Prison Life of Jefferson Davis*, 37–38.

10. Ibid., 40.

11. Davis, *Jefferson Davis, Ex-President*, 2:655–58.

12. The annotated volume is in Rare Books Division, Howard-Tilton Memorial Library, Tulane University. We are indebted to Wilbur E. Meneray for providing the information about Davis's comments. Davis, *Rise and Fall*, 2:705, merely notes "the needless torture to which I was subjected, and the heavy fetters riveted upon me."

13. Strode, *Jefferson Davis*, 3:302–11; Harrison, *Harrisons of Skimino*, 202–6.

14. *Richmond Enquirer*, May 13, 1867.

15. Vandiver, "Jefferson Davis," 3–18; McWhiney, "Jefferson Davis—the Unforgiven," 113–27.

16. Warren, *Jefferson Davis Gets His Citizenship Back*, 84; Woodward, *Mary Chesnut's Civil War*, 817, 818, 819.

17. Tate, *Jefferson Davis*, 299.

18. Wilson, *Baptized in Blood*, 50.

19. Peters, *America on Stone*, 97.

20. Miller, *Photographic History of the Civil War*, 9:293; Hamilton and Ostendorf, *Lincoln in Photographs*. A careful study of Davis photographs is badly needed.

21. Davis, *Papers*, 1:lxv; Holzer et al., *The Lincoln Image*, 160–88.

22. Holzer et al., *The Lincoln Image*, 108.

23. *Frank Leslie's Illustrated Newspaper*, May 8, 1886, p. 186; Ballard, "Cheers for Jefferson Davis," 8–15.

24. Ibid.

25. Warren, *Jefferson Davis Gets His Citizenship Back*, 92.

CHAPTER 13

1. Younger, *Inside the Confederate Government*, 46.

2. McMurry, " 'The *Enemy* at Richmond,' " 31.

3. Sherman, *Personal Memoirs*, 2:344.

4. Williams, *P. G. T. Beauregard*, 91.

5. Ibid., 98; Harwell, *Confederate Music*, 103, 124, 135, 138.

6. Williams, *P. G. T. Beauregard*, 317–18.

7. Hesseltine, *Confederate Leaders in the New South*, 110–12.

8. *The Forrest Monument: Its History and Dedication* (Memphis, Tenn.: Forrest Monument Association, 1905), 29–30, 37–38, 43–44; Wilson, *Patriotic Gore*, 306–7.

9. Thomas, *Bold Dragoon*, 73, 87, 90, 128, 171.

10. Wilson, *Patriotic Gore*, 307–22; *War and Its Heroes*, 35, 40.

CHAPTER 14

1. Humbert, *Edouard Detaille*, 6–8.

2. Poesch, *Art of the Old South*, 261–305; the Yankee turncoat from Virginia was David Hunter Strother, better known as Porte Crayon.

3. Figures compiled from Wright, *Artists in Virginia before 1900*.

4. McCauley, *Maryland Historical Prints*, 174.

5. Statistics compiled from Wright, *Artists in Virginia before 1900*.

6. William Barksdale Tabb to Conrad Wise Chapman, September 15, 1867, Conrad Wise Chapman Papers, Virginia Historical Society, Richmond.

7. [?] to Allen Christian Redwood, February 2, 1885, Allen Christian Redwood Papers, Museum of the Confederacy, Richmond, Virginia.

8. Ulrich Troubetzkoy, "Sheppard at Valentine," *Richmond News Leader*, December 27, 1969, clipping in Valentine Museum, Richmond, Virginia.

9. Pierce and Smith, *Citizens in Conflict*, 15; Simms, "Conrad Wise Chapman," 15; [Catterall and Taylor], *Conrad Wise Chapman*, 13–16.

10. [Catterall and Taylor], *Conrad Wise Chapman*, 16–20, plate 1; Pierce and Smith, *Citizens in Conflict*, 15.

11. McCarthy, *Detailed Minutiae*, 204.

12. Wiley, *Life of Johnny Reb*, 36, 161.

13. Ibid., 103.

14. Laura Seager Chapman, "Conrad Wise Chapman," typescript, Valentine Museum, Richmond; [Catterall and Taylor], *Conrad Wise Chapman*, 20; Henry A. Wise to John Gadsby Chapman, June 13, 1872, Conrad Wise Chapman Papers, Virginia Historical Society.

15. Pierce and Smith say he was transferred against his will (*Citizens in Conflict*, 20n), but see Conrad Wise Chapman to Henry A. Wise, August 25, 1862, photocopy in Valentine Museum from Wise Papers, University of Virginia, Charlottesville.

16. Pierce and Smith, *Citizens in Conflict*, 17; William Barksdale Tabb to Conrad Wise Chapman, September 15, 1867, Conrad Wise Chapman Papers, Virginia Historical Society.

17. See [Catterall and Taylor], *Conrad Wise Chapman*, 10.

18. Pierce and Smith, *Citizens in Conflict*, 17; Henry A. Wise to Conrad Wise Chapman, June 25, 1867, and William Barksdale Tabb to Conrad Wise Chapman, September 15, 1867, Conrad Wise Chapman Papers, Virginia Historical Society.

19. Conrad Wise Chapman to Granville G. Valentine, February

23, 1899, Valentine Museum, Richmond. On Detaille, see Humbert, *Edouard Detaille*.

20. The Hanhart advertisement is in the Anne S. K. Brown Military Collection, John Hay Library, Brown University. See also Henry A. Wise to John Gadsby Chapman, June 13, 1872, Conrad Wise Chapman Papers, Virginia Historical Society; Simms, "Conrad Wise Chapman," 27; Arthur Rose Guerard to James C. Young, November 24, 1929, Valentine Museum.

21. Simms, "Conrad Wise Chapman," 27; Arthur Rose Guerard to James C. Young, November 24, 1929, Valentine Museum.

22. [Catterall and Taylor], *Conrad Wise Chapman*, 49–63; Conrad Wise Chapman to Miss Harris and Miss Jaiser, n.d., photocopy, Valentine Museum.

23. Davis, "A. C. Redwood and the Confederate Image," 30–36.

24. [?] to Allen C. Redwood, February 2, 1885, Allen Christian Redwood Papers, Museum of the Confederacy, Richmond, Virginia. See also Osterweis, *Myth of the Lost Cause*, 38–39, 76.

25. Davis, "A. C. Redwood and the Confederate Image," 30–36; M. T. Ducross to Allen C. Redwood, November 6, 1866, Allen Christian Redwood Papers, Museum of the Confederacy, Richmond, Virginia.

26. McCauley, *Maryland Historical Prints*, 215; Sears, *Civil War Art*, 232–33; Davis, "A. C. Redwood and the Confederate Image," 35.

27. Jones, *Rebel War Clerk's Diary*, 1:239; Pember, *Southern Woman's Story*, 42–45.

28. Bradley T. Johnson to Allen C. Redwood, July 22, 1899, Allen Christian Redwood Papers, Museum of the Confederacy, Richmond, Virginia.

29. Grant, "William Ludwell Sheppard," 9; Troubetzkoy, "W. L. Sheppard," 26.

30. Bradley T. Johnson to Allen C. Redwood, March 27–April 7, 1901, Allen Christian Redwood Papers, Museum of the Confederacy, Richmond, Virginia.

31. Wiley, *Life of Johnny Reb*, pp. 81–82; Goldsborough, *Maryland Line in the Confederate Army*, 53.

32. Grant, "William Ludwell Sheppard," 14, 8.

33. Print Cabinet, Valentine Museum, Richmond, Virginia.

34. William Barksdale Tabb to Conrad Wise Chapman, September 15, 1867, Conrad Wise Chapman Papers, Virginia Historical Society.

35. F. D. Cossitt, "Sheppard Exhibit is Exceptional," *Richmond Times-Dispatch*, December 12, 1969 (clipping in Valentine Museum); Troubetzkoy, "Sheppard at Valentine"; Jon D. Longaker, "C. W. Chapman Civil War Work Shown," *Richmond Times-Dispatch*, September 30, 1962 (clipping in Valentine Museum); Grant, "William Ludwell Sheppard," 6; Redwood, "Johnny Reb at Play," 33.

CONCLUSION

1. Wilson, *Baptized in Blood*, 133; Connelly, *The Marble Man*, 41.

2. Wilson, *Baptized in Blood*, 52. This brief discussion depends heavily on Wilson's fine study.

3. *Southern Historical Society Papers* 3 (February 1877): 92–93; Connelly, *The Marble Man*, 115.

4. Strode, *Jefferson Davis*, 274; Jones, *Davis Memorial Volume*, p. ix.

5. Bernard DeVoto, *Saturday Review*, March 6, 1937, p. 8.

6. *Confederate Veteran* 36 (April 1928), cover. See Shafer, *Nationalism*, 161–65.

AFTERWORD

1. In addition to Wilson, *Baptized in Blood*, see Osterweis, *Myth of the Lost Cause*; Buck, *Road to Reunion*, 236–62; Woodward, *Origins of the New South*, 154–74; Hanum, "Confederate Cavaliers"; Durant, "The Gently Furled Banner." Gaston, *New South Creed*, defines a creed of reconciliation between North and South, peace between black and white, and economic development and diversification. For contrasting views of the relationship of the Lost Cause to the New South, see Wiener, *Social Origins of the New South*, and Billings, *Planters and the Making of a "New South."*

2. Chambers, *Art and Artists of the South*, 1.

3. Connelly and Bellows, *God and General Longstreet*, 117–19.

Bibliography

Adalbert J. Volck D.D.S. Sesquicentennial. Baltimore: College of Dental Surgery, 1978. Gallery note.

"Adalbert Volck, Maryland's Fifth Column Artist." *Black Heritage* 18, no. 3 (January–February 1979): 51–54.

Adams, Charles Francis. *Shall Cromwell Have a Statue? Address before the Phi Beta Kappa Society of the University of Chicago, June 17, 1902.* Boston: Charles E. Laurriat Company, 1902.

Addey, Markinfield. *"Stonewall Jackson": The Life and Military Career.* New York: C. T. Evans, 1863.

Alfriend, Frank H. *The Life of Jefferson Davis.* Cincinnati: Caxton Publishing House, 1868.

Anderson, George McCullough. *The Work of Adalbert Johann Volck, 1828–1912.* Baltimore: n.p., 1970.

Appomattox Court House. Washington, D.C.: National Park Service, n.d.

Badeau, Adam. "General Grant." *Century* 30 (May 1885): 151–63.

Ballard, Michael B. "Cheers for Jefferson Davis." *American History Illustrated* 16 (May 1981): 8–15.

————. "A Long Shadow: Jefferson Davis and the Final Days of the Confederacy." Ph.D. diss., Mississippi State University, 1983.

Barbee, David Rankin. "Dr. Craven's 'Prison Life of Jefferson Davis'—An Expose." *Tyler's Quarterly* 32 (1951): 282–95.

Barber, James G. *U. S. Grant: The Man and the Image.* Washington, D.C.: National Portrait Gallery, 1985.

Basler, Roy P., Marion Dolores Pratt, and Lloyd A. Dunlap, eds. *Collected Works of Abraham Lincoln.* 9 vols. New Brunswick: Rutgers University Press, 1953–55.

Beale, Howard K., ed. *Diary of Gideon Welles.* 3 vols. New York: Norton, 1960.

Beecher, Catherine E., and Harriet Beecher Stowe. *The New Housekeeper's Manual.* New York: J. B. Ford, 1873.

Bennett, Whitman. *Whittier: Bard of Freedom.* Chapel Hill: University of North Carolina Press, 1941.

Beringer, Richard E., Herman Hattaway, Archer Jones, and William N. Still, Jr. *Why the South Lost the Civil War.* Athens: University of Georgia Press, 1986.

Billings, Dwight B., Jr. *Planters and the Making of a "New South": Class, Politics, and Development in North Carolina, 1865–1900.* Chapel Hill: University of North Carolina Press, 1979.

Blackford, W. W. *War Years with Jeb Stuart.* New York: Scribner's, 1945.

Boritt, Gabor S., Harold Holzer, and Mark E. Neely, Jr. "The European Image of Abraham Lincoln." *Winterthur Portfolio* 22 (Summer–Autumn 1986): 153–83.

Bradley, Chester D. "Dr. Craven and the Prison Life of Jefferson Davis." *Virginia Magazine of History and Biography* 62 (1954): 50–94.

————. "Was Jefferson Davis Disguised as a Woman When Captured?" *Journal of Mississippi History* 36 (1974): 143–68.

Bruce, Dickson D., Jr. *Violence and Culture in the Antebellum South.* Austin: University of Texas Press, 1979.

Buck, Paul H. *The Road to Reunion.* Boston: Little, Brown, 1937.

Bundy, David S., ed. *Painting in the South, 1564–1980.* Richmond: Virginia Museum, 1983.

[Catterall, Louise F., and Donald R. Taylor]. *Conrad Wise Chapman, 1842–1910: An Exhibition of His Works in the Valentine Museum.* Richmond: The Valentine Museum, 1962.

Chambers, Bruce. *Art and Artists of the South: The Robert P. Coggins Collection.* Columbia: University of South Carolina Press, 1984.

Chromoliths of Louis Prang, The. New York: Clarkson N. Potter, 1973.

[Clay, Virginia]. *A Belle of the Fifties.* New York: Doubleday, 1904.

Connelly, Thomas L. *The Marble Man: Robert E. Lee and His Image in American Society.* Baton Rouge: Louisiana State University Press, 1977.

Connelly, Thomas L., and Barbara Bellows. *God and General Longstreet: The Lost Cause and the Southern Mind.* Baton Rouge: Louisiana State University Press, 1982.

Conningham, Frederic A. *Currier and Ives Prints: An Illustrated Check List.* New York: Crown, 1970.

Cook, Roy Bird. *The Family and Early Life of Stonewall Jackson.* Charleston, W.Va.: Charleston Printing Company, 1948.

Cooke, John Esten. *The Life of Stonewall Jackson.* New York: Charles B. Richardson, 1863.

————. *Stonewall Jackson and the Old Stonewall Brigade.* Edited by Richard Barksdale Harwell. Charlottesville: University Press of Virginia, 1954.

Coulter, E. Merton. *The Confederate States of America, 1861–1865.* Baton Rouge: Louisiana State University Press, 1960.

Crandall, Marjorie Lyle. *Confederate Imprints: A Check List Based Principally on the Collection of the Boston Athenaeum.* 2 vols. Boston: Boston Athenaeum, 1955.

Craven, Avery, ed. *"To Markie": The Letters of Robert E. Lee to Martha Custis Williams.* Cambridge: Harvard University Press, 1933.

Craven, John J. *Prison Life of Jefferson Davis*. New York: Carleton, 1866.

Crook, D. P. *The North, the South, and the Powers, 1861–1865*. New York: Wiley, 1974.

Dabney, Robert L. *Life and Campaigns of Lieut.-Gen. Thomas J. Jackson (Stonewall Jackson)*. New York: Blelock and Company, 1886.

Dabney, Virginius. *Richmond: The Story of a City*. New York: Doubleday, 1976.

Davis, Burke. *The Long Surrender*. New York: Random House, 1985.

Davis, Jefferson. *The Papers of Jefferson Davis*. 5 vols. to date. Baton Rouge: Louisiana State University Press, 1971–.

———. *The Rise and Fall of the Confederate Government*. 2 vols. New York: Appleton, 1881.

———. *A Short History of the Confederate States of America*. New York: Bedford, 1892.

Davis, Stephen. "A. C. Redwood and the Confederate Image." *Civil War Times Illustrated* 23 (October 1984): 30–36.

Davis, Varina Howell. *Jefferson Davis, Ex-President of the Confederate States of America: A Memoir*. 2 vols. New York: Belford Company, 1890.

Delaney, Edmund T. K. *The Kellys: Printmakers of New York and Philadelphia*. Chester: Connecticut River Publications, 1984.

DeLeon, T. C. *Belles, Beaux and Brains of the 60's*. New York: G. W. Dillingham Company, 1907.

Dietz, August. *The Postal Service of the Confederate States of America*. Richmond: Dietz Press, 1929.

Dimick, Howard T. "The Capture of Jefferson Davis." *Journal of Mississippi History* 29 (1947): 238–54.

Dodge, David. "Domestic Economy in the Confederacy." *Atlantic Monthly* 58 (August 1886): 229–42.

Douglas, Henry Kyd. *I Rode with Stonewall*. Chapel Hill: University of North Carolina Press, 1940.

Dowdey, Clifford. *Lee*. Boston: Little, Brown, 1965.

———, ed. *The Wartime Papers of R. E. Lee*. Boston: Little, Brown, 1961.

Durant, Susan E. "The Gently Furled Banner: The Development of the Myth of the Lost Cause, 1865–1900." Ph.D. diss., University of North Carolina, 1972.

Eaton, Clement. *A History of the Southern Confederacy*. 1954. Reprint. New York: Free Press, 1965.

———. *Jefferson Davis*. New York: Free Press, 1977.

Fears, J. Rufus, ed. *Selected Writings of Lord Acton*. Vol. 1, *Essays in the History of Liberty*. Indianapolis: Liberty Classics, 1985.

Fielding, Mantle. *Dictionary of American Painters, Sculptors, and Engravers*. Rev. ed. Greens Farms, Conn.: Modern Books, 1974.

Fishwick, Marshall. *General Lee's Photographer: The Life and Work of Michael Miley*. Chapel Hill: University of North Carolina Press, 1954.

Flood, Charles Bracelen. *Lee: The Last Years*. Boston: Houghton Mifflin, 1981.

Foley, Gardner P. H. "Adalbert Volck, Dentist and Artist." *Journal of the American College of Dentists* 16 (March 1949): 60–66.

Fox, John A. *The Capture of Jefferson Davis*. New York: n.p., 1964.

Frassanito, William A. *Grant and Lee: The Virginia Campaigns, 1864–1865*. New York: Scribner's, 1983.

Fredrickson, George M. *The Inner Civil War: Northern Intellectuals and the Crisis of the Union*. New York: Harper and Row, 1965.

Freeman, Douglas Southall. *R. E. Lee: A Biography*. 4 vols. New York: Scribner's, 1934.

———. *The South to Posterity: An Introduction to the Writing of Confederate History*. New York: Scribner's, 1951.

Fremantle, Arthur. *Three Months in the Southern States, April–June 1863*. Edinburgh: William Blackwood and Sons, 1863.

Gaston, Paul M. *The New South Creed: A Study of Southern Mythmaking*. New York: Vintage, 1973.

George Bellows and the War Series of 1918. New York: Hirschl and Adler Galleries, 1983.

Goetzmann, William H., and William N. Goetzmann. *The West of the Imagination*. New York: Norton, 1986.

Goldsborough, W. W. *The Maryland Line in the Confederate Army 1861–1865*. 1900. Reprint. Gaithersburg, Md.: Butternut Press, 1983.

Govan, Gilbert E., and James W. Livingood. *A Different Valor: The Story of General Joseph E. Johnston*. New York: Bobbs-Merrill, 1956.

Grant, Marena Rollins. "William Ludwell Sheppard: Artist-Illustrator." M.A. thesis, Virginia Commonwealth University, 1970.

Grant, Ulysses S. *Personal Memoirs*. 2 vols. New York: Charles L. Webster and Company, 1892.

Green, Brian M. *The Confederate States Five-Cent Green Lithograph*. New York: Philatelic Foundation, 1977.

———. *The Typographs of the Confederate States of America: Postage Stamps and Postal History*. New York: Philatelic Foundation, 1981.

Grimsley, Mark. "Jackson: The Wrath of God." *Civil War Times*

Illustrated 23 (March 1984): 10–19.

Groce, George C., and David H. Wallace. *The New York Historical Society's Dictionary of Artists in America, 1564–1860.* New Haven: Yale University Press, 1957.

Hallock, Charles. *A Complete Biographical Sketch of "Stonewall" Jackson.* Augusta, Ga.: Steam Power-Press Chronicle and Sentinel, 1863.

Halstead, Murat. "Heroic Illustrations of the Confederacy." *The Cosmopolitan* (August 1890): 496–507.

Hamilton, Charles, and Lloyd Ostendorf. *Lincoln in Photographs: An Album of Every Known Pose.* Dayton, Ohio: Morningside, 1985.

Hanchett, William. *Irish: Charles G. Halpine in Civil War America.* Syracuse: Syracuse University Press, 1970.

Hanum, Sharon E. "Confederate Cavaliers: The Myth of War and Defeat." Ph.D. diss., Rice University, 1965.

Harper, Robert S. *Lincoln and the Press.* New York: McGraw-Hill, 1951.

Harris, Neil. *Humbug: The Art of P. T. Barnum.* Chicago: University of Chicago Press, 1973.

Harrison, Fairfax. *The Harrisons of Skimino.* [New York]: n.p., 1910.

Harwell, Richard B. *Confederate Music.* Chapel Hill: University of North Carolina Press, 1950.

————. *More Confederate Imprints.* 2 vols. Richmond: Virginia State Library, 1957.

Hesseltine, William B. *Confederate Leaders in the New South.* Baton Rouge: Louisiana State University Press, 1950.

Hill, Tucker. *Victory in Defeat: Jefferson Davis and the Lost Cause.* Richmond: Museum of the Confederacy, 1986.

Holzer, Harold; Gabor S. Boritt, and Mark E. Neely, Jr. *The Lincoln Image: Abraham Lincoln and the Popular Print.* New York: Scribner's, 1984.

Humbert, Jean. *Edouard Detaille: l'heroisme d'un siècle.* Paris: Copernic, 1979.

Jackson, Henry W. R. *Confederate Monitor and Patriot's Friend, with Several Interesting Chapters of History Concerning Gen. Stonewall Jackson.* Atlanta: Franklin Steam Printing House, J. J. Toon and Company, 1862.

Jackson, Mary Anna. *Life and Letters of General Thomas J. Jackson.* New York: Harper and Brothers, 1892.

Jefferson Davis and "Stonewall" Jackson. Philadelphia: John E. Potter, 1866.

Johnson, Robert U., and Clarence C. Buel. *Battles and Leaders of the Civil War.* 4 vols. New York: The Century Company, 1887.

Johnston, Joseph E. *Narrative of Military Operations.* New York: Appleton, 1874.

Jones, J. William. *The Davis Memorial Volume: Or, Our Dead President, Jefferson Davis, and the World's Tribute to His Memory.* Richmond: Franklin, 1890.

————. *Personal Reminiscences of General Robert E. Lee.* New York: Appleton, 1875.

Jones, John B. *A Rebel War Clerk's Diary at the Confederate States Capital.* 2 vols. Philadelphia: Lippincott, 1866.

Jones, Katherine M., ed. *Heroines of Dixie.* New York: Bobbs-Merrill, 1955.

Kellogg, Robert H. *Life and Death in Rebel Prisons.* Hartford: Stebbins, 1865.

Lalumia, Matthew. "Realism and Anti-Aristocratic Sentiment in Victorian Depictions of the Crimean War." *Victorian Studies* 27 (Autumn 1983): 25–51.

Lee, Henry. *Memoirs of War in the Southern Department.* Rev. ed. New York: Charles B. Richardson, 1869.

Lee, Robert E., Jr. *Recollections and Letters of General Robert E. Lee.* New York: Doubleday, 1907.

Long, A. L. *Memoirs of Robert E. Lee.* London: Low, Marston, Searle and Rivington, 1886.

Lyne, Mrs. William. "The Restoration of Arlington Mansion." *Confederate Veteran* 37 (May 1929): 184–87.

M & M Karolik Collection of American Water Colors and Drawings, 1800–1875. 2 vols. Boston: Museum of Fine Arts, 1962.

McCarthy, Carlton. *Detailed Minutiae of Soldier Life in the Army of Northern Virginia 1861–1865.* Richmond: Carlton McCarthy and Company, 1884.

McCauley, Lois B. *A. Hoen on Stone: Lithographs of E. Weber and Company and A. Hoen and Company, Baltimore, 1835–1969.* Baltimore: Maryland Historical Society, 1969.

————. *Maryland Historical Prints, 1752 to 1889: A Selection from the Robert G. Merrick Collection.* Baltimore: Maryland Historical Society, 1975.

McElroy, Robert. *Jefferson Davis: The Unreal and the Real.* 2 vols. New York: Harper, 1937.

McGuire, Judith W. *Diary of a Southern Refugee during the War by a Lady of Virginia.* Richmond: J. W. Randolph and English, 1889.

McMurry, Richard M. " 'The *Enemy* at Richmond': Joseph E. Johnston and the Confederate Government." *Civil War History* 27 (March 1981): 5–31.

McWhiney, Grady. "Jefferson Davis—the Unforgiven." *Journal of Mississippi History* 42 (1980): 113–27.

————. "Jefferson Davis and the Art of War." *Civil War History*

21 (June 1975): 101–12.

Manierre, William R. "A Southern Response to Mrs. Stowe: The Letter of John R. Thompson." *Virginia Magazine of History and Biography* 69 (January 1961): 83–92.

Marzio, Peter. *The Democratic Art: Pictures for a 19th-Century America*. Boston: David R. Godine, 1979.

Mason, Emily V. *Popular Life of Gen. Robert Edward Lee*. Baltimore: John Murphy and Company, 1874.

Massey, Mary Elizabeth. *Ersatz in the Confederacy*. Columbia: University of South Carolina Press, 1952.

Maurice, Frederick, ed. *An Aide-de-Camp of Lee: The Papers of Colonel Charles Marshall*. Boston: Little, Brown, 1927.

Mead, Edward C. *A Genealogical History of the Lee Family*. New York: Charles B. Richardson, 1868.

Meredith, Roy. *The Face of Robert E. Lee in Life and Legend*. Rev. ed. New York: Fairfax Press, 1981.

Miers, Earl Schenck, ed. *When the World Ended: The Diary of Emma LeConte*. New York: Oxford University Press, 1957.

Miller, Francis Trevelyan. *The Photographic History of the Civil War*. 10 vols. New York: Review of Reviews Company, 1911.

Mott, Frank Luther. *A History of American Magazines*. 4 vols. Cambridge: Harvard University Press, 1957.

Murrell, William. *A History of American Graphic Humor*. 2 vols. New York: Cooper Square Publishers, 1967.

Myers, Robert Manson, ed. *The Children of Pride: A True Story of Georgia and the Civil War*. New Haven: Yale University Press, 1972.

Nevins, Allan, and Milton Halsey Thomas, eds. *The Diary of George Templeton Strong*. 3 vols. New York: Macmillan, 1952.

Osterweis, Rollin G. *The Myth of the Lost Cause, 1865–1900*. Hamden, Conn.: Archon Books, 1973.

Pember, Phoebe Yates. *A Southern Woman's Story: Life in Confederate Richmond*. Edited by Bell Irvin Wiley. St. Simonds Island, Ga.: Mockingbird Books, 1974.

Peters, Harry Twyford. *America on Stone: The Other Printmakers to the American People*. New York: Doubleday, 1931.

Philippe, Robert. *Political Graphics: Art as a Weapon*. New York: Abbeville Press, 1982.

Pierce, Sally, and Temple D. Smith. *Citizens in Conflict: Prints and Photographs of the American Civil War*. Boston: Boston Athenaeum, 1981.

Poesch, Jessie J. *The Art of the Old South: Painting, Sculpture, Architecture and the Products of Craftsmen, 1560–1860*. New York: Alfred A. Knopf, 1983.

———. "Growth and Development of the Old South: 1830 to 1900." In *Painting in the South: 1564–1980*, edited by David S. Bundy, 73–99. Richmond: Virginia Museum, 1983.

Pollard, Edward A. *Life of Jefferson Davis*. Philadelphia: National, 1869.

———. *Observations in the North: Eight Months in Prison and on Parole*. Richmond: E. W. Ayres, 1865.

———. *Southern History of the War: The First Year of the War*. New York: Charles B. Richardson, 1863.

Porscher, Francis Peyre. *Resources of the Southern Fields and Forests*. Charleston, S.C.: Walker, Evans, Coggswell, 1869.

Putnam, Sallie A. *Richmond during the War: Four Years of Personal Observation*. New York: Carleton, 1867.

Quill, J. Michael. *Prelude to the Radicals: The North and Reconstruction during 1865*. Washington: University Press of America, 1980.

Ramsey, James B. *True Eminence Founded on Holiness: A Discourse Occasioned by the Death of Lieut. Gen. T. J. Jackson*. Lynchburg: Virginian "Water-Power Presses," 1863.

Reagan, John H. *Memoirs with Special Reference to Secession and the Civil War*. New York: Neale, 1906.

Redwood, Allen C. "Johnny Reb at Play." *Scribner's Monthly* 17 (November 1878): 33–37.

Rhinesmith, W. Donald. "Traveller: Just the Horse for General Lee," *Virginia Cavalcade* 33 (Summer 1983): 38–47.

Riley, Franklin L., ed. *General Robert E. Lee after Appomattox*. New York: Macmillan, 1922.

Robert E. Lee: In Memoriam. Louisville: John P. Minton and Company, 1870.

Robertson, James I., Jr. *The Stonewall Brigade*. Baton Rouge: Louisiana State University Press, 1963.

Roland, Charles P. *The Confederacy*. Chicago: University of Chicago Press, 1960.

———. "The South at War." In *The Embattled Confederacy: Volume Three of the Image of War, 1861–1865*, edited by William C. Davis. New York: Doubleday, 1982.

Roman, Alfred. *The Military Operations of General Beauregard*. 2 vols. New York: Harper and Brothers, 1884.

Rowland, Dunbar, ed. *Jefferson Davis, Constitutionalist: His Letters, Papers and Speeches*. 10 vols. Jackson: Mississippi Department of Archives, 1923.

Royster, Charles. *Light Horse Harry Lee and the Legacy of the American Revolution*. New York: Alfred A. Knopf, 1981.

Russell, William Howard. *My Diary North and South*. 2 vols. London: Bradbury and Evans, 1863.

Sabin, Joseph, and Wilberforce Eames. *Bibliotheque Americana: A Dictionary of Books Relating to America.* 29 vols. New York: Sabin, 1868–92, and Bibliographic Society of America, 1928–36.

Salmon, Emily J. "The Burial of Latane: Symbol of the Lost Cause." *Virginia Cavalcade* 29 (Winter 1979): 118–29.

Salmon, Emily J., and John S. Salmon. "General Lee's Photographer," *Virginia Cavalcade* 33 (Fall 1983): 86–96.

Sears, Stephen W., ed. *The American Heritage Century Collection of Civil War Art.* 1974. Reprint. New York: American Heritage Publishing Company, 1983.

Shafer, Boyd C. *Nationalism: Myth and Reality.* New York: Harcourt, Brace and World, 1955.

Sherman, William T. *Personal Memoirs.* 2 vols., 3d ed. New York: Charles L. Webster and Company, 1890.

Sideman, Belle Becker, and Lillian Friedman, eds. *Europe Looks at the Civil War.* New York: Orion Press, 1960.

Simms, L. Moody, Jr. "Conrad Wise Chapman: A Virginia Expatriate Painter." *Virginia Cavalcade* 20 (Spring 1971): 13–28.

Smith, Francis H. *Discourse on the Life and Character of Lt. Gen. Thos. J. Jackson.* Richmond: Ritchie and Dunnavant, 1863.

Smith, Gene. *Lee and Grant.* New York: McGraw-Hill, 1984.

Smith-Rosenberg, Carroll. *Disorderly Conduct: Visions of Gender in Victorian America.* New York: Alfred A. Knopf, 1985.

Smyth, Clifford. *Robert E. Lee, Who Brought the South Back to the Union.* New York: Funk and Wagnalls, 1931.

Stauffer, David McKinley. *American Engravers upon Copper and Steel.* 3 vols. New York: The Grolier Club, 1907.

Stern, Philip Van Doren. *Robert E. Lee, the Man and the Soldier: A Pictorial Biography.* New York: Bonanza Books, 1963.

Stille, Charles J. *Memorial of the Great Central Fair . . . Held at Philadelphia.* Philadelphia: U.S. Sanitary Commission, 1865.

Strode, Hudson. *Jefferson Davis.* 3 vols. New York: Harcourt, 1955–1964.

————, ed. *Jefferson Davis: Private Letters, 1823–1889.* New York: Harcourt, 1966.

Tate, Allen. *Jefferson Davis: His Rise and Fall. A Biographical Narrative.* New York: Minton, 1929.

Taylor, Richard. *Destruction and Reconstruction: Personal Experiences of the Late War.* New York: Appleton, 1879.

Taylor, Walter H. *Four Years with General Lee.* New York: Appleton, 1878.

Thomas, Benjamin Platt. *Abraham Lincoln: A Biography.* New York: Alfred A. Knopf, 1952.

Thomas, Emory M. *Bold Dragoon: The Life of J. E. B. Stuart.* New York: Harper and Row, 1986.

————. *The Confederate Nation: 1861–1865.* New York: Harper and Row, 1979.

————. *The Confederate State of Richmond: A Biography of the Capital.* Austin: University of Texas Press, 1971.

Thompson, John R. "The Burial of Latane." *Southern Literary Messenger* 34 (July–August 1862): 475.

Todd, Richard Cecil. *Confederate Finance.* Athens: University of Georgia Press, 1954.

Troubetzkoy, Ulrich. "W. L. Sheppard: Artist of Action." *Virginia Cavalcade* 11 (Winter 1961–62): 20–26.

Valentine, Edward V. "Reminiscences of General Lee." In *General Robert E. Lee after Appomattox*, edited by Franklin L. Riley. New York: Macmillan, 1922.

Vandiver, Frank E. "Jefferson Davis—Leader Without Legend." *Journal of Southern History* 43 (1977): 3–18.

————. *Mighty Stonewall.* New York: McGraw-Hill, 1957.

————. *Their Tattered Flags: The Epic of the Confederacy.* New York: Harper's Magazine Press, 1970.

[Voss, Frederick]. *Adalbert Volck: Fifth Column Artist.* Washington: National Portrait Gallery, 1979. Gallery note.

————. "Adalbert Volck: The South's Answer to Thomas Nast." Paper presented at the North American Print Conference, 1983.

Wainwright, Nicholas B. *Philadelphia in the Romantic Age of Lithography.* Philadelphia: Historical Society of Pennsylvania, 1958.

War and Its Heroes, The. Richmond: Ayres and Wade, 1864.

Warren, Robert Penn. *Jefferson Davis Gets His Citizenship Back.* Lexington: University Press of Kentucky, 1980.

Wheeler, Richard. *Sword over Richmond: An Eyewitness History of McClellan's Peninsula Campaign.* New York: Harper and Row, 1986.

Wiener, Jonathan M. *Social Origins of the New South: Alabama, 1860–1885.* Baton Rouge: Louisiana State University Press, 1978.

Wiley, Bell Irvin. *Embattled Confederates: An Illustrated History of Southerners at War.* New York: Harper and Row, 1964.

————. *The Life of Johnny Reb: The Common Soldier of the Confederacy.* 1943. Reprint. Baton Rouge: Louisiana State University Press, 1978.

Wilkinson, John. *The Narrative of a Blockade-Runner.* New York: Sheldon and Company, 1877.

Williams, Hermann Warner, Jr. *The Civil War: The Artists' Record.* Boston: Beacon Press, 1961.

Williams, T. Harry. *P. G. T. Beauregard: Napoleon in Gray.* Baton Rouge: Louisiana State University Press, 1954.

Wilson, Charles Reagan. *Baptized in Blood: The Religion of the Lost Cause, 1865–1920.* Athens: University of Georgia Press, 1980.

Wilson, Edmund. *Patriotic Gore: Studies in the Literature of the American Civil War.* New York: Oxford University Press, 1962.

Wilson, James Harrison. "How Jefferson Davis Was Overtaken." In *The Annals of the War Written by Leading Participants North and South.* Philadelphia: Times, 1879.

Wilson, Martin L. "The Early-Lost Lamented Latane." *Virginia Country's Civil War* 1 (1983): 12–15.

Wilson, Rufus Rockwell. *Lincoln in Caricature.* New York: Horizon, 1953.

Woodward, C. Vann. "Gone With the Wind." *New York Review of Books,* July 17, 1986, p. 4.

————. *Origins of the New South, 1877–1913.* Baton Rouge: Louisiana State University Press, 1971.

————, ed. *Mary Chesnut's Civil War.* New Haven: Yale University Press, 1981.

Woodward, C. Vann, and Elisabeth Muhlenfeld, eds. *The Private Mary Chesnut: The Unpublished Civil War Diaries.* New York: Oxford University Press, 1984.

Wright, Mrs. D. Giraud. *A Southern Girl in '61: The War-Time Memories of a Confederate Senator's Daughter.* New York: Doubleday, 1905.

Wright, R. Lewis. *Artists in Virginia before 1900: An Annotated Checklist.* Charlottesville: University Press of Virginia, 1983.

Wyatt-Brown, Bertram. *Southern Honor: Ethics and Behavior in the Old South.* New York: Oxford University Press, 1982.

Young, John Russell. *Around the World with General Grant.* 2 vols. New York: American News Company, 1879.

Younger, Edward, ed. *Inside the Confederate Government: The Diary of Robert Garlick Hill Kean.* New York: Oxford University Press, 1957.

Index of Illustrations

Italic numbers give the location of the illustration; other references are to discussion in the text.

General Index

The names of printing and publishing firms appear in small capital letters. The titles of prints that are discussed but not illustrated are given here; all references to the illustrated prints are to be found in the preceding Index of Illustrations.

speech, 37; and Volck, 47; and Lee, 59; flight and capture of, 79–96, 175, 219; autobiography of, 82–83, 86, 94; imprisonment of, 169–73, 179, 186; as a martyr, 170–82, 223; release from prison, 173–75; inauguration of, 175; family of, 182–86; as an elder statesman, 186–89; death of, 190; and Joseph E. Johnston, 191–92; and Beauregard, 196, 197
Davis, Sarah Taylor, 182
Davis, Varina Howell, 14, 15, 18, 47, 82, 86, 93–95, 172, 173, 182
Davis, William M., 169
Davis, Winnie, 172, 182
Davis administration, 17–18, 100, 196
Deathbed scenes, 130, 150
DE LA RUE, THOMAS, COMPANY, 8, 48
Democratic party, 143
Detailed Minutiae of Soldier Life in the Army of Northern Virginia (McCarthy), 216, 219
Detaille, Edouard, 140, 206, 212
DeVoto, Bernard, 223
Diderot, Denis, 206
Dietz, August, 8
Douglas, Henry Kyd, 130–33
Douglass, Frederick, 100–101
Ducross, M. T., 214
Duncan, Blanton, 31
DUNCAN, B., AND COMPANY, 196
DUNN, GEORGE, AND COMPANY, 36
Dunn, Oscar J., 101
Durham, N.C., 192
Duval, Pierre S., 75

Early, Jubal A., 157
ECKHARDT, LOUIS E., AND BROTHERS, 53
Ellis, Gray, 106
Emancipation Proclamation, 173, 182, 186
English Civil War, 107
Engravers, scarcity of, 6
Eno, Henry C., 117
Episcopalianism, 45
Equestrian portraits, 15, 24, 129–33, 154, 157–59, 196, 204
European printmaking, 7, 18, 21, 48, 62, 67, 117, 140, 154, 194, 197, 201, 207, 209
Euston, B. B., 154
Evans, Charles T., 117
Ewell, Richard S., 122, 201
Extortionists, wartime, 37

Fabronius, Dominique, 101
Family portraits, 126–29, 147, 157, 182–86
Farragut, David G., 3, 5
Ferguson, P. H., 106
Ficklin, Major, 6
Fifteenth Amendment, 100
Fifty-fifth Virginia Volunteers, 213
Fifty-ninth Virginia Volunteers, 210
First Maryland Cavalry, 213, 216
Flags, Confederate, 8, 11, 103; color bearers, 214, 216
Forney, John W., 108–9, 116
Forrest, Nathan Bedford, 101, 201, 205
Fort Donelson, 113
Fortifications, pictures of, 210–12
Fort McHenry, 47
Fort Pillow, 201
Fortress Monroe, 95, 169–73, 179, 223
Fort Sumter, 6, 14, 23, 30, 103, 196
Forty-sixth Virginia Volunteers, 210
Frank Leslie's Illustrated Newspaper, 23, 26, 83, 190
Frederick, Md., 116–17
Fredericksburg, Battle of, 31, 66, 68, 112
Freeman, Douglas Southall, ix, xiii, 58
Fremantle, Arthur, 5, 31
Frietchie, Barbara, 116–17

Gardner, Alexander, 94, 157
Garfield, James A., 182
Garrison, William Lloyd, 143
Genealogical History of the Lee Family (Mead), 147, 148
General Stuart's Raid to the White House (Volck), 48
Georgia: secession of, 11
Germany, 223
Gettysburg, Battle of, 30, 36, 66, 204, 214
GIBSON AND COMPANY, 170
Gifford, Sanford Robinson, 207
Giles, J. L., 201
Girardet, P., 154
Gladstone, William, 169
GOUPIL ET CIE, 18, 154, 194, 197, 201, 207
GRAHAM, A. B., COMPANY, 163, 194
Grant, Ulysses S., 55, 106, 138, 154, 175, 192, 205; on Appomattox, 68, 74; portraits of, 69–78, 100, 101, 139, 182, 208; on Jackson, 116; and Lee, 143, 145
Grasshopper, The: A Humorous Cantata (Volck), 53
Grave scenes, 135, 143